THE ART OF THE WEST

Phaidon Press Limited, Littlegate House, St Ebbe's Street, Oxford,
OX1 1SQ

First published 1963
Third edition (photographically reprinted) 1980
© Phaidon Press Limited 1963

Original French text *Art d'Occident* first published by Librairie
Armand Colin, Paris

British Library Cataloguing in Publication Data
Focillon, Henri
 The art of the West. – 3rd ed. – (Landmarks in art history).
 2: Gothic art
 1. Architecture, Medieval – Europe
 I. Title II. Art of the West in the Middle Ages
 III. Series
 723 NA350

ISBN 0-7148-2100-4

Printed in Great Britain at The Pitman Press, Bath

CONTENTS

Gothic Art

cathedral workshops in the first half of the thirteenth century.—The Praxitelean age of Gothic sculpture. Parisian art and urbanity. Evolution of frames and figure types. The fourteenth century Virgins. The arts of luxury.—Funerary portraiture.—Diffusion in France: the Midi of the Rhône and the Midi of Toulouse. The Flemish problem. IV. Gothic Italy. Imperial obsession and Tuscan atticism.—Spain: vitality of the Romanesque tradition, French influences.—Germany, the Saxon School. Bamberg, Naumburg.—Originality of English sculpture. The monumental settings. The delicate figurines. The alabasters. Bibliography.

CHAPTER IV

GOTHIC PAINTING OF THE XIII AND XIV CENTURIES

PAGE 110

I. Two kinds of painting in the Middle Ages. Imitating light. Utilising light.—The French stained glass windows. Origins and first workshops. Saint-Denis—Influence of the Chartres windows in France and England. The Parisian glass-workers. Sainte-Chapelle. The rose-windows.—The fourteenth century. The grisaille windows. Technical innovations. Evolution of the style. II. The greatness of monumental painting in Italy. Dante's 'cathedral'. Italian painting prior to Giotto. Byzantine art in Tuscany: Cimabue. Roman pontifical art: Cavallini. Popular art, from the exodus of the Syrian monks to the first Franciscan icons.—Giotto and St. Francis. Giotto's art imparts a form to Franciscanism.—The difference between Giotto and his followers.—The Sienese. Tuscan orientalism. Expansion of Sienese art in Bohemia, Catalonia and Avignon. III. French painting. Evolution of wall painting in a new setting and under the influence of the glass painters. The monumental style in profane painting. The 'painted chambers', scenes of combat.—Devotional paintings.—The French miniature. The canons of Winchester and of Villard de Honnecourt. The architectural framework in the thirteenth century. Jean Pucelle. The camaieu. Invention of the printed picture.—New research at the end of the century on the rendering of space. Jacquemart de Hesdin. Jacques Coene, the Limbourg brothers. Bibliography.

The Close of the Middle Ages

CHAPTER V. THE SPIRIT OF FANTASY: GOTHIC BAROQUE

PAGE 139

I. The historical basis for the decline of the Gothic civilisation. The last movements of population.—The romantic spirit. The romance of God: the mystics. The romance of the devil: sorcery. The romance of destiny: astrology. Nostalgia for chivalry and classical antiquity.—Curiosity; the royal amateurs: Jean de Berry.—The spirit of fantasy and theatrical vision. II. The break up of architectural equilibrium. The *Flamboyant* style. The reversed curve and its origins: internal evolution or importation from England. Movement and colour. Play of effects rather than structure. Transformation of the vaults. Illusionism which conceals the masses. A pictorial art. Reappearance of Romanesque forms in decoration.—The French groups. The European groups. III. Civil architecture, towns and dwellings. Uniformity of the stylistic evolution. The half-timbered house. The castle. The city dwelling. The staircase tower. The house of Jacques Coeur. Bibliography.

CHAPTER VI. SLUTER AND VAN EYCK

PAGE 160

I. Sculpture under the influence of painting. The great Burgundian dukes and their milieu.—Sluter's antecedents. The Portal of Champmol. The tombs, the funerary liturgy. The Fountain of the Prophets. Moses.—The Sluterian workshops. The Burgundian Virgins.—Sculpture increasingly independent of architecture. The retables, influence of painting and the theatre. The sepulchres and *tableaux vivants*. The *Pietà* groups, religion and sorrow. II. Painting creates a new world. Pre-Eyckian experiments in miniature painting. Tardy development of panel painting.—Van Eyck, the new medium and modern pictorial material. The poetry of Van Eyck, the microcosm. Composition. Analytical genius in the study of the world and man. III. Rogier van der Weyden and the monumental style. A sculptor in painting. Use of the tympanum composition.—The Flemish schools and their masters. Tapestry.—Jerome Bosch. The reverse side of the Middle Ages. Destruction of the microcosm. The Anticosmos. Reintroduction of monsters. The fantastic landscape. IV. Flemish expansion. Germany prior to the influence of Van der Weyden: Westphalian art, the Hanseatic artists, the style of Cologne. Suddenness of the metamorphosis. Southern Germany. The Rhineland. The force of German draughtsmanship: Schongauer. The great cities of the Church councils. Witz. The Austrian primitives.—The Iberian groups and the Flemish vogue in Castile, Catalonia and Portugal. V. French painting. The 'Flemish' zone. Diversity of the centres, constancy of the influence.—The Parisian tradition. Western France. A return to the past, the *Rohan Hours*.—Southern France, Avignon, the 'tympanum painters'.—The Loire, Fouquet, his antecedents: the sculptors of the royal workshops. The monumental style in French painting.

CHAPTER VII

THE MEDIEVAL ASPECT OF THE ITALIAN RENAISSANCE

PAGE 191

I. The Middle Ages (in Italy) already a *Renaissance*. Gothic culture and Roman nostalgia. Historical factors common to Italian and Western culture. II. Persistence of medieval elements in Quattrocento painting, mingled with awareness of the new research of the Albertian group. Medieval origins of perspective. Uccello's battle and equestrian paintings. The illusionistic technique. III. The new forces. Tuscan architecture.—Return to the monumental style in painting. Masaccio.—Fusion of Gothic vitality and antique inspiration in sculpture. The medieval legacy and Tuscan Atticism safeguard Italian art in the fifteenth century. Bibliography.

CONCLUSION

Western Art. Traditions, influences, experiments. Pre-Romanesque Orientalism, Romanesque Orientalism. The new spirit. Influence of the Middle Ages on succeeding generations.

NOTE

The present edition of Focillon's text includes all the author's original annotation and bibliography. The Editor's additions to footnotes and bibliography are marked with an asterisk *. The Editor wishes to thank MM. André Chastel and Louis Grodecki for their kind assistance with some of the additional annotations. The numbers in the margins refer to the illustrations, which are grouped together in the plate-section following the text and which have been selected and arranged by the publishers.

Gothic Art

CHAPTER I

First Gothic Art

I

IN the first years of the twelfth century, there appeared in France—in the Midi, in Anjou, north of the Loire, and particularly in the *Domaine Royal* of the Capetians—a new structural member which proceeded, by a sequence of strictly logical steps, to call into existence the various accessories and techniques which it required in order to generate its own architecture and style. This evolution was as beautiful in its reasoning as the proof of a theorem. Everything that sprang from the vault rib—in the course of a few years, rather less than two generations—revealed the consistency, continuity and vigour of a closely reasoned argument. Its initial appearance was not made in the Paris area. But it was there that architects first drew the inevitable conclusions from it, by which, from being a mere strengthening device, it became the progenitor of an entire style. This logical progression, however, was based on a great number of experimental results. In order fully to understand the Gothic art of the twelfth century, its vitally experimental character must be borne in mind. One may say that the twelfth century was the great age of the Gothic experiments, just as the eleventh had been that of the Romanesque experiments, and like the latter, it eventually produced a clearly defined style, which remained Romanesque in its masses and, to some extent, in its equilibrium, but which was Gothic in structure. The first half of the thirteenth century carried still further the systematic application of the first principles and, having finally abandoned the Romanesque type of great church with tribunes, it went on to develop the consequences of the vault rib to their ultimate conclusion; the *Rayonnant* (Radiating) style refined upon the earlier solutions; while at the end of the Middle Ages their meaning was forgotten and their functions misapplied by the masters of the *Flamboyant* style.

Whence came the vault rib? We have already seen what endless avenues of research and hypothesis are opened by this question. If the principle was derived by the Christian architects from the ribbed domes of the Arabs, then the discredited theory[1]—based on a false appreciation of the functions of the vault rib and the pendentive—according to which the domes of western France

[1]Expounded by E. Corroyer, *L'architecture romane*, Bibliothèque de l'enseignement des Beaux-Arts, Paris, n.d.

played some part in its early history, would require to be re-examined. There are traces and occasional examples of the existence of the vault rib in Lombardy at an early date. It made a precocious appearance in Normandy and England. In its archaic forms it was of heavy section and simple profile. Its chief function may originally have been, not the covering of naves and ambulatories, but the reinforcement of domes (Quimperlé) and upper storeys (Bayeux, north tower), or in porches and crypts. The vault ribs of the Moissac porch and some others of the same type in southern France also belong to this class. But its future lay elsewhere, in the vaults of naves and aisles. Hence the importance of Durham. The immediate, if not the ultimate, source was Anglo-Norman, as is shown by its arrival in France, that is in the Ile-de-France, in association with alternating supports, tribunes, and a repertory of geometric ornament. Though it is true that it was tried out in other regions also, it was from Normandy that it was introduced into the *Domaine*, there to initiate a style which in turn outgrew its cradle and once again sought wider horizons.

The facts of history help us to understand why it chose the Paris area above all others and why, at this time, the centre of gravity of the great innovations shifted back to the north. The Ile-de-France had never possessed its own version of the Romanesque style, or, if you prefer, its own school; in general, it had remained faithful to the older schemes, to the wooden roof, and to heavy piers supporting arches which cut sharply into the wall; its Romanesque style, when it appeared, was the Gothic style. It passed almost without transition from an archaic form, which had been discarded long since in Burgundy and Languedoc, to a new and youthful form which rapidly outdistanced them all. This synchronism of Romanesque and Gothic art is vital to the proper understanding of their interrelationship and of the Romanesque significance of the Gothic beginnings. In other words, in this region where it developed with such speed and such unshakable audacity of conception, one of the fundamental advantages which the new style possessed lay in the fact that it was not called upon to overthrow an established classic form which already gave unified expression to the regional spirit. It had no predecessor, furthermore its experiments took place in a restricted area, centred on the old county of Clermont and radiating out along the valleys of the small tributaries of the Oise and the Aisne; they reacted one upon another, happy in their possession of a small and compact setting which was also royal land. We have touched on the obscure beginnings and the desperate politics of the Capetian dynasty. It owed its existence to the assent of the Church, and looked favourably on ecclesiastical foundations; in the early struggles for the unity of its dominions, it had relied on the people of the parishes, and the goodwill

which it showed towards the communes (a quality with which these feudal rulers were not always lavish) was again an instrument of policy. Hence it is significant that the development of Gothic art was closely linked with urbanism. The spiritual fervour of the pilgrimages did not, of course, die out in northern France in the twelfth century, and we shall see that the first French ribbed vault was connected with a translation of relics. But the primary expression of Gothic art lay in the cathedrals, and though it is true that there are great Romanesque cathedrals just as there are great Gothic abbeys, this sort of axial displacement, which resulted in the most important foundations being located in towns, must not be overlooked. To concur in this does not entail a resuscitation of Viollet-le-Duc's 'municipal' theory. From this time forward it becomes important to know whether the towns possessing the churches were populous and rich in resources, and whether safe roads existed for the carriage of materials from good quarries to the building sites. The people took a share in these immense enterprises and straggled down the roads from far and near to bring their offerings. The townsfolk did likewise. But it will not be forgotten that the first chapter of the history of Gothic art begins and ends with abbeys—with Morienval and Saint-Denis. These monastic origins linked it with Romanesque art, and its most active disciples in the rest of Europe were the monks of the Cistercian order.

It grew and increased with the Capetian strength, in close-packed towns, under energetic bishops. But in the combination of circumstances which favoured it, there was something more—a quality of mind which, here more than elsewhere, was capable of logical thought and the realization of its own potentialities. A spirit so swift to draw consequences could not fail to make its mark. These thoughtful workmen attained an epic plane, but only by the daring of their calculation of forces and the rapid and closely reasoned sequence of their experiments. Gothic art, so long thought of as mysterious and chaotic, was in fact based on an orderly and crystal-clear thought and on a practical ingenuity, which were regional characteristics. No doubt its whole future was implicit in the single proposition of the vault rib, leading to the distribution of thrusts, the subdivision of the vault and the independence of parts—but the conclusions had to be drawn. The Burgundians, chafing against a system which they endeavoured to lighten by means of the pointed barrel and the groined vault, might have done this; they were among the first to utilize the vault rib, but they were conservative as well as progressive, they were loath to give up the grandeur of their Romanesque art, and when they eventually came to terms with the French type, they received the essential decisions ready-made.

The earliest manifestations of the French vault rib must be looked for in the Norman lands at the end of the eleventh century and the beginning of the twelfth: Durham and the contemporary English rib-vaulted churches[1] presuppose earlier experiments. But it is around Paris, in the secluded valleys of the countryside of the Oise and the Aisne[2], where narrow streams flow amid a forest solitude, that examples are most numerous, and it is there, above all, that they proclaim the advent of a new style. Lefèvre-Pontalis' classic study of the religious architecture of the old diocese of Soissons, and the numerous monographs which supplement it, have established the principal facts. For this area, so rich in its future development, the starting point was Morienval[3]. In earlier days Dagobert had founded there an abbey of nuns. At the end of the eleventh century, it was a fine Romanesque church of solid-looking masses, with three parallel eastern apses and two towers; the introduction of the ribbed vault altered neither its external features, nor its silhouette. The remodelling of the sanctuary and east end was doubtless prompted by the translation of the relics of St. Annobert in 1122[4]. Thus in the Ile-de-France it was the semi-circular ambulatory which saw the first rude and simple applications of the new organ of structure which was to become the principle of a style. These unknown masons who first set the vault ribs of Morienval and the other churches of this area stood at the source of the French cathedrals. In this instance, a thick toric rib, of insignificant span, springs from Norman-style capitals of a puritanical poverty of carving; the abacus projects strongly. It has the appearance of a workshop device, cautiously applied to a limited programme. But the principle was established; the articulated vault had replaced the homogeneous vault. The rib made some headway in the churches of this area. One may say that it attacked the vital point from the very first; and it was again in the semi-circular ambulatory that the architect of Saint-Denis (1137–44) was to produce his masterpiece. But the importance of this latter building must not disguise from us the significance of some earlier, contemporary and slightly later experiments—the oldest parts of Saint-Étienne

[1]The dates are not undisputed. See R. de Lasteyrie, *Architecture religieuse en France à l'époque gothique*, p. 31, regarding the vaults of Durham, Winchester (after 1107), Peterborough (1118), Gloucester (between 1100 and 1120), etc. *The nave of Gloucester should be placed after 1122.
[2]This was the heart, but the Ile-de-France was more extensive, comprising Gâtinais, Hurepoix, Brie, Mantois, French Vexin, Beauvaisis, Valois, Noyonnais, Soissonnais, Laonnais and Parisis. See Auguste Longnon, Mémoires de la Société de l'histoire de Paris, I, p. 1, and R. de Lasteyrie, *L'architecture religieuse en France à l'époque gothique*, I, p. 7.
[3]The ribbed vault of the tower of Auvillers, near Clermont-en-Beauvaisis, sometimes attributed to the eleventh century, was remade later. That of the south aisle of Rhuis is hard to date.
[4]On the chronology of the ribbed vaults of the ambulatory and the choir, see the account by Brutails, Congrès archéologique de Beauvais, 1905, and the articles by E. Lefèvre-Pontalis and J. Bilson in the Bulletin monumental, 1908 and 1909.

at Beauvais[1], Saint-Martin-des-Champs[2] and Saint-Pierre de Montmartre in Paris (1137–47), the apse of Saint-Maclou at Pontoise and the porch of Saint-Leu-d'Esserent (about 1150), and, in Vexin, the long-disputed march between the Normans and the Capetians, Saint-Germer-de-Fly (where a kind of western transept survives) and the church of Villetertre, with Romanesque capitals of rustic vigour.[3] In these the architects began to study the various problems raised by the vault rib, relating to its function, its form, and its auxiliaries.

What is the actual function of the vault rib? Does it support? Does it uphold or relieve the vault? Is it an indispensable component or a mere reinforcement? Or is it no more than a mask for the intersection of planes in the groined vault, possessing a purely formal significance as the prolongation into the vaults of the design and profile of the piers, and of no further consequence to a system in which the thrusts are already distributed to the angles of the vault severy by the groins, and in which the stone covering has no need of additional support? For Viollet-le-Duc and for Choisy, the rib supports, and from this fact follows, as an inevitable consequence, the whole of Gothic structure, which works in an entirely rational way. For more recent authorities, and especially for M. Pol Abraham, whose criticism is delivered with trenchant severity, the rib does not support the vault, nor does the flying buttress resist the thrust. The whole system is purely formal, but by a kind of illusionism persuades the eye that the shafts and ribs are the essential structure.[4]

In this discussion, which is not pure archaeology, but is primarily concerned with the definition of an idea, we must pay particular attention to the history of the forms, as well as their technical analysis. The earliest experiments with the true vault rib show that it was beyond doubt conceived to exercise the function of

[1]South aisle, unaltered (but recently restored), built about 1130 or even, according to some authorities, between 1110 and 1120, by analogy with Saint-Lucien at Beauvais (which was, however, unvaulted), now destroyed but supposed to have been built from 1090 to 1109.

[2]According to E. Lefèvre-Pontalis, Congrès archéologique de Paris, 1919, p. 106, the chevet of Saint-Martin-des-Champs was built by Abbot Hugues I (1130–42).

[3]These churches are of uncertain date. The fine church of Saint-Germer was rebuilt, according to R. de Lasteyrie, op. cit., p. 17, following a donation of relics in 1132, but it is of superb assurance of style and certainly later than Saint-Denis. The church of Chars, a reduction to rural scale of the great cathedrals of the Domaine, is still later. According to C. Enlart, Monuments religieux de la région picarde, pp. 11 and 132, Notre-Dame at Airaines and the church of Lucheux, in Picardy, date from the years 1140–50.

[4]Recent writings in which this problem is raised and discussed are the following: V. Sabouret, L'évolution de la voûte romane du milieu du XIe siècle au début du XIIe, Le Génie Civil, 1934; P. Abraham, Viollet-le-Duc et le rationalisme médiéval, Paris, 1934, summarized in the Bulletin monumental for the same year, under the same title; by the same author, Nouvelle explication de l'architecture religieuse gothique, Gazette des Beaux-Arts, 1934; M. Aubert, Les plus anciennes croisées d'ogives, leur rôle dans la construction, Paris, 1934; H. Focillon, Le problème de l'ogive Bulletin de l'Office international des Instituts d'archéologie et d'histoire de l'art, 1935, and P. Abraham's reply in the same periodical and the same year; H. Masson, Le rationalisme dans l'architecture du moyen âge, Bulletin monumental, 1935.

support. The vault ribs of Armenia, thick, solid, and well built, form a complete and organic system, carrying sometimes heavy stone barrel vaults, sometimes the domed lower section of compound vaults, and sometimes (with the aid of walls built on top of the ribs) flagged ceilings. This technique, in which the structural function of the rib is beyond all doubt, is exactly reproduced in Western Europe, in military architecture at Étampes[1] and in religious architecture at Casale Monferrato. But examples of the use by Western architects of ribs carrying walls on the extrados, or ribs sprung from the mid-points of the sides and not from the angles of the vault severy, are far more numerous than that. For a long period, extending considerably beyond the initial stages, the rib was utilized as a support wherever an additional load increased the weight of the vault, as in porches and towers, at Bayeux, Saint-Guilhem, and Moissac. In the Saint-Aubin tower at Angers its decorative and formal possibilities are disregarded to the extent of concealing it behind a dome. The early Lombard ribs, which perhaps combined Oriental influence with the classical tradition, support domical vaults over square bays.

These are the essential elements of the first chapter of the development and must not be forgotten. The vault rib was an invention of the stone-mason. It was devised as a structural feature—though with formal potentialities which in Armenia were turned to remarkable advantage—and it was as a structural feature that it made such rapid progress abroad. But although the Oriental vault rib contributed by precept and experience to the diffusion or development of the new mode of vaulting, it did not succeed in exporting its highly original system *as a whole* to the West. It came into conflict with a conception of architecture which preferred to extend its buildings rather than to group the parts in a concentrated block, and with the old and powerful technique of the groined vault. In theory, the latter possesses all the advantages of the ribbed vault; it distributes the thrusts to the four angles of the bay, which alone require buttressing, and permits, by the piercing of windows in the wall-lunettes, the admission of direct light to the nave without compromising the solidity of the walls. It is thus perfectly reasonable to ask whether the ribbed vault is not simply a decorative version of the groined vault.

This is the position of those who assail Viollet-le-Duc's thesis. According to them, the rib is a formal element, intended to suggest an illusory structure. It does not support, any more than does the transverse arch. Its practical value is nil, since the groin, wherein the diagonal pressures are concentrated, is virtually an arch in itself. Nor is it possible to maintain that it braces the vault while the masonry is settling, since such a conception conflicts with the fundamental

*[1] See J. Baltrusaitis, *Le problème de l'ogive et l'Arménie*, Paris, 1936.

principle of the resistance of materials.[1] It is sufficient to compare the slenderness of its section with the frequently enormous thickness of the vaults, to realize how impossible it would be for it to support them. An additional proof of this is provided by war-damaged buildings in which the vaults have sustained violent shocks and nevertheless remained *in situ*, whereas the ribs have fallen. It is, however, admitted that the latter were not without value while the building was under construction, since they allowed the architect to establish in stone the main lines of his vault at a time when stereotomy was conducted by rule of thumb, and workshop geometry was the only aid.

Let it be observed at once that this admission is an extremely important one. This was something more than a convenience, it was a guarantee of the future of the penetration systems which were invented in great variety by the Gothic architects—the V-shaped vaults of the ambulatory of Notre-Dame in Paris, the triangular severies of Le Mans and Toledo, the trapezoidal severies, the combined vaulting of chapels and ambulatory, as at Soissons and Bayonne, and even, at an earlier date, the five-branched vaults of the radiating chapels of Saint-Denis. But these results could have been obtained with wooden centring. Why then go to the extra trouble and expense of stone centering? Did these arches or ribs really have no advantage other than the graphic value which facilitated the construction of difficult vaults? One may suggest first of all that the transverse arch, whose position is practically immaterial—the springing of the Romanesque barrel vault being continuous—is an improper parallel for the rib. The Romanesque transverse arch, which metrically divides the bays, underlies the vault at a point of no special significance and at right angles to the main axis; the rib lies diagonally, beneath a critical region. Critical, because it is the place where the essential pressures are located, which make the groin a virtual incorporated arch. But, that being so, was the relationship between these two arches of the same direction, the same span, the same profile—the one being simply the plastic expression of the other—really nothing more than a pleasing re-duplication? In fact, the development from a spontaneous diagonal arch to a rationally conceived diagonal arch was a very considerable step forward. The rib gave form, emphasis

19

[1] The fundamental principle of the resistance of materials is that of the conservation of plane sections. See P. Abraham, *Viollet-le-Duc et le rationalisme médiéval*, Paris, 1934, p. 48. 'In a homogeneous section such as that comprised by the rib and the vault, the work done varies in a constant ratio, the rib and the vault are subject to stresses of the same magnitude, and it is impossible for the former to discharge the latter of a portion of its load. Moreover, vault and rib are constructed with the same mortar, and in each case the limit of resistance depends on the power of the mortar to withstand compression.' But while the masonry is settling the work done by the rib and by the vault can be neither equal nor simultaneous. As the arch is built before the webs of the vault, its mortar must be set sooner, and its settling completed earlier. In addition, the materials, size and working of the masonry are different.

and—more important—strength, to the *place* where the main pressures were located, following a line of development whose intermediate stage must have been the rib tailed into the groin and working with it.

As for the phenomena of the settling and bracing of the vault, which throw light on another structural function of the rib, they may be summarized thus: the rib, settling less than the masonry of the vault cells, forms in the body of the vault a bracing element, which takes a portion of the load and converts it into thrust. The reason for this is that the materials of cells and ribs are not identical; the latter are more resistant, better constructed, and admit of less play. The objection of the thickness of the vaults in relation to the relative slenderness of the ribs (as at Reims, the thickest of all cathedrals) is valid only if the mass of the materials is invariably proportionate to their volume. In an old Romanesque church like Saint-Martin du Canigou, formidable vaults rest on spindly columns which seem relatively quite inadequate. Must one therefore conclude that they do not support the vault? Finally, although some ribs have fallen from vaults which are otherwise intact, are there not also many examples of ribs which remain intact despite the collapse of their vaults?

Let us look again at the historical facts. If the groined vault offered the same advantages as the ribbed vault, why was it so rarely used over naves, except for a few limited groups, such as the so-called Martinian churches of the Vézelay type, and the earliest Norman vaults, which remain hypothetical?[1] And if the rib was primarily formal, and intended simply to extend the pier-design into the vaults, why then was it adopted and propagated so widely by precisely those architects who were antagonistic to decorative effects and most insistent on the preservation of mural values even in the piers themselves—the Cistercians?

Thus the conception of the rib as a support, which is vindicated by the study of the earliest buildings in which it was used, retains its significance in the Gothic system itself. Viollet-le-Duc's doctrine is not a mere intellectual mirage. But to say that the Gothic system was a dialectic is to acknowledge implicitly that it was based on the development of forms, for architecture is dialectical by virtue of the progressive harmony and calculated interaction of its parts. This dialectic did not inhabit the regions of pure thought. It advanced, and extruded itself into history, by experimentation. Its creation and deliberate rejection of numbers of architectural monsters, with small prospect of survival, demonstrate the liberality of its researches and the firmness of its purpose. Despite errors of

*[1] No nave seems to have been vaulted in Normandy before the adoption of the rib-vault, c. 1120. But eleventh century naves with groined vaults are found in the Pyrenees, in Northern Italy and in the Rhineland. In England the small group analysed by C. Lynam, *The Nave of Chepstow Church*, Archaeological Journal, LXII, 1905, p. 270 ff., belongs to the early twelfth century.

calculation, or rather of foresight, these were undoubtedly the lines along which the medieval architect worked. And even if one admits that the strictness of the system disintegrated earlier than is generally thought, it remains true that his conception of the cathedral was that of Viollet-le-Duc.

The cathedral, however, was not a conception only. It was not an inference from the drawing board. It was an intellectual order, but it addressed itself to the sense of sight, and the vault rib also was intended to be seen. It replaced an apparently undifferentiated system, equilibrated by its mass and weight, by a complex visible skeleton, and relationships of light and shade which tended to become increasingly graphic. The germ of the linear architecture of the *Rayonnant* style was already present in Saint-Denis, Laon and Noyon. To disregard the part played by the formal elements—and the illusory effects—would be an error as serious as the definition of a building by its plan alone. The vault rib is a constructional, a structural, and a visual factor.

The problem of its profile is no less important than that of its function; it has been authoritatively discussed in all its aspects by John Bilson. It may be examined from the point of view of the height of the crown of the transverse arch as compared with that of the rib, in a vault-severy of square plan. If both transverse arch and rib are semicircular in profile, then the transverse arch, which spans the bay from side to side, will not rise so high as the rib, which spans it diagonally, since the side of a square is less than its diagonal. In other words, the height of the crown varies with the diameter of the arch. In this case, the vault is concave or domed, with a variation in the level of the keystones which may be quite considerable, and is so, indeed, in the earliest ribbed vaults, although it is even greater in the domical vaults, which are characteristic of the work of the architects of Anjou. In order to equalize the level of the keystones, and to rid the nave of the uncomfortable vista of domed vaults, all cut off and depressed by the intervention of the transverse arches, it was necessary either to raise the transverse arches, or to lower the ribs by giving them a segmental profile. The evolution proceeded from the domical vault to the segmental vault, and later from the square to the oblong plan.

As to the problem of the auxiliary members, the solution of the formeret or wall-rib was arrived at very quickly,[1] that of the flying buttress more slowly and

[1] The formeret or wall-rib was common in groined vaults in Italy from c. 970 and in Germany from the beginning of the eleventh century. It was not used in Normandy but is found in England after 1080. It appears in rib-vaults in the aisles of the nave at Gloucester cathedral soon after 1122. In France, after the groined vaults of Vézelay (1120) and of the Chapel of St. Aignan in Paris, it is used from c. 1135 in the rib-vaults of the Paris group of proto-Gothic buildings: north-west tower of Chartres cathedral, narthex of St. Denis, choirs of Saint-Martin-des-Champs and Saint-Pierre de Montmartre, etc.

by a curious sequence. The function of the formeret is not only to ensure a harmonious junction of the vaults and the side walls, but also to relieve the latter by supporting part of the weight of the vault cell. The formeret is a kind of lateral transverse arch. No transverse arch is indispensable. There are numerous examples of longitudinal barrel vaults and even of groined vaults without transverse arches (aisles of Saint-Savin). It is therefore not surprising that the ribbed vault in the beginning 'worked' perfectly well without formerets. But once their relieving function was appreciated, the wall lost its importance and became a thin partition. From that time forward it welcomed windows since they no longer endangered stability, until eventually the architect of Chartres carried the development to its logical conclusion by suppressing the upper walls altogether and replacing them by immense sheets of glass with the formeret supplying their upper termination.

The flying buttress likewise was not an immediate requisite. It was necessitated by high naves and wide windows. Its systematic employment was a late phenomenon. The equilibrium of the rib-vaulted churches was at first the Romanesque equilibrium—tribunes, and more or less massive buttresses with more or less numerous offsets. The rib-vaulted tribunes counteracted the arches of the nave with a system of lateral arches, thus providing a solution analogous with that of the half-barrel vaults of Auvergne, but more complex, which demanded great solidity and very meagre apertures in the upper walls. It was soon realized, however, that the critical points, against which the main thrusts were delivered, required special buttressing which the tribune arches were inadequate to supply.[1] They were supplemented first of all by buttress walls, which were hidden beneath the roofs and pierced by doorways to permit circulation. Laon, where they were discovered by Boeswilwald, the Cistercian abbey of Pontigny, and Notre-Dame in Paris, possessed in this way a first draft of the developed system of buttressing by means of buttress walls. But a wall built in horizontal courses does not act in the same way as an arch. The stroke of genius was not to bring the flying buttress out from under the roofs where it still lay hidden (as at Durham and the destroyed church of Saint-Évremond at Creil), but to conceive it in the arch form. From that moment the structure was complete. The flying buttress rose higher with the naves, it met the thrusts at their point of impact, or rather it sought for it empirically, or developed double flights, and linked them together, as at Chartres, with reinforcements like the spokes of a wheel; to guard against buckling below the point of impact, the wall was braced and strengthened

[1] Above the tribunes of Saint-Germer, the thrust of the vault is countered by a quadrant arch carrying a wall on the extrados.

by the insertion of a column *en délit*.[1] These remarkable systems of external struts, which are themselves upheld and counteracted by enormous free-standing buttresses, attained colossal development, so that the cathedral naves are surrounded by a kind of secondary volume, a sort of cage, in which both the oblique and the vertical directions are strongly stressed.

But this was the classic termination of a developed technique in full possession of its resources. The inferences follow so naturally and rapidly one from another, that even when one's aim is the exposition of the initial researches, one's thought runs on beyond them and is led inevitably to encompass the whole evolution. But in order to understand the Gothic architecture of the twelfth century and perceive the ways in which it differed from that of the next period, we must forgo this anticipation of our theme and restrict ourselves to the matter in hand. Though it is true that in its most sublime creations, for instance at Laon or Noyon, its structural solutions foreshadowed the future, it remained Romanesque in its feeling for mass, in the role assigned to the walls, in its equilibrium, and in its conception of the elevation and the supports. By bringing the ribbed vault into association with these factors, it was able, before the middle of the century, to create the masterpiece of Saint-Denis.

II

SAINT-MARTIN-DES-CHAMPS and Saint-Denis were contemporary, but whereas the former betrays, by the extreme irregularity of its plan and the purposeless variety of its rib systems, either an unfavourable site or an imprecise quality of thought, the latter, despite the alterations made by Pierre de Montereau, proclaims the stature and originality of the talent which was able to distil from the structural functions of the rib the essence of a truly architectural conception. Nave and transept are in the exquisite *Rayonnant* style of the time of St. Louis—a three-storey church, full of windows, replacing the earlier church, which must have possessed tribunes; but the narthex, and more particularly the choir, which are more than a century older (work was begun in the summer of 1129), are of much greater significance. The radiating chapels project only slightly from the apse, and the monostyle columns which stand in front of them form an additional colonnade around the east end, reduplicating the ambulatory with its trapezoidal bays. Each chapel has two windows, one on either side of a

[1] *i.e.* with the bedding lines of the blocks running vertically, to give additional strength.

supplementary rib—for there is a fifth branch which rises from a console between the windows up to the central keystone of the vault. The use of columns instead of solid walls seems to have been a device for the more advantageous display of the stained-glass windows, whose numbers had been doubled by the use of the supplementary rib.[1] In this way the problem of lighting, which had so long been conditioned by the wall, found one of its happiest solutions through the new treatment of structure. The rapidity with which this idea was taken up is a measure of the importance and the superiority of the prototype. It became a classic solution. To find it as far afield as the Iberian peninsula, as M. Lambert has done at Carboeiro, is an indication of the range of its influence. But the spring-time of Gothic art displayed other virtues at Saint-Denis—the beauty of its ample and admirably disposed volumes, the elegance of its proportions, and a kind of youthful purity which extends even to the profiles of the mouldings.[2]

Saint-Denis is not only a masterpiece. It is a fact, of considerable importance in the history of medieval civilization, and it is also a man. We do not know the great artist who built it but the man who imagined it, who inspired it with life, and with the poetry of his own career, is well known to us. Suger, abbot of Saint-Denis, chief minister to Louis VII, does not belong to those epic and saintly regions wherein dwelt the great abbots of Burgundy and the Midi, during the eleventh and early twelfth centuries. He appears surrounded by the life of history, and as he moves through it, he is completely human; yet, though seen thus from every side, and enmeshed in the details of action, he loses nothing of his greatness. He was a great prelate in his church, but a woodman in his forest, a lover of fine trees, which he himself selected, and of fine columns, which he transported from distant places. There was something rustic about the vigour of his undertakings, but his burning enthusiasm for his task created the fervour, the opportunities and the influence which were indispensable to its fulfilment. Suger[3] personally

[1] Further emphasis is given to this idea in L. Grodecki, *Le vitrail et l'architecture au XIIe et au XIIIe siècles*, in Gazette des Beaux-Arts, 1949, 11, pp. 5-24.

[2] It is difficult to determine the extent of the thirteenth-century alterations in the ambulatory. The columns seem fragile, especially if they were intended to carry tribunes. But their capitals have all the appearance of twelfth-century work, and they fit the shafts exactly. The terminal chapels to north and south have, instead of windows, ambitious twelfth-century compositions more appropriate to a portal than as interior decoration—an unusual feature in this position, except in connection with an old entrance. Mr. S. McK. Crosby, of Yale University, is preparing a much needed monograph on Saint-Denis, to which M. Levillain's excellent studies of the Carolingian church and crypt have provided a prelude. *The excavations carried out at Saint-Denis by Professor Crosby in 1938–39 and 1946–48 have led to very unexpected discoveries, which alter considerably the traditional views on the early stages of Gothic architecture; the most complete summary of the question will be found in S. McK. Crosby, *L'abbaye royale de Saint-Denis*, Paris, 1953.

[3] On the part played by Suger, see E. Mâle, *Art religieux du XIIe siècle en France*, chap. V. p. 151. *E. Panofsky, *Abbot Suger on the Abbey Church of Saint-Denis and its Art Treasures*, Princeton, 1946, has revised the interpretation of Suger's ideas and personality.

directed the activities of architects, sculptors, goldsmiths and painters. His
thought constantly pursued new and powerful forms. His verses, both inspired
and mediocre, depict his restlessness and humility, but they did not satisfy
his creative spirit. This lavished itself on iconography, on which he made
a lasting impression. It may be that the theme of the Precursors, which adorns
the finest of the medieval portals, was his invention. He outlined his projects to
his workshop of Lotharingian goldsmiths, which was under the direction of
Godefroy de Claire. In northern France, there had been nothing of this kind
since the days when, a century earlier, Gauzlin had undertaken to make Fleury-
sur-Loire an example for all Gaul. Gauzlin was interrupted in his enterprise.
Suger brought his to its conclusion, and, so that some record of his efforts and
their reward should be preserved, he wrote the *Liber de consecratione ecclesiae*.
In 1144, Louis VII, Eleanor of Aquitaine, and the great lords and prelates of
France assisted at the solemn ceremony. This was not an episode in monastic
annals, a fleeting instant of dynastic pomp: it was a great moment in a great
age.

Simultaneously and in the immediately succeeding years, other great churches,
with tribunes, and distinguished by their four-storey elevations,[1] were beginning
to rise in the *Domaine*. These inaugurated and defined the character of the first
period of Gothic cathedrals. The uniformity of the scheme was fundamental,
despite the variety of the treatment. The church grew very large and rose to
a great height, but it remained a collection of separate parts, laid one on top of
another, all strongly stressed and of equal importance. Above the main arcades
there are the tribune arches, surmounted by a relieving arch, then the apertures
—oculi, or galleries of colonnettes—which allow air to circulate to the roof-spaces,
and finally the narrow openings of the clerestory windows, almost invisible among
the vaults. The vista down the nave emphasizes the horizontality of the four
zones, interrupted but not disturbed by the alternating supports of the
sexpartite vaulting. In a whole group of churches, the distinction between the
strong and the weak supports ceases below the abacus of the main columns, which
are monostyle and all identical. The thirteenth century, following the example of
Chartres, abolished this idea of multiple storeys in favour of great clerestory
windows, extending from support to support and up to the formerets, and tall
arcades, rising through the old tribune-level, so that nothing remained between
arcades and windows except a narrow triforium which was eventually to be

[1]The present view is that the four-storey elevation did not come to the Ile-de-France before c. 1155
(Saint-Germer, choir of Noyon, nave of Cambrai, then Arras, Laon, Paris, etc.); it came from
western Belgium (c. 1135, Bruges and Tournai).

absorbed into the latter. One might think that a generous scale was a pre-requisite for these twelfth-century designs of many storeys: yet, in Vexin, the village church of Chars and, in Champagne, the choir of the old abbey church of
II Montiérender, are complete and exact small-scale versions of the great cathedrals with their tribunes.

This conception, which is remarkable for the uniformity with which it recurs, not throughout twelfth-century architecture, but in numbers of buildings of the first rank, did not exclude variety in the plan and the composition of masses. Some east ends have no radiating chapels. The transept is sometimes of considerable projection, with normal, straight end-walls; sometimes it has rounded ends; sometimes it does not project at all and is apparent only by its vertical development;[1] sometimes it is omitted altogether, and there is no interruption of the line of sight between the west door and the choir. The longitudinal type, which, like Notre-Dame in Paris, retracts its chapels and its transept, contrasts with the complex type, which extends them. The tower composition, the main fórmula for which had been established by the Romanesque façades of Normandy, may also include supplementary towers forming lateral façades at the ends of the transept. And in small and medium-sized churches there may also be found the Carolingian scheme of a tower set against the east end.

Noyon,[2] where the transept arms have rounded ends, Soissons, a generation
3 later, which retains this form only in the south transept, and other churches of the same group, not all of which survive—Cambrai, Notre-Dame at Valenciennes, Saint-Lucien at Beauvais, Chaalis, and, most important of all, Tournai—link up through Belgium with Carolingian prototypes.[3] Derived from the enclosed churches of the great monastic communities, it was an admirable but futureless conception, which the spirit of the thirteenth century replaced, developing the theme of the lateral façade, by a straight wall, with a triple portal and a triple

*[1]Double aisles throughout and a non-projecting transept: this is the plan of Notre-Dame in Paris, but it was already the plan of Suger's church at Saint-Denis: cf. S. McK. Crosby, *op. cit.*, pp. 48–50.
[2]The relics of St. Eloi were translated at Noyon in 1157. But was this in the old or the new cathedral ? The choir of the latter was probably not far advanced at this time. The treatment of the east end, as had been noted by Choisy and Lefèvre-Pontalis, shows marked similarities with that of Saint-Germain-des-Prés (1163). Mr. Charles Seymour, of Yale University, is preparing a new monograph on Noyon cathedral. I am indebted to him for more than one observation. *Ch. Seymour, Jr., Notre-Dame of Noyon in the Twelfth Century*, New Haven, U.S.A., 1939, is now one of the basic works on Gothic architecture.
*[3]An early ninth-century plan with rounded transepts has been excavated at Angers: G. H. Forsyth, *L'église Saint-Martin d'Angers*, Bulletin monumental, CX, 1952, pp. 201–28, and *The Church of Saint-Martin at Angers*, Princeton, 1953. It is not necessary to turn to Tournai for the origins of the twelfth-century series: Saint-Lucien at Beauvais, begun 1095, was both earlier and closer in type to the early Gothic examples; see E. Gall, *Die Abteikirche Saint-Lucien bei Beauvais*, Wiener Jahrbuch für Kunstgeschichte, IV, 1926, pp. 59–71, where only the reconstruction of rib-vaulting throughout the church is adventurous.

porch, under a rose-window, between two towers. The composition of the south 5
transept at Soissons is also most interesting by reason of the interrelationship of
the parts and the elegant structure of the piers. The master who designed it[1]
combined the plan of an apse with the elevation of a nave, and the two-storeyed
circular chapel which opens into it and which, on plan, seems a mere excrescence,
still further heightens the complexity of the effects.

Although it is legitimate to relate the plan of the rounded transept arms to the
trefoil plan of the Cologne churches, St. Maria im Kapitol, St. Aposteln and
Gross St. Martin, one very important difference must be observed: the trefoil
plan is a concentration of space, whereas the rounded transept is an extension
of it. In the trefoil plan, the three semicircles are in contact, whereas in the
plan with rounded transepts, a deep choir and the arms of a great transverse
nave lie between them. For this reason it seems likely that a thirteenth-century
German church with rounded transepts, St. Elisabeth in Marburg, although 72
it takes a hint from the Cologne types, is in fact more closely modelled on the
group which we have just discussed. The structure of the French churches of
this class reveals profound originality, particularly in the cathedral of Noyon. As
in the ambulatory of Saint-Denis, but with a more complex programme, related
to that of Laon though based on a different plan, we see here, from the very first,
an affirmation of the skeletal character of French Gothic architecture. In the tran-
sept of Noyon, one may see also a remarkable compensating device. Two passages,
one above the other, on the level of the second and third storeys of windows,
are so arranged as to balance each other, one inside and one outside the walls.

The architect of Laon, on the other hand, gave his transept square ends, with
considerable projection and generous proportions, to be matched later by those
of the choir, after the original apse, which may have possessed radiating chapels,
had been replaced by a square east end. Nowhere else, perhaps, did the develop-
ment of this great twelfth-century Gothic style attain such breadth and, in 15
nave and transept, such strict unity. The multiplicity of arcades, apertures and 16
windows anticipates the annulment of the wall in later Gothic architecture.
Those who continued the work after the termination of the initial campaigns,
who opened the deep porch in the façade, the model for the lateral porches at 12
Chartres, who raised the towers, the design of which Villard de Honnecourt was
so anxious to carry with him on his travels, and who hoisted up to their topmost
niches the stone oxen, which stretch their heads over the roofs of the town
towards a horizon of green fields—their work in no way belied the original
character of a building in which we can gauge, not only the dimensions of

[1]Under Bishop Nivelon de Chérizy (1177–1207).

architecture, but also a dimension of humanity. On its ancient acropolis, one of the strongholds of the last Carolingians, the silhouette of the church strikes a somewhat military note. Its seven towers lift it heavenwards. The lofty transept chapels—themselves almost towers—are pierced, like the transept of Noyon, with horizontal rows of windows, and were destined to exercise a wide influence. The composition of the masses was based on Tournai, that cathedral which, as we have seen, belonged partly to one age and partly to the next. Its plan, and the disposition of its towers had announced the majestic theme of the many-towered church, which, from Laon onwards, dominated the future of the French cathedrals. The architect of Chartres gave it classic authority and incorporated it in the style of the thirteenth century.[1]

This is the twofold significance of Laon cathedral: it was the complete realization of twelfth-century ideas, and it prepared the way for future development. But the shadow of the towers of Laon must not be permitted to obscure the greatness of Notre-Dame in Paris; they were almost contemporaries, but the foundation of Laon (1157)[2] preceded that of Notre-Dame (1163).[3] Like the charming collegiate church of Mantes,[4] with which it shares more than one family trait, Paris belongs to the longitudinal type: in the plan, as originally built, the insignificant transept did not project beyond the line of the aisle walls. This spatial unity, which was strengthened by the absence of radiating chapels, knits together to some extent the immense system of the five naves. The alternation of the supports of the sexpartite vaults—an alternation which is

17
13

*[1]Interesting views in J. Baltrusaitis, *Villes sur arcatures*, in Urbanisme et Architecture, Paris, 1954.
[2]This date is a hypothesis based on a bull of Alexander III. The building is said to have been begun and completed by Bishop Gautier de Mortagne (1155–74). See J. Quicherat, *Mélanges d'archéologie et d'histoire*, pp. 173–74. Cf. L. Broche, *La cathédrale de Laon* (Petites monographies) Paris, 1926; R. de Lasteyrie, *L'architecture religieuse en France à l'époque gothique*, I, p. 41, and especially E. Lambert, *La cathédrale de Laon*, Gazette des Beaux-Arts, 1927. In addition to the churches discussed, note also the cathedral of Senlis, begun about 1155, eastern parts completed about 1167, consecrated 1191; the church of Saint Rémi at Reims, rebuilt by Abbot Pierre de Celles (1162–81), is remarkable for the pairs of square severies (alternating with triangular cells) of the ambulatory vault; the choir of Notre-Dame-en-Vaux at Châlons-sur-Marne is like that of Saint-Rémi, and related, in elevation, to Noyon and Laon. *On Laon, add the excellent monograph by H. Adenauer, *Die Kathedrale von Laon*, Düsseldorf, 1934.
[3]The first stone is said to have been laid by Pope Alexander III during his stay in Paris in 1163. See M. Aubert, *Notre-Dame de Paris, sa place dans l'histoire de l'architecture* . . ., 2nd edition, Paris, 1929, p. 30. The choir was finished in 1177 and consecrated in 1182, and the nave was almost completed at the death of Maurice de Sully in 1196. The façade and towers were begun in the first year of the thirteenth century, and the latter were completed 1245–50. See V. Mortet, *L'âge des tours de Notre-Dame de Paris*, Bulletin monumental, 1903. An additional bay was added to each arm of the transept, beginning in 1258, by Jean de Chelles—continued by Pierre de Montereau. Pierre de Chelles was doubtless the architect of the chapels of the apse, built from 1296 to 1320.
[4]See André Rhein, *Notre-Dame de Mantes*, Paris, 1932; J. Bony, *La collégiale de Mantes*, in Congrès Archéologique, Paris-Mantes, 1946, pp. 163–220.* The Paris group includes also many smaller buildings, e.g. Champeaux.

concealed in the lowest storey of the nave by the handsome monostyle columns of
the main arcades—reappears in the columns between the pairs of aisles, those
with the strong stress being braced by colonnettes *en délit* surrounding the shaft
of the pier. The V-shaped vaulting of the ambulatory is no less noteworthy, as
an indication of the freedom with which these masters handled the structure.
prior to the establishment of the classic solutions. There is further proof of this in
the tribune vaults, which are tilted up towards the external walls in order to
receive light from windows opening above the roofs of the outer aisles.[1] Finally,
with its internal height of nearly 110 feet, it inaugurated the colossal phase: its
contemporaries average around 80 feet. A line of great churches sprang from
Notre-Dame, including others besides those which were grouped by Anthyme
Saint-Paul in the oddly named 'intimate school'. Even more than Arcueil, Beau-
mont or Mouzon,[2] cathedrals such as Bourges and Le Mans have strong ties which
link them with Notre-Dame. None the less we shall see to what extent
they diverge from, and even oppose, its solutions, and how inadequate the
archaeological evidence may be for purposes of a definition of architectural
character.

Such are the great churches with tribunes, whose powerful stylistic cohesion
by no means excluded variety in planning, structure and the composition of
masses. They are a homogeneous and admirable group. If one reduces them to
their component parts, one perceives how much they were able to pass on to the
next period. But if one envisages the style as a whole, one sees that it was opposed
to the style of the thirteenth century, which was characterized by the develop-
ment of all those parts of the structure which were conducive to the free circula-
tion of air, and, in the elevation, by the abandonment of the old Romanesque
cell, the tribune. But it is important to recognize that the latter had already been
discarded by some great churches of the twelfth century, and that in this respect
these heralded and prepared the way for the Chartres scheme. The same year in
which the first stone of Notre-Dame was laid saw the consecration of the new
choir of Saint-Germain-des-Prés, added to an eleventh-century nave:[3] this was
designed on the plan of Saint-Denis, but above the main arcades there was only
a row of small arches, later to be curtailed by the enlargement of the clerestory
windows, whose sills were lowered at the cost of replacing the twin arches of the

[1] M. Aubert, *Notre-Dame de Paris, sa place dans l'histoire de l'architecture* . . ., p. 112.
[2] In addition to Mantes and Beaumont-sur-Oise, the triforium of Notre-Dame appears also at
Saint-Leu-d'Esserent and Moret.
[3] Pope Alexander III presided at both ceremonies. In the seventeenth century the clerestory windows
of the choir were enlarged, by suppressing the upper half of the triforium. See E. Lefèvre-Pontalis,
Congrès archéologique de Paris, 1919, pp. 301 *et seq.*

2 triforium with a lintel. The cathedral of Sens[1] had been started long before, in the
second third of the century, on the borders of the *Domaine*, of Champagne, and
of Burgundy, and may perhaps express something of that impatience which
appears in the structural experiments of the Burgundian Romanesque style; like
the Anglo-Norman builders of the school of Jumièges, who heightened the main
arcades at the expense of the tribunes, the architect of Sens, over a plan of
longitudinal type, raised lofty aisles, and left nothing but a narrow zone of
arcading between them and the clerestory windows (later remade) which were
lost among the vaults. The piers composed of coupled columns are likewise an
original feature, but much more important was this simplified elevation, which
by a natural sequence of thought, was eventually to convert the aisles into true
lateral naves and to dissolve away the walls of the upper zone of the church until
nothing remained except the supports of the vault.

III

MEANTIME Burgundy was inspiring an architecture which was destined to a
slower and less varied evolution, but which possessed an immense potential of
expansion and was to carry the ribbed vault far afield—the architecture of the
Cistercians.[2] Its significance is, however, not regional only, and in interest it
exceeds even the great technical innovations. It was the expression of a far-
reaching phenomenon, a kind of historical *volte-face*. But it was rooted in a
particular area, as was the man who imagined the entire movement. Burgundian
in its use of porches, in the profiles of its mouldings, in its springing of arches and
vaults from corbels, in its precocious employment of the ribbed vault (of which
we have noted an early example in the narthex of Vézelay, and which was
developed to meet the demands of an extensive programme at Sens, perhaps

[1]Sens may be accepted as being of the same age as Saint-Denis. Its construction was begun by
Bishop Henri le Sanglier (1122–42), no doubt about 1135, and finished under Hugues de Toucy
(1142–68). R. de Lasteyrie, *Architecture religieuse en France à l'époque gothique*, I, p. 24, stresses the
precocity of some features: 'The main apse is not covered by a simple semidome enlivened with
decorative ribs, such as is found in many buildings of the time of Louis VI and Louis VII, but by a
number of vault-cells supported on ribs radiating from a common keystone . . . The architect
employed by Henri le Sanglier was acquainted with the use of sexpartite vaults; there are, however,
no examples which can be certainly attributed to an earlier, or even a contemporary date.' *The
vaults of the nave at Saint-Étienne, Caen, are now accepted as the prototype of all sexpartite vaults
and dated c. 1130.

*[2]Among the more recent works on Cistercian architecture, see especially M. Aubert, *L'architecture
cistercienne en France*, 2 vols., Paris, 1943; M.-A. Dimier, *Recueil de plans d'églises cisterciennes*,
Grignan and Paris, 1949; E. Lambert, *Remarques sur les plans d'églises dits cisterciens*, in L'Architec-
ture Monastique, special number of the Bulletin des Relations Artistiques France-Allemagne
(Mainz), May 1951; H.-P. Eydoux, *L'architecture des églises cisterciennes d'Allemagne*, Paris, 1952;
W. Krönig, *Zur Erforschung der Zisterzienser-Architektur*, Zeitschrift für Kunstgeschichte, XVI,
1953, pp. 222–33; H. Hahn, *Die frühe Kirchen-Baukunst der Zisterzienser*, Berlin, 1957.

even earlier than at Saint-Denis), and also in its two-storey elevation (like that of the Martinian churches and of Vézelay), Cistercian architecture was Burgundian also in origin and in the sites of its first foundations—Cîteaux, where St. Robert installed himself in 1098, where St. Bernard entered the order in 1112, and where the church was consecrated in 1148, La Ferté (1113), Pontigny (1114; the first church about 1150), Morimond (1115), Clairvaux (1115), whence was colonized Fontenay (1118; the church consecrated in 1147). St. Bernard, by birth lord of Fontaine, near Dijon, sprang from a land prolific in orators and men of energy. He was not of the same human and historical family as the artist saints of Cluny, nor was he a Suger, admirable for his passionate enthusiasm but celebrated in the annals rather on account of his pursuit of culture and his multifarious interests than for tense and lofty thought. St. Bernard's position was like that of the scholars from northern France who were scandalized by the idolatry of Conques. He too raised his voice against the cult of images, but he appeared in an age when they were especially strange and complex, and he defined them with surprising precision, in his *Apologia to Guillaume de Saint-Thierry* (about 1127), by his fulminations against 'that beauty rooted in deformity and that deformity which aspires to beauty'. In the struggle against the dialecticians and in the protest against Romanesque forms, the attack was launched against the same intellectual position. St. Bernard discerned, not only the hidden principle of style, but also the germ which, as it grew, was to overwhelm it with Baroque vegetation. But we must not suppose him to have been a genius who, by a master stroke, could depose one art and install another. He anticipated and gave expression to the weariness which these forms were beginning to inspire. He wiped the slate clean. He built an austere wall around the passionate austerity of the faith. To seek an aesthetic principle or a church plan in the regulations laid down by the general chapters is unrewarding, but there are a certain number of prohibitions, such as that relating to the construction of stone towers, which suggest the limits of the programme and the key to the system. Burgundy supplied the builders of these bare abbeys with materials and traditions of masoncraft, which, in the early stages, received an ascetic interpretation.

There was a period of Cistercian architecture which may be termed Romanesque, but it is Romanesque at its most unadorned. This is the admirable type exemplified by Fontenay, its plan drawn with the set-square, its dark nave covered with a pointed barrel vault, buttressed by the transverse barrels of the aisles. This type recurs with its main lines unaltered in Champagne (Trois-Fontaines), Rouergue (Silvanès, Bonneval), the Pyrenees (Lescale-Dieu), Switzerland (Bonmont, Hauterive), England (Fountains) and Scandinavia (Alvestra).

But the spiritual triumph of the strictest orders induces them to extend their programmes, and even the most impoverished style, most willingly adopted, does not lack potentialities of development and change. The history of the Franciscans can provide other examples. Even though it did not deny outright its original principles, and remained loyal to certain features which became accepted formulae, Cistercian architecture grew rapidly more complex, adopting the two-storey elevation, direct lighting of the nave, and finally the ribbed vault, which it disseminated widely. Without it, the Middle Ages would be incomplete; we should not know the elegance of their strictest expression. Above all, it contributed to the maintenance and extension of the overriding unity of the West.

The Cistercians generally adopted the square east end, and even when there is an apse—at first of very slight projection—the radiating chapels are not apparent externally. They are enclosed within a continuous wall and do nothing to interrupt its monotonous uniformity. The importance of the transept is a characteristic feature, a reaction, no doubt, against the sumptuous development of the Cluniac choir. It sometimes contains numerous chapels, with communicating doors pierced through the dividing walls. These chapels are disposed sometimes along the eastern side, sometimes on both sides, and sometimes all round the transept arm. The vaulting shafts descend, not to the ground, but to conical or slightly moulded corbels, below which the pier retains the appearance of a wall. A prevalent type has groin-vaulted aisles with ribbed vaults over the nave, but it is questionable in some cases—at Pontigny, for instance—whether the latter were intended from the start or were decided on at a later stage of the construction: the oblique setting of the capitals of the pilasters from which the ribs spring seems to favour the second hypothesis although oblique capitals of this type also occur in Cistercian naves at a time when ribbed vaults were in general use—this, however, may perhaps be an instance of that passive repetition of a pointless device, of which other examples can be found in the Middle Ages. There is no tower, and the façade disappears behind a porch, above which only a gable is seen, pierced with very simple windows or with an oculus.

These, then, were the basic features. They developed and spread. Fontenay remains the example of the pure Cistercian style, but the history of Pontigny tells of the replacement of the square east end—small and modest according to some, but possibly more complex—by the present structure, in which the polygonal outer wall conceals a splendid architectural composition, with an ambulatory of the greatest elegance and majesty, ribs sprung from the keystones of the

arcades, banded columns, and capitals in which a limited stock of motifs is skilfully applied. In the conventual buildings—cloisters, chapter houses, refectories and store rooms—the austere strength of Cistercian art is uniformly adapted to a variety of programmes and is allied, in such monumental structures as the building at Clairvaux which housed a store room below and the refectory of the lay-brothers above, with an amplitude of programme and a grandeur of masses which is rare outside the cathedrals: used nowadays as a prison and factory, the store-room of Clairvaux shelters its strange new inmates under rudely built vaults which penetrate directly into massive piers.

It is remarkable to observe how the one way of thought, so strict in its conception of masses and effects, could encompass such variety of treatment. This style, which took as its point of departure a few gaunt and powerful principles, never lost its vitality. The enumeration of square and apsidal east ends by no means exhausts the list of types. In Gascony, the east end of Flaran (1152–87) has an apse and four semi-circular chapels opening on a wide transept; in Languedoc, that of Fontfroide[1] has three polygonal and two square chapels. The pier-designs show a similar variety, and are sometimes highly original in their composition. The structure of Fontfroide seems at first sight to repeat the main lines of the Fontenay scheme. The nave is covered by a pointed barrel vault, with a Burgundian string course on the line of the springing. But the piers are a novel and admirable interpretation of the Cistercian theme of the interrupted support. The body of the pier, with its engaged columns, forms a complex system apparently suspended above the ground, from which it is separated by a polygonal mass of masonry, whose only ornament is a heavy quadrant moulding near the top. Towards the nave, a pair of engaged columns rest on a projecting part of this bulge, which is underlined at this point with a console. Thus there is established between the pavement and the bases a powerful zone of abstraction,

7

[1]See Viollet-le-Duc, *Dictionnaire de l'architecture*, III, p. 426, VIII, p. 92; E. Capelle, *L'abbaye de Fontfroide*, Toulouse, 1903; J. de Lahondès, article in the Congrès archéologique of 1905. Instances of this kind bring up the question of local characteristics and schools. But filiation and proximity do not necessarily entail the identity of secondary characteristics, as we have just seen in the case of the plans of Flaran and Fontfroide. The most consistent features of the great abbeys of Languedoc and Gascony (Fontfroide, Flaran, Lescale-Dieu, Silvanès) are those which are based on the Fontenay type of nave. The Catalan group likewise differ among themselves. The abbey of Santas Creus (founded 1152; church built 1174–1225) was a daughter of Grandselve, which in turn was a daughter of Clairvaux; Poblet (1149; church rebuilt from the last third of the twelfth century onwards) and Vallbona (1157; date of church uncertain) were daughters of Fontfroide, which was a daughter of Grandselve. Yet the plan of Poblet includes radiating chapels while Santas Creus and Vallbona have the square east end. The nave of Santas Creus has ribbed vaults, that of Poblet a pointed barrel vault. On the relationship between the Cistercian abbeys of Languedoc and certain Catalan cathedrals, see E. Lambert, *L'art gothique en Espagne aux XIIe et XIIIe siècles*, Paris, 1931, p. 99; on Cistercian art in Catalonia, P. Lavedan, *L'architecture gothique religieuse en Catalogne, Valence et Baléares*, Paris, 1935, p. 39.

formed by these bare plinths whose sole function seems to be to raise the whole
system, the whole church, into the air. In the chapter house, the piers of the bays
which open on the cloister are no less noteworthy. They are composed of four
well-spaced columns, not linked together by a central core, but with a fifth
column, also isolated, standing in the middle. Two of these carry the vault ribs,
though indirectly, by means of corbels, while the remaining pair receive the
second moulding of the arcades. This robust yet light composition is an indication
of the disappearance of the old mural values in the treatment of the supports, but
also of the pointless and ritualistic repetition of typical Cistercian features.

With these inflexions and nuances, which were due to differences of time
rather than of place and which left intact the main organic characteristics of this
monumental language, particularly the solid uniformity of the exterior masses
within which the internal volumes were immured, Cistercian architecture spread
out into the most diverse regions. By the middle of the twelfth century, the
order possessed no less than three hundred and fifty houses. It had penetrated
to Germany (1122), to England (1128), to Ireland, with Mellifont, a daughter of
Clairvaux, to Castile (1131), to Italy (1135), to Portugal (1140), to Catalonia, to
Scandinavia, and to Hungary, where its influence was considerable. On French
soil, it extended from Vaucelles, in Flanders, to the Provençal abbeys of Silvacane
and Le Thoronet. Nor was this style restricted only to the foundations of the
order. It left its mark on Gothic building as a whole. The architects of Fossanova,
Casamari and Chiaravalle introduced the French type of ribbed vault into the old
territory of the Lombard rib. English art owed some inflexions of its style to
Cîteaux. The Cistercian forms of Languedoc and Gascony recur in the thirteenth
century in Catalonia, in the cathedrals of Tarragona and Lerida. In the
neighbourhood of Burgos, the great abbey of Las Huelgas influenced a whole
group of buildings. In Portugal, Cistercian ideas were responsible not only for
Alcobaça but for deep impressions which persisted down into the *Rayonnant*
style. What the Cluniacs did for Romanesque art, in an earlier phase of the
Spanish crusade, the Cistercians did for Gothic art, over the whole of Western
Europe.

This architecture, stable and consistent though it was, moved with the times.
It is as difficult to distinguish periods in its development as it is to divide it into
schools. It had, however, its Romanesque type, that of Fontenay, to which it long
remained faithful, as we have just seen, in the south of France; then, at an early
date, it became Gothic by its adoption of the ribbed vault, which was often
introduced while the building was in the course of construction, and in conjunc-
tion with unusual types of springing—tapering to a point, or with corbels and

obliquely set capitals. It adopted the apsidal east end, and also, in its subsequent development during the thirteenth century, more flexible structural solutions which came closer to the skeletal type, as at Ourscamp, Longpont and Royaumont. But the conventual buildings of the time of St. Louis, even down to unseen members and purely utilitarian parts, proved that it remained fundamentally a great and austere stonemason's style. The type plan of a Cistercian church provided by Villard de Honnecourt, who had worked on the building sites of the order, still retains the square east end, to which he gives a development reminiscent of Laon.

Thus Cistercian architecture carried forward through time, and into Gothic art, a large measure of its primitive power and sobriety. It remained as a venerable witness of a very great spiritual revolution. To the men who built cathedrals rich in plastic effects, in depths of shadow, in subtle illumination and kaleidoscopic colour, it offered the example of an art which drew the whole secret of its beauty from rule, set-square and a cold uncompromising clarity of expression. But the essence of its historical function was not this. The thought of its founders went much further, and the results they achieved were immeasurable. They purged religious art of all that remained of the pomp and mystery of the East, along with the refinements of Cluniac culture and the virtuosity of the great dialecticians. The reform of St. Robert, extended and nourished by the thought and talent of St. Bernard, exceeded in scope the long series of reforms which the Benedictine order had experienced from Carolingian times onward. They had been concerned primarily with ethical values and the rules of monastic discipline, but this discovered a new horizon for the spirit, a new site for the faith. At a time when the Romanesque Baroque was multiplying its luxuriant and somewhat frenzied patterns, its last tales of magic, its last enigmas, this movement banned them from its churches, and for the adornment of the capitals rejected all but a monumental, simple and legible foliage which did not disturb the immobility of the stone. It forbade the erection of towers, and of chapels projecting externally, and hence proscribed all those astonishing compositions of masses which recall the centralized churches of Asia. It prohibited excessive exaltation of the nave over the aisles, maintaining a 2 : 1 ratio which gave the relationship a proper humility, and externally, it reverted to the ancient Western theme of the box church. The light which falls through the windows of plain glass, unadorned save for the floral arrangement of the leads, and the iconography of the manuscripts, in which space is found for the rude tasks of land-clearing, and whose linear style recalls Monte Cassino, are all included within the same definition. It testifies to a categorical will, exercised at a decisive moment.

IV

IT is not in Cistercian art that we shall find the materials for the study of the decorative sculpture peculiar to this first Gothic style, whose architecture we have already defined: a few combinations of mouldings, some broad flat leaves, without indentations, a system in strong contrast with the exquisite organization and tumultuous complexity of the Romanesque capitals—such was the range allowed by its self-imposed discipline. But there exists a twelfth-century Gothic sculpture, which, between the portal of Saint-Denis and the portal of Senlis (before 1186), that is in the space of two generations, produced vast ensembles, of remarkable uniformity, and with an inspiration different both from that of the Romanesque period and that of the thirteenth century, but which bequeathed to the latter an iconographical theme of incomparable majesty and, in particular instances and particular workshops, the tradition of certain forms.

Romanesque sculpture had been dominated by the iconography of the Apocalypse, and something of this survived, north of the Loire, in the sculpture of the second half of the twelfth century. But whereas in the great compositions of Languedoc and Burgundy an epic stagecraft based on patterns of movement had ceaselessly renewed, in accordance with its unchanging principle of composition, identical or closely related themes, henceforward the main tympanum of great numbers of churches was occupied by repetitions of a single uniformly treated subject—Christ in glory, surrounded by the symbolical figures of the four Evangelists. An idea, hitherto flexible, had hardened and crystallized in an image whose variations are almost imperceptible. The theme of the Last Judgement recurs at Saint-Denis, drawing its iconographical inspiration (but not its style) from Beaulieu, and at Laon, where it is treated with a wild grandeur and 'primitive' coarseness remote from the art of Languedoc.[1] The old portal at Chartres displays Christ in glory surrounded by the tetramorph between the Ascension on the right and the Virgin in Majesty on the left. Compared with the Cahors tympanum, the Chartres Ascension has economized numerous actors. Christ, who at Cahors was flanked by angels leaning backwards with a graceful flexion of the whole body and escorted by numerous other figures, here has the greater part of the relief to Himself and rises out of a wavy band of clouds, which is a vestige of the shattered and henceforth inactive ornamental composition; His legs disappear behind it. The Virgin in majesty is seated on

30

*[1]See E. Lambert, *Les portails sculptés de la cathédrale de Laon*, Gazette des Beaux-Arts, 1937, I, pp. 83–98. Corbeil also had a Last Judgement doorway, dated, c. 1180–90; see F. Salet, *Notre-Dame de Corbeil*, Bulletin monumental, C, 1941, pp. 81–118.

her throne, carrying the child on her knees, beneath a canopy whose colonnettes have broken away, erect, and strictly frontal, with no movement to suggest life and humanity. Together with the Christ within the tetramorph, she is the most characteristic theme of the tympana of the period, and she too has the same quality of static uniformity.

To trace the iconography of this Christ back to its Apocalyptic origins is a simple matter: at Chartres it is a symbol rather than a representation, a convention rather than a vision, yet it still suggested in the eyes of the faithful a mode of thought of which it was the final state. But whence came the Virgin? She seems older than her time, yet she betokens a new fervour. She is the beginning and the source of that iconography of the Virgin, of the Lady, Our Lady, which, in the poesy of the thirteenth century, irradiated the gentlest themes of the Gospels, and whose favourite motif was the moving association of the Mother in the glory of her Son, in the scene of the Coronation. Though it was only in the middle of the preceding century that she had first taken her place in the stone of the churches, enthroned in majesty like a heavenly queen, her image in this form was of earlier origin. It is identical with those reliquary-Virgins of Auvergne[1] of which the original model was perhaps the golden statue made for the Bishop of Clermont by his goldsmith Alleaume, which cannot have been very different from the St. Foy at Conques. In this way the Virgin entered into the miraculous life of the relics. Her image, in wood or metal, was carried in procession under a canopy of 22 woven material. The tympana, into which she was inserted unchanged, continued to display her to the faithful in just this fashion. Her canopy still protects her, but is transformed into an aedicule. Her stiff majesty is that of the primitive effigies. The manifest likeness which exists between the Virgin of the tympanum carved about 1170 and re-used in the thirteenth century in the Portail Sainte-Anne at 23

[1] See L. Bréhier, *La cathédrale de Clermont au Xe siècle et sa statue d'or de la Vierge*, Renaissance de l'Art français, 1924; *Une Vierge romane de Brioude au musée de Rouen*, Almanach de Brioude, 1926; *Notes sur les statues de Vierges romanes*, Revue d'Auvergne, 1933; *La statue-reliquaire de Saint-Étienne-sur-Blesle*, Almanach de Brioude, 1934. This type of Virgin was very widespread in the twelfth century, over an area extending from Spain to Sweden. There are several in the Brioude area alone. Their iconographical origin was the same as that of the Virgin in majesty, and parallel with that of the Adoration of the Magi; these were doubtless the result of the decision of the Council of Ephesus (431) regarding the divine maternity of Mary, and are in contrast with the tender type of Virgin, of which a much earlier example exists in Rome, in the catacomb of Priscilla (second century). Seated on an arcaded throne and holding the Christ Child, who gives a blessing, in a frontal pose, these Virgin images, generally carved in wood and about 2½ ft. in height, are of very uniform stylistic type. A compartment hollowed out of the back of the figure was intended for relics of the Virgin. But this compartment is sometimes absent, as in the case of the Virgin of Montvianeix (Puy-de-Dome), which is reminiscent of the statues in Geneva and in Notre-Dame at Orcival. She wears a priestly vestment as a sign of the priesthood of Mary, the Throne of Solomon, the symbol of the Church. Among the most beautiful Virgins of the series is that recently acquired by the Lyons Museum and that in the Worcester Museum (U.S.A.).

Notre-Dame in Paris, and the Virgin of the west front at Chartres, is due less to similarity of execution, as Vöge supposed when he attributed both to an anonym, whom he christened the Master of the Two Madonnas, than to the identity of the source and the immutability of the type. In Paris, she has several figures about her in addition to the attendant angels—the kneeling king, the bishop, and the scribe who records the royal donation. They are certainly of the same date as the figure of the Virgin, yet she seems much older, a survival from a remotely earlier age.

The great iconographical concept of the second half of the twelfth century was embodied in the portal of the Precursors of Christ. It introduced the faithful into the church of the Gospels by making them first pass through the Old Testament. In the splays of the doorway, it set up columns of stone carved in the semblance of the Prophets and Ancestors of Christ. Vöge thought to find the origin of these strange figures in Provençal sculpture, but the examples taken from the latter are later by half a century. Mâle provided cogent proof of the part played by Suger and Saint-Denis in the working-out of the theme. We no longer possess the figures which adorned the portal of the great Parisian basilica, but they are known to us from the drawings of Montfaucon.[1] Just as the iconography of the Last Judgement at Saint-Denis reveals the influence of the iconography of Beaulieu, so certain details of some of the jamb figures, for instance the crossed legs, might indicate another aspect of Languedoc influence. It is certain that Suger's collaborators in the creation of a new artistic province did not spring up out of the earth. Except in the case of the architecture, which was derived from experiments carried out locally or at no great distance, he recruited them, like Godefroy de Claire, from relatively remote workshops and building sites. The goldsmiths from Lotharingia, from the Meuse, brought with them the habits acquired in the casting and hammering of metals and the knowledge of a full, smooth, serene modelling. The Ile-de-France could offer nothing resembling the figures of Saint-Denis, but the *trumeaux* of Languedoc provided admirable examples of the association of the human figure with the function of a vertical supporting member, without however applying it to this interpretation of the Bible of the Jews as a monumental vestibule to the New Testament. There are then solid grounds for the acceptance of Suger as the originator of this idea, as

[*1]Heads from the Saint-Denis statues have been identified at the Walters Art Gallery in Baltimore and at the Fogg Art Museum; see M. C. Ross, *Monumental Sculptures from Saint-Denis, an Identification of Fragments from the Portal,* The Journal of the Walters Art Gallery, III, 1940, pp. 91–109. More recently a statue from the cloister at Saint-Denis has been identified in the collections of the Metropolitan Museum: see article by Miss V. K. Ostoia in the Bulletin of the Metropolitan Museum of Art, 1955.

well as of other iconographical inventions, and for the hypothesis that it was rendered in stone by masters who were southern French by birth or training. It is true, on the other hand, that the columns and pilasters which serve these figures as bases and pedestals are sometimes patterned with that luxuriance and virtuosity which is characteristic of the last stage of Romanesque sculpture, as in Saint-Lazare at Avallon, and sometimes fluted in the antique manner, like Burgundian pilasters. We know, too, that at a later date the theme was widely used in Burgundy; it formerly adorned the portal of Saint-Bénigne at Dijon, and still adorns that of Vermenton. Once again we face the problem: Burgundy or Languedoc?

Whatever the answer may be, it was particularly in northern France, around Paris, that the Precursor portal was characteristic of the iconography of the second half of the twelfth century, and it was there that it was bound up with the history of the earliest Gothic style. Thus it appears, in the immediate circle of influence of Saint-Denis, at Chartres, where it extends across the whole of west front (about 1145–50), at Étampes, Bourges, Saint-Loup de Naud,[1] and Le Mans, to mention only the most important of the surviving ensembles, among which we should also note Nesle-la-Reposte, Bourg-Argental and the north portal of Saint-Benoît-sur-Loire, where the lintel portrays the discovery and translation of the relics to which the abbey of Fleury owed its name and its renown. But most commonly the lintel is adorned with figures of the Apostles, and the tympanum shows Christ within the tetramorph, surrounded by heavy archivolts which are wrought into statuettes. The Precursors vary in number, but the iconography is remarkably constant.

The style is no less so, and likewise the profound originality of an art which gave to the images of men and women the form and proportions of the columns against which they stand, so that, with their heads surmounted by a capital and their feet scarcely projecting, or hanging vertically, they themselves seem like columns and have been so named. This appears to be the last word in that architectural conformity, which, in Romanesque art, imposed on living creatures not only the attitude but the figure-canon demanded by the structural functions.

[1]The portal of Saint-Loup de Naud is the only one of the series which retains a *trumeau* of the same date as the other statues. Those of the side doors at Bourges are thirteenth-century work. For the first time the voussoirs depict episodes from the life of the patron saint, instead of the Elders of the Apocalypse, as at Chartres, or Gospel scenes, as at Le Mans. The architecture of the church is interesting. The eastern parts go back to the eleventh century, and they were vaulted at that period, perhaps under the influence of Burgundy. The western bays of the nave, and the porch, date from about 1170. Their arrangement is peculiar, in that the alternation of the piers is not associated with sexpartite vaulting; this is also found in eastern France, in the Rhineland, at Vermenton in Burgundy, and, in Brie, at Voulton, a church which was copied from Saint-Loup de Naud. See F. Salet, *Saint-Loup de Naud*, Bulletin monumental, 1933.

The treatment of surface, the suggestion of modelling by means of line, the graphic folds, and the ornamental interpretation of light and shade, are such as to confirm us in this idea. So also, at Saint-Loup de Naud, the siren-birds which decorate the capitals. So also, throughout this style, the profusion of aedicules which display their obsessive miniature architecture around and above the figures. Yet, whereas the Romanesque conformity inevitably produced the most intense movement, the column figures are destined to eternal immobility, and the gesture by which they clasp book, sceptre or drapery to their narrow bodies remains always the same. They seem sunk in an age-long sleep, like the swathed dead who awoke at the sound of their prophetic voices.

Moreover, the sculpture of living forms abandoned the compositions based on abstract pattern, which the new art misunderstood, misinterpreted or forgot. It sought to control itself without the intervention of a stylistic principle whose appearances from this time forward are merely disconcerting. Even though it retained some vestiges of this in the simplified representation of the God of the Apocalypse, whom it also endowed with admirable touches of humanity, as in the central tympanum at Chartres, its interpreters do not hesitate to insert a reliquary statue in a monumental relief. But the figures on either side belong to the reality of life and the truth of history. They are no longer witnesses of the Apocalypse, or sages and monarchs of the East, but a church-building bishop and a Capetian king. If we cannot yet foresee here the future of the great monumental style which was to adorn the cathedrals of the thirteenth century, we can at least perceive all that it rejected, and comprehend the scope of this renunciation.

BIBLIOGRAPHY

ARCHITECTURE

R. de Lasteyrie, *L'architecture religieuse en France à l'époque gothique*, éd. par Marcel Aubert, 2 vols., Paris, 1926–27; C. Martin, *L'art gothique en France*, Paris, 1911; Anthyme Saint-Paul, *Histoire monumentale de la France*, new ed., Paris, 1929, *La transition*, Revue de l'Art chrétien, 1894–95; C. Enlart, *Monuments religieux de l'architecture romane et de transition dans les anciens diocèses d'Amiens et de Boulogne*, Amiens, 1895; E. Lefèvre-Pontalis, *L'architecture religieuse du XIe et du XIIe siècle dans l'ancien diocèse de Soissons*, 2 vols., Paris, 1894–98, *Les influences normandes au XIe et au XIIe siècle dans le Nord de la France*, Bulletin monumental, 1906, *La plan primitif de l'église de Morienval*, Bulletin monumental, 1908, and Notices in the Congrès Archéologiques de France, especially *Morienval* and *Saint-Leu-d'Esserent*, Congrès archéologique de Beauvais, 1905, *Soissons*, Congrès archéologique de Reims, 1911, *Saint Germain-des-Prés*, Congrès archéologique de Paris, 1919; P. Vitry and G. Brière, *L'église abbatiale de Saint-Denis et ses tombeaux*, 2nd ed., Paris, 1925; A. Besnard, *L'église de Saint-Germer de Fly*, Paris, 1913; F. Deshoulières, *L'église Saint-Pierre de Mont-matre*, Bulletin monumental, 1913; L. Barbier, *Étude sur la stabilité des absides de Noyon et de Saint-Germain-des-Prés*, Bulletin monumental, 1930; L. Broche, *La cathédrale de Laon*, Paris, 1926; H. Adenauer, *Die Kathedrale von Laon*, Düsseldorf, 1934; Marcel Aubert, *Notre-Dame de Paris, sa place dans l'histoire de l'architecture du XIIe au XIVe siècle*, Paris, 1919, 2nd ed., 1929; A. Rhein, *Notre-Dame de Mantes*, Paris, 1932; J. Bilson, *The Beginnings of Gothic Architecture*, Journal of the Royal Institute of British Architects, 1899, and *Durham Cathedral: The Chronology of its Vaults*, Archaeological Journal, 1922; L. Cloquet, *Notes sur l'architecture tournaisienne romane et gothique*, Tournai, 1895; E. Gall, *Niederrheinische und normännische Architektur im Zeitalter der Frühgotik*, Berlin, 1915.* E. Gall, *Die gotische Bau-kunst in Frankreich und Deutschland*, Leipzig, 1925, 2nd ed., Brunswick, 1955; M. Aubert, *Les plus anciennes croisées d'ogives, leur rôle dans la construction*, Bulletin monumental, 1934; H. Focillon, *Le problème de l'ogive*, Bulletin de l'Office international des Instituts d'archéologie et d'histoire de l'art, I, 1935 (reprinted in Recherche, I, 1939, and in H. Focillon, *Moyen-âge*, *survivances et réveils*, Montreal, 1945); E. Panofsky, *Abbot Suger on the Abbey Church of Saint-Denis and its Art Treasures*, Princeton, 1946; S. McK. Crosby, *L'abbaye royale de Saint-Denis*, Paris, 1953; O. von Simson, *The Gothic Cathedral, The Origins of Gothic Architecture and the Medieval Concept of Order*, New York, 1956; C. Seymour, *Notre-Dame of Noyon in the XIIth Century*, New Haven, 1939; L. Serbat, *Quelques églises anciennement détruites du nord de la France*, Bulletin monumental, 1929; E. Lambert, *L'ancienne abbaye de Saint-Vincent de Laon*, Comptes-rendus de l'Académic des Inscriptions et Belles-Lettres, 1939, pp. 124–138; P. Héliot, *Les anciennes cathédrales d'Arras*, Bulletin de la Commission Royale des Monuments et des Sites, IV, Brussels, 1953; Marquise A. de Maillé, *Provins. Les monuments religieux*, 2 vols., Paris, 1939; F. Salet, *La Madeleine de Vézelay*, Melun, 1949; A. Mussat, *Les origines du style gothique de l'ouest*, L'Information d'histoire de l'art, VI, 1961, pp. 8–16; J. Bony, *La collégiale de Mantes*, Congrès archéologique, Paris-Mantes, 1946, pp. 163–220; J. Warichez, *La cathédrale de Tournai*, 2 vols., Brussels, 1934–35; P. Rolland, *La cathédrale de Tournai et les courants architecturaux*, Revue Belge d'Archéologie et d'Histoire de l'Art, VII, 1937 and *La technique normande du mur évidé et l'architecture scaldienne*, ibid., X, 1940.

ART OF THE CISTERCIANS

Ph. Guignard, *Monuments primitifs de la règle cistercienne*, Dijon, 1878; Saint Bernard,

Apologia ad Guilielmum abbatem, Migne, *Patrologie latine*, t.CXCII; E. Vacandard, *Vie de Saint Bernard*, 4th ed., Paris, 1910; J. von Schlosser, *Die abendländische Klosteranlage des frühen Mittelalters*, Vienna, 1899; Dom E. Martène and Dom U. Durand, *Voyage littéraire de deux bénédictins*, Paris, 1717; J. Bilson, *The architecture of the Cistercians*, Archaeological Journal, 1909; H. Rose, *Die Baukunst der Cistercienser*, Munich, 1916; C. Enlart, *Origines françaises de l'architecture gothique en Italie*, Paris, 1894, *Villard de Honnecourt et les Cisterciens*, Bibliothèque de l'École des Chartres, 1895; L. Bégule, *L'abbaye de Fontenay et l'architecture cistercienne*; A. Anglès, *L'abbaye de Silvanès*, Bulletin monumental, 1908; G. Fontaine, *Pontigny, abbaye cistercienne*, Paris, 1928; R. Crozet, *L'abbaye de Noirlac*, Paris, 1932; A. Mettler, *Zur Klosteranlage der Cistercienser und zur Baugeschichte Maulbronns*, Stuttgart, 1909; J. Vendryès, *Melli font fille de Clairvaux*, Mélanges Schoepperle, Paris and New York, 1927; S. Curman, *Cistercienserordens bygnadskonst*, Stockholm, 1912.* M. A. Dimier, *Recueil de plans d'églises cisterciennes*, Grignan - Paris, 1949; M. Aubert, *L'architecture cistercienne en France*, 2 vols., Paris, 1943; F. Bucher, *Notre-Dame de Bonmont*, Bern, 1957; A. W. Clapham and H. G. Leask, *The Cistercian Order in Ireland*, Archaeological Journal, 1931; H. P. Eydoux, *L'architecture des églises cisterciennes d'Allemagne*, Paris, 1952; W. Krönig, *Zur Erforschung der Zisterzienser Architektur*, Zeitschrift für Kunstgeschichte, XVI, 1953; H. Hahn, *Die frühe Kirchenbaukunst der Zisterzienser*, Berlin, 1957; L. F. de Longhi *L'architettura delle chiese cisterciensi italiane*, Milan, 1958.

SCULPTURE

E. Mâle, *L'art religieux du XIIe siècle en France*, 3rd ed., Paris, 1928; W. Vöge, *Die Anfänge dés monumentalen Stils im Mittelalter*, Strasbourg, 1894; M. Aubert, *La sculpture française au debut de l'époque gothique*, Paris, 1929; H. Focillon, *L'art des sculpteurs romans*, chapitre sur la fin de l'art roman, Paris, 1931; L. E. Lefèvre, *Le portail royal d'Étampes*, 2n ed., Paris, 1908, *Le portail d'Étampes et les fausses scènes d'Ascension du XIIe siècle*, Bulletin de la Conference des sociétés savantes de Seine-et-Oise, 1907; R. de Lasteyrie, *La date de la porte Sainte-Anne à Notre-Dame de Paris*, Bulletin monumental, 1903; M. Aubert, *Senlis*, Paris, 1912.* S. McK. Crosby, *L'abbaye royale de Saint-Denis*, Paris, 1953; M. Aubert, *Le portail royal et la façade occidentale de la cathédrale de Chartres*, Bulletin monumental, 1941; A. Katzenellenbogen, *The Sculptural Programs of Chartres Cathedral*, Baltimore, 1959; H. Giesau, *Stand der Forschung über das Figurenportal des Mittelalters*, Beiträge zur Kunst des Mittelalters, 1948 (Berlin, 1950); J. Vanuxem, *Autour du Triomphe de la Vierge du portail de la cathédrale de Cambrai et de Saint-Nicolas d'Amiens*, Bulletin monumental, 1945, and *La sculpture du XIIe siècle à Cambrai et à Arras*, ibid., 1955; W. Sauerländer, *Beiträge zur Geschichte der frühgotischen Skulptur*, Zeitschrift für Kunstgeschichte, 1956, pp. 1–34, and *Die Marienkrönungsportalen von Senlis und Mantes*, Wallraf-Richartz Jahrbuch, 1958, pp. 115–162.

CHAPTER II

The Classic Phase

I

HAVING arrived at the close of this great epoch, let us pause for a moment to consider what had been achieved during these fifty years which had elapsed between the consecration of Saint-Denis (1144) and the burning of Fulbert's cathedral at Chartres (1194). Not only was the first Gothic style a complete and versatile system, of great organic beauty, but it also included every feature and design which we shall find in the art of the thirteenth century. Admittedly we shall not see the tribune again, except as a rarity, and the four-storey elevation was ousted by the increased vertical development of the aisles. The system of superimposed layers and spatial cells was replaced by a composition of uninterrupted vertical volumes. But was not this conception already fore-shadowed in the Romanesque period, by the Norman churches of the Jumièges type, in which the main arcades and the aisles had been heightened at the expense of the tribunes? In other churches of the same school, the latter were replaced by wall-arcades. Cistercian naves of the type of Pontigny II adopted a still more radical solution—the total elimination of the intermediate zone between main arcade and clerestory. Sens, while retaining a narrow triforium, enlarged its aisles to the scale of lateral naves. Finally, in the closing years of the twelfth century, the church of Saint-Vincent at Laon, now destroyed, introduced the Chartres type of elevation.[1]

First Gothic art had perfected a type of apse with several storeys of windows, of which Cérisy is the earliest example, and which culminated, after adaptation to a more advanced technique, in the transept of Noyon and the transept-chapels of Laon, where its audacious effects and skeletal development foreshadow the *Rayonnant* style. In comparison with these completely Gothic compositions, Notre-Dame in Paris seems older than it is. This architecture of shafts and windows, so subtle in its equilibration, was not extinguished by the success of the Chartres type. It lived on in Burgundy, where we shall see it again, not as an inert archaism, but as a mature and vigorous style. The greatness of Chartres, Reims and Amiens must not block our view of the horizon beyond, on which stand so many noble churches of earlier date, nor make us overlook the continuing

<div style="margin-left:3em">10</div>

[1]On Saint-Vincent at Laon, see E. Lambert, *Saint-Vincent de Laon*, Comptes-rendus de l'Académie des Inscriptions et Belles-Lettres, 1939, pp. 124–138.

activity of first Gothic art. The new cathedrals were themselves deeply indebted
to it. Their originality was not lessened thereby.

Lying as it does on the fringes of Beauce, on the edge of the sharp descent
down from the plateau, Chartres is both a town of the plains, ringed round with
a wide horizon of cornfields, and a town of the uplands, where the roofs climb
up steep slopes and along alleyways flanked by gables. To the east, the land on
which the church stands is intersected by a fault, so that the apse dominates the
void; westwards, the plateau falls gently away. The cathedral, like a fortress,
overlooks and controls the town. From the channels of the Eure which flow
round garden-islets at the foot of the escarpment, it seems to draw the town
upwards, as if to extend into the clouds its bridges, its mills, its tree-lined
boulevard, its fortified gateway, and its churches—Saint-André, Saint-Pierre
and Saint-Aignan. These sites and scenes among which Gothic thought developed
were incorporated into it. There, in the closing years of the twelfth century, it
conceived and began its masterpiece, and, from the principles which had been
tested by the architects of the preceding period, it evolved a new form of
architecture.

Work was begun in 1194, immediately after the burning of Fulbert's basilica.[1]
The site was limited on the east by the geological fault and on the west by a
façade, which the fire had partially spared, comprising a pair of towers and,
between them, the Royal Portal, which had been moved forward somewhat
earlier.[2] For this reason, the church is relatively short, with an extensive choir
taking up one-third of the length at the expense of the nave. The old foundations
were utilized, at the cost of a certain irregularity in the disposition of the piers
of the choir, which terminates in an ambulatory with radiating chapels. The
development of the transept was unrestricted, and each of its arms is conceived
as a monumental unit, terminated by a façade whose triple portal is sheltered
beneath a porch.[3] In addition to the towers of the west front and the spire over
the crossing, there are also two towers flanking each transept arm. Laon, as we
have seen, provided the model for this composition, as well as for the external

[1]The fire of 10th June 1194 spared, in addition to the eleventh-century crypt, the two towers built
in the middle of the twelfth century and the Royal Portal. The main structure and vaults of the new
cathedral, begun by Bishop Renaud de Mouçon, were completed in 1220. The lateral porches
belong for the most part to the second third of the thirteenth century. Among later additions, the
Saint-Piat chapel dates from the first half of the fourteenth century, and the Vendôme chapel from
1417. The spire of the north tower was built in 1506 by Jean Texier.
*[2]The Royal Portal is now considered to have been moved forward when work had hardly begun,
c. 1150 at the latest: see M. Aubert, Le portail royal et la façade occidentale de la cathédrale de
Chartres. Essai sur la date de leur exécution. Bulletin monumental, C, 1941, pp. 177–218.
*[3]On the successive stages in the design of the transept façades, see L. Grodecki, The Transept
Portals of Chartres Cathedral; the Date of their Construction according to Archaeological Data, Art
Bulletin, XXXIII, 1951, pp. 156–164.

passage of the chapels. The technical data are as follows: sexpartite vaulting is replaced by quadripartite, which ensures a unified distribution of parts, since one bay of the aisle now corresponds to one of the nave; the supports are conceived as an articulated system, whose members rise in tiers, according to function, from the pavement up to the vault; the flying buttress is envisaged and designed, not as a reinforcement, but as an integral element of the structure; the tribune is suppressed for the benefit of the aisles; and for the benefit of the clerestory the wall extending from the triforium up to the formeret is removed between each pair of piers, so that light falls, not through narrow and deep-set windows, but through immense sheets of glass opening to the sky. Note that each of these expedients is a function of the others, and reacts upon all of them. The unity of the bay demands unity of abutment and puts an end to that undulation of forces which is characteristic of churches with alternating supports. The double flights of flying buttresses, strutted with colonnettes, prop the critical points against which, at regular intervals, the thrusts are delivered, and permit the annulment of the upper wall, which becomes no more than a connecting web, or mere useless weight. They also deprive the tribunes of their function in the equilibrium of the church, so that the lateral vessels may be heightened without subdivision into storeys.

In this way the skeleton church was defined—a combination of active forces, in which the cohesion of the parts is ensured by their interaction, by the theorem of functions, by the structure of the specialized members, and even by the type of masonry. The twelfth century has already shown us almost all the elements of the system established in various types of church, of which one, of great beauty, was still Romanesque in composition—the church with tribunes. The architect of Chartres was both follower and innovator; we can no longer overlook the contribution of Saint-Vincent at Laon, but what he took from elsewhere he recreated. The elements of the solution remained the same, but he demanded more from them and his reasoning was more closely knit. The measure of his originality is perhaps given by his unchallenged domination of contemporary art. The thirteenth century began with Chartres, and the *Rayonnant* style which, in the second half of the same period and in the following century, seems at first sight to introduce new forms, in fact did no more than extend the reasoning and carry it forward to dangerous extremes of refinement.[1] Chartres, as compared with the line of great cathedrals which it inaugurated, had the advantage of

*[1] On the logic of Gothic architecture, see the important essay by E. Panofsky, *Gothic Architecture and Scholasticism*, Latrobe (Pennsylvania), 1951, where the analysis of the forms and methods of mediaeval logic brings a new light on the subject.

youth—not an abstract priority, but the vital quality of a style, in full command of its resources, making its first appearance. By its retention of the twelfth-century work in the old towers and the Royal Portal, it indicated the stock from which it sprang. It abandoned the alternation of supports, yet retained a vestige of it in the piers, which are alternately cylindrical and polygonal. The flights of flying buttresses, linked by squat columns, are of quadrant form. The archivolts of the clerestory windows are still semicircular. Finally the walls, cut from the rough shell-bearing limestone of the Berchère quarries, are no fragile partitions, but monumental masses. When one considers in addition that the tradition of the Royal Portal workshops continued to inspire the earliest sculptors of the transept doorways, it is apparent that Chartres, which in its youthful vigour took a long step beyond the twelfth century, nevertheless retained the charm and grandeur of the old ways.

The study of the great cathedrals of the thirteenth century comprises fewer varieties than that of twelfth-century cathedrals. There are fewer essential differences between Chartres, Reims and Amiens than there are between Sens and Paris, or even Paris and Laon. A classic mode of thought in architecture is as stable as a beautiful language, which, once established, has no need of neologisms.

14 Reims,[1] whose history was intimately associated with that of the monarchy, from the Hincmars and the Adalberos onwards, gave the cathedral of the coronation a nave of ten bays, but its transept has neither the monumental development of Chartres, nor the porches which there give exceptional relief and colour to the subsidiary façades. The eastern parts are seated on massive concretions which serve as a basis for the vertical development of the structure. On this formidable masonry rests an architecture whose elegance appears in the design of the windows, the profiles of the mouldings, the more open and audacious form of the flying buttresses, and even in the pinnacles surmounting the main buttresses,

[1]One year after the fire which, on 6th May 1210, had destroyed the old Carolingian cathedral of Reims, Archbishop Aubri de Humbert laid the first stone of the new church. The choir was completed in 1241, as were also, no doubt, the transept and the first two bays of the nave. This section was the work of Jean d'Orbais and his successor, Jean Le Loup. These masters were followed by Gaucher de Reims (about 1247) and Bernard de Soissons (from about 1255 to the end of the century). The west doors were begun by the middle of the thirteenth century, and the towers were in course of construction in 1299—they were finished in 1427. At the beginning of the sixteenth century the restoration of the transept gables was put in hand; these had been damaged by a fire in 1481. See L. Demaison's studies, *La cathédrale de Reims, son histoire, ses dates de construction*, Bulletin monumental, 1902, and *La cathédrale de Reims*, Congrès archéologique de Reims, 1911. *The chronology of Rheims Cathedral is difficult to establish in all its details. Important remarks were made by H. Deneux, *Des modifications apportées à la cathédrale au cours de sa construction du XIIIe au XVe siècles*, in Bulletin monumental, CVI, 1948, pp. 121–140; but the most penetrating analysis of all the problems involved is found in three recent articles by R. Branner in Speculum XXXVI, 1961, pp. 23–37; Zeitschrift für Kunstgeschichte, XXIV, 1961, pp. 220–241, and Journal of the Society of Architectural Historians, XXI, 1962, pp. 18–25.

which are contrived as niches containing figures of angels, and topped by little spires. The façade provides a gorgeous development of a theme which was renounced, with an exquisite sense of fitness and for the better co-ordination of the parts, by the Chartres architects, who allowed the Royal Portal to retain its full emphasis and pierced only a rose in the sober wall above the earlier triplet of windows. In Paris, despite the importance of the galleries and the enormous diameter of the rose, the wall preserves its severe strength and its character of a broadly modelled mass. The Reims architects composed a skeletal, highly-coloured *décor*, sustained by an armature of buttresses, hollowed out below with deep door-splays surmounted by openwork gables, overrun even in the upper storeys by an admirable sculpture, and enlivened with arches and colonnettes. The design is related to, but more elegant than, that of Amiens, where the volume and depth of the portals are so stressed that they seem almost to be porches, separate from the main building.

But Amiens[1] is above all a masterpiece of structure. The nave is the purest and most perfect expression of the Gothic system, with an absolute quality, an inerrant logic, which is rendered clearer and colder by the even light falling through uncoloured windows. Nowhere better than here can one grasp that harmonious progression of the supports, by which, as they ascend, new colonnettes are constantly added to sustain the springing of new arches. A horizontal string-course runs beneath the triforium-sill, and its ornamentation introduces into this elegant, severe order a slight movement and a just measure of relief. In details of this sort we see how sensitive the style is. Even in its strictest expression, this architecture is not exclusively intellectual. The nave of Amiens, running counter to the normal practice of commencing the church from the east end, is older than the choir. But no abrupt transition marks our passage from one age to another. Amiens shows us how homogeneous this art was in its successive variations, and the details which we notice in the choir suggest a change of programme rather than a new style. This is true of the glazed triforium, tending to merge with the clerestory, a characteristic feature of *Rayonnant* architecture. We see here an early stage of the development which was to end with the complete absorption of the triforium, but all this could have been foreseen from

<div style="text-align: right">
38

39
</div>

[1] The old cathedral at Amiens had been destroyed in 1218. Two years later the new building was begun, under Bishop Evrard de Fouilloy. The nave was completed in 1236,* the radiating chapels in 1247. In 1258, work was interrupted by a fire. The choir was completed before 1270. From 1220 to 1288, Robert de Luzarches, Thomas de Cormont, and his son Renaud, were successively masters of the works. The series of chapels between the buttresses was begun before 1292; the two latest were built for Cardinal de Lagrange, during his episcopate (1373–75). The north tower was begun about 1366; the south tower is the work of the early fifteenth century. *P. Frankl, *A French Gothic Cathedral: Amiens*, Art in America, XXXV, 1947, assesses the significance of the building.

the day when the architect of Chartres dispensed with the upper walls, and began to speculate concerning the void as his predecessors had speculated concerning the solid. The immense windows of the Amiens chapels, cages of glass sustained by piers and projecting buttresses, are a direct consequence of the same principle.

Such were the interconnections of the various forms which had evolved out of the one technique. The great development of aisles and clerestory was characteristic of thirteenth-century architecture, but the latter is not entirely comprehended within this definition—its unity of style was not that of an academic formula. Bourges,[1] whose conception had its roots deep in the twelfth century, and whose construction spanned several distinct periods, is a memorable example of the research and invention which were possible within this unity, and it acquaints us with one master of this great lineage whose genius had an individual cast. The cathedral of Bourges deploys five naves, whose height diminishes in steps from the centre, over a plan of longitudinal type, without transepts, and with radiating chapels of very modest size. Its lateral portals conform to the style and iconographical programme of the portals with column-figures. The V-shaped vaults of the Paris ambulatory recur in the crypt. The archbishop who began the work was the brother of Eudes de Sully, who began the façade of Notre-Dame. We have good reason to assume therefore that these analogies, supported by a historical fact, prove the derivation of Bourges from Paris. The interior composition adds a further element of great interest: the nave piers, composed of a cylindrical core surrounded by colonnettes, are of the same type as the strongly stressed piers in the aisles of Notre-Dame. Finally, the elevation of Bourges cathedral, seen in an abstract, strictly frontal view, so that it is reduced to a plane projection, reveals itself as a many-storeyed elevation, comparable with the great twelfth-century churches with tribunes, such as Paris and Laon. The connections are intimate and beyond dispute.

But this diagrammatic representation of the bay design is not the same thing as the monumental mass, and even a considerable number of indisputable archaeological indications is insufficient to define an architectural style. Bourges

[1]The project for a new cathedral originated in 1172. The lateral portals are of that period. Work was begun on the cathedral itself about 1190. The choir was completed about 1220, the nave not before 1270. The great window of the west front is the work of Guy de Dammartin (about 1390). Jacques Coeur was responsible for the building of the sacristy (1447). The north tower collapsed in 1506 and was rebuilt shortly after. For M. Aubert, *Notre-Dame de Paris*, p. 182–4, the Bourges scheme is imitated from Paris; for R. de Lasteyrie, *L'architecture religieuse en France à l'époque gothique*, I, p. 91, it is an original conception. Cf. the analysis of E. Lambert, *L'art gothique en Espagne aux XIIe et XIIIe siècles*, p. 141. *On Bourges, H. Focillon, *Généalogie de l'unique (Fragment)*, Deuxième Congrès International d'Esthétique et de Science de L'Art, Paris, 1937, II, pp. 120–127. On the previous building, see R. Gauchery and R. Branner, *La cathédrale de Bourges aux XIe et XIIe siècles*, in Bulletin monumental, CXI, 1953, pp. 105–123.

has four, or even five, storeys of windows and galleries—the outer aisle, forming the ground storey, the triforium and clerestory of the inner aisle, and the triforium and clerestory of the nave. But these storeys are not all in the same vertical plane; they rise step-wise from the outer wall to the centre. The second and third storeys, in particular, are pure fiction; the wall apertures suggest their existence, but in fact there are no tribunes, the piers soar uninterrupted to the springing of the main arcades, and the inner aisles are unrestricted in their vertical development. The conflicting researches of Sens and Paris were here combined and reconciled. Yet we shall have been misled by our genealogical method if it causes us to overlook the profound originality of this conception, which at one stroke resolved, by brilliant co-ordination, the problems of the five-aisle plan, of the many-storeyed elevation, and of the vertical development of the aisles. It may be asserted that, to arrive at this solution, it was sufficient merely to suppress the floor of the Paris tribunes. This is true. But to dare to do so, and accept the consequences, was quite another thing. The nave of Rouen *40* shows a bastard survival of the old Norman tribune which helps us to realize the courage of the decision which was taken at Bourges: the aisles rise without interruption, but from pier to pier, at the level of the absent tribunes, runs a gallery which is apparently suspended in mid-air. The cathedral of Bourges, though linked with Notre-Dame by so many characteristics, and by its history, is fundamentally different from it. It is a new invention. The master who conceived it was not only a daring builder. With these mighty masses he also devised a kind of optical illusion, by which, in this one church, he shows us several different churches: standing directly in front of each bay, we seem to see the finest and most complete of the twelfth-century cathedrals; but if we consider the aisles, we recognize the amplitude of scale which Chartres had bestowed on this part of the building. In the long nave, without transept, where the enormous piers, a combination of the columnar and compound types, succeed one another like elegant colossi, the architect introduced a perspective-correction, avoiding the apparent diminution of intervals by spacing his supports more widely towards the east. With its unbroken longitudinal axis, and its multiple naves diminishing in scale from the centre, the great vessel presents an overwhelming vista.

Just as the novelty of Chartres was attested by its filiation, so that of Bourges is confirmed by Coutances, Le Mans and Toledo. This last is a passive imitation, of heavier proportions, in which the only Spanish contribution is the design of some of the triforium arcades. The true poetry of Toledo must be looked for in the complexity of the buildings which history has built up around it and the

labyrinthine treasures deposited there by successive periods, but the frame in which these things are set is a French conception, based on Bourges. The choir of Le Mans,[1] which terminated an older nave, with great double bays in the style of western France, is one of the most audacious of medieval compositions. The east end, seen from the exterior, is the fully developed Gothic chevet, very rich in the composition of the masses, whereas that of Bourges, with its pointed chapels of slight projection, still belonged to an earlier period. At Le Mans, the flying buttresses seem not so much to prop the structure as to hoist it skywards with their vertical impetus. Plan and structure are composed for the purpose of seating and equilibrating the various parts in a complex interplay of counter-thrusts. The ambulatory has square bays, with triangular ribbed vaults between. This very advanced system here revives the old Carolingian scheme, of which we have seen one example in the chapel at Aix.

51

II

THUS Gothic art in the first half of the thirteenth century, despite its cohesive force and the close family bond of certain groups, by no means appears as a doctrinaire classicism, spinning monotonous speculations round a single formula. Chartres and Bourges have still the poetic quality of a discovery, or, one might say, the charm of present experience, still incomplete and still evolving. The *Rayonnant* style in its early stages did not lack this vital quality; it was endowed at first with the graces of life, but it tended rapidly to become a formula. We must ask, first of all, was this really a 'style'? Did it introduce fundamental modifications, or an entirely new spirit, into the economy of the building? And does this term *Rayonnant* denoting a certain arrangement of window tracery, adequately suggest its characteristics? Certainly no better than does 'Lancet style', as applied to the architecture of the preceding period. Once more the secondary features fail to define the significant aspects of an evolution. The principles of the latter were already implicit in earlier 'states' of Gothic architecture—the annulment of the solid in favour of the void in the clerestory of Chartres, and the bracing by means of masonry *en délit* in the colon-nettes round the strongly stressed piers in the aisles of Notre-Dame. It was

[1] The old cathedral of Le Mans had been altered on numerous occasions. Consecrated in 1093, burned in 1099, restored in the early years of the twelfth century and consecrated in 1120, the nave was vaulted under Bishop Guillaume de Passavant (1158). In 1217, Bishop Hamelin demolished the ramparts in order to enlarge the choir, which he consecrated in 1254. The transept was built from 1310 to 1430. The cathedral of Coutances was rebuilt after the fire of 1218, and work was completed between 1251 and 1274. *To these must be added, as the first work inspired by Bourges, the choir of Saint-Martin at Tours, c. 1210: see E. Lambert's brief indications in Bulletin de la Société Nationale des Antiquaires de France, 1945–7, pp. 189–91.

inevitable that the skeletal technique, based on the use of shafts and arches, to the detriment of the connecting tissue, should be carried to extreme limits; this morphological necessity was the reflection of a state of mind. It has been pointed out that since all the solutions of the problems of statics were already known, it was hardly possible to do more than make further inferences and refinements along the same lines. It must certainly be remembered that the masters who were active in the second third of the thirteenth century, and down to the end of the fourteenth, had before their eyes admirable and varied models, and that they studied them, not as archaeologists or dilettanti, but as men who, themselves facing this task of creation, had the most lively sense of their beauty. This is clearly shown by the legends which Villard de Honnecourt appends to his abstracts and sketches. The horizon of masterpieces restricted invention, but not the elegant perfection of exquisite techniques. The originality of the *Rayonnant* style appears neither in the plans nor in the relations of the masses, but in the treatment of structure and the harmony of effects. The multiplication of private chapels between the buttresses is an addition which is sometimes unfortunate, but which makes no essential difference to the old plans. The composition of the whole remained much as it was; in the medium-sized churches of the fourteenth century, however, the frequent replacement of the apse by the square east end should be noted. But before that, in the middle of the thirteenth century, more remarkable features become apparent in structure and execution—the bracing shafts, for instance, and the elimination of the wall, which are functions of each other.

Without leaving Amiens cathedral we can see an example of the increasing ascendancy of void over solid, which tended to reduce the structure to a system of arches and reinforced supports, to the detriment of the wall-masses and to the advantage of the windows. The elevation of the apsidal chapels consists solely of great sheets of glass upheld by powerfully projecting buttresses. In the choir and transept, the external wall of the triforium is glazed, so that, seen frontally from below, its arcades seem to be a continuation of the clerestory windows, from which they are separated only by a narrow strip of wall. This was the beginning of that attraction which the clerestory exercised over the triforium, and which, in the next century, and particularly in the *Flamboyant* period, was to lead, except in Normandy, to the two-storey type, in which the upper windows have entirely absorbed the gallery and nothing intervenes between them and the main arcades except a bare wall surface of variable importance. The opening up of the wall is characteristic of the art of Pierre de Montereau, both in his great chapels and in his alterations of older naves. Is there perhaps an influence from Champagne

underlying this particular development of Gothic thought? Pierre de Montereau was perhaps Pierre de Montreuil. . . . Certainly the chapel of Saint-Germain-en-Laye has the passages running through the buttresses at the level of the window-sills which are characteristic of the manner of Champagne. But what a gulf there is between the chapel of the Archbishop's Palace at Reims, still so laden with solid matter, and the Sainte-Chapelle of the former royal palace in Paris! As is well-known, this astonishing shrine of stone and glass was erected by St. Louis to house a relic of the Crown of Thorns. The dimensions of the Sainte-Chapelle, so much larger than the apsidal chapels at Amiens, gave the strangest and most paradoxical authority to a scheme which seems to defy gravity, at least when viewed from within. The wall mass, having been eliminated to make room for the stained-glass windows, reappears outside in the massive buttresses, as if the side-walls had been turned on hinges to a position at right-angles to their original one. In addition the archivolts of the windows receive a new load, to prevent them from yielding to the thrust of the vaults, in the form of a stone triangle, the gable, whose weight bears relatively lightly on the flanks of the arch but is concentrated over the keystone, playing a part analogous to that of the pinnacles of the buttresses. Everything, indeed, in this building betrays the refinement of its solutions, from the system of equilibrium which we have briefly analysed, devised for the sake of the interior effect, to the vaulting of the undercroft on which it stands. There is a severity in its grace which has nothing of mediocrity. This conception delighted its century, and was acclaimed as a masterpiece. It provoked imitations, such as the charming chapel of Saint-Germer, which terminates a twelfth-century nave on this note of ethereal elegance.

The liberal illumination of the nave was the aim which this same architect set himself in his alterations of the sombre and majestic churches of first Gothic art. It is impossible not to feel admiration, not only for the results achieved, but for the initiative which conceived and dared them. Carried forward by the natural evolution of the style, Pierre de Montereau[1] had no fear of perverting its spirit or its teaching when he set his hand to the old walls which his predecessors had raised, and indeed the choir of Saint-Denis harmonizes most admirably with the thirteenth-century nave, its huge clerestory windows, its great arcades and its transparent triforium. But the real masterpieces of *Rayonnant* art are without doubt the colossal rose-windows cut in the end-walls of the transepts at Saint-Denis and Notre-Dame, where the blind courses of inert stone are replaced by

[1]See H. Stein, *Pierre de Montereau, architecte de l'église abbatiale de Saint-Denis*, Mémoires de la Société Nationale des Antiquaires de France, vol. LXI, 1902. *On the work of Pierre de Montreuil at Saint-Denis, see now S. McK. Crosby, *L'abbaye royale de Saint-Denis*, Paris, 1953, pp. 57–65.

a skeletal armature which, within a net made up of radii, circles, and the arcades festooned around the circumference, entraps multicoloured light. The wall has fallen, and revealed a wheel of fire. In the composition of horizontals and verticals by which architecture is dominated, even when arches are admitted for vaults and wall apertures, it required some audacity to introduce these gigantic circles, reminiscent of the sun-discs of earliest folk-lore. But they too were the expression of a mode of thought which sought balance through the interaction of the parts: everything functions, everything is composed, to satisfy both eye and mind. Everything is tensed for action. When we compare these with the plate-tracery of the Chartres clerestory, or better still, with the rose-windows of the twelfth century, still cautious and massive, and in their very economy respecting the wall, we feel that the final step has been taken and that the architecture of co-ordinated forces has at last replaced, in its most magical form, the architecture of mass and substance. But it was in this very triumph that the danger lay. Architecture must have mass, and it must even impress us, though not overwhelm us, with the evidence of its weight. The just ratio of solid and void had been overstepped. Everywhere that the wall could be replaced by the coloured light of stained glass, the wall disappeared. Even the spandrels, between the circle and the square in which it was inscribed, were glazed in their turn. This was the final stage in an evolution, which, beginning with the modest oculus, had gradually enlarged it, until it now spilled over the circumference to occupy the whole of the space between the piers. The lesson of Chartres had borne fruit. But instead of the width of a single bay, the whole transept façade was now in question. Light falling from the transparent triforium, light from the enlarged clerestory windows, light from the rose windows of the transepts—except for the rigid bone structure, the whole building is as if dissolved in light. The development of the windows of Saint-Urbain at Troyes,[1] of the cathedral of Metz, and of Saint-Ouen at Rouen, provides most beautiful examples of the application of this principle.[2]

[1]Saint-Urbain at Troyes was founded in 1263 by Pope Urban IV, and the work went on so rapidly that the choir was consecrated in 1266. But a fire, followed by litigation against the treasurer of the works, Jean Langlois, retarded operations, and the church finally remained incomplete. See Lefèvre-Pontalis, Bulletin monumental, 1922, p. 480. The cathedral of Troyes is no less important in the history of the *Rayonnant* style; it retains the triforium, whereas Saint-Urbain and other churches of its type have only two storeys. In the choir, this triforium is glazed; is it earlier than that of Amiens? V. de Courcel, *Étude archéologique sur la cathédrale de Troyes*, Positions de thèses de l'École des Chartes, 1910, considers that the upper parts were complete by 1240. Nevertheless, the work, begun under Bishop Hervé (1206–23), made slow progress.
[*2]On the architecture of the late thirteenth and early fourteenth centuries, see: L. Schürenberg, *Die kirchliche Baukunst in Frankreich zwischen 1270 und 1380*, Berlin, 1934; W. Gross, *Die abendländische Architektur um 1300*, Stuttgart, 1948.

But the lighting was only one particular consequence of the opening up of the wall, though it is true that it was one which was desired, consistently sought, and very striking in its effects. The shedding of useless mass occurred also in other parts of the building, for instance, in the flying buttress, which sometimes tended to separate out into its constituent elements. Examples occur in which the extrados, comprising the sloping member which contains the drainage channel, is linked with the intrados, not by solid masonry, but by circular stone struts. If we now carry our minds back over the history of the flying buttress to the time when it was still a concealed buttress wall, pierced with a door to allow circulation, we shall perceive the two extremes of a regular progression in which mass had gradually been replaced by force, and inertia by action. When one considers the arches and windows of the *Rayonnant* style, it becomes apparent that the disappearance of the wall necessitated particular rigidity in the remainder of the structure, and the solid framework of these immense apertures was achieved by the association, as far as possible, of masonry *en délit* with the normal coursed masonry. In construction by horizontal courses, the stones lie one above the other in the same direction as the beds of rock in the quarry whence they were extracted. If, instead of being laid horizontally so that in some sense they recreate the quarry in the building, they are turned through a right angle and set vertically, *en délit*, they are capable of resisting great pressures. Thus the difference between the mullions of a window and the wall on either side consists not only in the fact that the former are single stones while the latter is coursed masonry, but also in the different directions of the grain of the stones. The quality of the stone from certain strata, for instance the small hard bank of Tonnerre, was of great assistance, in this respect, to the architects of Burgundy and Champagne.

Viollet-le-Duc[1] considered the justification of this technique lay in its bracing effect. He thus attributed to the members *en délit* a function similar to that of the vault rib, which is solid and fully settled while the settlement of the vault panels is still proceeding. It may be asked, however, whether these functions are really identical, and whether, when coursed masonry and members *en délit* are juxtaposed under the same load, the settlement of the former would not involve the fracture of the latter, since they are incompressible, or at the very least throw the system out of true. If so, then a church of this type might be stripped of all organs *en délit* and still maintain perfect balance with its plain coursed masonry alone. This is true, but it is equally true that the substitution of stones *en délit* for stones in horizontal courses represents an essential factor in Gothic architecture, which does not so much concern the transition from the 'elastic' to the

[1] *Dictionnaire d'architecture*, vol. IV, p. 136 *et seq.*

rigid state as the *absolute* tension and the attenuation of the supports. It is interesting to recall that this tendency first appeared, as the germ of a skeletal architectural style, in the twelfth century, in such examples as the piers in the aisle of Notre-Dame, and the transept of Noyon. But by their constantly increasing reliance on members of this kind, the architects tended towards a system of prefabricated parts, or, to use another expression, towards a sclerosis of the old supple organism. In the *Rayonnant* variations on the flying buttress, the future development of the straight stone prop may be discerned. The very profile of its arch, of thinner section and meeting the wall of the church at a more acute angle (as in the chevet of Semur-en-Auxois), predisposed it to this evolution.

This art of calculation and studied grace was not confined to chapels (though in these it found perhaps its most perfect expression) nor great churches. It also essayed the colossal scale, at Beauvais[1] and Cologne.[2] It was natural that it should *54* apply these technical solutions to gigantic programmes, for they were held to be absolutely sure and, since all useless weight had been eliminated, capable, at least theoretically, of unlimited expansion. It even introduced structural paradoxes, which, surprising enough in a building of normal size, here acquire a quality of daring eccentricity. The inner of the two free-standing buttresses which retain each double flight of flying buttresses rests in *porte-à-faux* (i.e. not vertically above but slightly to one side) on the aisle-pier, in order to avoid obstructing the aisle with an enormous mass of masonry. It overhangs this pier, and is only kept in balance by the twin arches which butt against it, both back and front. It is precisely this feature which gives the solution its peculiar elegance: the arches whose function it is to resist the thrusts of the vault, turn those very thrusts to account for the purpose of sustaining an unstable equilibrium. But the expenditure in external supports is none the less formidable. The masonry which had disappeared to make way for the windows, reappears, multiplied, in this forest of flying buttresses and free-standing buttresses which surrounds the sanctuary. Within, we find once more the choir of Amiens, with its verticality increased, and compressed upwards, with long sword-like windows,

[1]Beauvais cathedral was begun in 1247. The choir was completed in 1272. Owing to the excessive frailty of the supports and the buttressing system, the vaults collapsed in 1284. The rebuilding included intermediate piers in the main arcades and supplementary transverse arches in the vaults. The transept, in which Martin Chambige collaborated, was finished during the first third of the sixteenth century. Finally, the architect Jean Vaast erected an openwork spire, 500 ft. in height; this collapsed in 1573. Beauvais cathedral has an internal height of 157½ ft., and the central span is about 51 ft. wide. On the flying buttresses, or rather the free-standing buttresses in *porte-à-faux* which retain them, see E. Viollet-le-Duc, *Dictionnaire raisonné de l'architecture*, vol. I, p. 70, Fig. 61.
[2]Cologne cathedral was begun in 1248; the choir was not finished until 1320, and consecrated in 1322. The nave was not begun until 1350, when the transept was still incomplete. The work proceeded extremely slowly, was broken off in 1559, and not resumed until 1824.

a transparent triforium, and tense shafts. The choirs of Beauvais and Cologne, colossal transcriptions of Amiens, bequeathed to posterity their huge incompleteness. The piers at the crossing of Beauvais give some hint of what the tower must have been like prior to its collapse. Would Beauvais, completed, have been the last word in Gothic architecture? No doubt it would, but not more so than Amiens, of which, in the last analysis, it is merely an inflated version. Cologne, completed in the nineteenth century, is a French import into German architecture, which, while it utilized Gothic structure, more often than not remained loyal to the Romanesque system of masses and to Rhenish habits of composition.

III

IT is interesting to watch the behaviour of thirteenth-century art—the architecture of Chartres, the architecture of Bourges, or the *Rayonnant* style—when it crosses the frontier of the territory where it had matured, and produced its prototypes, to set off on its travels through the French provinces and the rest of Europe. There can be no question of presenting here a complete picture of all the local and national variants; what matters most is to show to what extent the uniform and authoritative style of the models which it offered was acceptable to the special genius, the traditions, the resources and the materials of the individual localities. Here, as always, the idea of influence has various nuances. Influence acted sometimes through passive imitation, sometimes through contamination; but it also happened that the combination of the new and the traditional produced forms of singular originality. This study is made very difficult by the fact that the various kinds of influence do not necessarily conform to any geographical division, and that a single region can often show very diverse phenomena. Some countries were vigorously conservative, some were open to influence and even capable of fresh invention, and some, while faithfully preserving certain older forms, also created and propagated completely new ones. At no time, perhaps, have the life and diffusion of plastic forms presented more curious analogies with the life and diffusion of linguistic forms.

We must deal first with the older centres, which had contributed generously to Gothic art from an early date, and whose role, perhaps, has not so far been adequately defined. Anjou, in the thirteenth century, combined archaic and advanced elements. Its archaism, however, acquaints us with an early state of the Gothic system, an independent evolution running parallel with that of the French heartland. We catch no more than a glimpse of the connections which

may have existed between the ribbed domes and the huge domical Angevin vaults, of great span, like those of Saint-Maurice at Angers.[1] The Plantagenet style retained this type of vault, but multiplied its ribs, allowing them to spring from the keystones of the lateral arches, and tailing them into the vault. In a great many churches—Airvault, Saint-Jouin-de-Marnes, Saint-Serge at Angers *46* —it created those star patterns of ridge-ribs and liernes which foreshadow *Flamboyant* vaulting.

Normandy had played a more important part. The true rib, as a structural member, had been utilized there in the vaulting of buildings from an early date, and it had spread from Normandy into the *Domaine*. But it was in the Ile-de-France that it developed all its potentialities and engendered a new style; and when, by an intriguing reversal of influence, it returned again to the territory where it had first been applied, it was in its French form, and accompanied by the whole system to which it had given birth.[2] It first appeared in this new guise in the Saint-Romain tower of Rouen cathedral, in the nave of Lisieux cathedral, in the collegiate church of Eu, and at Fécamp. It showed its full stature at Caen, in the choir of Saint-Étienne, the work of Master Guillaume, supreme in the arts of stone, 'petrarum summus in arte'. The seven radiating chapels opening from the ambulatory have ribbed vaults with a fifth branch as at Saint-Denis, but instead of replacing the internal divisions by columns throughout, a low wall is here allowed to remain between them. This is a Burgundian trait, for it turns up again in the choir of Vézelay, and must be connected with others of the same origin, such as the elbowed terminations of certain shafts. Thus there appears already, in these plain traces of influence, a hint of that process of contamination which was to lead eventually, particularly in the circle of Jean Deschamps, to eclecticism and the systematic application of pooled resources. The four turrets, however, which flank the choir, are an original conception which was imitated at Bayeux and Coutances. The east end of this latter cathedral, dominated by the enormous lantern tower over the crossing, is one of the most complex and perfect *44* works in the whole of Gothic architecture. In plan it recalls Pontigny (whose *45* banded columns recur at Saint-Étienne) and in elevation Le Mans, while the structure of the chapels, with their detached columns, is related to that of

[1] The vaults of Saint-Maurice at Angers, which are the masterpiece among the great concave, so-called domical, vaults, date from the restoration begun under Bishop Ellger (1125–49) and continued under Normand de Doué (1149–53), by which the old eleventh-century basilica was converted into a single nave by the suppression of the arcades, and reinforced with massive buttresses. The nave is more than 52 ft. wide, the span of the vault-ribs exceeds 62 ft., and their keystones are more than 10 ft. higher than those of the transverse arches and formerets. See J. Bilson, Congrès archéologique d'Angers, 1910, p. 205.

[2] See E. Lambert, *Caen roman et gothique*, Caen, 1935, p. 44 *et seq.*

Saint-Denis. But these relationships and formal connections, while they testify to the fruitfulness of mutual influences and the profound interaction of the different varieties of the style, leave room in many churches for such local features as the acutely pointed arches;[1] and in the nave of Rouen, there survives, as a sign and a witness, the old Norman tribune-system, in the form of a narrow gallery running from pier to pier, behind which the aisles rise uninterrupted to the base of the triforium.

Burgundy had a long experience of Gothic art, including the Vézelay narthex with its rib-vaulted bay (one of the earliest examples), the choir which was added to the Romanesque nave of the same church (after 1161), the cathedral of Sens, and finally the architecture of the Cistercian order, by which that art was diffused throughout the Christian West, and in central Europe. It remained loyal to its own past in its attachment to the Cistercian type, which it had created, with square east end, rectangular chapels, and two-storey elevation (Saint-Seine), in the unusual persistence of tribunes (Flavigny), in the use of porches, as at Saint-Père-sous-Vézelay, Semur, and Notre-Dame in Dijon, in the sexpartite vaulting, and in the springing of arches from corbels. The ambulatory of Auxerre cathedral, which has no chapel apart from the Lady chapel, is likewise of early type. Among the features which Burgundy shares with Champagne, are the openings pierced through the supports at the level of the clerestory in order to obtain a circulation gallery round the upper walls; the formeret and the archivolt of the window are separate, and the embrasure is vaulted independently. But influence from the areas of Soissons and Laon is even more apparent.[2] This had been the richest and most original locality of first Gothic art. Its continuing vitality was affirmed at Ourscamp, Longpont, Royaumont and Saint-Jean-des-Vignes. At the end of the twelfth century, the architect of Saint-Vincent at Laon, under Abbot Hugues (1174–1205), had adopted the three-storey elevation without tribunes, which is also found in the Praemonstratensian church of Saint-Martin. Saint-Vincent preceded and prefigured Chartres. At the same time the fine compositions of the Noyon transept and the Laon transept chapels, with

[*1]Many of these 'local' features are actually of English origin. On the stylistic exchanges between England and Normandy in that period, see C. M. Girdlestone, *Thirteenth-Century Gothic in England and Normandy: a Comparison*, in Archaeological Journal, CII, 1945, pp. 111–33.

[2]See E. Lambert, *L'art gothique en Espagne aux XIIe et XIIIe siècles*, p. 151; J. Vallery-Radot, *Une réplique peu connue de Saint-Yved de Braine*, Bulletin monumental, 1926, and the article by the same author on *Notre-Dame de Dijon*, Congrès archéologique de Dijon, 1928. C. Oursel, Bulletin paroissial de Notre-Dame de Dijon, February 1935, recalls the part played by the commune in the erection of this building, and the relationship between the Dijon charter of 1183 and that of Soissons; he also throws light on the connection between Braine, the dynastic chapel of the Counts of Dreux, and Notre-Dame in Dijon, to which Yolande de Dreux, wife of Hugh IV, Duke of Burgundy, contributed.

their ranges of windows, were under construction. This scheme also appears in the apse of Notre-Dame at Dijon (before 1229–before 1240), which borrows other features from the architecture of the Soissons area—the cylindrical piers in association with a tripartite elevation, and the chapels set obliquely as in Saint-Yved at Braine (1216), a characteristic which recurs in St. Maria at Trier and at Cuenca, in Spain. The Sainte-Chapelle of the Palace of Dijon, built during the first half of the thirteenth century, had the same arrangement.[1] With its east end imitated from the Laon chapels, its sexpartite vaults, its monostyle pillars, and its choir, without an ambulatory, flanked by diagonal chapels, Notre-Dame at Dijon seems at first sight archaistic. But, in fact, it is the continuation, alongside the Chartres formula, of a style which was very much alive—and which perhaps was also responsible for the elegance of the structure, the use of the *délit* technique, and the perfection of the equilibrium, which includes a daring *porte-à-faux*. This style spread into the regions beyond the Jura, and propagated its influence as far as Lausanne and Geneva.[2]

Champagne, which in the history of architecture is so closely linked with Burgundy, had contributed Notre-Dame-en-Vaux at Châlons and Saint-Rémi at Reims to first Gothic art, while to thirteenth-century art, it gave the great cathedral of Reims, one of its most perfect examples; in the south, at Provins, during the second half of the twelfth century, the architect of Saint-Quiriace had essayed, in his eight-branched vault, one of those experiments without a sequel, which none the less are sometimes numbered among the finest achievements of a style; in the same region, at Troyes, the cathedral and Saint-Urbain illustrate the new approach which wrung bold and novel forms out of the classic solutions—the cathedral, with its audacious structure, which was betrayed by the poor quality of the materials, and Saint-Urbain, with its systematic use of *délit*, its delicate, skeletal flying-buttresses, and its huge wall-apertures. In Picardy, the collegiate church of Saint-Quentin,[3] the work of Villard de Honnecourt, belongs to the same period of structural science. It combines its unambiguous structure with—in its two transepts—a reminiscence of an earlier age. Its lofty ambulatory, lit by

*[1]On this movement, see J. Bony, *The Resistance to Chartres in Early Thirteenth Century Architecture*, Journal of the British Archaeological Association, 3rd ser., XX–XXI, 1957–58, pp. 35–52. On Burgundy generally, R. Branner, *Burgundian Gothic Architecture*, London, 1960.

*[2]On the cathedral of Geneva the standard work is still C. Martin, *Saint-Pierre, ancienne cathédrale de Genève*, Geneva, 1910. On Lausanne, E. Bach, L. Blondel and A. Bovy, *La cathédrale de Lausanne*, Vol. 16 of the Kunstdenkmäler der Schweiz, Basle, 1944. On the whole question of Gothic architecture in Switzerland: J. Gantner, *Kunstgeschichte der Schweiz, II, Die gotische Kunst*, Frauenfeld, 1947.

[3]The choir was consecrated in 1257. The eastern transept, an unusual survival of an early type of plan, was begun in the first half of the thirteenth century. *In view of the close commercial links between England and Picardy the narrow eastern transept of Saint-Quentin is likely to have been derived from an English source: Lincoln (1192), definitely earlier than Saint-Quentin, had already, the typical narrow eastern transept.

wide windows, recalls, as at Beauvais, the tribuneless yet many-storeyed elevation defined at Bourges.

In Lorraine, the cathedral of Metz, and in Alsace, the cathedral of Strasbourg, extend the hegemony of the French style as far as the Rhineland, where Cologne is a repetition of Amiens. But, though Cologne is a copy, Strasbourg is an original work, notable for the beauty of the Vosges sandstone of which it is composed and for the abundance of its sculptural decoration, no less than for the continuity of its stylistic development, ranging from the eastern parts, which are still dominated by a Romanesque conception, to the west front, crowned by Ulrich von Ensingen's famous spire, one of the masterpieces of the declining Middle Ages. Dehio considered this façade to be the most beautiful invention of the *Rayonnant* style. A whole series of projects for it, drawn on parchment, are preserved in the museum of the cathedral. Together with Villard de Honnecourt's studies of the Reims elevation and the Laon tower, these precious drawings show the ideas of the masters in the pure state. But whereas Villard's sketches are notes of existing buildings, the Strasbourg designs[1] are a complete set of working drawings for a building as yet unrealized. These great linear compositions render admirably the mind of the master. Project B was eventually adopted, and was carried out up to the level of the second gallery. It is probably the last word in the proportional science and the geometrical co-ordination which made the architecture of this period perhaps the most refined expression of the classical spirit in Western Europe.

But in southern France, the old Romanesque country where Romanesque art itself had borne the imprint of so individual a feeling, the development was more complex. Gothic art appeared there prior to the Albigensian war, and cannot therefore be regarded as a forced import, an 'instrument of conquest', for work

[1] See H. Reinhardt and E. Fels, *La façade de la cathédrale de Strasbourg*, a comparative study of the early projects and the work as executed, Bulletin de la Société des Amis de la cathédrale de Strasbourg, 1935, especially p. 24 *et seq.*: 'The height of the façade, without the towers, is equal to its width. The length of the diagonal of this square gives the vertical height of the towers, including the cornice. An isosceles triangle inscribed in the rectangle so obtained gives the inclination of the gables. The width of the façade is divided into three equal parts: the towers, including the anterior buttresses, are equal to the central section. In each part rise eight vertical strips, springing apparently from the ground, and these, at some distance in front of the wall, determine the whole of the decorative system. Their lines are prolonged upwards by the mullions of the lateral windows, but in the centre they are interrupted by the great rose. Above it, however, they reappear in an openwork arcade, whose very compact system is based on the lancets of the buttresses.' The projected design set the door-gables against 'a superb tapestry composed of multiple lancets'. In the design as executed, this subtlety is lost, and the portals are set against a uniform curtain, a mural mass, in the ground-storey. I have recently had the opportunity of examining, at the Victoria and Albert Museum in London, a further project for the Strasbourg façade, and also one for Ulm cathedral.
*Add O. Kletzl, *Plan-Fragmente aus der deutschen Dombauhütte von Prag*, Veröffentlichungen des Archivs der Stadt, Stuttgart, 1939.

on the new rib-vaulted cathedral at Toulouse had begun before the town was besieged by Simon de Montfort in 1211. Nevertheless, the art of the men from the north, of the country of the *langue d'oïl*, had a peculiar historical significance in the country of the *langue d'oc*, and undoubtedly it was utilized there in a new way. The rib-vaulted structure was adapted to the single-nave plan, but the latter cannot, in this region where triple-nave basilicas abound and where Saint-Sernin spreads wide its five naves, be interpreted as a Romanesque survival. It is, however, a characteristic expression of the preference of the southern peoples for extension in breadth and for regular, clearly defined areas, immediately accessible to the eye, which is found not only in the south of France but also in Catalonia and Italy.

A demographic phenomenon peculiar to Languedoc[1] and the adjacent regions helped to maintain and propagate this type of church. The necessity of creating centres of population in an area devastated by religious wars led to the foundation of new towns—a factor whose importance we have already seen at the beginning of the eleventh century. These urban formations were particularly numerous in the regions which had been most severely tried, those of Toulouse and Albi. The movement was intensified at the end of the thirteenth century, but Raymond VII was authorized to found new towns as early as 1229; Cordes was his creation. Alphonse de Poitiers (1249–74) continued the work, which went on down to the Hundred Years' War. The little single naves, strong, easily and cheaply constructed, were also, in case of need, defensible. A number of them were modelled on the church of the Taur at Toulouse, whose character and style are quite foreign to the art of the north—with its crenellated façade surmounted by a wall-arcade and two ranges of triangular-headed apertures flanked by a pair of turrets.

Though common in Languedoc, the single-nave church is not confined to that province.[2] It occurs over a wide area which, in France alone, extends from Angers cathedral to the cathedrals of Orange and Cavaillon. The feature which normally distinguishes it here, and which should not be overlooked, for it is the principle of a great and original architectural style, is the projection of the buttress inside the church, which replaces the longitudinal partitioning of the aisles by a kind of transverse partitioning, without, however, intruding on the spacious volume of the nave. Was this an indigenous motif? It does not appear in the nave of Toulouse cathedral. It is generally brought into connection with Cistercian art,

[1] See P. Lavedan, *Histoire de l'urbanisme*, Paris, 1926, p. 281; R. Rey, *L'art gothique du Midi de la France*, Paris, 1934, p. 140.
[2] See P. Lavedan, *L'architecture religieuse gothique en Catalogne, Valence et Baléares*, Paris, 1935, chap. III, p. 61.

and the transverse barrel vaults of Fontenay. Long before the twelfth century, it had occurred in Mesopotamia, at Arnas (fourth–fifth century), and later in Basilicate, at Sant' Angelo al Raparo. It was very common in Catalonia in the thirteenth century, and was used there in combination with wooden roofs (San Félix at Jativa, Liria) as well as with ribbed vaults (Santa Catarina and San Francisco at Barcelona). In this way a structure of admirable strength and simplicity was formulated, a box which, like the Cistercian box, hid the internal organization behind a uniform wall. In programmes of small and moderate size, the churches are often very low and wide. Entering them, with the northern style in one's mind, is like going into a new world. The study of origins, filiations and mutual influences is apt to make us lose sight of the originality of the results. But whatever the point of departure of this form may have been, it led eventually to a highly individual style.

Another curious example of adaptation to new circumstances is seen in the number and importance of fortress-churches and churches with fortifications. At an earlier period, in the same region, Romanesque architecture had already submitted to this discipline, to which it was predisposed by the power of its masses and the dauntless strength of its construction. To control a country still heated with war, even long after the conquest, it was natural that churches, and even cathedrals, should be treated as strongholds. Sainte-Cécile at Albi[1] is, in every sense of the word, an extraordinary building. It shows the flexibility and grandeur with which Gothic architecture adapted itself to programmes, traditions and materials which were foreign to the spirit of its origins. We leave an evolution whose propositions follow so strictly one from another that we are sometimes tempted to consider it as a scientific demonstration, we emerge from churches whose very variations are a convincing demonstration of the unity of the style, and we are suddenly confronted with an admirable construction which refuses to fit into any of our categories. On a spur of land overlooking the river, the cathedral of Bishop Bernard de Castanet forms a compact mass, with an unbroken silhouette. It has neither transept nor eastern chapels. The western tower is as solid as a castle-keep. There are no flying buttresses, but massive rounded wall buttresses like towers, rise out of a glacis. Behind the brick curtain wall extends a vast and unbroken nave into which the buttresses project on either side; between the latter, chapels are contrived, which were later subdivided to form an upper

103

[1]The rebuilding of the old cathedral, ruined in the war, was planned as early as 1247. No decisive action was taken until the arrival of Bishop Bernard de Castanet (1277). The first stone was laid in 1282. In 1310, Pope Clement V issued an appeal to the faithful. The east end was completed about 1330, but the main structure was not finished until the time of Bishop Guillaume de la Voûte (1383–97).

storey, but which originally rose uninterrupted from pavement to vault. The main ribbed vaults are of considerable span. The equilibrium is assured by the great size of the buttresses, and this size responds not only to the demands of the static system but also to a programme which takes account of defensive requirements. Albi had no prototype and was never imitated. There is scope for an enquiry, in north Germany for instance, regarding the extent to which the brick-technique was able to produce similar effects and structural solutions elsewhere. But the austere spirit which inspired the great artist of Albi has left nothing comparable.

Among these churches of the Midi, a separate category must be reserved for the double-nave plan adopted by the Dominicans, of which attractive examples are provided by the churches of the Jacobin friars at Toulouse and Agen. The type may have been local, or it may have been imported, but it found here a most graceful and impressive formulation. A central colonnade, supporting the springing of each vault, divides the church into two equal and identical naves.[1] The principle of stepped naves was not essential to the stability, as is shown by the single-nave type and the Poitevin Romanesque churches with three naves of approximately equal height. The arrangement of the supports in these double-nave churches may be said to bring the main thrusts back into the interior and, as it were, to the centre of gravity; but this function in no way impaired the elegance of these shafts which bear so lightly their spreading branches of stone.

But besides the single-nave and double-nave churches, we also find, south of the Loire and down as far as the Pyrenees, the true French architecture, as defined in the second half of the thirteenth century, producing buildings which exhibit stylistic conformity as well as some measure of local adaptation. Bayonne (begun after 1258)[2] reproduces the Soissons scheme, with combined vaulting of chapels and ambulatory, and brings it into association with the

<div style="text-align: right">101</div>

[1]The plan resembles that of a chapter-house. It is conceived for purposes of public address and debate. The clerks of the University assembled weekly in the church of the Jacobins, whose prototype should perhaps be looked for in Saint-Sauveur at Rocamadour. See R. Rey, *op. cit.*, p. 51 *et. seq.* The construction of the Jacobin church at Toulouse was begun between 1260 and 1265; the apse was finished in 1285 and the building completed in 1304. *This chronology had already been questioned by E. Lambert, *L'église et le couvent des Jacobins de Toulouse et l'architecture dominicaine en France*, Bulletin monumental, CIV, 1946, pp. 141–186. Excavations coupled with a close study of the building have enabled M. Prin to establish the following sequence: (*a*) rectangular twin-naved church begun in 1230, with a wider south nave; (*b*) semi-circular east end and tower added, 1285–1298; (*c*) twin naves rebuilt, taller, equal in width and vaulted, between 1330 and 1385: see Annales du Midi, LXVII, 1957.

*[2]See E. Lambert, *Bayonne, Cathédrale et Cloître*, in Congrès Archéologique de Bordeaux et Bayonne, 1939, pp. 522–60. The choir alone belongs to the second half of the thirteenth century; transepts and nave were built only after 1310.

monumental conception of Reims: Thibaut IV, count of Champagne, had become King of Navarre in 1234. The art of the master of the works, Jean Deschamps (1218–95),[1] is remarkably homogeneous (cathedrals of Clermont and Limoges, choir of Narbonne). But the consistency of the style does not exclude a personal quality of research and certain interesting innovations, some of which are a kind of signature, peculiar to this manner, while others belong to the general evolution—the carrying of the circulation galleries round the supports,[2] the interpenetration of the mouldings, the early use of the ogee-curve in the moulding profiles, and—this feature, not peculiar to Jean Deschamps, was doubtless an adaptation to local custom—the terraces which replace the lean-to or span roofs over the aisles. In this family of churches there appears that modernity and that elegance of successful solutions which we call talent. And still more so in the building which is the masterpiece of northern Gothic in the country of the *langue d'oc*—Saint-Nazaire at Carcassonne. To a Romanesque nave, whose spirit he had the good taste to respect in his new work, the architect of Bishop Pierre de Rochefort was charged with the task of adding a sanctuary and transept. The great size of this latter, the interior disposition of the chapels in the transept arms, the slight projection of the polygonal east end, and the absence of flying buttresses, give the 'handwriting' of Saint-Nazaire a somewhat Cistercian look. ... But how different are the effects! The monostyle piers, which are intentionally reminiscent of some of the supports in the nave, carry light, level-crowned

57 vaults. Lit by wide windows and sustained simply by wall-buttresses, Saint-Nazaire is a much more original illustration of the art of the second half of the thirteenth century than the Sainte-Chapelle, which did no more than take over, isolate, and develop the idea of the great apsidal chapels. Could such a work have been produced in northern France? Assuredly it could. It came directly from there. But its creator may perhaps have found on this distant building-site more favourable conditions and less rigid discipline.

The study of the events of the thirteenth and fourteenth centuries in southern France prepares us to understand the history of Gothic art in Spain and Italy.

[1]Jean Deschamps or des Champs first appears in a document of 1286, in which he is referred to as master of the works of the cathedral of Narbonne. In 1287, he was at Clermont. As a travelling architect, he supervised several building-yards simultaneously. See Abbé Sigal, *Contribution à l'histoire de la cathédrale Saint-Just de Narbonne*, Bulletin de la Commission archéologique de Narbonne, 1921. This great cathedral remained unfinished. It was designed on a colossal scale: the choir is 177 ft. long, 157½ ft. wide, and 131 ft. high. It is a handsome *Rayonnant* building, of great purity, with two storeys of immense apertures and the features characteristic of the group—terraces over the aisles and chapels, supports with ogee profiles, etc. Also attributed to Jean Deschamps are the choir of Toulouse cathedral, at least its plan and the elevation as high as the triforium (work interrupted 1286), and the cathedral of Rodez. See R. Rey, *op. cit.*, p. 194 *et. seq.*
[2]Except at Clermont, where Viollet-le-Duc mentions it in error. Cf. L. Bréhier, *Le triforium de la cathédrale de Clermont*, Revue d'Auvergne, 1936.

We have already touched on Italian architecture in sketching the radiation of Cistercian art, and we saw how the latter, in Italy as in other parts of Europe, was the original apostle of the ribbed vault. Despite the interest of the foundations of the order, notably at Naples, under the Angevins, and despite the amplitude and beauty of the cathedrals of Siena and Orvieto, which transpose the morpho- *108* logy and syntax of the great Gothic language into a dialect with southern *109* inflexions, French architecture created no masterpieces in Italy.[1] In the north, it clashed with the authority of the Byzantine tradition, and in Tuscany, with that spirit of regular forms and harmonic proportions whose imprint appears in the famous campanile of Santa Maria del Fiore, designed by Giotto. It is not *104* impossible to discern in the art of Arnolfo di Cambio the premises of that rigorous dryness and austere purity which were characteristic of later Tuscan elegance. The history of Gothic architecture in Italy is inseparable from that of the religious orders: besides the Cistercian Gothic, there is a Franciscan Gothic, whose characteristics may be studied in the Florentine church of Santa Croce, *106* at the church of the Frari in Venice, and especially in the basilica of Assisi. In a *105* landscape of stern sweetness, on a bastion of Monte Subasio, the latter displays in somewhat arid majesty the mass of its upper and its lower church. The single nave, metrically scanned by clusters of engaged colonnettes, and lit by great windows whose embrasures are pierced by a circulation gallery, as in Burgundy, seems to have been designed to contain, and present in the most favourable light, the fresco-cycles with which it is adorned. The enormous vault-ribs in the crypt are not without beauty. They spring from stumpy polygonal blocks of masonry, which seem to serve them as bases rather than as supports. Finally, the Dominicans had a style, like the Cistercians and Franciscans, or rather they produced fairly numerous buildings, including the church and cloister of Santa Maria Novella in Florence. Among a great many very unequal works, in which the progress of monumental painting seems to conflict with both the development of the structure and the poetry of the allied effects, the Campo Santo at Pisa merits a place apart. It draws a delicate screen of marble around the solitude of the dead. It is planned like a cloister, but each gallery has the scale of a nave. Nevertheless, the true greatness of Gothic Italy is certainly not to be found

*1One may note with W. Braunfels, *Mittelalterliche Stadtbaukunst in der Toskana*, Berlin, 1953, that the real contribution made by Italy to mediaeval architecture and planning is not the cathedral but the town square, in which the façades of religious buildings were only one element, as in the case of Pisa and Pistoia. When artists of great plastic genius such as Giovanni Pisano and Arnolfo attempted façades on the grand scale in the French manner at Siena and Florence cathedrals, they did not succeed. Incidentally, the personnel of the cathedral workshops were often employed in the municipal building programmes, which resulted in the famous Piazzas of Siena and Florence, built around the seat of the Signoria.

among the monuments of architecture. It belonged to the poets and painters. The great Mediterranean cathedral of the fourteenth century is the Divine Comedy.

Spain, on the other hand, abounds in lovely churches. It, too, was Gothic territory, and its architectural enterprises were characterized by notable enthusiasm and variety.[1] We must not forget that it was the border country between Western Europe and Islam, and that, from the commencement of the crusading period, the stages of the reconquest were marked by Christian foundations. The situation was comparable to that of the Latin East, but, whereas the fall of the kingdom of Jerusalem restricted the activities of the architects to the island of Cyprus, where masters from Paris and Champagne built the churches of Nicosia and Famagusta,[2] architectural Spain, during the Gothic period, grew greater with each generation.

In this vast area, as yet disunited and developing its activities against various backgrounds—Pyrenean France, the western Mediterranean, the Atlantic Ocean, and the Muhammadan south—Catalonia has a place apart. At one time in its history it was joined to southern France by a common language and culture, by dynastic alliances, and by a certain community of purpose. Pedro II of Aragon came to the aid of his brother-in-law, Raymond VI, and was killed at Muret (1213). After the defeat of the Albigensians, when Languedoc had submitted to the men from the north and the seal of the king had been set on her towns and monuments, Catalonia returned, as it were, to its Spanish and Mediterranean function. In its intercourse with the French Midi, it had both given and received. It now entered on a period during which, whatever the origins and influences may have been, it treated religious architecture with powerful originality. A rapid review of its earliest Gothic cathedrals will make this clearer by contrast. Here too they were monuments of a militant Christianity which, in the first instance, had installed its religious observances in mosques abandoned by the

*[1]On Spanish Gothic, the latest work is L. Torres Balbás, *Arquitectura gótica*, Madrid, 1952 (Coll. Ars Hispaniae, Vol. VII).

[2]Cyprus, having been taken from the Byzantines by Richard Coeur de Lion (1191), passed first to the Templars, and later to Guy de Lusignan, after the fall of Jerusalem. Until the capture of Famagusta by the Genoese (1373), a great French period ensued, which produced an abundance of religious and military buildings—churches, abbeys, and others from southern French Gothic (ogee curve and terraces). The masters who were to have been entrusted with the construction of the cathedral of Cairo, planned by St. Louis, actually worked on that of Nicosia. This is a church of the Ile-de-France, with certain features in common with Gonesse and Saint-Leu-d'Esserent. Famagusta is a church of Champagne, with some elements of Amiens (rose-tracery of the apse-windows) and others from southern French Gothic (ogee curve and terraces). The apse is reminiscent of Saint-Urbain at Troyes. Engraved on a buttress of the south aisle is an inscription in French giving the state of the works in 1311 and the name of the bishop, Baudouin Lambert. The east end was complete at this time. The refectory of the abbey of Lapais recalls the nearly contemporary great hall in the palace of Avignon. See A. Carlier, *Chypre aux XIIIe et XIVe siècles*, L'Urbanisme, 1934.

enemy. Tarragona (1174–1287) and Lerida (1203–78) still have the Benedictine east end with chapels in echelon; Valencia (1262 to first half of the fourteenth century) has an ambulatory and very numerous radiating chapels. These are churches with nave and aisles differing considerably in height, but their elevation is a modest one, of two storeys. We have seen that, during the thirteenth century, there was a parallel development of the single-nave type. Both types persisted in the subsequent period, but the single volume influenced the triple volume, or rather, the same instinct for spatial extension, without regard to the height, also appears in the great aisled buildings—the cathedral and Santa Maria del Mar at Barcelona, the cathedrals of Palma, Manresa, and Tortosa, and the choir of the cathedral of Gerona.[1] Nave and aisles tend towards equality of height, as in Poitiers cathedral and the German Hallenkirchen (hall churches), but with a slight difference of level, which permits the inclusion of a register of small apertures, a low triforium, which serves to set off the enormous development of the main arcades—a scheme as original in comparison with Chartres, as that of Chartres is in comparison with Laon. When, to this fundamental characteristic, we add the diminution of the supports in number and volume, and the diminution or suppression of the flying buttresses, we see how remote this art is from the uniform, eclectic formula of Jean Deschamps. It is true that the plans of the Narbonne and Barcelona choirs are similar. But the analogy goes no further, and we have already sufficiently emphasized the dangers of the study of plans in isolation to dispense us from the necessity of further warning in this instance. Lavedan has clearly shown that whereas the Narbonne chapels are of the same height as the ambulatory and the aisles, providing a unified base for the upper parts of the chevet, the Barcelona architect has arranged his volumes in steps, rising from chapels to ambulatory and from ambulatory to choir, and has thus rendered superfluous the expenditure of flying-buttresses which were needed to stabilize the Narbonne lantern storey on its flat-topped block. Finally, the architect of the nave subdivided his immense aisles at half-height so as to form tribunes opening to the full width of the arcades and rising almost to the level of the main vaults, from which they are separated only by the narrow zone of apertures. Gerona is admirable for the amplitude of its volumes and the purity

[1]Barcelona cathedral was begun in 1298. Jaume Fabre, from Majorca, directed operations from 1317 onwards. The choir was finished about 1329, and the vaulting was complete by 1448. The earliest work in the cloister goes back to 1382. The choir of Gerona was begun in 1312. The old Romanesque nave was still in existence at the beginning of the fifteenth century. In 1416, Bishop Dalmau brought together a commission of architects to determine the design of a new nave. The opinion of the master of the works of the cathedral, Guillermo Boffy, in favour of a single nave, was finally accepted. The last bays were not vaulted until the seventeenth century. See P. Lavedan, *L'architecture religieuse gothique en Catalogne, Valence et Baléares*, p. 198. Palma cathedral was consecrated in 1346, but the nave was still being worked on in 1406.

of the bare interior walls, unbroken by projection or moulding or string course, and sharply cut by the openings of the galleries below the clerestory.

From the point of view of its plans and elevations alone, Gothic Spain, in the rest of the peninsula, was at first a province of French art. But from its impregnation with Islam, it retained characteristics, relics and potentialities, which, more or less hidden at first, were later to acquire a strange power, particularly during the decline of the Middle Ages. Its earliest rib-vaulted buildings, abbey-churches and cathedrals, show Burgundian influence, as at Carboeiro and the churches of Avila, where the cathedral choir is a repetition of Vézelay, and influence from south-western France, such as appears in the Aquitanian vaults of Gazolaz and San Pedro d'Estella. Later the influence of the north French cathedrals was predominant: we have seen at Toledo a wider, lower replica of the nave of Bourges; Bourges and Coutances recur in the structure and the composition of the masses at Burgos, while León (like Bayonne) follows closely on the lines laid down by Chartres and the art of Champagne. In turn, the influence of Burgos and León became diffused in Castile, at Palencia and Lugo, and was blended there, as also in Aragon and Andalusia, with Cistercian influence, which was propagated chiefly by the plan of the monastery of Las Huelgas. But at the end of the thirteenth and beginning of the fourteenth century, the character of Gothic architecture in Spain underwent a marked change. New centres came into existence, particularly, as we have just seen, in the Mediterranean possessions of the Aragonese crown. In Andalusia, the Almohad style gradually overcame the Gothic forms, though at first they appeared side by side.[1] After the capture of Seville by St. Ferdinand (1248), three civilizations—Moorish, Jewish and Christian—flourished and intermingled there under Alfonso X and his successors. With its brick vault-cells carried on stone ribs, Santa Ana de Triana is still very pure in style, and has only one star-hexagon, in a keystone. But the other churches become more and more remote from northern models. The ribbed vault appears only in the choir; nave and aisles are wood-roofed, while the square chapels are covered with domes, decorated with patterns of interlace. Sometimes, as at Santa Marina, the arches of doors and windows are of horseshoe and multifoil form, and gallery apertures are pierced to form a lattice of stars and polygons. Plaques of *azulejos* (glazed tile-work) enliven the walls, and at Santa Paula brick replaces stone throughout. The single square tower is a Mudejar minaret.

[1] See E. Lambert, *L'art gothique à Séville après la reconquête*, Revue archéologique, 1932. The Gothic contribution was notable in civil architecture, in buildings such as the palace of the younger son of Alfonso X, of which the Torreon de Don Fadrique survives, and the old Gothic palace of the Alcazar, of which only vestiges remain between the old Almohad palace and the Mudejar palace of Pedro the Cruel.

Similar features are found in the churches built at Cordova. From Castile to Catalonia, the diversity of accent of Gothic art in Spain may be discerned in the manner in which the influences come together and split up again. To regard all this as essentially Spanish is a mistake: this architecture belongs primarily to the great Western community, and its links are with France.

Beside it, however, there persisted those Muhammadan forms and techniques which had already produced the Mozarabic style and were now the inspiration of the Mudejar style. Alongside the Christian churches and overtopping them with their square-cut elegance, the East raised the minaret towers, pierced with the *ajimeces* (Moorish twin-light windows) which sometimes recur in the openings of the galleries in Spanish Gothic naves. The horseshoe arch figures in civil and religious architecture along with the lancet and equilateral forms. Certain buildings even admit the subtle geometric caprices of stucco or carved wood, the delicate ornamental setting of bricks, or even facings of painted and glazed tiles—all the filigree luxury whereby the Almoravid and Almohad styles hid the bare walls under mysterious symbols, the flowers, polygons and foliage scrolls which are like the reflection of an enchanted world in the mirror of the enamelled plaques. Whereas the central European synagogues, if one may judge by the celebrated example at Prague, resembled medium-sized churches and chapter houses, the Old Testament in Castile was housed in mosque-like sanctuaries. At Toledo, Santa Maria la Blanca, later turned into a Christian church, with its colonnades, and its bays capped with little domes, continues the style of the Bib el Mardom, and it is not without reason that the church of Corpus Christi at Segovia has been connected with the same group. The vitality of this style is especially remarkable in the south, in the churches built at Cordova, during the fourteenth century, by Alfonso XI and Pedro I. The ribbed domes of Cordova and Toledo had already been imitated in the preceding period. This kind of Christian Muhammadanism was later to produce, again at Cordova, the Villaviciosa chapel, and was to persist in secular architecture down to the sixteenth century. The middle ages in Spain have two aspects. In old red towns, not far from a cathedral whose harsh, military masses envelop a French plan and characteristics, unbroken walls enfold the solitude of an Arab patio, and a minaret with multifoil arches overlooks a monastery courtyard. Thus we find juxtaposed, and sometimes allied, two spiritual forms and two aesthetic forms, developed perhaps from the same very ancient stock, but in different directions, which had already given rise to encounters, exchanges and lasting parallelisms, in the course of the migrations which had brought them together in earlier phases of their history, in the Christian communities of the Caucasus, in Romanesque

France, in northern Spain, in Sicily, in southern Italy, and in the Latin East.

In common with the rest of the Iberian peninsula, Portugal too had its Gothic and its Mudejar styles. There also, Cîteaux and Cluny had organized the earliest religious foundations and marked them with their own powerful stamp: the old cathedral of Coimbra belongs to the type of the pilgrimage churches; its nave recalls Saint-Sernin and Santiago de Compostela, but its crenellated façade has a fortress look, with its bare and powerful walls and its tower-porch surmounted, despite the depth of the portal, by an upper portal with a balustrade. Cistercian art was destined to have a more lasting effect. Many Cistercian features occur throughout the Middle Ages in Portugal. Alcobaça, moreover, is one of the order's grandest and most beautiful houses. The apse is of the Pontigny type, but the three naves are to all appearances equal in height, as in the Romanesque churches of Poitou, and the churches of similar type in Germany. The master-piece of Gothic art in Portugal is of later date, and more complex. Santa Maria da Vitória at Batalha[1] commemorates the victory over the Spaniards won in 1385 by the bastard John I. It is not sufficient to recognize here, at the close of the fourteenth century, the characteristic features of the *Rayonnant* style—the vault structure, the technique of the flying buttresses with quatrefoil struts, and the breadth of the apertures—adapted to a Cistercian plan (oriented chapels opening on the transept); it is not sufficient to link it with the French lineage which descends from Amiens down to the great churches of the Midi. Like the latter Batalha substitutes terraces for roofs, but with a breadth which profoundly modifies the harmony of the masses and which has no parallel except in the Cypriot churches and the cathedral of Palma—the roofs of the latter date from a restoration undertaken at the end of the fourteenth century. If the Capellas Imperfeitas (Incomplete Chapels), which constitute, beyond the apse and on the same axis, a vast sepulchral rotunda with deep chapels forming the points of a star, were included in the original plan, the conception of Batalha may be said to be unique. Its terraces produce a grouping of rectangular profiles, linked by the inclination of the flying buttresses; the arrangement in breadth is emphasised in the façade by the Founder's Chapel, which resembles the Templar church at Thomar, except that the annular sanctuary is incribed within a square. In these basic characteristics, as also in the additions of the next period, Batalha is perhaps the last word and the most poetic expression of the Gothic art of the South, whose successive or simultaneous variations we have examined in the French Midi, in Italy, and in the Iberian peninsula.

*[1]Interesting remarks are found in E. Lambert, *Remarques sur le plan des églises abbatiales de Thomar et de Batalha*, Congreso do Mundo Português, 1940.

IV

IN the study of a stylistic diffusion, geography is not simply a theoretical framework, but commands respect as a system of vital and distinct forces which react in different ways. The rules of the inherent stylistic revolution, which cannot be disputed in the history of an architecture which we are bound to consider as the development of a single idea, were accepted by the different regions in differing degrees, according to their characters and resources. Just as there is no southern bloc of Gothic schools, so, too, the schools of northern and central Europe do not form a homogeneous group. The originality of English art in the Middle Ages was profound, and we are only now beginning to penetrate it. The early application of the vault rib did not result in an early development of the allied structural system.[1] Over vast Norman naves with gigantic piers, pointed arches and geometric ornament, the English masters raised ribbed vaults which, even when the Gothic style was in full flower, remained apparently indifferent to the logic of the supports, which are often interrupted. The union of ribs with Romanesque mass created, not a new style, but the stern strength of a final period of Romanesque art. The Cistercian diffusion imported new models and influenced the evolution, but it produced no *coup de théâtre* and made more concessions than might be imagined. Roche, however, in the middle of the twelfth century, shows many Burgundian features, and, a little later, certain characteristics of Sens recur at Canterbury, begun in 1175 by an architect from Sens, Master William—the sexpartite vault, the upper circulation gallery, the design of the triforium, and the coupled columns. Yet account must be taken of the profile of the arches, the colouristic effects and many other details which modify the 'imported' style in a curious way. Finally, in the closing years of the century, Chichester cathedral was rebuilt in the fashion of the great churches of the *Domaine Royal*. These buildings mark the turning point. On the basis of these experiments, or rather as a consequence of these lessons, a genuinely English Gothic style set out on its career. A large and stable stock of Norman characteristics subsisted, to testify to the community of origins. But the Norman features, the Cistercian survivals, and the elements borrowed from the churches of the *Domaine* in no way restricted the individuality of this style, which conceived them differently from the French builders, and with a less rigorous logic of structure and arrangement. The plans often have square east ends, which lend

[1] On the beginnings of Gothic architecture in England, see T. S. R. Boase, *English Art* 1100–1216, Oxford, 1953, where a very complete bibliography will also be found. The introduction of French features between 1160 and 1190 has been discussed by J. Bony, *French Influences on the Origins of English Gothic Architecture*, Journal of the Warburg and Courtauld Institutes, XII, 1949.

themselves to the development of enormous windows. The double transept survived, whereas in France it disappeared almost entirely after the closing years of the eleventh century. The vaults include subsidiary members, ridge ribs and tiercerons, which were intended not so much to support or brace them as to subdivide the large surfaces which were difficult to construct. These dangerous auxiliaries of the rib were not developed in France until the very moment when the structural logic began to give way.[1] The supports are often of slender section; banded colonnettes are common; so are circular capitals, undecorated or inscribed only with geometrical motifs. The acuteness of the arches and the complexity of the mouldings complete the picture. No less notable is the uncertainty of the arrangement of storeys in naves such as those of Wells and Salisbury, which in this respect differ from the 'French' parts of Lincoln and York—the York nave has been compared with that of Clermont. Whereas France affirms the bay division in the elevation, metrically scans the storeys, gives the clerestory windows their full monumental development, and expresses the laws of the system in the economics of the supports, which descend to the ground, the architect of Salisbury is parsimonious with his clerestory apertures, breaks off his clustered colonnettes with a corbel and sets a continuous triforium over the main arcades. We can discern here the intellectual frontier which determined whether analogies or differences should predominate. The composition of the masses, dominated by the powerful Norman central towers (Lincoln, York, Salisbury), is only distantly related to continental types, for the harmonic façade is submitted to a process of distortion or stretching, which, at Peterborough, minimizes the towers for the benefit of the portal and, at Lincoln, extends in front of them a vast screen, a decorative outwork, having no relation to the rest of the building.[2] Even at Wells, where the design is more legible, the west front, pitted with deep shadows between the buttresses and resting on a heavy, richly moulded base, exhibits the paradox of weighty members allied with fragility in the effects. Arcading, a heritage from late Romanesque profusion, frets the walls of Early English churches. The problem of the location of the sculpture, which in the French churches had been solved by a distribution devised with a view to the balance of plain and decorated, is answered here by a sort of chequer-pattern of niches which, to the French eye, is lacking in monumentality; a reflection of it is seen in the west front of Rouen, the upper levels of

[1] On the first tiercerons, those of Saint-Hugh's choir at Lincoln, and on the stylistic significance of the invention, see P. Frankl, *The 'Crazy' Vaults of Lincoln Cathedral*, Art Bulletin, XXXV, 1953, pp. 95–107.
[2] G. F. Webb, *The Sources of the Design of the West Front of Peterborough Cathedral*, Archaeological Journal, CVI, Supplement (Memorial Volume to Sir Alfred Clapham), 1952, pp. 113–20.

which are in the English style, and were completed by the masters of the Duke of Bedford during the occupation.

The second Gothic period, that of the Decorated or Curvilinear style, was contemporary with the French *Rayonnant* style.[1] The square east ends favoured the disappearance of the walls, which were replaced by immense stained-glass windows: the evolutionary sequence may be discerned by comparing the super-posed apertures of the chapter house of Christ Church at Oxford or the Five Sisters at York with the lighter structures at Merton College and particularly in the choir of Carlisle. But the most remarkable feature is the precocious appear-ance of those Baroque forms, which were destined to replace a stable architecture, whose values were primarily structural, by an architecture of movement and effects. It is true that the Gothic of the South has shown us the reversed curve in some of the moulding-profiles of Jean Deschamps: but there it amounts to no more than an insignificant sympton, whereas in England it achieves its full stylistic development, its power of disequilibrium, and its decorative luxuriance, in tomb canopies like that of Eleanor Percy in Beverley Minster. What was the reason for this precocity? In fact, all curves reside in the compasses and every formal reasoning implies its ultimate consequence; the English genius did not measure its effects by the strictness and legibility of structural functions (even today some English archaeologists feel French Gothic architecture to be arid and excessively 'skeletal'), and arrived sooner at the extremes of possibility. It was perhaps assisted in this to some extent by the aptitude of the ancient peoples of the British Isles for curvilinear composition, of which so many examples may be found in the ornamental repertory of Celtic, Irish and Anglo-Saxon art. However this may be, we have here one more characteristic to be credited to the English originality in the treatment of forms.

It is clear then that the evolution of the successive Gothic 'styles' was far from being synchronized in the various regions of Europe. Those which were soonest masters of themselves, and whose youthful maturity, definite and homogeneous, naturally provided acceptable models, were also those whose influence was felt beyond their own boundaries. This was what occurred in the case of the style evolved in the *Domaine Royal*, Champagne and Burgundy, and it may well be

[1]On the evolution of Gothic in England, the best guide is now G. Webb, *Architecture in Britain: The Middle Ages*, Harmondsworth (Pelican History of Art), 1956. No less essential are Vols. III–V of the Oxford History of English Art. See also J. Harvey, *Henry Yevele: The Life of an English Architect*, London, 1944, *Gothic England, a Survey of National Culture*, 1300–1550, London, 1947, *Saint-Stephen's Chapel and the Origin of the Perpendicular Style*, Burlington Magazine, 1946; M. Hastings, *St. Stephen's Chapel and its Place in the development of Perpendicular Style in England*, Cambridge, 1955.

asked whether the precocity of the Decorated style was not similarly responsible for the rise of the French Flamboyant style.

In contrast with the advanced centres, there were others which were conservative or retarded. We have already seen how the French Midi remained attached to the spirit of the old forms. The same tendency is no less apparent in the Netherlands, and still more so in Germany.

Belgian Gothic was slow to escape from the domination of the great art which had preceded it.[1] The Romanesque interpretation of masses persisted well into the thirteenth century at Audenarde, in the Scheldt valley, and in Zeeland. About 1180, however, at Orval, and from 1210 to 1270, at Villers, the Cistercians had built large churches exhibiting a vigorous style in which the Burgundian formula was modified by contributions from the regions of Laon and Soissons. But their influence, which was in any case restricted, arrived late, and it may be said that Gothic architecture in this area passed without transition from the style of Laon to a much more advanced stage of development. Even then it retained its predilection for certain archaic schemes. If the admirable choir of Tournai (begun 1242, consecrated 1255) is a member of the Soissons family, like the choirs of Saint-Nicolas at Ghent and Notre-Dame at Bruges, the choir of Sainte-Gudule in Brussels, in which the design of the apertures was inspired by Reims or Cambrai, nevertheless retains traces of the habits of fifty years before. Generally speaking, the architects of the area thicken the piers and make the masses heavier. The nave of Tongres retains massive columns; its triforium is impoverished, and the clerestory windows, behind their Norman gallery, remain undeveloped. Notre-Dame at Huy (1311) is a more balanced conception—despite the odd composition of the supports, wherein the thin colonnette which rises to the transverse arch is quite crushed by the enormous columns from which spring the main arcades. But the elegance of French art, as expressed in Saint-Ouen at Rouen, provides a happy inspiration for the choir of Notre-Dame at Hal (1409), and farther north, in Holland, for Utrecht cathedral and the choirs of Haarlem and Breda. The *Rayonnant* style, which had grown up at Amiens and achieved its perfect harmony in Saint-Urbain at Troyes, and at Metz and the buildings which derive from it, represents the second phase of the diffusion of French architecture in Europe. Faced by a weakened

*[1] On Belgium, see S. Leurs, *Geschiedenis van de Vlaamsche kunst*, Antwerp, 1937; S. Brigode, *Les églises gothiques de Belgique*, Brussels, 1944, and *L'architecture religieuse dans le sud-ouest de la Belgique*, Bulletin van de Koninklijke Commissie voor Monumenten en Landschappen, I, 1949, pp. 85–353; R. M. Lemaire, *La formation du style gothique brabançon*, Antwerp, 1949. On the Netherlands, M. D. Ozinga, *De Gothische kerkelijke bouwkunst*, Amsterdam, 1953.

Romanesque opposition, it acquired to some extent an unrestricted international currency.

But this opposition was strong and obstinate in the German centres. It is not that the ribbed vault was unknown there; from the early years of the thirteenth century French architects or Germans who had worked on French building-sites were applying it, with a certain amount of variety in programme. But they deduced no style from it. The rib remained a structural procedure, not an architectural conception. Germany remained attached to the type of the Rhenish basilicas, with their Carolingian survivals and their 'Lombard' architectural sculpture. This unified, homogeneous and massive style lay heavy on the development of German art, and made it sluggish in movement. The thirteenth century here remained Romanesque, both in the composition of plans and the composition of masses. The rotunda persists in St. Gereon at Cologne, the trefoil plan at Bonn and Marburg, and the double-apse plan at Bamberg. The bay system remained archaic, with one bay of the nave corresponding to two in the aisles, the latter still with groined vaults, as at St. Martin in Worms and at Arnsburg while the apsidal chapels of the transepts retained the semidome. At Bamberg and Bonn one is struck by the contradiction of the internal structure and the system of external masses, and, in the structure itself, by the persistence of primitive Gothic forms—no flying buttresses, domical vaults over square plan, and colonnettes carried on corbels. This last feature inevitably suggests the Cistercians. Their work and activity were considerable throughout central Europe: it is noteworthy, also, that their earliest foundations in Germany, such as Maulbronn and Bebenhausen, were wood-roofed. Later huge abbeys such as Ebrach and Heisterbach propagated in Germany the Burgundian characteristics which recur in St. Sebaldus at Nuremberg Champagne, or rather the Soissons area, also contributed, with the combined vaulting of ambulatory and chapels, which was imitated at Lübeck. But it is hard to be sure whether St. Maria at Trier is really a combination of the quatrefoil plan with the plan of Saint-Yved at Braine, since the latter may itself be of Germanic origin. Finally, the *Domaine* churches exercised an unquestionable influence, mainly through the towers of Laon, on which those of Naumburg and Magdeburg were modelled. It is interesting, however, to see at Limburg on the Lahn, consecrated in 1235, the elevation and the capitals of the great French tribune churches of the twelfth century used in conjunction with the Romanesque system of arcades and bands, and apsidal chapels hollowed like niches out of the solid wall. Still Romanesque, in their system of equilibrium, are the Westphalian churches with three naves of equal height, whose domical vaults over square plan possess ridge ribs; these

buildings, having no flying buttresses, and presenting an unbroken mass, without either transept or ambulatory, may be brought into connection with the churches of south-western France: the commercial relations which existed between Angers, Münster and Osnabrück help to explain this remarkable filiation. Also Romanesque—despite their Gothic structure[1]—and imitated from the Rhenish rotundas, are the fine German rotundas of the thirteenth century. Such was the first period of rib-vaulted architecture in Germany: the thirteenth century there corresponds to the twelfth century in France, and even the general treatment of the masonry belongs to an earlier age. Yet, while this style was still in full vigour, Germany accepted the *Rayonnant* style without resistance, and the choir of Cologne, begun in 1248 and consecrated in 1322, even precedes the choir of Amiens. It is probable that its architect, Master Gerhard, was of French origin (this is admitted by Dehio), and it is possible that he may have worked at Amiens itself. In any case, the interval between the nave-campaign and the choir-campaign at Amiens does not signify any break in the evolution, and the unity of that masterpiece has already been sufficiently demonstrated, as has also the continuity of the development which leads from Chartres to the vast, light and skeletal style which we call *Rayonnant*. The travels of French masters carried French forms still farther afield: to Scandinavia, where in 1287 Étienne de Bonneuil took over the direction of the works at Uppsala; to Bohemia, whither Charles IV, the husband of Blanche of Valois, summoned Mathieu of Arras in 1344, to construct, after the model of Narbonne cathedral, the admirable choir of the cathedral of St. Guy in Prague, which was continued by Peter Parler; to Poland, where St. Stanislas in Cracow is built on a French plan; and finally to Hungary, which was the field of operations of Cistercian architects, of Villard de Honnecourt, of Jean de Saint-Dié, who was working on the cathedral of Gyula Fehervar (Alba Julia) in 1287, and the unknown master who at Kassa (Kaschau) reproduced the plan of Braine.[2]

Thus Europe—west, south, north and centre—took up, with marked inequalities in the speed of the development, this conception which had evolved in scarcely more than a century, from Morienval to Saint-Denis, and from Saint-Denis

[1]A fine example of 'Romanesque Gothic' is provided by Basle cathedral, built to replace the cathedral of Henry II after the fire of 1185, on a plan which includes a transept, and an ambulatory without radiating chapels, which was originally flanked by two towers. The elevation is of three storeys, with huge tribunes. In spite of Lombard, Burgundian and north French features, and the later additions, it forms a homogeneous and powerful whole. Its influence was felt in Alsace and at Worms and Bamberg. Mlle. S. Brodtbeck devotes an important chapter to the rib-vaulted Romanesque churches in her book *L'art roman en Suisse*. *See also J. Gantner, *Histoire de l'art en Suisse*, Vol. I.
*[2]On the expansion of Gothic, a useful handbook is J. H. Harvey, *The Gothic World* 1100–1600, London, 1950; an excellent cross-section c. 1300 is given by W. Gross, *Die abendländische Architektur um* 1300, Stuttgart, 1948.

and Chartres to the choir of Amiens. To cite these examples is to indicate, not only the cradle of the evolution, but also the area of the decisive experiments and, if it may be said once again, of the classic elaboration. On the basis of these forms, which were completely intelligible, for they were links in a chain of logic, Europe worked variously, according to the needs of individual centres, the authority of earlier traditions, and the more or less favourable circumstances offered by history. Here Gothic art submits to adaptation. Here it exports complete copies. Here the masters combine them to create something new. Cîteaux carried abroad the first lessons, very bare and powerful, and certain countries—England and Germany, for instance—incorporated them permanently under this form. Nowhere did they impinge on virgin soil. In Spain they clashed with Islam, in Italy with Byzantine art, in Germany with the Romanesque tradition of the Rhineland, and in England with an established style which had been turning the ribbed vault to monumental advantage since the first years of the twelfth century. But in Spain the Romanesque and Gothic styles advanced vigorously with the reconquest; they were its direct expression, its authentic symbol and sanction. From neighbouring France, Spain accepted without discussion the oecumenical architecture of Western Christianity. Yet it also spared, accepted and even favoured the forms which had been passed down from the age of its brilliant servitude. Medieval art in Spain displays the profound duality which is characteristic of the historical career of that country. It is both Africa, and Western Europe. In England, the precocity of the structure explains, or, at least, helps us to understand, the precocity of the development; the insularity of this region, which was accentuated by the detachment of Normandy from it, is accountable for the independence and rapidity of its evolution, even though some influence from France was undoubtedly felt. As to Germany, which had entered the European and Christian communities only in the time of Charlemagne, it was tardy in architecture as in history. It long remained loyal to the great Carolingian schemes and the forms of first Romanesque art. It cautiously introduced an archaic type of rib-vaulted structure into the Romanesque mass, and this very backwardness proves that the art of the rib was very far from being 'Gothic'. Finally, a general equilibrium seems to have been reached with the *Rayonnant* style, even in Italy, at Genoa cathedral, and later, under Charles of Anjou, at Naples. At the moment when the activity of the French building-sites was interrupted or slowed down by the war with England, the architectural language which they had perfected some generations earlier was accepted almost throughout Europe.

BIBLIOGRAPHY

GENERAL WORKS—ARCHITECTURE IN FRANCE

H. Stein, *Les architectes des cathédrales gothiques*, 2nd ed., Paris, 1930; A. Aufauvre and C. Fichot, *Les monuments de Seine-et-Marne*, Paris, 1858; C. Fichot, *Statistique monumentale de l'Aube*, 2 vols., Paris, 1882–89; E. Lefèvre-Pontalis, *L'architecture gothique de la Champagne méridionale*, Congrès archéologique de Troyes-Provins, 1902, *Les caractères distinctifs des écoles gothiques de la Champagne et de la Bourgogne*, Congrès archéologique d'Avallon, 1907; A. Buhot de Kersers, *Histoire et statistique monumentale du département du Cher*, 8 vols., Bourges, 1875–91; Chanoine J. M. Abgrall, *Architecture bretonne*, Quimper, 1904; F. Lesueur, *Les influences angevines dans les églises gothique du Blésois et du Vendômois*, Congrès archéologique d'Angers, 1910; Mgr. C. Dehaisnes, *Histoire de l'art dans l'Artois, la Flandre et le Hainaut avant le XVIe siècle*, 3 vols., Lille, 1886; L. Bégule, *Antiquités et richesses d'art du département du Rhône*, Lyons, 1925; E. Mâle, *Art et artistes du moyen âge*, Paris, 1927 (Architecture gothique du Midi de la France); J. Brutails, *Les vieilles églises de la Gironde*, Bordeaux, 1908; E. Bonnet, *Antiquités et monuments du département de l'Hérault*, Montpellier, 1908; R. Rey, *L'art gothique du Midi de la France*, Paris, 1934; *P. Frankl, *The Gothic Literary Sources and Interpretations through Eight Centuries*, Princeton, 1960; P. du Colombier, *Les chantiers des cathédrales*, Paris, 1953; J. Gimpel, *Les bâtisseurs des cathédrales*, Paris, 1958; M. Aubert, *La construction au moyen âge*, Bulletin monumental, 1960–1961; D. Knoop and G. P. Jones, *The Medieval Mason*, Manchester, 1933; L. F. Salzman, *Building in England down to 1540*, Oxford, 1952; J. H. Harvey, *The Medieval Office of Works*, Journal of the British Archaeological Association, 3rd series, VI, 1941; R. Branner, *Drawings from a Gothic Architect's Shop: The Reims Palimpsest*, Journal of the Society of Architectural Historians, XVII, 1958, pp. 9–21; H. Sedlmayr, *Die Entstehung der Kathedrale*, Zurich, 1951; H. Jantzen, *Über den gotischen Kirchenraum*, Freiburger Wissenschaftliche Gesellschaft, XV, 1928 (reprinted with other articles, Berlin, 1951); E. Panofsky, *Gothic Architecture and Scholasticism*, Latrobe, Pennsylvania, 1951, new ed., London, 1957; J. Bony, *The Resistance to Chartres in Early Thirteenth Century Architecture*, Journal of the British Archaeological Association, 3rd series, XX–XXI, 1957–58, pp. 35–52; R. Branner, *Burgundian Gothic Architecture*, London, 1960, and *Paris and the Origins of Rayonnant Gothic Architecture, down to 1240*, Art Bulletin, 1962, pp. 39–51; L. Schürenberg, *Die kirchliche Baukunst in Frankreich zwischen 1270 und 1380*, Berlin, 1934; C. M. Girdlestone, *Thirteenth Century Gothic in England and Normandy, A Comparison*, Archaeological Journal, CII, 1945; V. Allègre, *Les richesses médiévales du Tarn. Art gothique*, Toulouse, 1954.

MONOGRAPHS ON FRENCH BUILDINGS

R. Merlet, *La cathédrale de Chartres*, Paris, 1909; G. Durand, *Monographie de la cathédrale d'Amiens*, 2 vols., Amiens, 1901–03; L. Lefrançois-Pillion, *La cathédrale d'Amiens*, Paris, 1937; L. Demaison, *La cathédrale de Reims*, Paris, 1910; A. Boinet, *La cathédrale de Bourges*, Paris, n.d.; E. Lefèvre-Pontalis, *La cathédrale de Coutances*, Congrès archéologique de Caen, 1908; G. Fleury, *La cathédrale du Mans*, Paris, 1910; H. Stein, *Le Palais de justice et la Sainte-Chapelle de Paris*, 2nd ed., Paris, 1927; V. Leblond, *La cathédrale de Beauvais*, Paris, 1926; A. Babeau, *Saint-Urbain de Troyes*, Troyes, 1891; A. Carlier, *L'église de Rampillon*, Paris, 1930; M. Aubert (ed.), *La cathédrale de Metz*, Paris, 1930; Abbé A. Loisel, *La cathédrale de Rouen*, Paris, 1913; A. Masson, *L'Église Saint-Ouen de Rouen*, Rouen, 1930; L. de

Farcy, *Monographie de la cathédrale d'Angers*, 2 vols., Angers, 1902–05; V. Flipo, *La cathédrale de Dijon*, Paris, 1929; M. L. Springer, *Notre-Dame in Dijon*, Stettin, 1934; R. Fage, *La cathédrale de Limoges*, Paris, 1913; H. Chardon du Ranquet, *La cathédrale de Clermont*, Paris, n.d.; L. Serbat, *Narbonne*, Congrès archéologique de Carcassonne, 1906; J. Laran, *La cathédrale d'Albi*, Paris, 1911. *E. Mâle, *Notre-Dame de Chartres*, Paris, 1948; M. Aubert, *La cathédrale de Chartres*, Paris-Grenoble, 1952; L. Grodecki, *The Transept Portals of Chartres Cathedral: The Date of their Construction according to Archaeological Data*. Art Bulletin, 1951, pp. 156–164, and *Chronologie de la cathédrale de Chartres*, Bulletin monumental, 1958, pp. 91–119; R. Branner, *The North Transept and the First West Façades of Reims Cathedral*, Zeitschrift für Kunstgeschichte, XXIV, 1961, pp. 220–241; S. McK. Crosby, *L'abbaye royale de Saint-Denis*, Paris, 1953; J. Walter, *La cathédrale de Strasbourg*, Paris, 1933; H. Haug, R. Will, T. Rieger, V. Beyer, and P. Ahnne, *La cathédrale de Strasbourg*, Strasbourg, 1957; G. Maillet, *La cathédrale de Châlons-sur-Marne*, Paris, 1946; F. Salet, *Saint-Urbain de Troyes*, Congrès archéologique de Troyes, 1955, pp. 96–122, and *L'église de Mussy-sur-Seine*, ibid., pp. 320–337; G. Lanfry, *La cathédrale dans la cité romaine et la Normandie ducale*, Cahiers de Notre-Dame de Rouen, 1956; E. Lambert, *Caen roman et gothique*, Bulletin de la Societé des Antiquaires de Normandie, XLIII, 1935, pp. 5–70, and *Bayonne, cathédrale et cloître*, Congrès archéologique de Bordeaux–Bayonne, 1939, pp. 522–560; E. Mâle, *La cathédrale d'Albi*, Paris, 1950.

ARCHITECTURE IN EUROPE

E. Lambert, *l'Art gothique en Espagne aux XIIe et XIIIe siècles*, Paris, 1931; P. Lavedan, *L'architecture gothique religieuse en Catalogne, Valence et Baléares*, Paris, 1935; C. Enlart, *Origines françaises de l'architecture gothique en Italie*, Paris, 1894; A. K. Porter, *Lombard architecture*, 2 vols. and plates, New Haven, 1918; C. Enlart, *L'art gothique et la Renaissance en Chypre*, 2 vols., Paris, 1899; M. Laurent, *L'architecture et la sculpture en Belgique*, Paris, 1928; Chanoine R. Maere, *L'église Saint-Gudule à Bruxelles*, Brussels, 1925; L. Ninane, *L'église Saint-Jacques à Gand*, Ghent, 1928; Baron P. Verhaegen, *L'église Saint-Nicolas de Gand*, Ghent, 1936; G. H. West, *Gothic Architecture in England and France*, London, 1927; K. Escher, *Englische Kathedralen*, Munich, 1927; P. Biver, *L'église abbatiale de Westminster*, Paris, 1923; G. Dehio, *Handbuch der deutschen Kunstdenkmäler*, 5 vols., Berlin, 1920; H. Rosenau, *Der Kölner Dom*, Cologne, 1931; P. Clemen, *Die Kunstdenkmäler der Stadt Bonn*, Düsseldorf, 1905; A. Mackeprang and C. Jensen, *Danmarks Kirker*, Copenhagen, 1933; S. Curman and J. Roosval, *Sveriges Kyrkor*, Uppsala, 1912–32; L. Dietrichson, *Die Holzbaukunst Norwegens*, Dresden, 1893. *J. H. Harvey, *The Gothic World*, London, 1950; W. Gross, *Die Abendländische Architektur um 1300*, Stuttgart, 1948; B. Bevan, *History of Spanish Architecture*, London, 1938; L. Torres Balbas, *Architectura gótica* (Ars Hispaniae, VII), Madrid, 1952; R. Wagner-Rieger, *Die italienische Baukunst zu Beginn der Gotik*, 2 vols., Graz, 1957; W. Paatz, *Werden und Wesen der Trecento Architektur in Toskana*, Burg-bei-Magdeburg, 1937; V. Mariani, *Arnolfo di Cambio*, Rome, 1943; M. Weinberger, *The First Façade of the Cathedral of Florence*, Journal of the Warburg and Courtauld Institutes, IV, 1940–41; W. Braunfels, *Mittelalterliche Stadtbaukunst der Toskana*, Berlin, 1953; G. Fogolari, *I Frari e i Santi Giovanni e Paolo*, Milan, 1949; S. Leurs, ed., *Geschiedenis van de vlaamsche kunst*, Antwerp, 1937; S. Brigode, *Les églises gothiques de Belgique*, Brussels, 1944, and *L'architecture religieuse dans le sud-ouest de la Belgique, I. Des origines à la fin du XVe siècle*, Bulletin van de Koninklijke Commissie voor Monumenten en Landschappen, I, 1949, pp. 85–353; L. Devliegher, *De opkomst van de kerkelijke gotische bouwkunst in West-Vlaanderen gedurende de XIIIe eeuw*, ibid., V, 1954, pp. 177–345, and VII, 1956, pp. 7–121; M. D.

Ozinga, *De Gothische kerkelijke bouwkunst* (De Schoonheid van ons land), Amsterdam, 1953; J. Gantner, *Kunstgeschichte der Schweiz, II. Die gotische Kunst*, Frauenfeld, 1948; E. Bach, L. Blondel and A. Bovy, *La cathédrale de Lausanne* (Kunstdenkmäler der Schweiz, XVI), Basle, 1944; G. Webb, *Architecture in Britain. The Middle Ages* (Pelican History of Art), Harmondsworth, 1956; T. S. R. Boase, *English Art*, 1100–1216 (Oxford History of English Art), Oxford, 1953; P. Brieger, *English Art*, 1216–1307 (id.), Oxford, 1957; J. H. Harvey, *English Mediaeval Architects: A Biographical Dictionary down to* 1550, London, 1954; J. Bony, *French Influences on the Origins of English Gothic Architecture*, Journal of the Warburg and Courtauld Institutes, XII, 1949; G. F. Webb, *The Decorative Character of Westminster Abbey*, ibid., 1949, and *Ely Cathedral*, London, 1951; J. M. Hastings, *St. Stephen's Chapel and its Place in the Development of Perpendicular Style in England*, Cambridge, 1955; F. E. Howard, *The Mediaeval Styles of the English Parish Church*, London, 1936; E. Gall, *Dome und Kloster-kirchen am Rhein*, Munich, 1956; *Der Kölner Dom*, Festschrift des Zentral-Dombau-Vereins, Cologne, 1948; W. Rave, *Westfälische Baukunst*, Münster-in-Westfalen, 1953; G. Gall, *Zur Baugeschichte des Regensburger Domes*, Zeitschrift für Kunstgeschichte, XVII, 1954, pp. 61–78; R. Krautheimer, *Die Kirchen der Bettelorden in Deutschland*, Cologne, 1925; K. M. Swoboda, *Peter Parler, der Baukünstler und Bildhauer*, Vienna, 1940; C. M. Smidt, *Roskilde Domkirkes middelalderlige Bygningshistorie*, Copenhagen, 1949.

Architectural Sculpture and Gothic Humanism

I

THE combination of the ribbed vault with Romanesque masses, by its inherent conflict, helps us to realize that Romanesque art and Gothic art were not successive forms, following naturally one from the other, but that the former opposed the advance of the latter and, over and above this, that whereas Romanesque art was the scion of an ancient lineage, with links that led far back into the past, the researches which allowed the architects of the Ile-de-France to develop a style out of the vault rib, and to pursue its consequences down to the structural paradoxes of *Rayonnant* architecture, were essentially modern. This view receives remarkable confirmation from the study of the sculpture. The image of human life, as displayed in the cathedrals, shows nothing that is foreign to us, or which we cannot recognize as familiar. Whereas Romanesque sculpture led us into an unknown realm, into a labyrinth of transformations, and into the most secret regions of spiritual life, Gothic sculpture brings us back again to ourselves and the things we know in nature. We do not feel that it is centuries away from us. It seems of yesterday, like a collection of family traditions, which are tinged but not weakened by the passage of time. In these great expanses of stone, despite the size and majestic character of the figures, we feel that intimacy of emotion produced only by works which, their age notwithstanding, remain the eternal contemporaries of man. If one were called upon to give a psychological characterization of the various phases of medieval sculpture, one might perhaps convey something of the difference, even irreconcilability, of their qualities by saying that Romanesque sculpture was the expression of faith, that Gothic sculpture was the expression of piety, and that the sculpture of the decline was the expression of devotion. Romanesque faith, shot through with visions and prodigies, accepted and cherished the mysterious; it moved among superhuman things; it trembled in anticipation of rewards and punishments; the miracle was its law, and the unknowable its nourishment. From these epic heights, round which resounded the thunders of Sinai, the piety of the thirteenth century brings us back to the paths of the Gospel; in God-made-man, it cherished humanity; it loved and respected God's creatures as He loved them; it accepted the benefit which He brought to men of good will—peace on earth— and extended it to include even death, which was no more than a sleep in the

Lord. Finally, the devotion of the decline, more demanding and perhaps more sensitive in its emotions, replaced this serenity with its own unease, passionately devoted itself to the terrible scenes of Calvary, fixed them, contemplated them, made them live again, suffered them anew, with a dramatic pageantry and mystic power of re-creation which conferred holiness even on the accessory and the indifferent object. Iconography, style and technique were all equally expressive of these profound differences.

It is true, of course, that the iconography of the twelfth century had fore-shadowed to some extent the Gothic iconography, in its general interpretation of the Old and the New Testaments, in its recognition of symbolic correspon-dences between the two—an idea revived by Suger—and in the attention which it devoted to the cult of the saints. But it was dominated by the Apocalypse, from which it derived its fearful visions and its image of Christ the Judge, enthroned in glory, with His inhuman *entourage*. From the Apocalypse it drew, if not all its resources, at least its predominant tonality, which was that of the epic poem. It transformed the *Psychomachia* into a *chanson de geste*. It gave an Oriental tinge to Christian poetry, and exaggerated proportions to its heroes. Into its world it welcomed monsters conceived out of chaos, and obeying laws foreign to those of actual life. Thirteenth-century iconography made simultaneous renunciation of the visions, the epic, the East and the monsters. It was evangelic, human, Western and natural. It brought Christ down almost to the same level as His people; He stands, with His bare feet on the asp and the basilisk, between the Apostles, who seem to move aside to make way for Him, so that we may see Him the better, as He raises His hand, a grave and gentle Teacher, a young and loving Father. True, He is still enthroned on high in the tympanum, presiding over the resurrection of the dead and the eternal doom, but even there He is the Christ of the Gospels and retains His gentle humanity. This latter quality completely irradiates the scene of the Coronation, wherein Mother and Son are tenderly united. The thirteenth century surrounded the youthful image of the Virgin with an affectionate fervour which, while glorifying woman, respected her femininity, just as, in the beauty of the angels, it preserved, as a fadeless flower, the fleeting charm of adolescence among the children of men. From Annunciation to Coronation she retains her birthright of grace, derived from her human clay; she is no longer the stone idol of earlier ages, but the celestial sister of human mothers. This perfect moment, when art takes hold of life between the uncer-tainties of the juvenile form and the fatigues of maturity, this moment of poise and of the first blossoming, like the ἀκμή of the Greeks, was present in all its poetry in thirteenth-century iconography, which extended it even to the features

of the dead, rejuvenated and at peace, and even the Prophets, Martyrs and Confessors, burdened with years, even the diocesan saints, grown old in their apostolic labours, still draw from it a tranquil majesty which illumines their decrepitude.

This iconographical period and tone, however, were not the expression of a false idealism. The accent of life is not effaced in the great peace of the cathedrals. They are not dedicated to the beatitudes alone. The whole of creation, full and frank, takes its place within them. Built and decorated, as they were, in the days of the great encyclopaedias, when the middle age sought for the first time to assess itself, its intellectual resources and its stock of knowledge, and, in short, tested its possession of the world and of man, they too are encyclopaedic. In adopting the plan of the *Speculum majus* of Vincent of Beauvais in order to render an account of their treasures, Emile Mâle[1] was not forcing them into an alien mould, but revealing the harmony of the system of the images and the system of the ideas, developing the basic thirteenth-century conception of the hierarchy of the created world, and respecting the imposing structure, not of an expositional framework, but of the 'realms' of spiritual life. In each of these divisions the latter moves in accordance with a rhythm of concealed relationships, to which art gives a musical quality, and whose symbolic significance it translates but does not reveal. The forms obey the law of numbers and the law of symbols. The world is in God, the world is an idea in the mind of God, art is the writing down of that idea, and the liturgy is perhaps its dramatization. Each 'mirror' reflects, not a group of inanimate images, but the perpetual rising up in God of beings and forms. When we say that the iconography of the thirteenth century is encyclopaedic, we mean, not only that it is universal and all-embracing, but also that, within its immense orb, of which God is the centre, a secret force binds together, and draws into its gravitational field, all the aspects of life.

This conception was at its most ardent and poetical in this period. It seems to be inventing and evolving its whole universe simultaneously. But the profound harmony which existed between religious thought and contemporary iconography must not mislead us into thinking that the latter was a by-product of theology. It was theological, and the theologians had a considerable share in it, but this art goes far beyond any definition which might seek to confine it to the

[1] *L'art religieux du XIIIe siècle en France*, 7th ed., Paris, 1931, Introduction, II, Méthode à suivre dans l'étude de l'iconographie, Les miroirs de Vincent de Beauvais, p. 23. The *Speculum majus* probably dates from the middle of the thirteenth century. The Jesuits produced a four-volume edition, Douai, 1624. It includes only three parts—The Mirror of Nature, The Mirror of Science, and The Mirror of History. The Mirror of Morals dates from the beginning of the fourteenth century, but was probably envisaged in the original scheme. Mâle, *op. cit.*, *loc. cit.*, p. 24, note 2. See *ibid.*, Livre I, Le Miroir de la Nature, III, pp. 46–62.

interpretation of scholastic, liturgical or symbolic themes. It is still too close to the discovery of the world, too much absorbed in its wondering contemplation. The supernatural is the underlying principle of the natural, but nature exists none the less. It was the error of the Romantic school, and, no doubt, of Huysmans, to confer on thirteenth century iconography a hieroglyphic character. The cathedral interpreted according to Guillaume Durand and Vincent of Beauvais is certainly a valid conception, but it also possesses a poetic strength which lies outside the scope of the systems. 'Man walks there through forests of symbols', but they are symbols which wear the youthful features of living things. This is the point which is so well brought out by M. Mâle. 'The sculptors of the Middle Ages . . . do not seek to read into the tender flowers of April the mystery of the Fall and the Redemption. On the first spring days, they go off into the woodlands of the Ile-de-France, where humble plants are just breaking through the crust. The ferns, curled up like strong springs, are still covered with their downy wool, but already, along the streams, the arum is about to flower. They gather the buds, and the leaves which are ready to open, and contemplate them with that loving, passionate curiosity, which we others feel only in earliest childhood but which true artists retain all their lives.' Thus youthful humanity is surrounded by youthful vegetation. The stone of the churches is radiant with perpetual spring.

The Mirror of Nature shows us the wood outside the little town, and the small suburban garden close at hand where hazel nuts grow, and strawberries, and a few stems of vine. It is as if some infant hand had gathered these altar decorations and hung them in the church, fresh-plucked, for an unending holy day. There too are the beasts of the earth and the creatures of fable; but even more than the wonders from the bestiaries, the sculptors loved the old familiar companions of human life, studied them endlessly, and prodigally multiplied their images, now with the zest of a ribald tale, now with a kind of affectionate respect. Sixteen draught-oxen, hoisted to the tops of the towers of Laon, high above the field, celebrate in stone the patient beasts which dragged up the hill the stones of which the cathedral is composed. On all this creation, sprung from His thoughts, the Eternal Father meditates, and rests His cheek on His hand, like a good gardener, his day's work done. And man also, as he appears in the Mirror of Science,[1] gives himself up to labour as to a work of redemption; no distinction is made between the skill and labour of the hands and the skill and labour of the mind. On the plinths of the churches, the calendar of Works and Days, carved in rectangle or quatrefoil, warned the passer-by of tasks to be

[1]See E. Mâle, *L'art religieux du XIIIe siècle en France*, Livre II, Le Miroir de la Science, p. 63.

performed, and the figures of the Seven Liberal Arts promised him the delights of knowledge.[1]

Just as Nature is the thought of God, and just as hand and mind work according to His ways, so also the history of the world[2] is the history of the Lord extended through the lengthy annals of human life. It begins with the Creation, and its main episodes are the Fall of Man and his Redemption, between which lie the long series of prophetic centuries, when the elders of Israel, the heralds of Christ, prefigured His word and proclaimed His mission. The cathedrals were first and foremost the genealogical tree of the Saviour, and the tall regal and priestly figures which adorn them outline not only His fleshly descent but also His spiritual lineage. The notion of the concordance of the two Testaments here achieves its fullest meaning, so that one might almost say that the thirteenth-century cathedrals composed, in monumental terms, a kind of third Testament, formed from the intimate union of the Jewish and the Christian Bibles. The ranks of the kings of Judah are deployed on the façades—at Paris, Amiens, and Chartres. The procession of the Prophets advances out of the depths of ages. At last, the promise is fulfilled, and Christ is born in the stable. Under the influence of the liturgy, the thirteenth century retained of His life only those cycles which correspond with the major festivals of the year, the Christmas cycle and the Easter cycle, the Nativity and the Passion. These are also the most moving pages of the whole moving story; above all, they are perhaps the most human. The Parables have their place—the Wise Virgins, the Good Samaritan, the Prodigal Son, Dives and Lazarus—as the direct expression of the Word of God. The apocryphal gospels are not excluded: they serve especially to enrich the story of the Virgin, her glorious and anguished life, her Dormition, her Entombment, her Coronation, and her miracles. The thirteenth century did not set her apart from the Son, but associated her intimately with His earthly career and seated her beside Him in the regions of eternity. Here, certainly, is the most sublime aspect of this iconography. The cult of the Virgin was not only a phase in the history of piety, but was at the very heart of the life of the Middle Ages, and implied no diminution of its energetic character and virile grandeur. In the Child who rests in her strong arms, the Virgin bears the whole weight of the crucified Christ. On these images and examples the Saints fix their gaze. As the lives of the Prophets were a prefiguration, so their lives are an imitation, by virtue of their renunciations, labours, miracles and sufferings. The history of the world

[*1]See J. C. Webster, *The Labors of the Months in Antique and Medieval Art*, Chicago, 1938; W. Déonna, *Die Darstellung der freien Künste in der Kathedrale Saint-Pierre in Genf*, Pro Arte, VI, 1947.

[2]See E. Mâle, *L'art religieux du XIIIe siècle en France*, Livre IV, Le Miroir historique, p. 133.

is the history of the saints, and the geography of the world is that of their hermitages, their miraculous springs, their tombs and their pilgrimages. The church militant stands in the doorways alongside the church prophetic and the church apostolic. Each diocese finds room for its local saints, and the guilds have theirs also; these patrons of the Christian life strengthen by their example the lessons of the Mirror of Morals. The Virtues no longer fight; the age-old duel which was carved in the Romanesque churches of Poitou and Saintonge is now concluded; calm and erect, the victors trample on the prostrate vices.

This vast panorama of life, extending through the untrammelled realms of faith, included also a few of such remnants of the antique world as could be put to didactic uses, by showing, for instance, the frailties of the flesh among the great (Aristotle and Virgil deceived by the wiles of woman and by their own weakness), or perhaps the herald of the Last Days, the Erythraean Sibyl.[1] Of profane history, it recalled and celebrated the Christian heroes, such as *83* Charlemagne and St. Louis. On St. Theodore at Chartres it bestowed the pride and charm of the young knight of the time. But there is nothing to compare with the memory of the epic deeds of knightly prowess which was revived in the portal of Modena, except the windows at Chartres dedicated to Charlemagne and those at Saint-Denis which commemorate the Crusades: but these latter were earlier by half a century, and still belonged to the age of the epics.[2] The great epic of the new period was the Last Judgement. It no longer possesses the tumultuous violence of Apocalyptic art, though this did, in fact, survive in certain representations of the Four Horsemen—for instance, at Amiens and Paris. A terrible silence reigns over the various episodes of the Judgement, ranged in the several registers of the tympana. At Laon, no disorder attends the separation of the good from the evil. So it is also at Chartres, where blessed and damned *76* follow one after another in neat files. So, too, at Reims, where demons, dragging on a chain, drag off to their torments the resigned sinners, clerks and laymen, with a king and a bishop among their number. In the Portail des Libraires at Rouen, *75* and at Bourges, the damned break out in frenzy. But St. Michael weighing souls *77* is full of the grace of youth, and the scene of the general Resurrection, in the lintel *78* of Rampillon, has nothing tragic or funereal about it. These delicately formed nudes, this slim adolescence of the flesh, holds the promise of beatitude in its beauty of form, no longer subject to decay.

[1] See J. Adhémar, *Influences antiques dans l'art du Moyen-Age français*, London, 1939.
[2] The Crusade window did not belong to Suger's first scheme. E. Panofsky, *Abbot Suger on the Abbey Church of Saint-Denis and its Art Treasures*, Princeton, 1946, p. 195, places this addition in the third quarter of the thirteenth century, but L. Grodecki is of the opinion that it was made by Suger himself, probably c. 1150.

The history of art can show nothing comparable with this sculptured exegesis of a great system of religious thought. In spite of the abundance of its myths, the Greek genius did not multiply the representations of them on its buildings. Those which it selected are admirable, but the very principle of the selection precluded variety and was still more inimical to profusion. The distinction, in fact, goes still deeper, for it involves two opposing conceptions of life and nature. Medieval art set man in the centre, but the rich diversity of the world was indispensable to it, as was also the arrangement of episodes and prodigies according to a higher order, conceived by God. But antique art, in its best period, saw man surrounded only by light, and the order which it imposed on its figures was a harmony born of reason. Thus these two classic states of the human spirit are fundamentally distinct, though they drank from the same fountains of eternal youth and often show striking similarities in the treatment of forms. If some parallel to the Western iconography of the thirteenth century is required, it is perhaps in Buddhist iconography that its elements may best be found. That, too, evolves, not around an inaccessible deity or a perfect athlete, but around a god who assumed human form, whose life was a model of holy living, and a commentary and symbol of a philosophy. The numerous scenes are arranged in fixed cycles: the cycle of the innumerable *jatakas*, or previous existences; the cycle of the Nativity, notable for the episode of the seven steps taken by the Predestined One immediately after his birth into the world; the cycle of the vocation, with the scenes of the four meetings by which he was persuaded; the ascetic cycle, with his temptation; the cycle of teaching, and finally the cycle of Nirvâna. Admittedly, there is nothing resembling the scenes of the Gospels, but there are a great number of edifying stories, an exalted mission, and a life whose every chapter has a meaning and whose representation is a lesson. The Buddha is surrounded by his apostles and the saints of his church. His and their teaching breathes the purest charity and counsels renunciation. The life about them is illusory, but the forms which it assumes are inhabited by the spirit, and worthy of respect, compassion and love. The plants which sheltered the reverie of the Sage, or bore his body, are sacred. All creation mourns the Nirvâna, and all the beasts of the earth come running to the death-bed of the Buddha. A strong spirit of naturalism animates the iconography of this religion, despite the fact that it holds nature to be but a dream. It expresses, moreover, a conception of man and life, based on detachment and charity, which is not different in essence from the moral teaching of the Gospels. Finally, it had, like early Christian art, a Hellenistic period prior to its assumption of true Asiatic forms. In this aspect, the narrative length, and the symbolic and didactic character of the temple-sculptures make

them comparable with the art of the Western cathedrals. But Indian iconography, by its very nature, turned early to formulae, and life ebbed away from the Sage, so that his meditation tended towards a complete vacuity, which enfolded a vacant soul and an immobile body, the shrine of his sacred absence. Though human and evangelical in his origins, the God of Asia drifted into sleep, and grew rigid, as an idol of gold. Furthermore, the buildings which bear his image and his story are quite unrelated to those of Christian architecture, and it would be difficult to explain or even to imagine Gothic iconography apart from the profoundly original architecture in which it is embodied and located.

II

GOTHIC architecture did not determine Gothic form, yet it indubitably affected it—though in a quite different way from that in which Romanesque architecture affected Romanesque form. The latter was entirely determined by the system of which it formed a part. Organic life imposed no canon on the sculptured figure, which was ready to suffer anything—to grow taller or shorter, to enlarge one or other of its parts out of all proportion, to multiply its limbs, to divide its body into two, and to twist itself into the most paradoxical attitudes. Hence the appearance of caprice, which concealed a strict subservience. Man was not man but an architectural member, a function, or an ornament. Gothic man, on the other hand, obeys both the laws of the architectural system to which he belongs and also, so to speak, the biological laws of the species which he represents. Let there be no mistake—this was not a return to the humanistic outlook. This respect for the natural equilibrium of life was valid not only for the human figure, but for animals and plants as well. We are here face to face with an entirely new morphology, to which Europe has been faithful in the main down to our own day, with inflexions and nuances which, despite their significance and interest, have not changed its character to any considerable extent.

The second half of the twelfth century saw the rapid and progressive dissolution, north of the Loire, of the Romanesque system, notably in the compositional procedures and the abandonment of those experiments in the movement of figures, which had been so remarkable a feature of the styles of Languedoc and Burgundy since the beginning of the century. The tympana were emptied of their tumult at a single stroke; no more than a shell of the old style survived, and that only in the surface modelling and the calligraphy of the drapery. The column

statues, which are really undulating walls formed in the semblance of human figures and are perhaps simply a continuation of the reliefs of the *trumeaux*, display simultaneously both the final phase in the subjection of sculpture to structural functions and the impending development of self-sufficient figures. About the same time true statues appeared on the façades of Saintonge and Poitou, set against bare walls, with nothing but a console beneath and the remnant of an arch above, the vestige of the vanished setting (Châteauneuf-sur-Charente, Matha, etc.). Practically independent, solid, and ample in their volumes, they might well figure in the door splays of first Gothic art. Thus the internal evolution of the Romanesque style led on the one hand to a kind of academism, which continued, by force of inertia, to apply old graphic formulae whose justification had disappeared, and, on the other, to a style which, discarding the outworn rules, already based itself on the imitation of the relationships, masses and outlines of the natural world. Simultaneously, and this is the essential point, architecture underwent a radical transformation. It ceased to offer sculpture its former locations, and no longer required it to participate in the structural functions.

The reason for this was the change which had taken place in the structure itself, making it primarily a system of arches and supports, with the walls between them reduced to thin partitions and opened up in great windows; the masses, too, were changed, and tended more and more to become void space; so also were the effects, which now shunned, in France at least, all those elements which made the interrelationship of the parts less immediately intelligible. Hence the evolution of the capital, which abandoned figure-scenes and became almost entirely ornamental. Except in the case of the monostyle pier, where it supports the colonnettes which rise to the springing of the vault, neither its volume nor its function are what they were formerly. It can no longer tolerate the highly-coloured profusion and the charming scenes which interrupt the vigour of the vertical impulse and the pure continuity of the function. Foliage ornament, even when its modelling is luxuriant, or its crockets very prominent, interrupt the passage of the eye much less than do complex patterns burdened with meanings and monstrous images. In this, the taste of the time was in agreement with the inherent demands of the style, and the life of the spirit found its ideas confirmed by the life of forms. In the eyes of the thirteenth-century architect, as in those of St. Bernard and the Cistercian builders, Romanesque sculpture must have seemed an independent romanticism harmful to the delightful economy of their design, and the capital a field entirely unsuited to the new experimental treatment of the human figure.

Such experiments remained possible in the portals and the upper parts of the building, and these positions were, indeed, favourable to them. Thirteenth-century art accepted Suger's innovations and drew the greatest possible advantage from them. The column figures cease to suggest the function of support, detach themselves from the wall or jamb, and even combine together, without sacrificing their individual interest and their statuesque self-sufficiency, to form group compositions. Movement again surges through and animates them, but with the flexions of life, not those of ornament. The archivolts retain the rich figure-carving which had been characteristic of south-western France, with the vertical axis of the figures following the circumference of the curve: but the Romanesque figures, which had respected the mouldings to the point of becoming indistinguishable from them, are transformed into statuettes deliberately limited in scale, in order to avoid an overemphatic curvature, and often carried on little pedestals, or else suspended like ex-votos. This remarkable deflection of a long-established form is in itself sufficient to convey a sense of the gulf which separates Gothic sculpture from Romanesque sculpture in the interpretation of the relationships which bind the decoration to the structure of the building. Finally, it happens frequently that the noble field of the tympanum is subdivided into several distinct registers. The wealth of iconography, the development of the taste for anecdote, and the difficulty of fitting the numerous actors of extensive compositions into a semicircle, without doing violence to normal proportions and attitudes, induced the sculptors to adopt this horizontal panelling, by which the lintel is doubled, trebled, or even quadrupled.

But the strength and originality of the monumental harmony remained unimpaired. This style, in spite of the numbers and high quality of the reliefs, seems dominated by the conception of the statue, though there is no suggestion that the statue is an isolated work of art, assigned to a particular position merely on grounds of good taste or iconography. The monumentality of the figures is created by their proportions, mass and modelling. The proportions are those of a vigorous and powerfully built breed of men, with that relaxed stance which comes from heavy work performed with the minimum expenditure of effort. It is the physique of fine sturdy artisans, such as were commonly to be seen on the building sites.[1] It was only about the middle of the thirteenth century, if we can trust

[1]Regarding working conditions, see *Le Livre des métiers de Paris*, published in 1837 in the series of Documents inédits de l'histoire de France; Didron, *Annales archéologiques*, I, p. 138, p. 215, p. 242 (the first publication of the Chartres window showing sculptors at work); V. Mortet, *Fabrique des grandes cathédrales et statuaire religieuse au moyen âge*, Bulletin monumental, 1902, and *La maîtrise d'oeuvres au XIIIe siècle*, Bulletin monumental, 1906; L. Lefrançois-Pillion, *Les sculpteurs français du XIIIe siècle*, chaps. V, VI.

the album of Villard de Honnecourt, that they began to acquire the elongated stature, the slightly fragile elegance, and the combination of the slender waist with breadth of shoulder that we see in his triangulated figures. Viollet-le-Duc,[1] however, observes that these correct proportions are subject to optical corrections, a kind of perspective science, in order to avoid the distorted foreshortening of statues placed at great heights. And it was certainly for the same reason, though the adjustment was less, that some *trumeaux*-figures, such as the lovely Virgin of the west front at Amiens, show marked elongation of the neck, to avoid giving the impression that the head has sunk between the shoulders. Their masses have the stability of architectural masses, even when in motion; and their balanced movements are themselves the expression of a profound equilibrium, and produce no broken or jerky outlines. These creatures of stone, sturdy and large, occupy space amply, but they tear no uncivil holes in it. Their gestures are monumental because they are slow, restrained and few in number. It is in the reliefs, and reliefs of late date, that the animated gesture and expression may be found. The resignation of the damned at Reims, as they are drawn along on their chain, is perhaps simply this great monumental calm. It appears also, and this is a more significant trait, in the modelling of the figures.

To say that it is a mural modelling is not to suggest that it is dry and flat like the wall, but that it harmonizes with its surroundings and does not compromise the unity of the effect. The problem which these artists set themselves involved a reconciliation of opposites. It was not a question of making man architectural by geometrical processes, but of setting up an erect and recognizable image, without exposing the fragile flesh to the risk of being crushed beneath the terrifying overhang of the masses of the building. So well did they succeed that the man of stone is sometimes more stable, and more of a 'monument', than an over-florid façade, covered with outworks and apertures. They achieved this, particularly

[1]His observations in the article *Sculpture* of the *Dictionnaire d'architecture*, are very important. The artists of the thirteenth century carved numerous colossal statues, in which the execution becomes progressively simpler as the scale increases. The gallery of the Kings at Amiens is remarkable for the extreme simplicity of the draperies, for the sacrifice of subsidiary detail, and for clarity of pose, for which *even deliberate distortions* are called into play. The features of the heads are carved with a view to being seen at 100 ft. from the ground. The eye is set relatively far from the bridge of the excessively prominent nose. The eyebrows are rendered as a sharp ridge. The hair is shown in broad masses. The whole thing is conceived, not for the studio, but for the actual position. At Reims, the statues on the pinnacles (13 ft. high) have excessively short arms, excessively long necks, drooping shoulders, stumpy legs, and the upper part of the skull made very wide and high. All these faults are deliberate. Viollet-le-Duc finds the same principles applied to the execution of ornament. Colossal ornament is broad and simple, with vigorous masses and lively projections. At Notre-Dame in Paris, its scale increases with the height of the building. At Amiens, the band beneath the gallery of the Kings (at a height of 92 ft.) is narrower (1 ft.) and more delicately modelled than the frieze which is situated below the dripstone (at a height of 142 ft.) which expands its crockets and its broad, bold fig-leaves over a band 2 ft. wide.

in the first years of the thirteenth century, by modelling in large simple planes,
on which light falls without complexity, and they shunned (even at Reims)
excessively complicated draperies and charmingly executed details: experiments
in these latter fields are, on the other hand, characteristic of French art in the
fourteenth century—perhaps because less was built then, and built differently,
and because form was envisaged in more restless, liquid and attractive shapes.
Even then it retained something of its stability and its old frankness of modelling.
At the time when Chartres cathedral was being built, the image-makers worked
alongside the stone-masons on the building site: we see them in one of the windows
attacking their material with powerful blows. Thus the crisp edges, the vivacity
and the broad lines of the roughing-out were retained in the finished statue.
This art did not lend itself to the rendering of the idiosyncrasies of individuals or
the ephemeral poetry of facial personality, but tended to produce invariable
types. And yet, with extraordinary economy of means, it created unforgettable
figures which are like nothing but themselves. Such are the St. Firmin at Amiens,
an admirable reflection of Christian contemplation and priestly dignity, and the
84 St. Joseph at Reims, vivid and sprightly, full of sly humour, a teller of good
stories and abundant in wit.

III

Thus the goffered modelling of the Romanesque sculptors fell away like an
outmoded garment, and was replaced by tranquil surfaces. Thus the volumes
were filled out with new and strong substance, and human stature increased in
all three dimensions. The progress of this evolution may be followed in northern
France and Burgundy during the second half of the twelfth century, and runs
parallel with the academic and Baroque manifestations of the last phase of
Romanesque sculpture. We have seen the first signs of it at Saint-Denis itself,
and it seems almost certain that the art of the Lotharingian goldsmiths was no
stranger to it. Whereas the enamel workers of Limoges continued to transpose
into their hard, brilliant material the painting style of the twelfth century, and
accentuated its linear character by raising narrow bands of metal from the ground,
enclosing the forms within rigid boundaries, masters like Godefroy de Claire and
Nicolas de Verdun, in their rich figure style, with its direct and fitting treatment
of the material, foreshadowed, on the reduced scale of the arts of precious metal,
the future of monumental sculpture.[1] The Last Judgement at Laon is intermediate

*[1] On the art of the Lotharingian goldsmiths, see above, p. 170; the best handbooks are by S. Collon-
Gevaert, *L'orfèvrerie mosane au Moyen-Age*, Brussels, 1943, and *Histoire des Arts du Métal en
Belgique*, Mémoires de l'Académie Royale de Belgique, VII, 1951.

between the reliefs of Saint-Denis and the great Gothic reliefs, just as the St. Stephen at Sens stands between the column figures and the statues of the thirteenth century. The tympanum of the Life of the Virgin, from the old church of Saint-Pierre-le-Puellier at Bourges, although its figure style remains Romanesque, illustrates, by its sequence of anecdotes ranged in horizontal rows, the abandonment of the strict and subtle processes of Romanesque composition. At the same period, in the closing years of the twelfth century, the master of the Death of the Virgin at Senlis still retained a taste for surfaces streaked and wrinkled with long channel-like folds, but the charmingly youthful angels who surround the funeral couch with the beating of their wings, and the gestures with which they prepare to carry off the slumbering Virgin to the rewards of eternity inaugurate the springtime of Gothic art and the expression of a new sensibility.

Chartres, in the successive phases of its sculpture, demonstrates the continuity of Gothic thought. So, too, does Reims, but with a remarkable variety of manner, out of which there emerged a style which was certainly the most original of the thirteenth century, the style of the Reims workshop proper. Amiens, besides the statue of St. Firmin, possesses, in the Beau Dieu, the most sublime and pregnant expression of the monumental art of the Middle Ages. These are the peaks, but it is necessary to pursue everywhere, in village churches such as Saint-Sulpice-de-Favières and Rampillon, as well as in the great cathedrals such as Paris, Sens, Bourges and Rouen, the manifold aspects of an activity which, with dauntless strength and youthful grace, seized hold on life, and produced masterpieces even on buildings of minor importance. From the reliefs of the plinths up to the voussoir carvings, from the lintels, tympana and gables up to the pinnacles of the buttresses, from the portal statues to the figures of the upper galleries, man is everywhere, man the image of God, man in every condition of life, labouring with hands or mind, the husbandman, the doctor, the bishop, the martyr, the Son of God, the angels, and the dead resurrected in the glory of their unsullied flesh. What an immense widening of the Mediterranean humanism!

A cathedral is in itself a whole world, all mankind. The Chartres masters combined past and present. They not only preserved the example of the Royal Portal, which had survived the fire, they also maintained its traditions, allied with the new stylistic current, in the earliest statues of the north portal. There is still something wild and primeval about the figures of the Precursors. But in the south portal the martyrs and confessors are contemporary personages, transfigured by the monumental order and the serenity of the stone. Likewise with

the Christ of the Last Judgement, bared to the waist, while the Christ of the
Coronation, despite His humanity and His marked plasticity, is instinct with the
glory of His destiny and the majesty of the Father. The figures on the porches
which cover and adorn the lateral portals date from the second third of the
century,[1] and are more supple in movement and gentler in sentiment, but the
sculpture of Chartres always retained a characteristic gravity, as if it were the
embodiment of some vast rural reverie and the prolongation, with its forms
partaking of both old and new, of the mysterious thought of its column statues.
The span of years covered by the Reims sculpture was no less, rather the contrary,
but it is much more diverse, and this diversity extends to the iconographical
scheme itself, whereas at Amiens, for instance, the latter is characterized by its
classic beauty, and at Auxerre, by its subtle unity. The variations of plastic
quality and emotional expression in the successive workshops at Reims are no less
marked.[2] The small door which formerly opened from the north transept into
the cloister has a Virgin in Majesty with the Child on her knees, and other
reliefs relating to the funeral liturgy, which link the Reims sculpture with the
most youthful and tender forms in French art during the last twenty years of the
twelfth century. The sculptures which adorn the other two doors of the north
transept are more than a generation—perhaps even half a century—later in date.
One is dedicated to St. Sixtus and the saints of the diocese, the other to Christ and
the Last Judgement—an unusual position for this essential theme, which normally
figures on the west fronts of great churches, so that the possibility of a later
re-arrangement has been proposed. The tympana are subdivided into several
registers, carrying frieze-like compositions, of anecdotal character. Some of the
jamb figures are very short and the whole effect is not free from stiffness and
monotony. The drapery style, however, with its numerous thin and broken folds,
suggests that these figures represent a first interpretation of the antique at

*[1] For a revised chronology of the works, see L. Grodecki, *The Transept Portals of Chartres Cathedral...*,
Art Bulletin, 1951. On the iconography, A. Katzenellenbogen, *The Sculptural Programs of Chartres
Cathedral*, Baltimore, 1959.
*[2] On the sequence of the Reims workshops, the first serious analysis was made by W. Vöge, *Vom
gotischen Schwung und den plastischen Schulen des 13. Jahrhunderts*, Repertorium für Kunstwissen-
schaft, 1904, p. 1 ff. P. Vitry, *La cathédrale de Reims*, 2 vols., Paris, 1919, used early studies by
L. Lefrançois-Pillion, who eventually published *Les sculpteurs de la cathédrale de Reims*, Paris, 1928.
But the great landmark in the Reims studies was the article by E. Panofsky, *Über die Reihenfolge der
vier Meister von Reims*, Jahrbuch für Kunstwissenschaft, 1927, pp. 55–82. Since then, see also
W. Medding, *Der Josephmeister von Reims*, Jahrbuch der preussischen Kunstsammlungen, 1929,
p. 299 ff. The problem is much more complex than was at first imagined. After the work of the
first master, whose connections with Chartres have always been accepted, the two major changes of
style occur c. 1220–25, when the workshop of the Antique Figures appears at the north transept
doorways, and c. 1235–40, when the lead passes to new masters coming from Amiens and Paris.
The essential part played by Paris in the formation of the new style of the mid-thirteenth century
becomes daily more evident.

Reims.[1] The St. Paul, with his hollow cheeks and prominent cheekbones, his eyes shadowed by hugely arched brows, is a startling characterization. As for the figures of the reliefs, whether we look at the dead rising from their tombs or the angels bringing the little naked souls to Abraham's bosom, we find an elegant restraint, a succinct firmness, and especially an air of youthfulness, which are characteristic, perhaps, of this first 'Atticism' of Champagne. But it is the west front which displays, in a series covering the whole of the thirteenth century, the full variety of this sculpture, which was tied to no formula, and can show us, adjoining the Precursors' portal, inspired by that of the north transept at Chartres, though still more rude, the Presentation and Annunciation of the portal of the Virgin, in which the French genius achieved its sublimest and most refined purity of expression. How can one convey in concrete terms this modesty of form, this contemplative tranquillity of light beneath which the modelling of the body appears as a scarcely perceptible undulation, this air of simplicity about the Virgin, the handmaid of the Lord? The adjacent group, that of the Visitation, which is clearly inspired by the antique, helps, by force of contrast, to make apparent the profound originality of work indebted only to its own tradition and its own poetry of life: these superb Roman matrons, enwrapped in a mesh of handsome draperies, hint at the perils of premature 'Renaissances'. Classical statuary was known to the Middle Ages and was studied by medieval sculptors: but if the latter sometimes came close to its grandest and most harmonious aspects, this was due much less to imitation than to a natural correspondence and profound affinity, which were entirely unconscious. The Beau Dieu of Amiens is more classical than the Visitation. Eventually the exquisite individuality of the Reims genius, gradually disentangling itself from the teaching of Chartres and Amiens, was able to express itself in touches of the most delicate precision and the most intimate spirituality, in figures like the St. Joseph, the prophetess Anna and the angel to the right of St. Nicaise (or St. Denis).

In the history of every style there comes a happy time when monumental strength and refinement of form, the solidity of fine, impersonal masses, representing a higher and more tranquil order than our own, and the nuances and

*[1]On the workshop of the Antique Figures, add to E. Panofsky, *op. cit.*, H. Bunjes, *Die Skulpturen der Liebfrauenkirche in Trier*, Trierer Zeitschrift, 1937, pp. 180–226; J. Adhémar, *Influences antiques dans l'art du Moyen-Age français*, London, 1939, pp. 273 et seq. This workshop derives its inspiration from the style of Nicholas of Verdun, and stands somewhat apart from the general trend of French Gothic sculpture. Villard de Honnecourt and the sculptor who made at Chartres the statues of Saint-Laumer and Saint-Avit (c. 1230) are closely related to the Reims workshop, and so is the Bamberg master (c. 1240-45). The statue of Saint-Sixte, the Beau Dieu of the Judgement doorway and five statues of the west front (Visitation group, angel at the left of Saint-Nicaise, Queen of Sheba and bearded Prophet at her side) show the impact of the Amiens and Paris masters on the Antique Figures style; they must date from c. 1240. I owe these precisions to the kindness of M. Louis Grodecki.

hidden places of human psychology, hang in momentary equipoise. The art of
the monuments tended to constancy of human types: even among the diversity
of Reims we can find more than one example; the Apostles of the central door at
Amiens provide another. A psychological art tends towards overabundance of
detail as well as overabundance of meaning. The French genius long preserved a
just balance between these contrary tendencies, even in its portraits, which
retained throughout the later Middle Ages, even in painting, their monumental
grandeur. The second half of the thirteenth century, however, particularly at
Reims and at Paris, was the favoured period in which this flower of humanity.
blossomed. The slenderer, less imposing bodies bend on more numerous axes.
The smiling features, the gently inclined heads, the grace of the gestures, and
even of the movements of the draperies, harmonize with a benevolent, tender or
roguish air. The stones of the churches bear witness to a way of life which was
refining both manners and emotions. This was the Praxitelean age of Gothic
sculpture. It was prolonged into the fourteenth century, when the supple grace
of the style is not free from a certain monotony. But in many earlier monuments
it is still associated with grandeur of form and the deployment of vast composi-
73 tions—at Bourges, for instance, in the tympanum of the central doorway,
executed about 1280, with its angels carrying the instruments of the Passion and
its St. Michael weighing souls. The influence of this workshop and that of
Reims seem to coalesce at Rampillon, where the scene of the Resurrection of
the Dead displays most charming nudes, of great nobility of form. Medieval
art would be incomplete without these renderings of the male and female body.
Already in the Romanesque period they had taken their place in the churches.
The lintel of Autun shows how the masters of the twelfth century twisted them
into the expression of forceful sentiment as well as into conformity with the still
potent rules of the ornamental style. The Judgement portal at Reims offers a
calmer interpretation and a smoother modelling. On the boundaries of southern
77 Champagne, a few miles from Provins, the village church of Rampillon enjoyed
78 the services of a master who had been trained, perhaps, on the great building-
sites not far away: his nudes have the innocence of the adolescent form, they are
radiant with tender youth. Thus the humanism of Christianity raises the glorified
flesh out of the tomb; hastily it starts up, free and unveiled, at the feet of the
Lord. It is but one aspect, though one worthy of note, of the history of form in
the thirteenth century.

The role of Parisian art in this development was considerable. It introduced
a special tone, peculiar to itself, which becomes apparent when one compares,
94 for example, the Virgin of Notre-Dame and the Vierge Dorée of Amiens, the one

tall and slender, with fine-drawn cheeks and delicate profile, the other radiant with the happiness of motherhood. Thus the individual spirit of the various centres made itself felt in an evolution which nevertheless retained its character of inevitability and obeyed, with remarkable consistency, the laws of the life of the styles, as if these were biological processes. The general conditions of life in Paris were different from those of Chartres, Bourges, Amiens, Reims or Beauvais. It was the centre and head of Capetian operations, the source of the commands and the political impulses, the place where the élite were congregated and which, already at this time, set the tone of French life. Its 'provincial' character, by which I mean its individual accent as a stylistic centre and locality, was doubtless derived from its natural aptitudes, from the *genius loci*, but also indubitably from the operation of its historical function. Paris, at this time and long before, was essentially the great town. It possessed in the highest degree that virtue—rarer in restricted or remote centres—of urbanity, which polished the grain and sharpened the edges, while at the same time allowing human relationships a liberty of action which only later stiffened into etiquette. It imposed on them restraint, moderation and, as it were, a linear quality. And we may add that, in this great town of craftsmen, it accorded well with the taste for things well and strictly made. This aspect of contemporary manners seems to find expression in the elegant ponderation of the sculpture. It is not merely human; it exemplifies a refinement and a decorum which are not always characteristic of the courts of princes. The Apostles of the Sainte-Chapelle, which we have no serious reason to suppose much later than the consecration date, still carry within them the nobility of the monumental age, are still lords in stone, but they also possess the Parisian tone.[1] The fourteenth century was to develop its charm, with all the restrictive implications of that word.

Without wishing to force the parallelism with antique sculpture which has been touched on in connection with the early Attic style of Reims and the developed classical style of the Beau Dieu at Amiens, we are tempted to consider that Gothic art passed through an Alexandrian period in France between about 1250 and 1350, though with fewer impurities and foreign deposits. The secular feeling of works such as the brackets of Lyons cathedral, the romantic flavour and lyrical fancy of the reliefs of the Portail des Libraires at the cathedral of Rouen, are like a first sketch of it, later to be spoiled by excessive pictorialism and medallist's devices. The very suavity of certain nudes sometimes deceives us,

74

*[1] F. Salet, *Les statues d'Apôtres de la Sainte-Chapelle conservées au Musée de Cluny*, Bulletin Monumental, CIX, 1951, pp. 135–156, has shown that all these figures must be dated 1245–48, in spite of some differences of style. See also the additional note, *ibid.*, CXII, 1954, pp. 357–363.

and, under the caress of favourable light, evokes from the mutilated image of Adam the memory of a youthful Hellenistic torso. This accent is difficult to define, for it occurs always in conjunction with that characteristic medieval and Western inflexion caused by the fact that the hand wielding the tool had a background of centuries of experience acquired in hewing the masonry of walls. We *80* find one example, among others, in the elegant Genesis of Auxerre, where, within the compass of a shallow relief, something of the old tradition still mingles with the flowing profiles, elongated forms and supple modelling.

These, none the less, were new features. Sculpture was also influenced by a phenomenon of a more general kind, though one which harmonized with and reinforced these—a certain transformation of the frames within which it was set, or rather the dislocation of the old concord between the building and its decoration. To hang statues on piers, as in Saint-Nazaire at Carcassonne, which follows the example set by the Sainte-Chapelle, is to accept the independence of the image and to transform the church, by this interruption of the vitality and purity of the architectural lines, into a museum devoted to the 'exhibition' of works of art. The applied relief also multiplied, and its stone pictures, in their rectangular or quatrefoil frames, were set in any desired position, not only on huge plinths, as in the south transept of Notre-Dame in Paris, but also up the door-jambs, breaking and perverting their structural function, as in the Portail des Libraires. The nearer their approach to self-sufficiency, the more graceful and spirited is their execution, and they become like lightweight, portable objects which can be taken in the hand and studied at close quarters.

These shiftings of stress made themselves felt also in the images of the saints, of the angels, and even of the Virgin herself.[1] From the old type of the Virgin in Majesty, which had played so large a part in Christian art and whose image had been propagated down to the close of the Romanesque period by the

[1] See R. Koechlin, *La statuaire dans la région de Troyes au XIVe et au XVe siècle*, Congrès Archéologique, Troyes-Provins, 1902; J. Heinrich, *Die Entwicklung der Madonnenstatue in der Skulptur Nord-Frankreichs von 1250 bis 1350*, Leipzig 1933, and particularly L. Lefrançois-Pillion *Les statues de la Vierge à l'Enfant dans la sculpture française du XIVe siècle*, Gazette des Beaux-Arts, 1935. The dated figures are as follows: the marble Virgin (1340) and the silver-gilt Virgin (1349) which were given by Jeanne d'Évreux to the abbey of Saint-Denis; the alabaster Virgin of Langres, commissioned in 1341 from Évrard d'Orleans; the Virgin of Huarte Araquil (Navarre), which has disappeared, but is described by Dieulafoy and dated 1349 by inscription. Madame Lefrançois-Pillion, however, has succeeded in reconstituting the earlier evolution which led up to the type established between 1340 and 1350; the earliest figures are the Virgin of Notre-Dame at Pontoise, the Virgin of Saint-Nazaire at Carcassonne (1300–22), the first of the two Virgins of Écouis (prior to 1314), the Virgins of Magny-en-Vexin, Maisoncelles, Mainneville, etc. They achieved an extensive diffusion both by actual export (Pamplona) and by imitation or parallel inspiration. They are found in Sweden (Uppsala), England (Winchester) and Germany (Erfurt, Soest, Halberstadt), where their influence is interesting, suggesting some highly individual inflexions. In addition, they were not unknown to Nino Pisano.

Auvergne Virgins, combining the functions of statue and reliquary, a regal dignity had descended to the portal statues and long persisted amongst them. At Paris and Amiens—and doubtless in other regions also—round about 1280, Mary became at once more feminine and more maternal. The Vierge Dorée of Amiens *94* indubitably exercised an influence on stone sculpture and still more on ivories. At the same time the Virgin tended to abandon her architectural frame, and it has been rightly observed that her image appears on very few fourteenth-century *trumeaux*. Independent figures, on the other hand, are extremely numerous. The reason is that the cult of the Virgin had assumed a special form, becoming both more popular and more private than before. She is the Virgin of the Rosary, in the tiny secluded oratory, and she is the Virgin of the cross-roads and street-corner, in her little niche supported on its ornamental bracket. In her commonest (if not constant) form, she is no longer erect and frontal, but submits gracefully to the principle of the multi-axial pose, beloved of all Alexandrianisms, and of which the raising of the hip, motivated by the weight of the Child she carries on her arm, is but one element. In her disengaged hand she carries a sceptre or a flower. She is draped in a mantle, the two ends of which are joined beneath the hand which supports Jesus. Her face is very youthful, with tiny, delicate features, short beneath the swelling forehead, and a great air of nobility, tinged sometimes with melancholy. She exemplifies an age which brought God close to man, which no longer set Him in exalted regions, but needed His familiarity. Often, this charming young lady retains no more of her old royal birthright than is sufficient to raise the pride of noble race above the level of worldliness.

Thus there was produced a manifest harmony of style and thought between sculpture and the arts of luxury, which, after their long subjection to the laws of architecture, now more or less shook off this bondage and lent themselves, with the exquisite character bestowed on them by the rarity of their materials and the smallness of their scale, to new aims. Down to the middle of the thirteenth century the seated ivory Virgins had preserved the mass, stability and grandeur of line of the old Virgins in Majesty of the preceding period. But in less than two generations, these figures, which had hitherto retained their monumentality despite the reduction of scale, became figurines, and, in the ivory plaquettes, the forms, gracefully curved, subtly outlined, and overspread by soft light, interrupted here and there by skilfully disposed accents of shadow, are those of quite another race of men. Their silhouette is identical with that of the little nimbly-drawn figures in the margins of manuscripts decorated by Jean Pucelle. The secular ivories, mirror-cases among them, welcomed, along with the iconography *125* of courtly literature—the Dame de Vergi, the chess game of Huon of Bordeaux,

the knightly deeds of Perceval—the happenings, the amusements and the favourite day-dreams of worldly life, to which the romantic spirit of the house of Valois and the moral disorder of the end of the century were to add a note of fairy-like enchantment. The Parisian ivories,[1] which found their way all over Western Europe, contributed to the remarkable unity of style which once again characterized a European language, rich in dialects, but homogeneous in principle. Taste made its appearance—taste, that modern factor, the expression of the preferences of a cultured élite, the combination of heightened pleasure and calculated moderation, a conception entirely foreign both to the epic art of the Romanesque masters and to the monumental genius of first Gothic art and the grand style of the thirteenth century. The region in which tne visionaries have their being lies beyond taste, and the architectural, iconographical and plastic harmony of the cathedrals demands a more elevated definition. Taste, in the fourteenth century, is already a form of tact, of sociability.

The same period developed the art of portraiture, born of tomb sculpture. It is true that the statuary of the cathedrals can show more than one example of figures which seem to breathe authenticity, and whose facial expression is so definite that they induce a convincing and inescapable impression of being portraits from life. It would be desirable to re-study from this point of view the figures of the corbels, some of which seem to go beyond mere liveliness of invention, and especially the Burgundian masks, of which there is a fine series in the triforium of Notre-Dame at Dijon. But in the large figures the law of constancy of

[1]The importance of the part played by Paris is proved. The statutes of the Paris trades are the only ones which include ivory-carvers, who were elsewhere split up among different guilds, from the painters of images to the comb-makers. The names of several masters are known, though it is not possible to connect them with extant works. Jean le Scelleur worked for Mahaut d'Artois (1315-25) and Philippe le Long. The inventory of Charles V (1380) acquaints us with the name of Jean Le Braellier. The names of ivory-carvers grow numerous in the accounts at this time, and, throughout the fourteenth century, the inventories enumerate many objects of ivory. Great numbers have come down to us—little altarpieces for the private chapel, statuettes, writing-tablets, and mirror-cases. Their diffusion made a considerable contribution to the unity of tone of Western art in the fourteenth century, and if we trace their history further back, we find that they reproduce in little the entire evolution of sculpture from the late twelfth century onwards. The lovely Coronation of the Virgin, in the Louvre, could be enlarged to the scale of a tympanum. In a more evolved style, the workshop of the Soissons diptych (London, Victoria and Albert Museum) still retains the breadth and the stability of monumental art. The Virgin who takes her name from the Sainte-Chapelle already defines the fourteenth-century type. Influence from the art of the miniature makes itself felt in the numerous scenes of the 'tableaux cloans' (folding pictures), but the Triptych of Saint-Sulpice-du-Tarn (Cluny) undoubtedly represents an exquisite balancing of the great tradition against the charm of the new manner. The latter is not without monotony, particularly in minor pieces. The closing years of the century inject into it, along with tricks of perspective and the openwork technique, a greater intensity of emotion and a greater violence of action. Besides R. Koechlin's basic work on the Gothic ivories, see also his treatment of the subject in *Histoire de l'art* (André Michel, ed.), vol. II, Part I, p. 460, and *L'atelier du diptyque de Soissons*, Gazette des Beaux-Arts, 1905, II. *Add the excellent little book by L. Grodecki, *Ivoires français*, Paris, 1947; also J. Natanson, *Gothic Ivories of the Thirteenth and Fourteenth Centuries*, London, 1951.

type had prevailed over the study of the individual, and the general over the particular.[1] For long the sculptors created tomb effigies of this type, giving them all the same youthful air, the same inner contentment.[2] At a later stage, they made use of the death-mask, which, moulded from the dead body, was intended to cover the face during the funeral ceremonies. In the cathedral of Cosenza in Calabria, Isabella of Aragon, Queen of France, who died while returning from the eighth crusade, was represented, by an unknown French master, in prayer before the Virgin. Her features bear the imprint of the death-struggle. The artist has sought for the image of life in agony and death.[3] The image of man moves on from the tranquil open-eyed slumber of the effigies to the deathly grimace of his last moments. This mask, in which life is caught in the moment of struggle before it departs, is not the end, but the beginning of a series of experiments in which the portraits of the dead are introduced, less violently, into the stone of their tombs. Through a series of transitions and studies, among which the female effigies are not the least remarkable, with the chin band framing their cheeks and lending an air of youthful purity even to worldlings most deeply ravaged by life and death, we come to the great male portraits, men whose fleshly likeness has been eternized in stone, the noble Charles V of Beauneveu,[4] the slender Léon de Lusignan, and Bertrand Duguesclin, rude, flat-nosed, a man of the people, just as he appears in his portraits in contemporary manuscripts. The taste of the time has perpetuated not only the ephemeral adornments but also the physical deformities of the great lords who were its creators. The Constable Louis de Sancerre squinted; hence a whole series of cross-eyed statues. We have come far from the commemorative tombs which, a hundred years earlier, St. Louis

[1]See my study, *Les origines monumentales du portrait français*, Mélanges Iorga, Paris, 1933. On the Burgundian masks, see H. Chabeuf, *Tête sculptée à Notre-Dame de Dijon (XIIIe siècle)*, Revue de l'art chrétien, 1900. He rightly lays stress on a head of half life-size in the south transept, over the door leading to the galleries, the portrait of a contemporary of Hugues IV, of one of those Burgundians who, in the thirteenth century, were called 'Li moqueux de Dijon'. *On the beginnings of portrait sculpture, P. Deschamps, *La statue de Saint-Louis à Mainneville (Eure)*, Monuments et Mémoires publiés par l'Académie des Inscriptions et Belles-Lettres, Fondation Eugène Piot, XXXVII, 1941 (for 1939).

[2]See E. Mâle, *L'art religieux en France à la fin du moyen âge*, p. 400.

[3]See E. Bertaux, *Études d'histoire et d'art*, Paris, 1911, Le tombeau d'une reine de France en Calabre p. 3-28.

[4]André Beauneveu, born at Valenciennes, architect, sculptor and painter, was first of all (1360) in the service of the Countess of Bar, Yolande of Flanders. In 1365, he was working on the Saint-Denis tombs: Philippe VI, Jean le Bon and Charles V—though the latter was to live for fifteen years more. From 1374 to about 1380 he was employed in various works of painting and sculpture at Valenciennes, Cambrai and Ypres. He was at that time 'tomb-maker' to the Count of Flanders. In 1393 and 1397, he was 'master of the works of carving and painting' to Jean de Berry, and was working on the duke's castle at Mehun-sur-Yèvre. See the *Chroniques* of Froissart, Book IV, chap. XIV, and R. de Lasteyrie, *Les miniatures d'André Beauneveu et de Jacquemart de Hesdin*, Monuments Piot, III, 1896.

had had made for certain of his ancestors, in the conventional fashion of the accepted royal type. But we are no less remote from the corpse of Cosenza. The restraint of the period and the charm of the environment mask the aggressive and terrifying aspects of the realistic analysis. The Flemings who worked for the French royalty conformed to this spirit of decorum. The figure of Robert of Artois (about 1320), the work of Pépin de Huy, and the effigies of Jeanne d'Évreux and her husband, executed half a century later by Hennequin de Liège, exemplify, among others, this characteristically French quality, which is seen in such firm and pure form in the admirable series of engraved or tomb-slabs. These beautiful drawings on the stone seem to purge the effigy of the dead of all its carnal substance and terrestrial mass. The image is preserved as if in the linear network of memory. Anecdotal details intrude, for instance in professional tombs, but how much more they are stressed and insisted on in the contemporary German groups, where penetrating naturalism is carried so far as to encumber the effect. Thus a great Christian thought passed away, along with the majestic uniformity of the dead. But it is noteworthy that statues of living personages retained down to the end of the century, in those workshops which were employed by the Valois court, the essential features of the monumental style, even though they were enriched by delicate suggestions of individual personality. We no longer possess those which adorned the famous staircase in the Louvre, the work of Raymond du Temple, but we may still see in the Louvre those of Charles V and Jeanne de Bourbon, in the guise of St. Louis and Marguerite de Provence, which were made for the chapel of the Quinze-Vingts.[1] That they are truthful likenesses is vouched for by the literary portraits of these princes, such as those of Christine de Pisan; in any case, we scarcely feel the need of such proof, or of that provided by the many miniatures in which Charles V figures. But in these statues, as in those which decorate the chimney-piece of the great hall in the Palace of Poitiers,[2] we recognize, besides the charm, restraint and urbanity characteristic of the Parisian style, the dominance of the monumental tradition, still full of majesty. At Poitiers, the faces have a more flowing softness and the transitions are seen with the painter's eye. But the Charles V of the Louvre is worthy of a church portal.

[1] It was long believed that they came from the chapel of the Célestins. But the arguments advanced by G. Huart, in a communication to the Société des Antiquaires de France, published in Gazette des Beaux-Arts, 1932, I, p. 375, are convincing. *Add the important article by P. Pradel, *Les tombeaux de Charles V*, in Bulletin monumental, CIX, 1951, pp. 273-296; see also, by the same author, *Le visage inconnu de Louis d'Orléans frère de Charles VI*, Revue des Arts, II, 1952, pp. 93-98.
[2] See Comte de Loisne, *La statue de Jeanne de Boulogne*, Bulletin de la Société des Antiquaires de France, 1915, p. 119-22; Comte P. Durrieu, *Portrait de Jeanne de Boulogne*, ibid., 1916, p. 103-6; L. Magne, *Le Palais de Justice de Poitiers*, Paris, 1904.

This development is remarkable for its continuity and clarity, but can it be considered to apply to France as a whole? What was the Midi producing? And in the royal workshops, the Parisian centre, what part was played by the Flemings? Southern France had two aspects—the Midi of the Rhône and the Midi of Toulouse. Did the great artistic centre of papal Avignon react upon sculpture as it did upon painting? This may be doubted. There is nothing particularly local about the corbels of the pontifical palace, and the tomb of John XXII, at the Charterhouse of Villeneuve, must be English work. A few touches of Italian influence in the voussoirs of the left-hand portal at Saint-Maurice in Vienne, which for the most part conforms to the French style of the later fourteenth century, do not suffice to give a specific accent to a group which is ill-defined and whose works are few and far between. In Guyenne, at a rather earlier period, the east end and the portal of Bordeaux cathedral, executed for Clement V, have statues and reliefs in the north French style, like the surviving parts of the sculptured decoration of Saint-Nazaire at Carcassonne. Toulouse maintained the Romanesque tradition in the capitals of the cloister of the Augustins, but in a less brilliant, rich and varied form than that of the Romanesque-Gothic Baroque of Catalonia. The most important group comprises the statues named after the college of Rieux, which are now in the Toulouse Museum. They were executed to the order of Jean Tissendier, Bishop of Rieux (1324–48), for the sepulchral chapel which he founded at the church of the Cordeliers in Toulouse, following the model of Saint-Nazaire. They represent the Apostles, St. John the Baptist, and Franciscan saints, together with Christ and the Virgin, now in the museum of Bayonne. They do not connect with that art of the Avignon area which is so difficult to draw into a definition, whether we study it on the façade of La Chaise-Dieu (about 1375) or on the portal of Vienne (about 1380). Nor do they connect with the art of the north French workshops. Short and solidly built, their large heads often tilted over one shoulder, retaining more than a trace of the original vivid polychromy, and executed with a mixture of coarseness and refinement, they seem to be both archaic and advanced. At first sight, one feels that the St. Paul anticipates the Prophets of Sluter—but the direction of the research, the ornamental intention and the patterned treatment of the beard, are of totally different character. Perhaps this style has links with Catalonia? The workshops of the Tarragona portal come to mind. Certainly it is a style which is far from mediocre, and which seems to be practically unique in France, and even in its own region.

The Flemish problem, however, is a much larger one. It relates to a great and productive area, and an incessant interchange, vouched for by numerous texts.

From the Meuse quarries, rich in materials both beautiful and perilous (because of the ease with which they are worked and the transparency of the epidermis), from the country of the brass-workers, the chasers and founders of metals, the sculptors of images in blue stone, there arrived in France artists of the highest class, favourites of royalty. What did they bring with them?

Situated as they are between France and Germany, the historical destiny of the Netherlands, theoretically at least, seems composed of the conflict and harmonization of influences from without. In its earliest architectural monuments and far into the thirteenth century their affiliations were Romanesque and Rhenish, but one can also find, in some of the Tournai fonts which were exported to England, in the surviving architectural reliefs, and in Mosan metalwork, variable traces of southern contributions and Carolingian reminiscences. It is possible that the techniques of the bronze-workers and metal-chasers also affected the stone sculpture. But the Gothic sculpture of these regions is French. The persistent and uninterrupted migration of artists from the Netherlands into France during the fourteenth century, the parts played by men like Pépin de Huy and Beauneveu, the scale of their Parisian establishments, their commissions and their renown, led Courajod to interpret the stylistic evolution of French sculpture in the fourteenth century as the product of their native genius and the direct result of their activities. Hence there arose the doctrine of 'Flemish' influence and the progress of 'realism', from which art-historians have not entirely freed themselves even now. Idealism and realism are the offscourings of a system of aesthetics whose categories cannot be applied with impunity to a morphological analysis which seeks to understand the manner in which a monumental style was replaced by an anecdotal style. A twofold error (an error of localization, and an error of interpretation) has produced a false antithesis of Flemish realism and French idealism. In fact, the southern Netherlands and northern France formed a single unit, as is demonstrated in turn by the Porte Mantille at Tournai, by the thirteenth-century Virgins, and, in the following century, by the tympanum of the Childhood of Christ at Huy: it has been observed that one of the Kings, who kneels before Christ, has slipped his arm through his crown, in order to carry it more conveniently, but this pleasant familiarity is neither specifically Flemish, nor specifically 'bourgeois', it is one of the happy discoveries in which the art of the time abounded, while the King who stands beside his companion is a figure such as can be found by dozens in the Parisian ivories. It is by their quality of charm, and in their female figures, that these 'realists' impress us most. Their particular regional note consists in their tendency to shorten the proportions, thicken the volumes and refine upon the virtuosity of execution.

126

IV

WE cannot attain a thorough understanding of the historical development and the characteristics of Gothic sculpture in Europe, by merely studying its geographical distribution. We are compelled to observe the geographical framework, but we must make allowances therein for the operation of two principles, the importance and cogency of which we have already noted in connection with the evolution and expansion of the architecture. The first of these is that of the simultaneity of development on a number of different planes. The various centres were not all living the same moment of time, or in accordance with a uniform temporal rhythm: Romanesque centres in full activity existed alongside advanced Gothic centres, and others where the spirit and style of the Renaissance was already established. We are justified in selecting French sculpture as our point of departure because, like the architecture of the same country, it was the completest and most rapidly crystallized expression of the Gothic idea; more than that, it certainly played a leading part in the formation of the European style of the fourteenth century, and had even foreshadowed and prepared the way for it in the preceding period, though it is necessary to take note of other important phenomena which are not always passive survivals, long-drawn decadences, or irregular anticipations. The second principle is that of the intercommunication of these very varied centres; but the history of influences is not necessarily the history of imitations. The latter are common, but they are not uniform, and the character of the personal or local reaction deserves special attention. In the study of Gothic art as in the study of Romanesque art, a map of stylistic movements should be superimposed on the map of the various regions, and it should be supplemented by a series of sections, giving some indication of the relative thickness of the old sedimentary strata and the new alluvial deposits. Though it may be impossible, and perhaps dangerous, to give precise measurements for these, it is indispensable to bear in mind the ideas of which they would be the visible symbols.

The province which was most unlike the French provinces, and where there evolved, together with a highly original sculpture, a grand and powerfully organized conception of man and nature, is Italy. It may be said that Gothic architecture, in spite of the scale of certain programmes, was never fundamentally understood there, and remained a foreign element. It failed to provide sculpture with monumental settings for an abundant and well-distributed iconography. The elegant reliefs of Orvieto cathedral are applied to the façade like a veneer, are *111* not incorporated in the structure but trickle over it without order or logical *112*

sequence.[1] With a few admirable exceptions, such as the Lucca tympanum or the campanile in Florence, the essential monuments of the history of sculpture in Italy in the thirteenth and fourteenth centuries are all pulpits and tombs. This dissociation of architecture and sculpture is a significant fact, and the restrictions which it imposes on iconography are immediately apparent. However great the Italian art of the Middle Ages may have been, it was also narrow. The time had not yet come when it could comprehend man as a whole; not until far into the fifteenth century did it give expression, like the art of the cathedrals, to the encyclopaedic curiosity of the intellect. This sculpture seized on certain subjects with poetic violence, and neglected others. When it was able to spread itself more widely and give, in the fifty-four reliefs of the campanile, a broader view of faith, the world, and human existence, it concentrated primarily on the tasks and the pageantry of man in his municipal aspect.

If we examine the life of the forms, we find here not a style in the process of formation, but an abrupt break in the tradition, bearing the marks both of regression and of anticipation. Whilst the Northern cathedrals were animated by a resolutely modern conception, Gothic Italy turned in the first instance to seek instruction from the Constantinian renaissance. The eternal regret for the glories of the past found, not in an Italian, but in the Emperor Frederick II, the spirit and power which could endow the illusion with the prestige of ephemeral reality. Imperial Capua is the setting of a dream and the remains of an ambition. Buildings in the Roman manner and a huge, emphatic and powerful statuary revived, for the German emperor, the memory of the empire of the Caesars. But his castles he built on a different pattern; thus at Castel del Monte, in the territory of Bari, we find the moulding profiles of Champagne. These two currents of influence must have provided the background against which was formed the genius of Nicola Pisano, or, as we should rather call him, Nicola of Apulia.[2] It is true, however, that he also owed something to the town where he executed his masterpiece, the pulpit of the baptistery, and where one may still see, in the Campo Santo, the antique sarcophagi which must have inspired him. Indeed, it is from the art of the Roman tombs, and particularly from the so-called continuous style, which heaps together the forms, often in furious mêlée, on the sides of the funerary cists, that the art of Nicola Pisano seems to emerge, still young despite the lapse of centuries. The movement, the squat proportions of the figures, and the fullness of the plasticity are the same in both cases. The

*[1]See E. Carli, *Le sculture del Duomo di Orvieto*, Bergamo, 1947.
*[2]On the southern origins of Nicola Pisano and the 'imperial' spirit of his art, see G. Nicco-Fasola, *Nicola Pisano, Orientamenti sulla formazione del gusto italiano*, Rome, 1941; also W. R. Valentiner's article in the Art Quarterly, 1952.

scenes of the Nativity, Crucifixion and Last Judgement are packed together and set in motion on six rectangular panels, supported by capitals and framed by mouldings which are reminiscent of Castel del Monte and the churches of northern Europe. This singular combination is repeated and given greater precision in the pulpit of Siena cathedral, begun in 1266: in the two registers of figures, between colonnettes and parapet, there appear the flexibility and charm of French sculpture, to such an extent that it has been suggested that Nicola may have had contacts with some wandering French master of the type of Villard de Honnecourt. But the Lucca portal, compressed with the most eloquent power into its heavy masonry, owes everything to the daring genius of its creator, so markedly superior to even the best of the Constantinian marble workers. Nicola's teaching was continued by his pupils: by his son Giovanni,[1] (the architect of the Campo Santo in Pisa), in the pulpit of Pisa cathedral, where he rediscovered and successfully interpreted the principle of the classical caryatid, and in that of Sant' Andrea in Pistoia, some years earlier (1281), which is preserved intact and *113* which gives expression to a more slender, fragile and abrupt talent; and by Arnolfo di Cambio, the inventor of the many-storeyed tomb, conceived as an ample architectural composition, which was the ancestor of the ostentatious stone catafalques of the Baroque period (tomb of Cardinal de Braye at Orvieto). The statue of Charles of Anjou, which is preserved on the Capitol, still looks back, in the heavy fullness of its masses, to the art of imperial Capua, but the reliefs of the tabernacle of Santa Cecilia are already a painter's sculpture. Thus we begin to distinguish the outlines of two currents in the history of sculpture in Italy, one tending towards generous volumes, colossal proportions, and dramatic expression, the other, in a more supple and fluid material, seeking subtlety of form, and, in relief, proceeding by little touches, and small studied planes, while awaiting the eventual shattering of space and its renewal through the devices of perspective.

Rome, but for the exile in Avignon, might have hastened the progress of the former of these two manners, and become the centre of a great pontifical style in sculpture, parallel with the calm majesty which had already been defined by the paintings of Cavallini. Naples, under the Angevins, received and favoured its exponents, whilst in Tuscany, Tino da Camaino and Giovanni di Balduccio continued the great sepulchral style of Arnolfo.[2] At the exit from the passes of the

*[1]On the Gothic background of Giovanni's art, see H. Keller, *Giovanni Pisano*, Vienna, 1942. P. Bacci has established in Dedalo, I, 1920, p. 311, that the plans for the Campo Santo at Pisa were not the work of Giovanni di Nicola Pisano, but of a certain Giovanni di Simone. On Arnolfo, see the monograph by V. Mariani, Rome, 1943.
*[2]Tino di Camaino has been studied by E. Carli, *Tino di Camaino scultore*, Florence, 1934, and by W. R. Valentiner, *Tino di Camaino*, Detroit, 1935.

Alps, the northern towns exemplified another Italy, which was in more direct contact with the Gothic idea and more closely interwoven with the life of the West. The Scaligeri had themselves carved on the tops of their tombs, not as Roman emperors, but as knights in battle harness, sitting stiffly on their chargers. At Milan, Bernabo Visconti is mounted, not on the steed of Marcus Aurelius, but on a creature with thick legs, absolutely straight, like pillars, and with a delicate, bowed head.[1] At Venice, which was both Oriental and Gothic, and where the dynasty of the Massegne was succeeded by the dynasty of the Buon, an original style, which unhappily lacked the strength to resist the Tuscan influence, adorned with a sturdy luxury the seaward capitals of the Doge's Palace. This ancient Byzantine city, this bank, arsenal and counting house, rich with the booty seized in Constantinople in 1204, glittering with mosaics on backgrounds of gold, was closely linked with the West through its towns on the Terra Firma. But the Florentine phenomenon was yet more remarkable. Architecturally Gothic by reason of buildings such as Santa Croce, Santa Maria Novella and the Palazzo della Signoria, Florence was Gothic also, in Andrea Pisano, by its modernity of feeling, by its harmony with the fourteenth century, and by the manner in which it conceived form and incorporated it into an architectural programme.[2] The ancient art of the bronze doors, which in earlier days had been exemplified in the north by the door of San Zeno in Verona, and in the south by the doors with engraved designs or applied reliefs, which were made for the patricians of Amalfi or the Norman princes, was renewed in Andrea Pisano's doors for the *114* Florentine baptistery (1330). The figures inscribed in the quatrefoils possess not only an elegance of line and that firm suppleness which seems to preserve intact the impression of the modeller's hand in the wax, they have also a contemplative quality, and a human charm. It is the same with the lovely reliefs of the Campanile, where both the inspiration of Giotto and a cool dream of antiquity found a welcome. Nothing could be farther from the Apulian style and the tradition which derived from it. It may be that Andrea Pisano knew Parisian ivories. But in a correspondence of this nature, we must see not so much the crude literalness of 'influence' as the profounder and more delicate accord of two Atticisms, a similar poetical urbanity, a similar refinement of simplicity. This tone long survived in Florentine art. It outlived the fifteenth-century experiments concerning the nature of form and the nature of space. It achieved perhaps its greatest purity in the wood-sculpture of Nino Pisano. Thus Florence enriched Italy with an essential note, entirely opposed to the obsession with ancient Rome, and one

*[1] C. Baroni, *Scultura gotica lombarda*, Milan, 1944.
*[2] See I. Toesca, *Andrea e Nino Pisano*, Florence, 1950.

which was to enable it to find its way more surely, without renouncing its modernism, to those aspects of the antique genius which were exquisite and truly strong.

The stressing of these lively contrasts was an indispensable preliminary, before passing on to the study of regions like Spain, the Netherlands and Germany, where Gothic sculpture advanced on a wide front and clashed with survivals, which sometimes coloured it in very individual ways, before it eventually achieved the unequal unity which was characteristic of the fourteenth century. In Spain, as in Germany, an art with an old but still vigorous tradition preceded the tardy appearance of Gothic sculpture, which there seems not so much a natural and inevitable consequence of what had gone before as a blending of external influence with local traditions. The Hispanic accent was more explicit and perhaps more persistent in sculpture than it was in architecture, at least at the beginning of the Gothic period. We feel this in the two masterpieces which dominate the sculpture of the first phase—the west door of San Vicente at Avila and particularly the Pòrtico de la Gloria at Santiago de Compostela. It is certainly *32* true that Burgundian influence is apparent in both cases, and that the art of Vézelay and Avallon played some part in their elaboration. But a style is not the resultant of a number of influences or a summation of archaeological symptoms. At Avila, the violent flexions of the body are a continuation, in fuller forms, of the epic fervour of Romanesque sculpture, allied with an intensity which is peculiarly Spanish. A similar trait characterizes the genius of Master Mateo, the architect of the superhuman figures at Compostela—Prophets and Apostles, who were never more impressively robed in the majesty of their mission. These monumental blocks, so mysteriously dramatic, seem to belong to the Biblical age. Almost a generation earlier (1183) than the Precursors of the north portal at Chartres, they stand on the threshold of Gothic art and anticipate its evolution. The latter made its appearance half a century later at the cathedral of Burgos,[1] first of all in the Sarmental portal. Was this the work of a master from the Ile-de- *97* France ? Certainly the Apostles on the lintel and the figures in the archivolts are *98* not unrelated to the sculpture of Paris (Prophets of the Virgin's door), but the Apocalyptic Christ of the tympanum, surrounded by the Evangelists, both in their symbolic and their human guise, is evidence of a quite different thought and an older iconographic conception. The little cloister door is more striking: it has the charm of choir-screen sculpture, and a quality of elegant intimacy

*[1]Two important studies: B. Deknatel, *The Thirteenth Century Gothic Sculpture of the Cathedrals of Burgos and Leon*, Art Bulletin, XVII, 1935; H. Mahn, *Kathedralplastik in Spanien, die monumentale Figuralskulptur in Altkastilien, Leon und Navarra zwischen* 1230 *und* 1280, Reutlingen, 1935.

which is identical with that of French art, particularly Parisian art, in the second half of the thirteenth century. Intensity has been replaced by urbanity. On the other hand, it would be hard to find in France, at any rate in the same period, a
96 work comparable with the statue of Violante of Aragon in the cloister, so vivid and personal in accent, and so daring in the rendering of the face. As to the sculpture of León cathedral, it represents the production of several different workshops: the south portal of the transept was inspired by the Sarmental door; and in the Virgin doorways of the west front, influence from Chartres has been noted. Iconographically, this influence can hardly be doubted, but the figure-style of the Entombment runs to thinner forms; other differences have been noted in the types and costumes of the blessed at the gate of Paradise. The artist, whoever he was, sought to give his style a Spanish colouring. He may have possessed it naturally. It is certain, none the less, that the French current is strong in his work, as it is in the whole of this group. In Castile, Navarre, and particularly in Catalonia, however, down to the end of the thirteenth century and even beyond, Romanesque art retained its vigour, and it would be a mistake to regard it as a belated style, prolonged by some miracle or aberration beyond its authentic period of activity. The portal of Agramunt (1283) is a masterpiece of Baroque luxuriance, in which a composition derived from south-western France seems to sparkle with an Oriental brilliance, while the keystone bears a curved relief of very archaic character. Even when, in the fourteenth century, French influence pushed forward into Navarre, in the work of Jacques Pérut at Pamplona, and into Castile, in the clock door of Toledo cathedral, and when Italian influence and the Pisan style were appearing in the Mediterranean towns of the Aragonese kingdom, Jayme Castayls, charged with the completion of the portal of Tarragona (1375), set up wild Prophets who are in some respects earlier in style than those executed in 1270 for the same door, though those also seem much earlier than they are. The time-sequence of Spanish art is not the time-sequence of French art.

Should we perhaps make the same reservation with regard to sculpture in Germany? We must not forget the strength of its Carolingian substructure, the grandeur of its eleventh-century style, and the importance and interest of its earliest plastic experiments, in ivory, stucco, bronze and the precious metals. No doubt the bronze columns which were despatched from Werden to Corbie in 990 continued the 'Roman' manner of the Aachen workshops. This we have seen also in the Bernward column and in the reliefs of St. Michael at Hildesheim, while the baptismal fonts of the same church, supported by kneeling atlantes, show that it was still intact and vigorous in the thirteenth century. The Carolingian

tradition of large-scale stuccoes, used in conjunction with architecture, was likewise remembered, and was able, in the thirteenth century, to produce the fine figures in the choir of Halberstadt, in a style comparable with that of Godefroy de Claire. Neither Romanesque sculpture nor the art of the workers in stucco and bronze was eclipsed by Gothic sculpture. The former persisted down to the later Middle Ages; the St. Paul at Münster bridges the gap between Romanesque Baroque and the Flamboyant style. The latter is still archaic in the south porch of Paderborn (1260?). It is startling to find still in use here the aedicular canopies which were characteristic of the so-called Transitional style in northern France in the middle and late twelfth century. Similarly in the south portal of Münster cathedral, the earlier parts of which are still more primitive in style, and where, later on, the old conventional arched frames contain statues as energetically Gothic as those of the knight and of Mary Magdalene—the latter already Burgundian.

The great thirteenth-century Saxon school, from whose strength and purity a truly German plastic ideal was developed, combined with its own natural laws a traditional background and some echoes of France. It would be difficult and premature to attempt a comprehensive stylistic definition. Its manifestations at Freiberg, Magdeburg and Bamberg do not form an entirely homogeneous group, and in each of these churches the style differed from generation to generation and from workshop to workshop. The monumental settings carry our thought *90* back to an earlier age of architecture. At Bamberg, the well-known figures of the Adamspforte adorn engaged columns which carry archivolts with chevron ornament, and the entire composition of the north door is Romanesque. The parallelism and harmony of the architectural and sculptural evolutions, so clearly marked in France, does not hold good in Germany. The style of the best of the Saxon statues is in advance, not only of the architectural setting, but also of other contemporary statues of the same group. In such figures influences from French art play some part, but are heavily edited. There may be a connection between the wooden Virgin of the Freiberg Calvary (which has nothing of the Chartres style) and figures such as the Virgin of the Belle Croix at Sens, wrapped closely in her draperies; but the Adoration of the Magi, in the tympanum of the Goldene Pforte, remarkably balanced in its composition, is still redolent of the manner of the stucco-workers and the goldsmiths, not in the movement of the folds, but in their strident multiplicity. In iconography, the German contribution is indisputable. No doubt Germany did not invent the Wise and Foolish Virgins, but it did elevate them to the remarkable role and prominence which they have in the north portal of Magdeburg; and it dealt similarly with the nude figures of Adam and *91*

Eve which give their name to a door at Bamberg, and with the very singular
motif of the Prophets who carry the Apostles upright on their shoulders in the
Goldene Pforte of the same cathedral. It is true that this startling symbol of the
continuity of the Scriptures is based on a window at Chartres, but Germany
was the first to embody it in stone, creating tall human columns which the French
decorum of the thirteenth century would have rejected as inappropriate to the
church portal, but which may perhaps be explained in the Teutonic lands by the
persistence of an older mode of vision. An audacity of this kind would not have
disconcerted the French masters of the Romanesque period. Finally, in the style
also, the north door of Magdeburg (1240?) permits us to distinguish some
strongly marked original features: in the tympanum, the Virgin of the Assump-
tion does not rise heavenwards by her own impetus, but is a reliquary statue
carried in a kind of litter, the handles of which are grasped by two angels, and
with an altar cloth hanging from it. As for the Wise and Foolish Virgins of the
jambs, which are no doubt rather later, they possess already all the characteristics
of the fourteenth century treatment of the same theme, such as that of Erfurt,
with that vehemence of expression which strikes us always as a little naive,
a multiplicity of folds, a proudly arched pose, and the movements much
decomposed, as if seen in slow motion.

This very individual language assumed its most characteristic intonation at
Bamberg, at the moment when it came to terms—in the most striking way—with
the French monumental style. As a witness of the persistence of older fashions,
we have first of all the tympanum of the north door which commemorates the
consecration of 1237: under the thick archivolts studded with cabochons we find
stiff figures lined up on either side of a reliquary Virgin—a Transitional relief, a
hundred years behind the times. The six statues of the Adamspforte, however,
are in general agreement with the principles of French sculpture, and have all
the plastic solidity which is lacking in the style of Westphalia. More than this,
the figures of the Empress Kunigunde and the Emperor Henry, together with
those of Church and Synagogue over the Fürstenportal, and the supposed
Conrad III, have a manifest connection with the Queen of Sheba, King Solomon,
Church, Synagogue and certain of the figures of Kings at Reims cathedral, so
that there is reason to think that some German master, who worked and left
his mark at Reims, later profited in Germany from the lessons which he had learned.[1]
But the Bamberg style shows a twofold tendency, not inherent in the Champagne

[1] On the Bamberg-Reims question, see, besides A. Weese's text, the plates on which the figures of the
two cathedrals are placed side by side. Cf. some interesting lines by L. Lefrançois-Pillion, *Les
sculpteurs de Reims*, p. 57. See above, pp. 84–85.

manner, towards heaviness in the volumes and dryness in the modelling. To these it adds a certain superficial pomp, which recurs in the handsome feudal and military statues of Naumburg, on the Slavic marches, warrior-lords accompanied by ladies—Gepa, Uta—of virile feminity. The great artist who executed them, probably about 1270, far from clinging to the past, heralds the evolution of the future.[1]

93

Twenty years earlier and much nearer to France, on the Rhine, the masters (of very different inspiration) who carved the Coronation and Death of the Virgin on the tympana of the south transept of Strasbourg, likewise made use of a personal language: the drapery style, with its many hurried folds, all equally stressed, has nothing of the broad monumental peace which seems to bathe in light the handsome volumes of France; the interest in movement and in pathetic expression is evocative of the theatrical spirit of the later Middle Ages. The statues of Church and Synagogue, however, with their elegance and their meditative character, belong to a different stylistic region. The Strasbourg Synagogue has often been compared to that of Reims: but the latter is stockier, her face is not so long, nor does she turn away to present almost a side-view as does her sister of Alsace, who is more sober and dry in execution and who carries over into stone something of the treatment of wood. These are great works, which find no parallel in the remainder of the rich iconographic and plastic development of the cathedral, whose west front abounds in figures and scenes of an anecdotal character, animated by an expressive power which often reinforces their meaning, and other figures in an attractively mannered style in which the characteristic features of the first half of the fourteenth century are apparent. The lively invention of the frieze running round the upper part of the structure recalls the grotesques of the Portail des Libraires and those of Sens, in a rather different style. This is the reawakening of the Romanesque imagination, of the old dream of the Bestiaries, but now freed from the strict order to which the spirit of the twelfth century had enslaved them. An unruly crowd of little tales springs up in German art, from the middle of the twelfth century onwards, and swarms over the church portals. The Apostles of Cologne, and the statues and reliefs of St. Laurentius and St. Sebaldus in Nuremberg, are still to some extent in the great tradition, but it was in the thirteenth-century cathedrals of Saxony that the monumental order found its grandest and strictest expression in Germany.

Spain, Germany and, in less extensive programmes, the Netherlands, adopted

[1]See J. H. Giesau's study, Jahrbuch für Kunstwissenschaft, 1924. *Also J. H. Giesau, *Die Meissner Bildwerke. Ein Beitrag zur Kunst des Naumburger Meisters*, Burg, 1936; and H. Beenken, *Der Meister von Naumburg*, Berlin, 1939, who, after Giesau, traces the first works of the Master of Naumburg to Amiens. The statues of founders are now dated c. 1260.

the monumental arrangement of sculpture which had been established in France. The Italian masters worked in a more restricted field; it would have been impossible to adapt an encyclopaedic system of thought, with which, in any case, they were not concerned, to the dimensions of pulpits, tombs and door-leaves. The colossal buildings which were erected in England seem, on the other hand, to offer ample scope for it. But in studying the English sculpture of the Gothic period, we must bear two factors in mind—the heterogeneous character of its earlier development and the composition of the façades on which it was used. The English architecture of the twelfth century had no more need of monumental sculpture than had the Romanesque art of Normandy. There was none of the multiplicity of experiments in form which preceded the Gothic style in other countries, and which often fought a long rearguard action against the latter's advance. The skilful reliefs of Chichester, reputed to be Saxon, the frieze of the west front at Lincoln, comparable to the frieze of Beaucaire, the debatable traces of Languedoc influence at Malmesbury, and the Apocalyptic Christ of Rochester, in the French 'Transitional' style, represent not so much a coherent evolution, as a series of aberrant phenomena.[1] The true greatness of sculpture in the British Isles must be looked for in another place and at an earlier period—on the bases and limbs of the sculptured crosses of Ireland and the north of England. The influence of these reliefs on the development of the monumental style remains indeterminate. With regard to the second point, the architecture of the thirteenth century produced a very unusual scheme for its decorative sculpture by covering the west fronts with ranges of wall arcades. These uniform rows of niches are the main setting for the figure sculpture and constitute a revival of the ancient theme of the figure in the arch. It is not without grandeur, as is shown by certain of the Wells statues, in a powerfully dry style. There is more charm and variety in the spandrels. In addition, in the second third of the thirteenth century, the composition of a number of tympana, at Lincoln, Salisbury and Westminster, demonstrate the skill with which the sculptors combined the forms according to the demands of architecture. The sculpture is monumental in its habit of taking up its position at the critical points: the springing of the ribs—for instance, in the lovely chapter-houses—and the keystones (but also pedestals and balustrades) receive a remarkable profusion of decorative heads. It is interesting to see them

154
155
156

*[1]On these twelfth-century experiments, see T. S. Boase, *English Art* 1100–1216, Oxford, 1953, and G. Zarnecki, *Later English Romanesque Sculpture*, 1140–1210, London, 1953. The statues from St. Mary's, York, of c. 1210, still preserve a Romanesque character in spite of their close stylistic connections with the late twelfth century workshop of Sens, as proved by W. Sauerländer, *Sens and York*, Journal of the British Archaeological Association, 1959, pp. 53–69.

figuring in the capitals, where they perhaps continue a tradition which appears first in Irish art.[1] There exists therefore an English sculpture which is determined by architecture, by its situation, and even, in the flexions of the body and in its somewhat frigid charm, by the movement of the Curvilinear style. To the perpendicularity and the elegant stiffness of the figures in the niches, and to the more flexible compositions of the spandrels and the tympana, with their inscribed multifoil frames, a natural complement is provided by the frailer, more polished figurines, which appear on tomb-canopies and archivolts, each half-enclosed within a kind of casket formed of leaves and foliage scrolls. This style took on a special tonality in the unctuous alabasters of the next period, of which there are examples in Guyenne. The progress of the anecdotal manner in the fourteenth century and the craft skill of the artists accentuated this quality.[2] In the originality of this sculptural evolution, special consideration must be given to the thirteenth-century tomb statues, which are quite unlike the effigies of France and Spain, and the great sepulchral reliefs of Germany, where the intensity of the facial expression sometimes comes close to caricature: carved in Purbeck marble, in wood, or in freestone, the figures of the English tombs are remarkable for their unconventional gestures and their lively movement. Once again, the forceful expression of life emerges from the image of death.

If we try to comprehend the totality of this immense assemblage of figures, sculptured in the course of two centuries by the masters of Western Europe, we readily perceive that its variations were dominated by the rules of the art of building, as defined in France in the second half of the twelfth century. In the French cathedrals, iconography and morphology grew up with the architecture itself, which offered generous scope for the deployment of the images. Man and the world are no longer half-seen, with a visionary eye, through a grille of ornament. The hierarchic and symbolic systems in which all created things have their place have shed all trace of the occult. Man, rediscovered, created humanism. This was a renaissance, and like other renaissances, it tended to draw everything

*[1]On this minor decorative sculpture it is convenient to refer to J. C. P. Cave, *Roof Bosses in Medieval Churches*, Cambridge, 1948, *Medieval Carvings in Exeter Cathedral*, London, 1953; N. Pevsner, *The Leaves of Southwell*, London, 1945; L. E. Tanner, *Unknown Westminster Abbey*, London, 1948. The part played by the Westminster school has been stressed recently by G. F. Webb, *The Decorative Character of Westminster Abbey*, Journal of the Warburg and Courtauld Institutes, XII, 1949, pp. 16–20, and by A. Anderson, *English Influence in Norwegian and Swedish Figure Sculpture in Wood*, 1220–1270, Stockholm, 1949.
*[2]On the fourteenth century, see J. Evans, *English Art 1307–1461*, Oxford, 1949. Among the latest publications on alabaster carvings, see W. L. Hildburgh, *Mediaeval English Alabaster Figures of the Virgin and Child*, Burlington Magazine, 1946, pp. 30 and 63, and *English Alabaster Tables of about the Third Quarter of the Fourteenth-Century*, Art Bulletin, XXXII, 1950, pp. 1–23. On tombs, add to F. H. Crossley, *English Church Monuments A.D. 1150–1550*, London, 1921; A. Gardner, *Alabaster Tombs of the Pre-Reformation Period in England*, Cambridge, 1940.

into its scope; it sought to be both universally understood and universally adopted. But it expressed itself through the language of the masons, and its ideas took their places in high churches, against the walls, between the piers, beneath the arches, and at different heights. Structural form no longer moulded plastic form, but it still provided its setting, exalted it, simplified it, and composed it according to perspective and light. Man was no longer a function in the structure, but he remained its companion, worked together with the masses and contributed to the effects. Cut from the same block of stone as the church itself, he is there in his natural environment; he did not desert it, but developed with the church. In proportion as the structure eliminated inert mass, opened up the walls between slighter members, and eventually arrived at the inevitable conclusion of the Gothic conception of architecture—a skeletal system of active forces—so the human form also was growing lighter, more supple and finely stressed over its multiple axes; the flexions of the body are a sign, not of fatigue or weakness, but of complete possession of its organic strength. Into this equilibrium new values were introduced, which were eventually to prove its undoing. The enquiry into life, hitherto directed and limited by the monumental order, became enriched by a spirit of enquiry concerning death. The art of the tomb-maker, between which and the art of the image-maker there had long been agreement, now began to clash with it and propel it down strange paths. The death-mask initiated the portraiture of the living. The unanimous and uniform grandeur of the Christian peace was gradually displaced by the marks of human agitation, the quivering of our individual being. But the images long continued to enjoy the advantage of having been conceived and having grown up in the architecture. This remained a fundamental trait of French art. The same graph may be drawn for other countries, but is less pure, less rapid. At length, in the fourteenth century, a measure of agreement was reached: but it was preceded by very irregular, and essentially diverse movements. Italy preferred the great models of its imperial past to the Gothic modernism. The long persistence of Carolingian techniques and Romanesque architecture did not, however, prevent Germany from discovering and developing its unanimity with the West; this allowed it to define for the first time certain aspects of its native genius—a vigorous and emphatic conception of life and form, in which theatrical ostentation mingled with vehement emotional frankness. At Compostela, Gothic Spain created one of the first masterpieces of the new sculpture, but one which still bears the marks of Romanesque dreams and passions; to these Spain remained faithful, even after its acceptance of the French style. Lastly, England made use of sculpture in its own peculiar architectural settings, in spandrels, and on corbels;

the caprices of the Curvilinear style undulate around mannered statuettes. Yet these various tonalities, seen from a certain distance, blend into a single harmony. Despite the political differences and the variety of the individual regions, despite the simultaneous existence of advanced and retarded manners, Western Europe was united in a single system of thought, whose architecture, as in the days when architecture was used by the Romans as a means of extending their empire, was not its passive expression, but its effective agent. If we consider statues of the most varied provenance, those whose stylistic nuances might well be used to characterize the spirit of their group of culture—such as the St. Theodore of Chartres, the Markgraf Ekkehard at Naumburg, Alfonso the Wise and Violante of Aragon in the cloister of Burgos, and even the Charles of Anjou on the Capitol—we find the same sturdy race, a race, which, in its various settings, had built a common culture.

BIBLIOGRAPHY

GOTHIC SCULPTURE

E. Mâle, *L'art religieux du XIIIe siècle en France*, 7th ed., Paris, 1931; R. de Lasteyrie, *Études sur la sculpture française du moyen âge*, Monuments Piot, VIII, 1902; L. Lefrançois-Pillion, *Les Sculpteurs français du XIIIe siècle*, 2nd ed., Paris, 1931; D. Jalabert, *La flore gothique, ses origines, son évolution du XIIe au XVe siècle*, Bulletin monumental, 1932; P. Vitry, *La sculpture française sous le règne de saint Louis*, Paris, 1929; L. Courajod and P. F. Marcoux, *Musée de sculpture comparée, Catalogue raisonné, XIVe et XVe siècles*, Paris, 1892; E. Houvet, *La cathédrale de Chartres*, 7 vols. of plates, Chartres, 1920–21; P. Vitry, *La cathédrale de Reims*, 2 vols., Paris, 1915; L. Lefrançois-Pillion, *Les sculpteurs de Reims*, Paris, 1928; A. Boinet, *Les sculptures de la cathédrale de Bourges*, Paris, 1912; E. Maillard, *Les sculptures de la cathédrale de Poitiers*, Poitiers, 1921; Abbé R. Fourrey, *La cathédrale d'Auxerre, essai iconographique*, Auxerre, 1931; R. Koechlin, *La sculpture belge et les influences françaises au XIIIe et XIVe siècles*, Gazette des Beaux-Arts, 1903; E. Bertaux, *L'art dans l'Italie méridionale*, Paris, 1904; G. Weise, *Spanische Plastik*, I and II, Reutlingen, 1925–27; E. Panofsky, *Die Deutsche Plastik des XI. bis XIII. Jahrhunderts*, 2 vols., Munich, 1924; W. Pinder, *Die Deutsche Plastik des XIV. und XV. Jahrhunderts*, Munich, 1924; E. Wiese, *Schlesische Plastik vom Beginn des XIV. bis zur Mitte des XV. Jahrhunderts*, Leipzig, 1923; E. Luthgen, *Gotische Plastik in den Rheinländern*, Bonn, 1921; A. Goldschmidt, *Studien zur Geschichte der Saechsischen Skulptur in der Uebergangszeit*, Berlin, 1903, *Gotische Madonnenstatuen in Deutschland*, Augsburg, 1923; G. Dehio, *Zu den Skulpturen des Bamberger Domes*, Jahrbuch der Berliner Museen, 1890; W. Vöge, *Über die Bamberger Dom Skulpturen*, Repertorium für Kunstwissenschaft, 1890; A. Weese, *Die Bamberger Dom Skulpturen*, 2 vols., Strasbourg, 1914; M. D. Anderson, *The Medieval Carver*, Cambridge, 1935; E. S. Prior and A. Gardner, *English Medieval Figure-Sculpture*, London, 1904–05; W. H. St. J. Hope and E. S. Prior, *English Medieval Alabaster Works*, London, 1913; H. Wilm, *Die gotische Holzfigur*, Leipzig, 1923.* M. Aubert, *La sculpture française au moyen âge*, Paris, 1947; E. Lambert, *Les portails sculptés de la cathédrale de Laon*, Gazette des Beaux-Arts, 1937 (1), pp. 83–98; L. Grodecki, *La première sculpture gothique: Wilhelm Vöge et l'état actuel des problèmes*, Bulletin monumental, 1959, pp. 265–289; M. Aubert, *La cathédrale de Chartres*, Paris-Grenoble, 1952; A. Katzenellenbogen, *The Sculptural Programs of Chartres Cathedral*, Baltimore, 1959; P. Kidson and U. Pariser, *Sculpture at Chartres*, London, 1958; W. Sauerländer, *Die kunstgeschichtliche Stellung der Westportale von Notre-Dame in Paris. Ein Beitrag zur Genesis des hochgotischen Stiles in der französischen Skulptur*, Marburger Jahrbuch für Kunstwissenschaft, XVII, 1959, pp. 1–56; T. G. Frisch, *The Twelve Choir Statues of the Cathedral of Reims*, Art Bulletin, XLII, 1960, pp. 1–24; J. Adhémar, *Influences antiques dans l'art du moyen âge français*, London, 1939; F. Salet, *Les statues d'apôtres de la Sainte-Chapelle conservées au Musée de Cluny*, Bulletin monumental, 1951, and *Nouvelle note sur les statues d'apôtres de la Sainte-Chapelle*, ibid., 1954; J. Baltrusaitis, *Le moyen âge fantastique. Antiquités et exotismes dans l'art gothique*, Paris, 1955, and *Réveils et prodiges. Le gothique fantastique*, Paris, 1960; L. Lefrançois-Pillion and J. Lafond, *L'art du XIVe siècle en France*, Paris, 1954; W. H. Forsyth, *The Virgin and Child in French XIVth Century Sculpture. A Method of Classification*, Art Bulletin, 1957, pp. 171–182; P. Pradel, *Les tombeaux de Charles V*, Bulletin monumental, 1951; pp. 273–296; J. de Borchgrave d'Altena, *Œuvres de nor imagiers romans et gothiques: sculpteurs, ivoiriers, orfèvres, fondeurs*, 1025 à 1550, Brussels, 1944; J. Pope-Hennessy, *Italian Gothic Sculpture*, London, 1955; A. del Castillo, *El Portico de la Gloria*, Santiago, 1949;

G. Gaillard, *Le Porche de la Gloire à Saint-Jacques de Compostelle et ses origines espagnoles*, Cahiers de Civilisation Médiévale, I, Poitiers, 1958, pp. 465–473; W. Boeck, *Der Bamberger Meister*, Tübingen, 1960; A. Gardner, *English Medieval Sculpture*, Cambridge, 1951; L. Stone, *Sculpture in Britain: The Middle Ages* (Pelican History of Art), Harmondsworth, 1955; W. Sauerländer, *Sens and York. An Inquiry into the Sculptures from St. Mary's Abbey in the Yorkshire Museum*, Journal of the British Archaeological Association, 3rd series, XXII, 1959, pp. 53–69; N. Pevsner, *The Leaves of Southwell*, London, 1945; A. Andersson, *English Influence in Norwegian and Swedish Figure Sculpture in Wood, 1220–1270*, Stockholm, 1949; M. Blindheim, *Main Trends of East Norwegian Wooden Figure Sculpture in the Second Half of the XIIIth Century*, Oslo, 1952.

Gothic Painting of the Thirteenth and Fourteenth Centuries

THE monumental order, especially in the twelfth and thirteenth centuries, dominated both architecture and sculpture, by virtue of the same laws; with all its nuances, its depths and its abundance, it was primarily, if not exclusively, an intellectual order. The forms within which it is inscribed derived from a reasoned argument concerning space, forces, and the best method of bringing those forces into equilibrium. A cathedral is a universe devised by the power of human thought, and in this respect is totally unlike the most marvellous concretions in nature. This, at any rate, is what we find in France. But we should misunderstand the spirit of the Middle Ages if we were to measure it, everywhere and always, with compass, rule and set-square. Certain regions of its activity, though they too are subordinated to the life of architecture, are irradiated by a magical gleam whose source is not architectural. In the history of painting, there can be nothing grander and more strange than the translucent form of monumental painting—the stained glass window. Here we must begin our study, which will lead us thereafter to the admirable development of the fresco in Italy: thus we shall be brought back to the solid walls, before going on to analyse the smaller and more fragile monuments, the painted and gilded panels, and the manuscripts, in which the image of man and the world—in a setting of arches, lobes and finials which is still that of the churches, and with a dazzling limpidity of colour which recalls the windows—is enriched with the treasures of a new intimacy and profundity.

I

THERE are two kinds of painting: one imitates the light of the sun, with its play of brightness and shadow, and seeks to create the illusion of a complete space, modelled in depth; the other accepts natural lighting and utilizes it for its own purposes, which are not those of nature, gives it a novel and peculiar character, and embodies it in a flattened space, either by the device of transparency or that of touches and backgrounds of gold, in such a way that it may be said to compose and construct its own individual light. Gothic painting is essentially of the second category; even when it tends to give the figures the fullness of their substance, as for instance in Italian frescoes, it respects the character of the wall. This is still more true of the mural painting of the North, and especially

of glass painting—translucent fresco—the most extraordinary creation of medieval art. It was long thought that the art of stained glass had been imported from the East at the time of the Crusades, and it is true that the Arabs were acquainted with the technique of encrusting coloured glass in a plaster armature. But we learn from the chroniclers and poets that this process was utilized in Merovingian Gaul. The crux of originality consisted of the insertion and composition of figures therein, the addition of painted and fired details, and finally the assembly of the elements within a metallic mesh which retained them in place and supplied a vigorous outline. The art of the coloured window, the art of figures in glass, made its appearance at that great moment of innovations, the end of the tenth century, or perhaps even rather earlier, if we may trust the monk of Saint-Bénigne at Dijon or the story of St. Liudger's miraculous healing of a blind man, whose newly opened eyes rested first on the painted images of the windows. Technically, the connection with cloisonné metalwork is beyond doubt, but the filigree gold is replaced by lead. This forms not only the setting, but also the design, and is an integral part of the effect. Its powerful script defines the form; it makes the colours sing. These beings traversed by light are not of our world, but are figures of theophany, the glorious dead living in their perpetual spring-time, which forms them, dazzling and without mass, out of the material of its own light. But the vigorous lines which run round and across them bring them nearer to our own level. They are held fast in this dark and supple net. Without the leads, not only would the energy of the forms disappear, but the different hues would run together, and all this bright radiance would sink into a multi-coloured twilight. Apart from the reliquary cover of eighth-century date, discovered in a cemetery of the Aisne department, which bears a design of a cross between the alpha and omega, and has no connection with the monumental style, the earliest extant examples of stained glass are the windows of Saint-Denis. Were these the fountain-head of the development? If we consider the scope of Suger's work, the boldness of his undertakings, the abundance of his icono-graphic innovations, and particularly the part he played in the elaboration of style, by virtue of his incorporation of the monumental theme of the Precursors in the stones of the portal of his church,[1] this seems perfectly credible. In the

59

[1]This, at any rate, is the view advanced, with good reason, by É. Mâle, *L'art religieux du XIIe siècle en France*, chap. V, p. 151, esp. III, Les vitraux symboliques du XIIIe siècle ont leur origine à Saint-Denis, pp. 160–4. *E. Panofsky, *Abbot Suger on the Abbey Church of Saint-Denis and its Art Treasures*, Princeton, 1946, pp. 192–201, has shown that Suger's allegories were not exactly typo-logical. The sources of the symbolic windows of the thirteenth century are to be found rather in the enamels of the Meuse district and in the twelfth-century stained glass from the cathedral of Châlons-sur-Marne. But what was invented at Saint-Denis was a new style of stained glass and a new relation between glass decoration and architecture. On this point see L. Grodecki, *Le vitrail et l'architecture*

history of medieval art each step followed from the preceding one, the whole development forming one interlocking whole. Even if Saint-Denis was not the ultimate source of every element, yet the genius of its great abbot played a decisive part in realizing and shaping the essential features, the architectural composition which follows from the application of the vault rib, the portal sculpture, and most probably also the decoration of the windows. Such is the sense and import of the little medallions—parts of huge ensembles—which have survived. The lost windows of Notre-Dame in Paris were in line of descent from them, and perhaps also the admirable windows of the west front at Chartres, in the same way as the statues of the Portail Royal followed on from those of Saint-Denis. Le Mans, Poitiers and Angers provide additional evidence of the greatness of this art in the second half of the twelfth century, with its iron armatures retaining the leads and not yet following the outline of the frames, with its blue grounds and its red grounds, with its ornamental richness and the powerful intensity of its figures. About the earliest windows of Chartres, everything has already been said. But their radiance must not be allowed to eclipse such works as the Virgin in Majesty at Angers, with her long almond-shaped face, her border, reminiscent of certain Irish ornamental bands which passed into the common stock of Carolingian art, and her angels, curved in precise conformity with the curve of the medallions. This is still the great Romanesque calligraphy, shaping the form in accordance with the demands of the field. Similarly in the

61 Crucifixion window at Poitiers, where the angels who make the gesture of holding the mandorla describe a pure arc, in a movement whose violence is accentuated by the strong linearity of the leads.[1]

The thirteenth century multiplied these astounding images. Apertures of increasing size, which gradually eliminated mural painting by restricting the surfaces to which it could be applied, had to be filled with painted glass. The abundance of life, the diversities of the human figure, and the riches

au XIIe et au XIIIe siècles, Gazette des Beaux-Arts, 1949, II, pp. 5–24, Suger et l'architecture monastique, L'Architecture Monastique, special number of the Bulletin des Relations Artistiques France-Allemagne, Mainz, May 1951.

*[1]Recent research has confirmed these views on the diversity of the twelfth-century schools of stained glass. Within the limits of present-day France, four groups at least have to be distinguished: the Saint-Denis group, the Mosan group of Champagne, the workshops of western France (Le Mans, Vendôme, Poitiers, Angers, etc.) and the Rhenish group in the east. See R. Crozet, Le Vitrail de la Crucifixion à la cathédrale de Poitiers, Gazette des Beaux-Arts, 1934, I, pp. 218 et seq.; L. Grodecki, Les vitraux de la cathédrale de Poitiers, Congrès Archéologique de Poitiers, 1951, pp. 138 et seq., Quelques observations sur le vitrail au XIIe siècle en Rhénanie et en France, Mémorial du voyage en Rhénanie de la Société Nationale des Antiquaires de France, Paris, 1953, pp. 241–248, Vitraux de France du XIe au XVIe siècle, Catalogue of the Exhibition held at the Musée des Arts Décoratifs, Paris, 1953; H. Wentzel, Meisterwerke der Glasmalerei, Berlin, 1951. The most up to date treatment of the problems of stained glass can now be found in M. Aubert, A. Chastel, L. Grodecki, etc., Le vitrail français, Paris, 1958.

of the stories are distributed over immense solar tapestries which set the Scriptures, the Golden Legend, profane history and the operations of the crafts against the open sky, without disturbing the purity of the architectural thought. Medallions of different sizes, sometimes with inscribed quatrefoils, are set side by side, and combined in ornamental compositions. They are set against a background of mosaic or lattice, blue on red, within borders which are less rich and of drier style than those of the preceding period. The epic fervour of the twelfth century has given way, in the large figures, to a kind of reserved majesty, while the smaller scenes shine with a poetry which is both natural and supernatural, conceived with a charmingly naive veracity, but transposed on to a higher plane. The chilly tones of the backgrounds, whose blending tends towards violet, set off the warmth and diaphanous solidity of the rest—glowing reds, which painting, even with the finest patina, cannot approach, and rich, deep greens, without that saturation which was later to characterize certain Central European groups. Even when the dominant violet produces an almost nocturnal effect, an offering to light is still made. No doubt it was Chartres that provided the poetry and the great models of this celestial imagery which spread abroad, eventually to England, but first of all in France, to Bourges, Laon and countless other churches.[1] We can only conjecture what part Paris may have played in this expansion during the first half of the thirteenth century. But the Parisian glassmen were the tutors of later generations. The Sainte-Chapelle was in some sense built around its windows. The colossal yet delicate rose windows of the transepts of Notre-Dame are like the fiery wheels of the Biblical chariot, but within their mesh they shelter an image of life which belongs to the regions of celestial peace, bathed in light.

63

58

Thus the *Rayonnant* style, by eliminating the walls between the bony structure of the church, enlarged the space, at once near and far away, within which the inaccessible presences reside. It bathes the naves in rays of rose-pink, yellow, green and violet hue, set off sometimes by delicate borders of white, and through

*[1] The history of stained glass in the thirteenth century has been treated by L. Grodecki and M. Aubert in the collective work just mentioned: *Le vitrail français*, Paris, 1958. The preponderance of the Chartres workshops has often been exaggerated. But it has been proved that one of the three ateliers at work in the ambulatory of Bourges was led by a master coming from Poitiers: L. Grodecki, *A Stained Glass Atelier of the Thirteenth Century. A Study of Windows in the Cathedrals of Bourges, Chartres and Poitiers*, Journal of the Warburg and Courtauld Institutes, XI, 1948, pp. 87–111. The leading position has been claimed for Paris by J. Lafond, *The Stained Glass Decoration of Lincoln Cathedral in the Thirteenth Century*, Archaeological Journal, CIII, 1946, pp. 119–156. Finally on the importance of the district Reims-Laon-Soissons, see L. Grodecki, *Un vitrail démembré de la cathédrale de Soissons*, Gazette des Beaux-Arts, 1953, II, pp. 169–176, and the notices on the Saint-Quentin windows in the Catalogue of the Exhibition *Vitraux de France du XIe au XVIe siècle*, Musée des Arts Décoratifs, Paris, 1953, pp. 56–58.

a network wrought with figures, it filters a luminous vibration which comes from beyond the world. Wall painting competes with and emulates these sumptuous harmonies, and seeks to withstand their brilliance by heightening its range of colour and setting it off with bright accents and incrustations, but the economy of Western architecture allows it no more than a reduced station and precarious conditions of life. It maintained its position in Romanesque territory, in the south of France, where the spirit of stained glass did not penetrate, except in churches which, like Saint-Nazaire at Carcassonne, belong entirely to Northern art.

57

Was it for purely economic reasons, because of the enormous development of the apertures, that the *Rayonnant* style, particularly in the fourteenth century, adopted grisaille windows, using them to an ever increasing extent in place of coloured windows, or combining the two forms in the same panel, as at Auxerre? Perhaps the advantages were felt of utilizing these vast openings to diffuse through the churches a light more even and more gently revealing. Furthermore, the internal tonality of architecture changed with each new period of its development. The noble and sturdy Romanesque harmonies based on ochrous tones, were succeeded by the powerful chords of blues and reds, blending into ambiguous violet, and these chords were in turn replaced by a refined monotone of transparent foliage scrolls against a grey ground, a subtle negation of colour. The Cistercians had loved and practised this elegant asceticism in the twelfth century. It revived to take its place in an architecture sober in conception and delicate in drawing. The coloured medallions and panels which stray into the grey fields of the windows, as in the choir of Saint-Urbain at Troyes, seem the remains of a much older art, no longer in harmony with the spirit of the time. Later still, the economy of the stained glass window was profoundly modified by the use of great cold sheets of white glass, by the discovery of the silver-stain method of producing yellow, by the technical advances which made possible the production of large sheets of coloured glass, and by the processes of damascening and plating, producing shot effects, and effects analogous with those of transparent glazes in painting. As the pieces of glass grow larger, the role of the leads becomes less essential, their network slackens and disintegrates, and the whole magnificent, vigorous, interlacing, multiple calligraphy gradually disappears and gives way to forms which evolve from a broad heraldic schematism to the imitation of reality. The material itself acquires pictorial qualities which redeem it from its native rawness and endow it with refinement. Fourteenth-century glass, however, has the merits of limpidity and optical delicacy. The influence of the Rouen workshop was diffused over Normandy and England.

The series of windows at Évreux, ranging from 1330 to 1380,[1] conducts us stage by stage, and with great charm, to the solecism of the later Middle Ages—the transparent picture hung up in the window, a negation of the monumental style. Every art which refines away the energetic irregularity of its becoming 'blemishes' is on the downward slope, especially when it loses the support of architecture and is invaded by the illusion of space.

II

THE latter part of this observation might justly be applied to the history of monumental painting in Italy in the Middle Ages. But we must also take account of another factor which pervades the entire culture of that great country, and provides a more reliable clue to its variations than does the pure and simple sequence of periods. The Italian genius has two aspects. It is an ordered and stable genius, and it is a Baroque genius. It tends, on the one hand, towards monumental equilibrium, the taste and instinct for which were a heritage from its Roman origins, and, on the other, to expressive disorder, pathetic vehemence, and theatrical illusionism. No people built its walls more stoutly, and none covered them with more singular paradoxes in the shape of formal aberrations and *trompe-l'oeil* realism. These forceful masons were also suppliers of likenesses. Hence arose two great spiritual families, and two simultaneous and divergent directions in its history, that of the powerful builders, and that of the illusionists; in art, we find solid and austere masters, filled with a generous spirit and authentic sentiment, and beside them, and often following in their wake, other men of romantic, captious and unstable genius. The latter, however, profited by their curiosity. Their ingenious impatience, their nostalgia for the golden age, their contemplation of the future through the medium of the past, are forces to be reckoned with. We shall see what they achieved for and against the Middle Ages, which we are envisaging as a modern order, in powerful agreement with the historical forces and spiritual needs of the time.

*[1]J. Lafond, *Les vitraux royaux du XIVe siècle à la cathédrale d'Evreux*, Bulletin monumental, CI, 1942, pp. 69–93, stresses the importance of the Evreux windows as documents on the development of Parisian painting in the second half of the fourteenth century. The article deals with a late fourteenth-century series (1390–98) and solves the problems of identification. See also S. Honoré-Duvergé, *Le prétendu vitrail de Charles le Mauvais à la cathédrale d'Evreux*, Bulletin monumental, CI, 1942, pp. 57–68. On the earlier series of windows at Evreux, see J. Lafond, Les vitraux de Jumièges, in Canon L. Jouen's monograph, *L'abbaye de Jumièges*, Rouen, 1926, second edition, 1937.

Dante and Giotto are of the lineage of the cathedral builders and the great sculptors of the West. They have the same boldness of scale, the same close-knit thought, the same universal power, the same feeling for every kind of human greatness. Like a church, whose crypts penetrate the depths, which welcomes sinners in its many naves, and lifts their eyes and their thoughts to the upper windows, radiant with the light of the regions of eternity, the Divine Comedy includes the subterranean, the terrestrial and the paradisiacal within its triple division of human and supernatural life. The circles of damnation and the resplendent levels whereon the blessed have their being are the registers of the Last Judgement. But the men and women who throng the realm of shadow and the realm of light resemble the portal statues rather than the figurines of the tympana: they have the same tall severity, the same broad modelling, and the same monumental character. We no longer interpret them in the manner of the Romantics, who liked to endow them with the convulsive quality of the Flamboyant style; we compare them more appropriately with the great images of an art which was not yet tormented by their passions, but whose stature and fullness they share. The exile from Florence found the homeland of his thoughts not only on the slopes of the University, but also under the colossal shadow of Notre-Dame in Paris. To say this is not to deprive him of his national birthright. He is Italy itself, but he upholds and exemplifies the universality of the Middle Ages. Giotto is the interpreter of a different thought. Dante is deeply immersed in public quarrels and party hatreds. Giotto commemorates the Gospels and the story of the *poverello* of Assisi. Yet both have the same gift of violence expressed in the same austere line. Even more than those of the poet, the figures of the painter are full of sculptural solidity—but they do not destroy the wall upon which his genius installs them, but rather respect it, and even reinforce its equilibrium and mass. Giotto defines monumental painting, not only for his own age, but for centuries to come.

In order to comprehend as a whole the historical panorama of which he is the centre, we must first consider the monumental painting of Italy before his time, not as a single straight line of development, but as a complex system, in which three separate currents may be distinguished—the Byzantine art of Tuscany, Roman pontifical art, and a popular art of ancient origin and very varied expression. In Florence Cimabue, and in Siena Duccio di Buoninsegna, are representatives of a strong and vital tradition, which was not specifically Italian, but which emerged from their hands as the Tuscan form of the great Mediterranean art initiated by the Macedonian renaissance. From its Byzantine origins, this art derived its simple grandeur, the authority of its broad mural calligraphy, which

was as indispensable to the painters as to the mosaicists, and its skill in the creation of those ornamental linear undulations which bend into such elegant curves the bodies of the angels on either side of the massive majesty of the Virgin in glory. In a space practically without depth, and with only the soberest expression and gesture, it suggests great intensity of feeling. The colour-scale is delicate, lively and clear, set off, in altarpieces and icons, by the gilded backgrounds, the gilded haloes and, among the Sienese, the gilded hems which run in elegant arabesques along the edges of the garments. We have ceased to regard as archaic this style in the full flower of its youth, whose sap long continued to give sustenance to Italian painting. When the people carried the *Maestà* in procession, singing *116* hymns and shouting for joy,[1] they were not paying homage to an old miraculous image; they were confusedly aware that the springtime of the Florentine genius was come, and they gave it their greeting. Cimabue joined besides in the vivid and ardent expression of Franciscan fervour in the decoration of the church of Assisi, to which Roman masters also contributed.

The place of origin of these latter, and particularly the thought of the great artist who is the dominant figure among them, transports us to other memories and other regions. Rome, a city of ruins at the beginning of the middle ages, was nevertheless the seat of papal power, which was enhanced by its possession of the lands of St. Peter; after a period during which the influence of Greek culture, which had been introduced in the first place by Popes of Asiatic origin, was supreme, there was a return to the models offered by the Constantinian renaissance and the triumphal art which had flourished in former times under

[1]We owe our knowledge of this event to Vasari, who speaks of it in connection with the great Madonna painted for Santa Maria Novella. The latter is now thought to be a work of Duccio. See *infra*, p. 125, note 1. Vasari probably confused it with the Santa Trinità Madonna, or with Duccio's *Maestà*, which was carried to Siena cathedral on the 9th June, 1311. Cenno di Pepe, called Cimabue, was born in Florence about 1240, and died at some time after 1302; in 1272, he was living in Rome; it is generally agreed that the fresco of the Virgin with angels and St. Francis, at Assisi, is his work. The Madonna of the Uffizi is said to have been executed in Florence at a time when he was still under the influence of Coppo di Marcovaldo; the Louvre Madonna, in a broader style, is supposed to be subsequent to the Roman period and of some date between 1275 and 1290. See Vasari, *Vite*, ed. D. Frey, Munich, 1911; P. Schubring, Zeitschrift für Christliche Kunst, XIV, 1901, col. 355–9; R. Van Marle, *La peinture romaine du moyen âge*, Strasbourg, 1921; L. Hautecoeur, *La peinture au Musée du Louvre, écoles italiennes, XIIIe, XIVe, XVe siècles*, Paris, n.d., p. 16. *To which must be added: A. Aubert, *Cimabue Frage*, Leipzig, 1907, and A. Nicholson, *Cimabue*, London, 1932. The question of the attribution of the Madonna Ruccellai at the Uffizi is discussed in P. d'Ancona, *Les primitifs italiens, du XIe au XIIIe siècle*, Paris, 1935; it is now almost unanimously considered to be the work of Duccio, since a document of 1285 records that the confraternity of the Laudesi at Santa Maria Novella commissioned a Virgin in majesty from the Sienese master. It is very likely that Cimabue worked at first, in his youth, at the mosaics of the Baptistery of Florence, which was the great Tuscan monumental workshop around 1260; he may have worked particularly on the Histories of Joseph. At Assisi the frescoes in the transept of the upper church are attributed to Cimabue's workshop.

the peace of the Church. Between the vicissitudes of the conflict of Papacy and Empire and the exile in Avignon, there sprang up a great pontifical tradition, which found expression in works corresponding, to some extent, with the spirit of the imperial art of Apulia. A specifically Roman feeling appears, however, in a tranquil majesty which is quite foreign to the vehement genius of Nicola Pisano, the last of the great sculptors of antique sarcophagi. These two aspects of a single thought are historically complementary. The mosaicist and painter Cavallini,[1] who was rescued from oblivion by a successful investigation carried out at the beginning of the present century, has left us, in the old churches of Trastevere, an ample series of works which are dominated by the august image of Christ—no longer the ascetic Syrian monk, no longer the Byzantine Pantocrator, but as has been aptly said, the Christian Jupiter. The Apostles are *togati*, sitting with quiet dignity. The fullness of the volumes and the style of the draperies proclaim that the painter had seen, if not copied, the monuments of Roman sculpture. Here began the story of that resurrection of the past, which was not inspired by the dreams of a laureate poet, but by the moral wealth, the tradition and the models which were offered by the Eternal City.

But this is not yet the whole of Italian painting prior to Giotto. Below these upper levels there existed an art which responded to popular instincts, and gave them lively expression. The faith of the people was not that of the dignitaries and pontiffs. It required stronger, and perhaps cruder, nourishment. An open-hearted race demanded sentimental anecdotes, drama and miracles; it delighted in the recital of the lives of the martyrs; it desired to know the most efficacious saints and the relics which would cure diseases. It endowed the Scriptures with this same tone. An event whose effects have not so far been exactly measured

[1]Cavallini's frescoes at Santa Cecilia in Trastevere were discovered by F. Hermanin in 1900. The 'Florentine' interpretation of the origins of Italian painting, propagated by Vasari, was thereby revealed as highly inaccurate, or at least very incomplete. Cavallini's name appears for the first time in a bill of sale of the year 1272. He was born about 1250. He contributed some part (difficult to define) to the work carried out by the Roman school in Santa Maria Maggiore, the Sancta Sanctorum, and San Paolo fuori le Mura (copies exist which were made for Cardinal Barberini in 1635): the Old Testament scenes in the latter church are attributed to him by Ghiberti, in his *Commentario*, II, ed. J. von Schlosser, Berlin, 1912, I, p. 39. His presence at Assisi, as one of a group of Roman painters, was likewise an incident of his youth. The mosaics of Santa Maria in Trastevere, like the paintings in Santa Cecilia, are authenticated by the *Commentarii*. See A. Busuioceanu, *Pietro Cavallini e la pittura romana del Dugento e del Trecento*, Ephemeris Dacoromana, III, 1925. *The present state of the question is that, if it is impossible to attribute to Cavallini the frescoes discovered in the old transept of Santa Maria Maggiore, on the other hand he certainly took part in the works carried out by the Roman masters at Saint-Peter's, at the Vatican and at San Paolo fuori le Mura, as well as in the two churches of the Trastevere. It is much less sure that he ever worked at Assisi. On the 'return to the sources' in the Roman milieu at the end of the thirteenth century, see W. Paeseler, *Der Rückgriff der römischer Spätdugentomalerei auf die christliche Spätantike*, Beiträge zur Kunst des Mittelalters, 1950.

had introduced Italy to images which bore the marks of Oriental vehemence and of the heat generated by a famous controversy. Four centuries before, Greek monks, driven out by the Iconoclasts, had found refuge in the south of the peninsula, carrying within themselves, and perhaps in manuscripts and icons, that passion and asperity, of which Syrian art, since the Rabula Gospels, had been the storehouse and the distributing centre. At all events, we find in San Clemente, in a cycle of paintings which is in strong contrast with the charming story of the child saved from the sea, scenes of theatrical brutality, accompanied by inscriptions and invectives in Latin slang. This tone, if not this style, can be found in other church frescoes in Rome. It becomes graver, but without sacrificing its character, in the edifying imagery which the earliest art of the Franciscans displayed in little panels on either side of the icons of the saint.

Here there intervened a spiritual force, whose effect upon the whole of medieval culture was both strong and deep, and it is important for us to gauge the extent of its ascendancy over the arts.[1] It did not inhabit the arid regions of asceticism, but a human landscape. St. Francis was a mystic; the revelation of La Verna struck him like a thunderbolt, transfixing him with the jets of fire and blood which sprang from the five wounds. He was a friend of life, to whom no living thing was alien. In this respect he was like an unregulated overflowing expression of that universal sympathy which was characteristic of the greatness of the thirteenth century. But the universe, which the cathedrals distributed in their hierarchies of stone, the Divine ideas, which the makers of images enumerated in their statues, he saw with a poet's eye, with all its tenderness, its eternal insubstantiality, and gave it no other contour than that of his wandering songs, dedicated to God's creatures, and as fluid as the air. In the ranks of the reformers, it was he who came nearest to the Gospels. His life, his words, his little rustic odes, are filled with their transparency. His whole rule is an imitation of the Lord, of His way of living our life. The man of the Oratory of San Damiano, where God gave him a sign, and of the rock in the Casentino, where God gave him His own wounds, was not a church builder, and did not shape his renunciation and his

*[1]One tends now to reduce the importance of Franciscanism in the development of Italian art, which had been so much exaggerated by H. Thode (1885), and to see in it not so much an explanation of the new naturalistic trend as an original reaction of the Italian conscience to certain currents of sensibility coming from the West and from Byzantium: see R. Jullian, *Le franciscanisme et l'art italien*, Phoebus, I, 1946. After a period of ascetic orientation, in which the Order adopted the stern Cistercian plan and a purely oriental iconography, the need for a splendid celebration of the Franciscan legend prevailed at Assisi. The solemn version Giotto gave of the life of the patron saint was peculiar to him. The gentle and suave interpretation, the Gothic one, appeared only at a much later date, among the Sienese masters, particularly the exquisite Sassetta, in the retable of Borgo San Sepolcro (1437–44), fragments of which are in London and at Chantilly.

love by the yardstick of forms. There are Franciscan sanctuaries, but there is no Franciscan architecture. His voice carried into deeper places; he made the contemplation of Calvary an integral part of medieval faith, and thereby gave it new life. The Passion of the Son and the Compassion of the Mother, a Christianity dedicated to sorrow, were the underlying principles of a spiritual revolution which was propagated by the *Meditations* of the pseudo-Bonaventura, and which was reflected not only in the arrangement, but also in the spirit, of the iconography. With an odd contrariness, the dramatic and funereal genius of the fifteenth century, in the North and West, had its roots in that same Italy which was destined to surrender itself to a different gospel—one of gay silence—and visions of joy. Hence, in his love of life, in his ability to feel the charm and goodness of the things of nature, St. Francis of Assisi was a man of the thirteenth century. But by his mysticism he heralded and prepared the way, not—as Renan and Thode believed—for the Renaissance, but for the last phase of the Middle Ages.

How did his thought, example and preaching react upon the development of forms? By virtue of the impression made by a great life, which remained warm and immediate in the memory of men. His wonderful career lent itself to story-telling, and the development of Franciscanism demanded it. The representation of those episodes which were dear to the hearts of the people, and particularly of his finest miracles, were as indispensable to the attraction of the faithful as were the portraits which were offered for their veneration. Both were multiplied by thirteenth-century Italy. From the image painted on the wall of the Sacro Speco at Subiaco to the strong, clumsy effigy of Margaritone of Arezzo, and from Berlinghieri's panel to that of Giunta Pisano, seems at first sight a monotonous and repetitious array; nevertheless, from beneath the Byzantine undulation or the popular accent, the spark of life shines through. The scenes which accompany these images are at first few in number—some Miracles, the Sermon to the Birds and the Stigmatization. The choice of the two latter reveals, from the very beginning, the two sides of the Franciscan spirit. They stand out from among the miracles—of exorcism and healing—which were aimed directly at the popular piety of thirteenth-century Italy. The Stigmatization rapidly acquired special importance and a high symbolic significance. It is as if this summit of the saint's holy life has attracted to itself the various episodes scattered on its slopes, and absorbed all their spiritual substance. This iconographical evolution reflects the evolution of an idea.

The church at Assisi, however, gave the painters the opportunity of a more extensive treatment. One after another, the best masters of Italy painted there.

The beginnings of Giotto[1] are intermingled with the art of Giunta, Cimabue and Torriti, but his genius emerges as of sturdier build. The tradition reported by Vasari tells how, when he was a young shepherd boy in Tuscany he made skilful drawings of his sheep upon a rock, and was carried off to Florence by Cimabue, who was delighted with his talent. This is the most familiar of the fables which twine, like delicate imaginary plants, around predestined youth. It has its meaning; it helps us to understand the way in which a peasant shoot was grafted on to the great aristocratic tradition of Tuscan painting, and restored its youth. The cycle of scenes in the upper church inaugurated a new breadth and range in fresco painting. In the first place, Giotto demanded the whole of the life of the saint. The official biography compiled by St. Bonaventura did not satisfy him. He must have had recourse to the elegant and touching narrative of Thomas of Celano and, still more, to the traditions which had lived on in the hearts of friends, and had been handed down to form the basis of the Legend of the *Tres Socii*. But we must not envisage him only as a highly sensitive hagiographical illustrator: he was a decorator of walls. His inspiration was attuned to the requirements of popular feeling, but he ennobled them. He may have known and felt the strength of the movement which had carried Nicola of Pisa back to the antique marbles, but the calm quality of his relief is nearer to Cavallini. From this time forward his particular preoccupation was the painting of the human figure on the wall—and a human figure which was neither floral ornament, nor yet a powerful outline. He conceived of space as a three-dimensional environment, and not as a tightly stretched curtain, but this environment is not undifferentiated and limitless—Giotto does not open it to infinity. It is the narrow room of a

[1]Giotto di Bondone was born at Colle di Vespignano, according to Vasari in 1276, but, if it is true that he died in Florence in 1337 at the age of 70, this should be 1266. He is said to have been called to Assisi by Giovanni di Muro, General of the Franciscan order from 1296 to 1304. On the St. Francis series and the discussions concerning its attribution, see L. Hautecoeur, *Les primitifs italiens*, Paris, 1931, p. 72. It is not certain that Giotto interrupted his stay in Assisi in order to go to Rome, in 1298, on the invitation of Cardinal Jacopo Gaetani degli Stefaneschi, and L. Venturi, L'arte, 1919, p. 229 contests the traditional attribution of the Lateran fresco, Pope Boniface VIII proclaiming the Jubilee, which, however, is much more reminiscent of his style than of his contemporaries. . . . In 1304–05, according to Moschetti, after 1305, according to Van Marle, he decorated the Arena chapel (Santa Maria della Carità), built by Enrico Scrovegni, in Padua. In 1306, according to Vasari, he was called to Avignon, and, according to Benvenuto Cellini, he went to Paris. This is very uncertain. On the influence of French sculpture in the Arena chapel, see L. Hautecoeur, *Les primitifs italiens*, p. 82. Having completed the Arena frescoes, did Giotto then return to Assisi to paint the symbolic compositions on the vaults of the lower church there? On the contrary: they are indubitably the work of a follower, Giovanni da Milano or Taddeo Gaddi. The frescoes of Santa Croce in Florence were painted after 1317. About 1320, Giotto decorated the chapel of Mary Magdalene at Assisi. Between 1330 and 1333, he was called to Naples by Robert of Anjou. There is no insurmountable objection to his meeting with Dante in Padua, as reported by Benvenuto da Imola. Of the Last Judgement painted, together with scenes from the life of Mary Magdalene, in the Bargello, there remain, among other figures of 'reconciled' Florentines, portraits of Dante and of Brunetto Latini.

sculptor's workshop, or the shallow stage of a theatre, scarcely more than the
space of low relief. Here the drama is played out, with a repertory of gesture
which is restricted, but decisive in its concentrated violence. The vast analytical
enquiry of the men of the Quattrocento was later to penetrate every secret of the
human machine, even down to the refinements of its nervous activity. But on
these walls we feel no need for the disciplines of that school of athletes. Giotto,
though he was its forerunner and herald, stands as far apart from it as he does
from the Benedictine style and the 'Greek' frescoes of the twelfth century. In
his fine sense of interval, no less than in the authority of his figures, he is an
exponent of the monumental style at its most majestic, and in his unified
modelling and the simplicity and noble mass of his draperies he betrays his
connections with Gothic statuary.

Thus we are brought face to face with a great human life, envisaged and
experienced in its three fundamental phases—the vocation, the mission and the
death of St. Francis—with his canonization for epilogue, and, in addition (for
this was still necessary), four scenes of miracles wrought after his death. The
relative proportions of the various parts of the iconography have changed since
Berlinghieri grouped the scenes around the portrait preserved in San Francesco
in Pescia. The painters who worked in the south transept of the lower church
reverted to earlier practice, with their scenes of healing and miraculous interven-
tion. But above, we have the majestic narrative of a human life, in all its strength,
clarity, truth and exemplary character. And if the death and obsequies of the
saint, depicted by the first and most talented of the painter's disciples, are
dwelt on at some length, this is due perhaps not so much to the analogy of the
drama of Calvary, whose true mystical reflection may be found in the scene of
La Verna, as to the desire to surround the great master of all-embracing love
with the sorrowful love of the many who mourned their departed friend. Later,
in Florence, on the walls of the Bardi chapel in the church of Santa Croce, Giotto
summed up his Franciscan conception with an austere purity, and unfailing
elevation of spirit, of which we may still see moving evidence beneath the repaint-
ing of the Death of St. Francis. On the other hand, in some scenes of the great
cycle at Assisi—the Sermon to the Birds, the Christmas at Greccio, or the despair
of the widow of Celano—we find the charm of youthful maturity combined with
a bold intensity of feeling.

Between these two series, Giotto executed the decoration of the Arena chapel
in Padua. He is supposed, on the basis of a disputed text, to have met Dante
there. But though it is possible, at this distance of time, to detect psychological
correspondences in the works of the two masters, is it really arguable that these

were matters in which it was possible to exercise a free choice in the life of that century? Each of them lives in his own world and pursues his own dreams. The dream which Giotto unfolds on the walls of the family chapel of the Scrovegni is an extended meditation on the Gospels and the Life of the Virgin. Nowhere, *117* not even in the finest scenes at Assisi, does he display more consummate skill in the organization of figure compositions. The gracious and romantic episodes of the Apocryphal Gospels, the intimate, domestic note in the story of Mary's parents and her childhood, he elevates to the level of his own thought, and, without sacrificing any of its humanity, allows some of the winds of Messianic inspiration to blow through it. Joachim with the shepherds, the Meeting at the Golden Gate, and the Watching of the Rods breathe the mysterious power of the older Bible, the Book of the tribulations, the hopes, the exile and the high destiny of man. Beneath the large compositions are figures symbolizing the Virtues, painted in grisaille. These form a link with the iconography of the cathedrals and are particularly noteworthy, in a period when Gothic sculpture began to be tinged with more brittle attractions, for their solid style, expressing in simple masses the generosity of its sentiment.

Were Giotto's followers faithful to his example? Or in other words, did the Giottesque painters constitute a prolongation of Giotto's style?[1] We shall appreciate how different was their spirit if we leave painting for a moment and compare the arrangement of the campanile of Florence, together with its plastic decoration, as laid down, in its broad lines, by Giotto, and the tabernacle of Orcagna at Or San Michele, a sumptuous and delightful work by a painter-goldsmith. There is *115* much more here than a difference of scale and programme. It is true that the feeling for grandeur of form remained a permanent asset of Italian fresco-painting. The paintings of Andrea da Firenze in the Spanish Chapel of Santa Maria Novella, and the great mural illustration of the *Mirror of Penitence* in the Campo Santo of Pisa show that the image of man suffered neither reduction nor attenuation; it still dominates the wall, but the system in which it moves and has its

*[1] Italian art of the Trecento shows itself to be more independent than had at first been thought of the great examples of Giotto and Duccio. Simone Martini confirms the existence of a tendency toward a minor, delicate, courtly form of Gothic, the equivalent of which has been found throughout contemporary culture: see G. Weise, *Die geistige Welt der Gotik und ihre Bedeutung für Italien*, Halle, 1939. About the middle of the century a deliberate return becomes evident toward hieratic non-Giottesque types which can probably be explained by the sudden disappearance of the leading masters, especially the Lorenzetti who are not mentioned after 1348, and by the wave of penitence and confusion which followed the frightful ravages of the Black Death: see M. Meiss, *Painting in Florence and Siena after the Black Death*, Princeton, 1951. Among Trecento Bolognese painters such as Vitale, one finds a violent popular vein, an original harshness, which have recently been stressed by R. Longhi, *La mostra del Trecento bolognese*, Paragone, May 1950. At Padua, Giusto de Menabuoi adapts a number of Giottesque features to Byzantine formulas: S. Bettini, *Giusto de, Menabuoi e l'arte del Trecento*, Padua, 1944.

place is no longer the same. A kind of anecdotal arabesque, interspersed with various self-sufficient episodes, has taken the place of the powerfully constructed compositions which had been so strictly governed by the art of distributing and massing the component parts, of balancing objects and intervals, and of composing the whole, including even the dramatic situation, so as to convey to eye and mind the majesty of the equilibrium. At the same time the anxiety of perspective began to agitate the fresco space; it appeared first of all in the painting of architecture and, by the analysis of the three-dimensional relationships of that art, the eye made gradual progress in this perilous education. When Giotto painted at Assisi the scene of St. Francis renouncing worldly life, he set his figures against a background of light stage scenery; in the Bardi chapel, the podium of the temple is seen from one corner, but this angle, lying between the figure groups, forms the axis of the compositon, and the recession of the massive walls does not oppress us by insisting on the hollowness of space. Taddeo Gaddi, on the other hand, in his Presentation of the Virgin, devises a clumsy and complex architectural diagram, and seeks to construct space like a building, so as to create on the flat and solid wall a calculated illusion of depth. These, however, were but the first experiments in an investigation which was conducted on systematic lines in the following century, and which was eventually to substitute geometric space for monumental space. The roughly blocked-out landscapes, whose severe masses supply a base for some of Giotto's frescoes, begin to suggest a certain vague relationship between man and the universe. This tendency was perhaps still more marked among the Giottesque painters of northern Italy, but for different reasons. In the great towns of the Veneto, Padua and especially Verona, connected with the West by the plain of Lombardy and with Central Europe by the passes of the Alps, Italian thought, even when its unity was strongest, assumed unusual forms. Verona, red and black, with its Roman bridge, the crenellated bridge built by the house of Scaliger, and the tomb-statues of certain princes of that house who dignified themselves with the names of dog and mastiff, and Padua, with its brick-built, domed basilica dedicated to the new saint of upper Italy, have few features in common with the Tuscan background. The skill of the bronze-founders, heirs to the technical traditions of the Carolingian workshops of the Rhineland, had produced masterpieces there. Painters like Guariento, Jacopo d'Avanzo and especially Altichiero are distinct from the true Giottesque group: the imagination and vision of the last-named, who in some respects is related to Tommaso da Modena, do not render man as an isolated block in a clear, limited and well-defined space, but extend him in a kind of ornamental world, as if the dying Middle Ages were reverting to the spirit of Romanesque art.

Medieval Italy was remarkable for the persistence with which the different localities retained, beneath the patterns of influence and counter-influence, their own individual characters, which coloured the forms in which they clothed the life of these styles—papal Rome, Angevin Naples, Verona under the Scaligeri and, in Tuscany itself, the two entirely distinct fourteenth-century centres, Florence and Siena. The art of the latter seems conservative at first sight, for it clung, until quite late in the fifteenth century, to an ageing stock of forms which it made no attempt to renew, and to the calligraphy of a style which had long since lost the quality of discovery and innovation which it had once possessed. This art sprang from the strong stem of Duccio.[1] The monumental panels of the *Maestà* type have, in the beginning, the same austere power and peaceful dignity as the great Florentine Madonnas. Later they become more flexible and tender, in little gold-patterned panels, framed in arches and sprinkled with ornaments. Their long sad eyes, their charming femininity, the exquisite character of a colour-scale which is brilliant even in blended tones and which loves the contrast of blacks, gold grounds and the most delicate flower-like tints—these qualities of form, this visual taste and this rare feeling for the note of sumptuousness in the handling of the materials of the art, suggest links with places farther east than Byzantium. When one recalls the Persian gardens, the Asiatic fauna, and the oriental carpets, which, in the first half of the Quattrocento, invest Tuscan painting with the refinements of an exotic atmosphere, one must ask whether Sienese art was not the point of entry for these singular influences, and—a wider question—whether there is not good reason to think that these same influences were responsible for the supple, 'profiled' character of Tuscan drawing. The continuity of the antique tradition is a myth, like the fable of an eternally Roman Italy: the Etruscans retained Asiatic forms within the imported Greek archaic style; the Latin basilicas and baths adopted Iranian techniques; and Byzantine Ravenna and Arab Sicily raised on the Italian skyline silhouettes which owe nothing to the West. Trading voyages established contacts between Asia and the great Mediterranean marts. Even if Siena had never sheltered a Chinese colony within its walls, it would still be necessary to acknowledge the fact of Tuscan Orientalism, and it would still be possible to explain it. Nothing could be more remote from the style of Giotto.

In fresco, moreover, Sienese art evolved a spatial structure which is not that of its gilded panels—creations of goldsmiths as much as of painters—nor that of

[1]Duccio di Buoninsegna, who was born in Siena between 1255 and 1260, died in 1319, after a disreputable life. There is one certain work, the *Maestà* painted for Siena cathedral (1310-11). On the attribution to him of the Madonna Ruccellai, and the consequences thereof, see L. Hautecoeur, *Les primitifs italiens*, Paris, 1931, p. 116, *and P. d'Ancona, *Les primitifs italiens, du XIe au XIIIe siècle*, Paris, 1935. The attribution is now almost universally accepted.

Giotto, nor that of the rational perspective whose earliest examples are found
among the Giottesque masters of Florence. The allegories of Good and Bad
120 Government, executed by Ambrogio Lorenzetti on the walls of the Palazzo
Pubblico in Siena, display a cartographic landscape which seeks to include as
much of the world as possible—people, buildings and terrain—beneath a high
horizon. This individual conception, in which the verisimilitude of the images
acquires a quality of enchantment, as if the world were a pageant seen from a
hilltop a great way off, was still current among the Northern landscape painters
in the sixteenth century; it survived the development of geometrical perspective
and the interpretation of space as architecture. Finally, the secular feeling,
which found expression, in French mural painting of the fourteenth century, in
hunting scenes and battle-pieces, was linked, by masters like the Lorenzetti,
with the happiness of life. In the squares of the wisely governed city, young girls
dance their joyful rounds. Flimsy draperies reveal the beauty of woman. She is
no mere ornament, nor even the episodic symbol of public prosperity. She
presides over it with triumphant grace. Some have seen in her the first ray of
dawn piercing the darkness and confusion of the time. . . . But this is to forget
that there had been a prelude to this ode to joy in the cathedrals of the thirteenth
century. It is none the less true that the grave optimism of Christianity was of
another kind and that its light came from a different source.

The diffusion of Sienese art was very wide;[1] it extended to every part of Western
Europe. It made a profound impression in Italy, from Naples to the foothills of
the Alps. It crossed the mountains, and is found in the heart of Bohemia; it
crossed the sea to Catalonia, in whose painters, from Ferrer Bassa to Jaume
Huguet, this style was deeply ingrained. The Catalan 'Virgen de la Leche' is a
Sienese Madonna adapted to a more lush taste; the panels of the retables are
composed on similar principles to the Sienese panels—both are descended from
a common ancestor, the great *pala* of Siena cathedral. More crudely, and with a
wilder harmony, the Aragonese painters paid tribute to the same style. In
Avignon, however, in the papal *entourage*, due to the presence of Simone Martini[2]

*[1]On the diffusion of Italian art prior to the great Sienese expansion, see M. Meiss, *Fresques italiennes
cavallinesques et autres à Béziers*, Gazette des Beaux-Arts, 1937, and O. Pächt, *A Giottesque Episode
in English Mediaeval Art*, Journal of the Warburg and Courtauld Institutes, VI, 1943, pp. 51–70.
[2]Simone Martini was born in Siena in 1284; the name Memmi, which he adopted, was not a
patronymic as Vasari supposed, but there is a strong possibility that it was derived from the name
of his master and father-in-law, Memmo di Filipuccio. The *Maestà* of the Palazzo Pubblico in
Siena was painted in 1315. About 1320, Simone was working for Robert of Anjou; he painted the
life of St. Martin in a chapel at Assisi (1322–26 according to Van Marle; 1333–39 according to
Pérató); he travelled to Avignon in 1339. According to Giacomo di Nicola, L'Arte, 1906, p. 336,
his fresco at Notre-Dame-des-Doms represents St. George (not Laura), and the portrait of the
donor is that of Cardinal Stefaneschi. The painter died in Avignon in 1344.

and his works, and not to any indirect influence, there flourished a great workshop of genuinely Sienese character. The paintings of Notre-Dame-des-Doms have now practically disappeared, but those which decorate the wardrobe chamber of the palace of the popes display, with almost unimpaired *124* freshness, the charming artificiality of a magical forest. In it, men are hunting, with fine hounds whose elegant lines suggest and foreshadow the art of Pisanello; fish are caught in a fish-pond; and the fowler hides among the green branches. Was this smiling and mysterious poetry a gift from Siena to the West? France also contributed something to it, and even more to the frescoes of Sorgues, *119* executed twenty years later (about 1360). The spiritual harmony which linked Dante and Giotto recurs in that between Petrarch and the painters of Siena. Ambrogio Lorenzetti might have illustrated the *Trionfi* in the style of the *Good Government;* the tradition that Simone painted Madonna Laura over the doorway of Notre-Dame-des-Doms is an apt reflection of profound affinities. On the walls of the wardrobe chamber we may look upon the landscapes of happiness.

<h2 style="text-align:center">III</h2>

THE art of northern France was not unaware of Italy, any more than Italy was unaware of it. In 1298, the French painter Étienne of Auxerre had been sent to Rome by Philippe le Bel—on the eve of that jubilee of 1300 which was the last glorious page in the papal annals prior to the exile in Avignon. This is a solitary fact, whose consequences we are not in a position to estimate. But in the next century the miniatures of Jean Pucelle reveal the existence of a most delicate and sensitive blending of the Parisian and the Sienese spirit, similar to that which united Andrea Pisano and the French ivory carvers in an identical feeling for grace of form. In these same miniatures we may also recognize the extent of the threat which the nuances, flexions and charms of the new spirit offered to that monumental equilibrium which we found so precisely defined by the architecture and sculpture of the thirteenth century, by the stained glass, which introduced its dazzling majestic figures in the intervals of sky seen between the stonework, and lastly by man's image in the form in which Giotto had installed it upon the walls, with due consideration, not only for the inherent plastic dignity of the forms, but also for the mass and stability of the walls themselves.

What remained in France of the great pictorial tradition which had determined the appearance of so many walls down to the end of the twelfth century, and even later—for works like the Mystic Marriage of St. Catherine at Montmorillon

probably belong to the following century, not to mention the paintings of pure
Romanesque style with which certain churches of Mayenne, Cher and Nièvre
were adorned in the same period? Was there not a natural antipathy between
this austere art and the spirit of a time which expressed itself in the elegant
precision of *Rayonnant* architecture and in a charming, supple sculpture, of the
most refined execution? Were the forms of wall-painting able to retain some
vestige of their long-accustomed grandeur? Religious art, in the second half of
the thirteenth and during the fourteenth centuries, no longer disposed, as we have
seen, of the wide wall spaces of the preceding period. The apertures had devoured
the wall. The figures were constricted by new frames, by medallions at Petit-
Quevilly and Saint-Émilion, and by quatrefoils in the Sainte-Chapelle, where
glass incrustations superimposed the colour and substance of the windows on the
substance of the wall itself; elsewhere (as in the cathedral of Clermont), the
walls were painted in tempera with retables and triptychs, confining within
precise limits the donations of private persons and the offerings of confraternities.
But what the Church lost represented, to some extent, a gain for secular art and
for such of the ecclesiastical buildings as could offer an expanse of wall free from
the many-hued radiance of the windows. In feudal architecture, in the lofty halls
of the keeps and fortified palaces, in the greater town houses, there was unlimited
scope, if not for great painting, at least for decoration on a grand scale. It was the
work of obscure artisans, its meagre iconography reduced to a few monotonous
and conventional themes—the old combat of the Siren and the Centaur, a
tournament, or a pair of knights fighting in a forest.[1] Compositions such as those
of the castle of Saint-Floret and the house at Hérisson, in Allier, cannot be
compared with the great visions of sylvan landscape and the enchanted hunts
which surround the papal wardrobe at Avignon. Nevertheless, these scenes of
decorative chivalry played a part in the history of French painting, just as they
did in the definition of contemporary society. They looked forward to those
'painted chambers' which enjoyed so great a vogue under the first Valois
monarchs. We have to rely on descriptions and references in the accounts for our
idea of these schemes, which must have been relatively ambitious; such were the
paintings which Évrard d'Orléans (the sculptor of the Langres Virgin) executed
at Conflans in 1330 for Mahaut of Artois, the paintings by the same artist in
the King's castles, and those which Jean le Bon commissioned from Jean Coste
in 1349 for Vaudreuil—a Life of Caesar. Besides these, we know that at the end

*[1]On the exceptionally wide range of subjects commissioned in England by Henry III, see T.
Borenius, *The Cycle of Images in the Palaces and Castles of Henry III*, Journal of the Warburg and
Courtauld Institutes, VI, 1943, pp. 40–50.

of the thirteenth century, Queen Marie of Brabant had her portrait painted on the walls of the castle of Étampes, in a hunting scene.

This last fact is of some importance, for it makes it easier to understand the traces of mural style and majestic form which survive in the portrait of Jean le Bon, whose breadth, solidity and weight may be studied in the Louvre. This profile is beyond all doubt an excellent likeness, for it reveals a human being of a particular age, temperament and type and has none of the conventionality characteristic of mass-produced dynastic portraits. This scion of Valois, attractive, chivalrous and weak, achieves royalty through the style of his painter, Girard d'Orléans. The gessoed panel which bears his image has almost the strength of a monumental support. Here, as in the tomb-sculpture, the investigation of nature is conducted with a scrupulous regard for that grandeur and nobility of vision which were part of the original heritage of French art. Pre-Eyckian painting, on the eve of the decisive transformation, still occasionally retained this accent, even if only by virtue of the material of which it was made. The *Martyrdom of St. Denis* by Henri Bellechose, in the Louvre, is not merely an enlarged miniature; it is certainly a subtle and delicate work of art, but it is still mural in its velvety harmonies and in its balanced forms, vigorously drawn, which brook no atmospheric effects or openings into distance. But for this continuity, where should we find the key, in the fifteenth century, to the monumentality of some of Fouquet's pages?

This was one aspect. But there was another, quite unlike this. Through its technical multiplicity, painting was drawn into life, into its refinement and luxury. An overwhelming new fashion was emerging which was soon to destroy the Middle Ages by replacing the immensity of the churches, the strong and skilful harmonies precisely rendered in linear compositions, which remain undisturbed by the abstract light of the grisaille windows, by a precious image, miraculous in its colouring, a microcosm to be held in the hand. There exists a group of small French paintings, similar, in format and purpose, to the ivories which were favoured for private devotions—the Cardon Virgin, the Virgin of the Carrand collection in the Bargello, the Wilton Diptych in the National Gallery in London, and, in the Worcester Museum (U.S.A.), the Virgin with Pierre de Luxembourg, painted in a colour-scale of red and blue which seems to have been peculiar to the Paris workshops. The Boston Museum (U.S.A.) has a little Virgin from Avignon, more French than Sienese—and there are others besides which would need to be assembled, compared and categorized. Though the Worcester Virgin, on its tiny scale, still retains something of an older monumental dignity, it is the note of exquisiteness and a kind of gentility of manners

which distinguish most of these pictures.[1] Their style is parallel with that of the manuscripts of the first three quarters of the fourteenth century.

The greatness of Romanesque painting had impregnated every kind of picture, even down to book-illumination, with the majesty of the walls. From the thirteenth century onwards, the art of illumination, like that of enamelled metal-work, was practised in lay workshops, but though this fact did not fail to affect the evolution of the style, the influence operated in a contrary sense to that experienced by the champlevé enamels, which hardened into fixed formulae—an example of the extremely variable application of sociological factors to the history of forms. In addition, French miniature painting also received influences from without. It was in England that the powerful framework of pre-Romanesque and Romanesque style had first broken down and been replaced by a new type of humanity, slender and contorted, with thin, flexible limbs. Paris was not unaware of Winchester; leaving violence and oddity aside, it evolved a similar lay-figure. The schematic people of Villard de Honnecourt, composed of two triangles with their apexes touching—this forms the constricted waist, while the shoulders coincide with the base of the upper triangle—are members of the same family. These creatures with their thread-like structure are anthropometric abstracts of the figurines which inhabit the world of the *Rayonnant* style. It is a more nervous, more active and frailer race than its predecessor. It is very graceful in the Sainte-Chapelle gospels, the Psalter of St. Louis in the Bibliothèque Nationale (about 1256) and in secular manuscripts such as the *Chanson de Guilelclin de Soignes*, decorated about 1285 for Marie of Brabant. In the Breviary of Châlons-sur-Marne (Bibliothèque de l'Arsenal), painted prior to the canoniza-tion of St. Louis in 1297, there is a Christ in Majesty of paradoxical proportions—taller, despite his seated position, than a tall standing figure—who is the most typical specimen of this morphology.

The art of St. Louis' day retained these supple figures within light yet solid frames. The book continued to be architectural—not only by reason of its noble margins, like jambs and lintels of white stone, or of the regular courses of script, or the delicate network of the initial letters, enclosing brilliant colours, like the leads of the windows, on a ground of gold burnished with a wolf's fang, but also because the miniature itself (like the reliquaries and the furniture) was an archi-tect's composition, by virtue of the colonnettes and arcades which frame it; it belongs to the monumental Gothic manner in its flower-strewn backgrounds,

*[1]The history of French panel painting in the fourteenth century is treated in C. Sterling, *La peinture française: les primitifs*, Paris, 1938, and by the same author, under his war pseudonym, C. Jacques, *Les peintres du moyen-âge*, Paris, 1942. G. Ring, *A Century of French Painting*, 1400–1500, London, 1949, covers the end of the fourteenth century, from c. 1390.

penetrated by no hint of perspective, and in its colour-harmony, dominated, as in the windows, by blues and reds. Indeed, a literal transcription of a window may be found in the composition of medallions and half-medallions of the Jesse tree in the Psalter of St. Louis and Blanche of Castile (Bibliothèque de l'Arsenal). Sometimes, however, the frames are of an entirely different kind, introducing into the full flower of the thirteenth-century style compositional ideas of much earlier date; in the angles of the borders the old interlace animal sometimes reappears and coils himself into strange shapes, as if the Middle Ages were maintaining contact, through such minor reminiscences, with the forms from which they sprang.

Master Honoré, whom we find established in Paris in 1288, in the illuminators' quarter, the Rue Boutebrie, and who in 1296 decorated a Psalter for Philippe le Bel, was for long an exponent of this typically Parisian and royal manner, which initiated some lasting features of the Paris school. Jacques Maciot and Jean Pucelle made no abrupt break with it. The manuscripts of the early years of the fourteenth century, such as the *Cité de Dieu* of 1317, continue the same tradition. But a new spirit appears in the Bible of Robert of Billyng (1327) and especially in the Belleville Breviary (before 1343). Jean Pucelle's figures are more comely, *123* more sensitive, and combine to form more flexible harmonies. In the margins he installs a show of finely wrought ornamental blossoms, which are in part herbaceous border and in part masterpieces of metalwork; on the horizontal bars from which these hang, like iron shop-signs, he sets whimsical figurines, which prove that he knew not only the Sienese, but also the English and their grotesques. They stand out from a background of plain parchment, beside an oratory or a little tree. This invasion of the margins, this vignette-style, is reminiscent of the illustrations of the Romantic period.

Was this a generalized manner? On the contrary, the workshop of each master had its own tradition and accent. Under Charles V, when, with the inspiration or, at all events, the patronage, of great royal amateurs such as the Duc de Berry, artists from northern France, Flanders and Hainaut were embarking not on bulk importation, but on a series of experiments in space, form and colour, one among them, André Beauneveu, in his Psalter of the Duc de Berry, retained for his prophets and apostles the fourteenth century figure-canon, but in alliance with simple lines, calm tones and a statuesque harmony. A number of works in which economy of colour has been carried to the limit, in the charming severity of grisaille, provide a kind of respite prior to the great experimental phase. The small *Heures de Notre-Dame*, by Jean Pucelle, were already 'illuminated in black and white'. Without suggesting a strict parallelism between two very different

classes of fact, it is not inapposite to recall that the major art of black and white, that of the printed picture, was invented in France about 1370.[1] This attenuation of colour is very apparent in certain manuscripts. The illustrations to Guillaume de Machaut in the Morgan Library, in rectangular frames formed by a thin band of yellow or grey, use pale pinks and greens for their dreamy figures set in discreet landscapes. This refinement of visual taste finds its highest expression in the monochrome drawings on cloth, the mitre of samite in Cluny Museum and in particular the altar-frontal known as the *Parement de Narbonne*, in the Louvre (1374). Lines drawn with the pen and a delicate grisaille modelling suffice to create a skilful rendering of form. In an architectural setting formed of arches, amid the scenes of the Passion, Charles V and his Queen kneel on either side of the Crucifixion. Like the Quinze-Vingts statues, the *Parement de Narbonne* provides an epitome, in a pure and sober technique, of the final phase of a great classic system of thought.

But the middle ages were turning towards new lines of research. The greater liberty of the corporations in the northern towns may have favoured these, but their effect on the mellow heritage of Parisian art, which continued to command the loyalty of the Duc de Berry, was tempered by an eclecticism of rare discernment. In the *Grandes Heures* and the *Très belles Heures* which he executed for this prince, Jacquemart de Hesdin offered no more than an extremely skilful continuation of the tradition of Jean Pucelle. But Jean de Bandol, called Jean of Bruges, in the Bible of Jean de Vaudetar, painted a picture, in the modern sense of the word, to commemorate the occasion of the presentation of the book to the King (1372). In the Boucicaut Hours, Jacques Coene of Bruges introduced the forms of the world and the poetry of the elements—the earth on which man stands, the air which surrounds him, and the water, which intervenes between the various planes to suggest distance and depth—a mysterious new scenery disposed about the numerous figures and lively episodes. Finally, in the *Très*

[1]See H. Bouchot, *Le bois Protat*, Gazette des Beaux-Arts, 1902, and A. Blum, *Un nouvel ancêtre de la gravure sur bois*, Gazette des Beaux-Arts, 1923. The Protat woodblock—so-called after the printer who discovered it—is a plank of walnut intended for cloth-printing, and bearing an engraved fragment of a Crucifixion composition. From the style of the uncial inscription on the scroll, it is possible to date it to the period around 1370. The Christ bearing the Cross in the Edmond de Rothschild collection is an impression on paper, that is, a true print, the earliest known. Roughly contemporary with the Protat woodblock, as appears from the details of the costume and armour, it is of Burgundian origin. An inventory of 1377 mentions two books on paper, containing legends of the saints and a paraphrase of the Gospels (Cambrai). On the early stages of the print, see W. L. Schreiber, *Handbuch der Holz- und Metallschnitte des XV. Jahrhunderts*, 2nd edition, 8 vol., Leipzig, 1926–30; P. A. Lemoisne, *Les xylographies du XIVe et du XVe siècle au Cabinet des Estampes de la Bibliothèque Nationale*, 2 vols., Paris, 1927–30; A. Blum, *Les origines de la gravure en France*, Paris and Brussels, 1927, and *Les origines du livre à gravures en France*, Paris and Brussels, 1928; L. Rosenthal, *Les origines de la gravure*, Annales de l'Université de Lyon, 1930.

Riches Heures of Berry (before 1416), the brothers Limbourg constructed a *127*
complete world in which life's dreams are inextricably interwoven with life's
reality—castles studied with the keen eye of the goldsmith making a reliquary,
with the same insistence on detail and the same vertiginous diminution sharpen-
ing the angles and emphasizing the contours; romantic landscapes of hunts and
excursions in the forest; rustic landscapes with peasants at their tasks; visionary
landscapes of bliss and horror, overhung by erratic mountains, torn asunder by
gulfs. The exemplary representation of the male nude, standing in the zodiacal
ellipse,[1] provides the introduction to this book of wonders, and to a new period.

These were, in fact, symptoms and experiments of a profound revolution, the
seeds of which had not yet ripened in the structure of the churches; here the
fundamental laws remained in force, and the fourteenth century continued to
respect the functional character of architecture. The next century, during which
the Middle Ages disintegrated, was to witness the effects of this revolution,
whereby architectural primacy was replaced by the primacy of painting, the
monumental order was shattered by pictorial art, and the romance of contem-
porary life and classical antiquity overran the territory which for two centuries
had been dominated by the classic spirit of the great builders.

*[1]For the interpretation of this famous miniature, see the excellent article by H. Bober, *The Zodiacal
Miniature of the Très Riches Heures of the Duke of Berry, Its Sources and Meaning*, Journal of the
Warburg and Courtauld Institutes, XI, 1948, pp. 1–34.

BIBLIOGRAPHY

PAINTING AND DECORATIVE ARTS IN THE WEST

H. Martin, *La miniature française du XIIIe au XVe siècle*, Paris, and Brussels 1923; L. Gillet, *La peinture française, Moyen âge, Renaissance*, Paris, and Brussels 1928; A. de Laborde, *Les manuscrits à peintures de la Cité de Dieu de Saint Augustin*, 3 vols., Paris, 1909, *La Bible moralisée conservée à Oxford*, 5 vols., Paris, 1911–25; H. Martin, *Les principaux manuscrits à peintures de la Bibliothèque de l'Arsenal*, Paris, 1927; E. G. Millar, *Les principaux manuscrits à peintures d'origine française du British Museum*, 2 vols., Paris, 1931–32; C. Gaspar and F. Lyna, *Les principaux manuscrits à peintures de la Bibliothèque royale de Belgique*, 2 vols., Paris, 1937–45; L. Delisle, *Les Heures dites de Jean Pucelle*, Paris, 1910; R. André-Michel, *Les fresques de la tour de la Garde-Robe*, Paris, 1916; F. de Lasteyrie, *Histoire de la peinture sur verre*, 2 vols., Paris, 1853–57; N. H. J. Westlake, *History of Design on Painted Glass*, 4 vols., London, 1880–84; J. L. Fischer, *Handbuch der Glasmalerei*, Leipzig, 1914; L. Magne, *L'oeuvre des peintres verriers français*, Paris, 1885; J. J. Gruber, *Quelques aspects de l'art et de la technique du vitrail en France*, Institut d'art et d'archéologie de l'Université de Paris, Travaux du groupe d'histoire de l'art, 1928; Y. Delaporte and E. Houvet, *Les vitraux de la cathédrale de Chartres*, 1 vol. and 3 albums of plates, Chartres, 1926; H. Oidtmann, *Die Rheinischen Glasmalereien*, 2 vols., Düsseldorf, 1922–29; F. de Lasteyrie, *Histoire de l'orfèvrerie*, Paris, 1875; E. Molinier, *Histoire générale des arts appliqués à l'industrie, IV, Orfèvrerie*, Paris, 1900; R. Koechlin, *Les ivoires gothiques français*, 2 vols., and plates, Paris, 1924. *J. Dupont and C. Gnudi, *La peinture gothique* (Skira: Les grand siècles de la peinture), Geneva, 1954; J. Porcher, *L'enluminure française*, Paris, 1959, (*Medieval French Miniatures*, New York, 1960); G. Haseloff, *Die Psalterillustration im 13. Jahrhundert*, Kiel, 1938; G. Guignard, *La miniature gothique*, Art de France, I, 1961, pp. 278–280; E. G. Millar, *The Parisian Miniaturist Honoré*, London, 1959; R. Blum, *Jean Pucelle et la miniature parisienne du XIVe siècle*, Scriptorium, III, 1949; K. Morand, *Jean Pucelle: A Re-examination of the Evidence*, Burlington Magazine, CIII, 1961, pp. 206–211; Y. Bonnefoy, *Peintures murales de la France gothique*, Paris, 1954; M. Rickert, *Painting in Britain: The Middle Ages* (Pelican History of Art), Harmondsworth, 1954; P. Brieger, *English Art, 1216–1307* (Oxford History of English Art), Oxford, 1957; J. Evans, *English Art, 1307–1461* (same collection), Oxford, 1949; F. Wormald, *Paintings in Westminster Abbey and Contemporary Paintings*, Proceedings of the British Academy, XXXV, 1949; P. Tudor-Craig, *The Painted Chamber at Westminster*, Archaeological Journal, CXIV, 1957, pp. 92–105; E. W. Tristram, *English Medieval Wall Painting, II. The Thirteenth Century*, Oxford, 1950; A. Stange, *Deutsche Malerei der Gotik*, Vols. I and II, Berlin, 1934–1936; A. Matejček and J. Pešina, *Czech Gothic Painting*, Prague, 1950; M. Aubert, A. Chastel, L. Grodecki, J.-J. Gruber, J. Lafond, F. Mathey, J. Taralon, and J. Verrier, *Le vitrail français*, Paris, 1958; J. Verrier, *La cathédrale de Bourges et ses vitraux*, Paris, 1943; L. Grodecki, *A Stained Glass Atelier of the Thirteenth Century*, Journal of the Warburg and Courtauld Institutes, XI, 1948, and *Les vitraux soissonnais du Louvre, du Musée Marmottan et des collections américaines*, Revue des Arts, 1960, pp. 163–178; L. Grodecki and J. Lafond, *Les vitraux de Notre-Dame et de la Sainte-Chapelle de Paris* (Corpus vitrearum medii aevi, France, I), Paris, 1959; J. Lafond, *Le vitrail en Normandie de 1250 à 1300*, Bulletin monumental, 1953, and *Les vitraux royaux du XIVe siècle à la cathédrale d'Evreux*, ibid., 1942; B. Rackham, *The Ancient Glass of Canterbury Cathedral*, London, 1949; J. Lafond, *The Stained Glass Decoration of Lincoln Cathedral in the Thirteenth Century*, Archaeological Journal, CIII, 1946; J. A. Knowles, *Essays in the*

History of the York School of Glass-Painting, London, 1936; C. Woodforde, *English Stained Glass and Glass Painters in the Fourteenth Century*, Proceedings of the British Academy, XXV, 1939; H. Wentzel, *Meisterwerke der Glasmalerei* (Denkmäler Deutscher Kunst), Berlin, 1951; M. M. Gauthier, *Emaux limousins champlevés des XIIe, XIIIe et XIVe siècles*, Paris, 1950; S. Gevaert, *L'orfévrerie mosane au moyen âge*, Brussels, 1943; S. Collon-Gevaert, *Histoire des arts du métal en Belgique*, Mémoires de l'Académie Royale de Belgique, Classe des Beaux-Arts, VII, Brussels, 1951; L. Grodecki, *Ivoires français*, Paris, 1947; A.G.I. Christie, *English Mediaeval Embroidery*, Oxford, 1938.

ITALIAN PAINTING

R. Van Marle, *The Development of the Italian Schools of Painting*, 19 vols., The Hague, 1923–38; F. T. Perrens, *Histoire de Florence*, 9 vols., Paris, 1877–90; R. Davidsohn, *Geschichte von Florenz*, 4 vols., Berlin, 1896–1912; R. L. Douglas, *A History of Siena*, 1902; A. Sabatier, A. Masseron, H. Hauvette, H. Focillon, E. Gilson and E. Jordon, *L'influence de Saint François d'Assise sur la civilisation italienne*, Paris, 1926; (Focillon's article *Saint François d'Assise et la peinture italienne au XIIIe et au XIVe siècle*, has been reprinted in *Moyen âge, survivances et réveils*, Montreal, 1945); L. Hautecoeur, *Les primitifs italiens*, Paris, 1931; G. Soulier, *Les influences orientales dans la peinture toscane*, Paris, 1924, and *Cimabue, Duccio et les premières écoles de Toscane*, Bibliothèque de l'Institut français de Florence, Paris, 1929; J. Strzygowski, *Cimabue und Rom*, Vienna, 1888; P. Toesca, *La pittura fiorentina del Trecento*, Florence, 1929; O. Siren, *Giotto*, Stockholm, 1906; J. B. Supino, *Giotto*, 2 vols., Florence, 1921; E. Jacobsen, *Das Trecento in der Gemäldegalerie zu Siena*, Strasbourg, 1907; E. Sandberg-Vavala, *La pittura senese del Trecento e del primo Quattrocento*, Verona, 1926; G. H. Edgell, *A History of Sienese Painting*, New York, 1932; A. Goßche, *Simone Martini*, Leipzig, 1899; E. von Meyenburg, *Ambrogio Lorenzetti*, Zurich, 1903; L. Bronstein, *Altichiero*, Paris, 1932. *G. Weise, *Die geistige Welt der Gotik und ihre Bedeutung für Italien*, Halle, 1939; P. d'Ancona, *Les primitifs italiens, du XIe au XIIIe siècle*, Paris, 1935; R. Oertel, *Die Frühzeit der italienischen Malerei*, Stuttgart, 1953; R. Longhi, *Giudizio sul Duecento*, Proporzioni, II, 1948; M. Salmi, *I mosaici del bel San Giovanni e la pittura nel secolo XIII*, Dedalo, 1931; P. Toesca, *Storia dell'arte italiana*, II. *Il Trecento*, Turin, 1951; H. B. Gutman, *The Rebirth of the Fine Arts and Franciscan Thought*, Franciscan Studies, V, 1945; R. Jullian, *Le franciscanisme et l'art italien*, Phoebus, I, 1946; R. Salvini, *Giotto, Bibliografia*, Rome, 1938; L. Tintori and M. Meiss, *The Painting of the Life of St. Francis in Assisi. With Notes on the Arena Chapel*, New York, 1962; P. Murray, *Notes on Some Early Giotto Sources*, Journal of the Warburg and Courtauld Institutes, XVI, 1953; C. H. Weigelt, *Sienese Painting of the Trecento*, Florence–Paris, 1930; E. Carli, *Sienese Painting*, Greenwich, U.S.A., 1957; C. Brandi, *Duccio*, Florence, 1951; A. de Rinaldis, *Simone Martini*, Rome, 1936; G. Sinibaldi, *I Lorenzetti*, Siena, 1933; G. Rowley, *Ambrogio Lorenzetti*, 2 vols., Princeton, 1958; P. Sanpaolesi, *Le sinopie del Campo Santo di Pisa*, Bollettino d'Arte, XXXIV, 1948; M. Meiss, *Painting in Florence and Siena after the Black Death*, Princeton, 1951; M. Salmi, *La miniatura italiana*, Milan, 1955; E. Carli, *Vetrate italiane*, Rome, 1955.

The Close of the Middle Ages

The Spirit of Fantasy: Gothic Baroque

I

THE end of a period is not an abrupt cessation of the tendencies which have characterized it. On the contrary, there seems to be a physiology of history, comparable with the physiology of the human body, and displaying, like the latter, symptoms of gradual decline. We shall find sufficient confirmation of this within the fields of the life of the spirit and of artistic production. But there were in addition, in the fifteenth century, a certain number of events whose significance has been evaluated with greater or less accuracy, and which, besides their political, social, economic and technical implications, were of great moment for the history of man. It is generally agreed that the Middle Ages endured down to the capture of Constantinople by the Turks in 1453, and that, at that date, the modern world came into being. The various reasons which are alleged—the exodus of Greek scholars, the diffusion of classical culture—are of little weight, but the fact is still valuable as an index and datum line, and it directs our attention to wider movements. The end of the Middle Ages was in fact marked, if not with the mass migrations of its beginnings, at least with the final ripples of those immense upheavals. The great Seljuk invasion had long been advancing within the Greek empire. The destruction of the latter put an end to all that remained of the political organization which Rome had established in the eastern Mediterranean basin. Forty years later, Ferdinand took Granada and the Moors of Spain were pressed back into Africa. This, however, was not a compensatory phenomenon. To appreciate its significance, it should be considered in connection with the invasion of Egypt by Selim I, who expelled the dynasty of the Circassian Mamelukes; this marked the end of the true Arab civilization, which was replaced by Ottoman culture. Thus the second half of the fifteenth century and the opening years of the sixteenth witnessed the disappearance or the reduction to secondary rank of the three great civilizations which had provided the framework of the European Middle Ages—the Byzantine civilization, which survived only in a provincial form, in the Danubian and Balkan lands, the Arab civilization proper, which was penned in Morocco and North Africa, and finally the Gothic civilization.

The historical circumstances which attended and brought about the decline of the latter were of several kinds. Particularly in the case of France they were

obvious and decisive. The Gothic system of thought, in its most complete expression, was French thought extended to cover the whole of the West. The strength of France was drained by the war with England. A whole social class had been expended, and their old military techniques were on the brink of annihilation by new inventions which destroyed the effectiveness of armour and curtain walls. The burgher class, the constant ally of the Capetian king, tended to assume, not the first rank, but the active role. The collective resources and particularly the social cohesion of the thirteenth century were no longer available for great undertakings. Simultaneously, the kingdom was menaced by the sudden rise of the house of Burgundy, the heir to Flanders, and, at a later date, by the formidable imaginings of the 'Grand Duke of the West'. There was a shift, or rather a multiplication of centres—Paris on the one hand, and, on the other, Dijon, Bruges and Ghent. It was in the towns of the dukedom, and in Italy, that the innovating experiments were carried out. Claus Sluter, Van Eyck, the Veronese and even the Florentines of the first half of the fifteenth century were still medieval in the framework of their existence, in the tone of their moral life and in the systematization of their thought, but they constructed man and space in accordance with data of an entirely different kind. In Italy, the romanticism of vanished antiquity coincided with the romantic forms of Gothic thought. But whereas for the latter these represented the last phase of an evolution, in Italy on the other hand, they were forerunners of the return to what was considered to be the golden age and the historical mission of the country.

At the end of the fourteenth century and the beginning of the fifteenth, a kind of fantasy of the spirit replaced in the West that strong and stable feeling for life which had characterized the preceding period. Civilizations begin with epic poetry and theology: they end with romance. Theology itself became romantic. The romantic spirit, considered not as a *genre* but as the expression, of an instinct, revealed not so much the need to represent life, as to reconstruct and colour it, and to introduce into it those elements which it seems to reject, the marvels of the imagination; it even extended into the conduct of life itself, which it was able to turn into a work of art or a fairy tale, as, for instance, in the festivities indulged in by a cultivated *élite*, and in costume, which has never been so odd and so deliberately strange as it was in France in the reign of Charles VI. It is curious to note how it insinuated itself into the highest levels of religious feeling. Concurrently with the decline of scholasticism as a speculative force, as it withered and came to rely, in its vulgar aspects at least, on automatism, faith, in so far as it was not invaded by petty practices of devoutness, acquired a sensitive and effusive quality, in such works as the *Imitatio Christi*, that most

delicate, most profound and most effective romance of the Christian life. It is possible to consider the mystics—St. Bridget of Sweden, Heinrich Suso—as extraordinary romancers of themselves, not through any multiplicity of their experiences, but through their dream and vision of one experience, the most sublime and dazzling of all, communion with God. The preoccupation with death, which weighed so heavily on the later Middle Ages,[1] likewise created its romance, the legend of the three living and the three dead, and its sepulchral ballet, the Dance of Death. And was not sorcery in the final analysis merely the romance of the devil? As to astrology, it was both the science of irrefutable certainties and the romance of destiny. The Middle Ages long remained faithful to the Hellenistic representation and conception of the heavens. The Arabs introduced the knowledge of the ancient Mesopotamian techniques of stellar divination, and instructed the West in the mode of tracing, between the celestial signs, the mysterious network of the stars. The constellations assumed new shapes. The gods which reside in them and whose names they bear, along with the characteristics and attributes derived from classical mythology, were invested with a cloak of more ancient iconography, in order to clarify the links by which they were joined to the various human 'families' and to the different parts of the body. Astrology was not simply a pictorial form of astronomy. It put man in the centre of a system of remote forces. It extended him into a fourth dimension of veiled certainties. The predestined romance of each individual life was set against a perspective of infinity.[2]

The fantasy of chivalry was no less remarkable. Chivalry, on the point of death, endeavoured to reassert itself by an effort of the imagination. This, no doubt, was the significance of the vogue for new versions and sequels of the *chansons de geste*, for the prose romances of the Round Table, and, in actual historical life even more than in the art of the storytellers, the tone of romance which originally coloured those singular institutions, the orders of chivalry founded in the fourteenth century. Was there a political idea behind the Golden Fleece, founded by the Burgundian Dukes, or in the Star, founded by Jean le Bon? Certainly nothing comparable with the vigorous spirit which inspired the military monks

*[1]The beginnings of this trend of sensibility have been analysed recently by M. Meiss, *Painting in Florence and Siena after the Black Death*, Princeton, 1951; see also two articles by E. C. Williams, *The Dance of Death in Painting and Sculpture in the Middle Ages*, Journal of the British Archaeological Association, 3rd series, I, 1937, p. 229 ff., and *Mural Paintings of the Three Living and the Three Dead in England*, ibid., VII, 1942, p. 31 ff.; and W. Stammler, *Der Totentanz, Entstehung und Deutung*, Munich, 1948.

*[2]On astrology, refer to the fundamental work by F. Saxl and H. Meier, *Catalogue of Astrological and Mythological Manuscripts of the Latin Middle Ages, III, Manuscripts in English Libraries*, edited by H. Bober, 2 vols., London, 1953. Vols. I and II were published by the Heidelberger Akademie der Wissenschaften in 1915 and 1927.

of the Holy Land, but rather a brilliant, unreal dream, with no direct bearing on the life of the period. The decorative schemes of the palaces multiplied around these dreamers the favourite figures of their visions, the battle pieces, and the images of the heroes and heroines, as they were painted in the castle of La Manta, in Piedmont, carved on the Maubergeon tower at Poitiers, and woven in the tapestries (high-warp weavers are mentioned in the 1303 Book of Trades), as were also the stories of Troy, and of Jason and Medea.[1] It was by this circuitous route that classical antiquity found its way into the medieval imagination of the West, and it is in this sense that we must interpret the commission, which Jean le Bon gave to his painter Girard of Orleans, for a Life of Caesar to decorate the castle of Vaudreuil. For the King of France, as for the tyrants of the petty feudal courts of Italy, Greece and Rome were primarily 'mirrors' of chivalry and heroism. On Italian soil, however, such evocations possessed a quality of nostalgia. In France, they merely added some great names and some inspiring stories to the tapestry of the heroes of romance.

To these romantic dreams we must add a certain vein of exoticism,[2] and a curiosity of a more general kind, though with strictly defined limits. This curiosity was not a thirst for knowledge, but was concerned with the rare and the strange, with curios, the crumbs of remote civilizations. The great works commissioned or inspired by the royal amateurs are not a complete illustration of their aesthetic tastes. Splendid as they were in their buildings and other enterprises, all princes were in addition covetous of the things of fairy tale, and greedy for the possession of unique objects. We shall see one development of this poetry of the object in the art of Van Eyck. Jean de France, Duc de Berry, the third son of Jean le Bon and the brother of Charles V and Philip the Bold, never lost, throughout his long life (1340–1416), his feeling for the romance of things rare and beautiful. In his palaces at Bourges and Poitiers, in the Hôtel de Nesle, in Paris, opposite the Louvre of the King his brother, and in his castles at Étampes and Mehun-sur-Yèvre, he not only carried out vast works but he also assembled

[1]The hall in which the vow of the Pheasant was sworn (1453); was adorned with hangings representing the Twelve Labours of Hercules, the mythical ancestor of the Dukes of Burgundy. We still possess extensive sets of these romance-tapestries—the Romance of Troy (divided between the cathedral of Zamora, the Metropolitan Museum of New York and the Bargello), the Romance of Thebes (in the cathedral of Zamora), the Knight of the Swan (St. Catherine in Cracow and the Kunstgewerbemuseum in Vienna), the Romance of Arthur (New York), etc. *On the Arthurian themes, see R. S. Loomis, *Arthurian Legends in Mediaeval Art*, London and New York, 1938. A late fourteenth century tapestry showing the Nine Worthies has been studied by J. J. Rorimer and M. B. Freeman, *The Nine Heroes Tapestries at the Cloisters*, The Metropolitan Museum of Art Bulletin, New Series, VII, 1948–9, p. 243–260.

*[2]This important aspect of the art of the late Middle Ages has been revealed in a book by J. Baltrusaitis, *Le Moyen-âge fantastique*, Paris, 1955.

great collections of curiosities—classical medals, cameos, ivories, inlaid furniture, gems and books. His inventories supplement, with their legendary—though authentic—vista, what we know of his taste from the commissions which he gave to Beauneveu and the brothers Limbourg. Like so many of his contemporaries, he introduced a note of fiction into his life, by his chivalrous love for the Lady Oursine, to whom mysterious allusion is made in the little emblematic bears of his punning device, by the settings in which his life was passed, by his meditations on the marvels with which he surrounded himself, and by his wide background, comprising classical antiquity, Italy and the East—both the Byzantine and the Arabic East, which had become fashionable for the moment through the French visits of the Emperors Andronicus and Manuel and through the romantic, disastrous crusade of Nicopolis, from which the Count of Nevers brought back precious stuffs for his uncle, the Duc de Berry. We have a memento of this in the Oriental costumes of the *Très Riches Heures*, and in two of the early miniatures, by a master of the same workshop, of the *Antiquités judaïques*, through which pass, together with superbly robed Saracens, the exotic animals of the ducal menagerie.

It is true that we seem, in all this, to penetrate the spirit of only one social class, and that the bourgeoisie replied to it with satire, in *Renart le Contrefait*, or, as one might perhaps say, with the romance of the romance. Ought we to interpret this social antagonism as the underlying principle of a spiritual dichotomy which appears in the arts as an opposition of the vigorous 'realism', the spirit of observation, the study of nature and the special poetry of the common-sense school as against the irrational fantasy of the romance and of the romantic attitude generally? On the contrary, the bourgeoisie participated, just as the nobility and the lower classes did, in this rich imaginative life which set the key for the century, and, if it was less impregnated with it, since it needed it less, its religious life at any rate was entirely animated by it. The manner in which it conceived and felt God, the mysteries of the Christian faith, the sacraments, the liturgy, and the images also, could not possibly have run counter to that of its period. Furthermore (and here perhaps we touch on the fundamental point), the opposition between fantasy and realism is more apparent than real, and if we tried to interpret the art of the last phase of the Middle Ages in this way we should expose ourselves to the risk of being misled by an artificial contrast. All fantasy needs vigorous 'likenesses' in order to make its illusions convincing to itself and to confer a flavour of actuality on the creations of the imagination. Every romanticism believes that it is achieving truth. But it loads it with expressive attributes and picturesque accessories. It is theatrical by nature and it combines all its elements

with a view to stage-effects. By some such general principle, no doubt, we should account for the influence of the mystery-plays on religious art. It is possible to believe that theatre and iconography (despite actual borrowings and mutual influences) were responding simultaneously to the same demands of the human sensibility, as with the iconography of the French painting of the first half of the nineteenth century and the *mise en scène* of contemporary melodramas. The power of illusion possessed by a false objectivity was manifested in a series of artifices which imitated nature only in order to excel it. This theatrical vision was under no necessity to confine its activities to the theatre. It became prominent as monumental art declined. The architecture which had hitherto dominated and controlled it was in dissolution. This break-up of architecture was not only an essential aspect of the history of the waning Middle Ages; it was also one of the contributory factors. A Romanesque basilica and a thirteenth-century cathedral were not mere silhouettes on the horizons of history; they were centres of activity and influence. The men who had built them had conceived them in this way. Even if we consider it only as a symptom, the disorganization of architecture suggests the reasons for the end of a civilization.

II

THE *Flamboyant* style derives its name from certain particularly noticeable effects in its tracery, whereby the mesh of stone bars takes on the undulations of flickering flames. These forms, which may be of great complexity, are all built up on the basis of the reversed curve. The reversed curve consists of a continuous line composed of two arcs subtended by the same chord and struck from centres lying on opposite sides of the line: the ogee arch shows its elementary and most familiar use; the curve, prolonged by the reversed curve or curve of opposite direction, appears to undulate, and then resume its original course; in the tracery, the 'dagger' (*soufflet*) and 'falchion' (*mouchette*), in the shape of an incurving leaf, are fairly simple applications of the same principle. It is immediately apparent that the reversed curve is by definition capable of imposing a particular kind of movement on the architectural lines, whose natural equilibrium tends to be upset, and immediately re-established, by these changes of direction. It may even be said that it is the essential basis of every kind of Baroque architecture, which is always constructed, in a greater or less degree, according to multiple rhythms.

From what source did it enter French Gothic architecture? Was it derived, in the natural course of development, from the profile of the pointed arch? Or was

it introduced from abroad ? Anthyme Saint-Paul[1] thought that he had discovered early examples of it in French churches of the thirteenth century. These examples are contested. Enlart emphasized the early occurrence of the reversed curve in the English Decorated style[2] and concluded that it was imported into France under the favourable conditions offered by the Hundred Years' War. Against this it is alleged that there is little likelihood that the Curvilinear style would have imposed its dominion on the Continent at a time when it had ceased to be fashionable in England; but this objection is in fact of slight moment, since it is not always the latest novelty which is exported. In truth, the reversed curve is implied in compositions of simple curves. In the rose window of a cathedral, for example, the conjunction of the semicircles which form a border round the external circumference and the pointed arches, which, like petals of an immense flower, alternate with them, displays the profile of the reversed curve to the eye which can seek it out (Paris); a similar effect is produced by the conjunction of the pointed arches of window or triforium arcade with the lower lobe of a quatrefoil above (Évreux). That English examples assisted this figure to consolidate its component parts and give the resultant composition independent existence is perfectly possible; on the other hand, that the pointed ends of the daggers and falchions were held to guarantee good drainage, as against the dangerous water-holding capacity of the circular lobes, is very probable, in this architecture where for so long every element had been carefully calculated, where arches are struts and where cusps strengthen the weak points by increasing the thickness of the stone bars. It is certain, however, that the proliferation of reversed curves is a phenomenon of wider implications and that, in the Flamboyant style as in other phases of the life of the styles, it is important to study the character, movement and tone of the decoration without isolating it from architecture proper. If its

[1] *L'architecture française et la guerre de Cent Ans*, Bulletin monumental, 1908 and 1909. The arcading of the flying-buttresses which surround the choir of Amiens is of *Flamboyant* design; it was long believed to date from the year 1269, since that date is inscribed on one of the clerestory windows, but is in fact not earlier than the fifteenth century. The windows of the choir-chapels of the cathedral of Narbonne were altered in the same period. Similarly at Toulouse cathedral. For the example taken from Saint-Bertrand-de-Comminges, see R. de Lasteyrie's observations, *Architecture religieuse en France à l'époque gothique*, II, Paris, 1927, pp. 41–44. *The question has not advanced much since the publication of R. de Lasteyrie's text book. M. M. Tamir, *The English Origin of the Flamboyant Style*, Gazette des Beaux-Arts, 1946, I, pp. 257–68, stresses only more strongly the differences between the architectural traditions of France and England in the fourteenth and fifteenth centuries. The recent book by J. Baltrusaitis, *Moyen-âge fantastique*, Paris, 1955, contains an important chapter on the sources of the ogee arch and its different interpretations in France and in England.

[2] Choir-screen of Canterbury cathedral (1304), niches below the windows of the octagon at Ely (1322–35), choir stalls at Bristol (1330), tombs of William de la Marcia (d. 1302) at Wells, Aymer de Valence (d. 1323) at Westminster, Bishop Gower (d. 1328) at St. Davids, Eleanor Percy at Beverley Minster (1336–40), etc. F. Bond, *Gothic Architecture in England*, London, 1905, Chap. XXXIII, cites a large number of windows in this style prior to 1350.

luxuriance is concentrated at this particular point and if it tends to dissociate itself and give greater importance to the play of effects than to the organization of the masses and the laws of the structure, this was because the latter were themselves infected, or to use another expression, were subjected to a special treatment.

In the thirteenth-century building, everything is logical. What does this statement mean? Not that the church is a pure theorem, but that all its parts are in agreement one with another. The ribbed vault involves and demands a whole series of consequences, the plan of a pier expresses its structure, and, in this system from which inertia has been banished, every element is a function and every function is specialized, as in the higher animals. The evolution of this art in the second half of the thirteenth and during the fourteenth century was, as we have seen, entirely natural and involved no betrayal of its first principles. The architecture of the fifteenth century, on the other hand, bears witness to a great confusion of thought. Looking first at the vaults, we find them encumbered with subsidiary members, with extra diagonal ribs, with ridge-ribs, tiercerons, liernes[1] and all the elements of the stellar compositions which, in northern France and Germany, achieve effects of extreme complexity,[2] while the vaults themselves grow flatter and are ultimately transformed into coffered ceilings.[3] The structure has lost its significance and become a decorative effect. The same thing happens with the piers, or rather with their component parts, each one of which, in the classic period, had displayed and defined its own function; in the fifteenth century, the colonnettes are simply mouldings. They have the same profile as the mouldings of the vault ribs, of which they are merely continuations: thus the capitals, which often in the fourteenth century were simply bands of ornament, now disappeared altogether, since, there being nothing to support, they were no longer of any value. On the other hand, it also happens that the moulded ribs, instead of being extended down the body of the pier, are tapered so as to bury themselves in the stone at impost level. In either case, whether the ribs are prolonged down to the ground as mouldings, or vanish by penetrating the pier, there is no true springing of the vault, and the same forgetfulness of the

[1]In England (where the ridge-rib was often necessitated by the arrangement of the masonry of the vault), ridge ribs and tiercerons are used in the eastern bays of Ely (1234–52), in the nave and choir of Lincoln (1256–80), and at Lichfield (second half of the thirteenth century). The earliest French example is that of the crossing at Amiens (1260). The same procedure reappeared a century later in the chapel of St. John the Baptist in the same cathedral (about 1375) and became general from the beginning of the fifteenth century. It is not unknown for the diagonal ribs to be entirely replaced by ridge-ribs and tiercerons (Ambierle, Tours cathedral).

[2]Among the numerous examples in northern and eastern France, those of the chapel of the Holy Spirit at Rue and those of Saint-Nicolas-du-Port are especially noteworthy.

[3]In the Lady Chapel at La Ferté-Bernard, the ribs no longer support vault-cells but stone slabs.

specialized functions is again apparent. Pier and arch have coalesced.[1] A vital element of Gothic construction is similarly affected by the altered conception of the flying buttress. We have seen that it long preserved its true character, which consisted in being an arch and in meeting an active force with an active force, irrespective of whether it was strutted with colonnettes as at Chartres, or its inert mass, between extrados and intrados, simply discarded as at Saint-Urbain. We have already noted, at Semur, its slender section and the acuteness of the angle at which it meets the apse wall. In the evening of Gothic architecture, in the late *Flamboyant* style, it assumed two forms which, though entirely different, are symptomatic of the same malaise—sometimes stiffened into a rigid prop, and sometimes bent into a reversed curve.[2]

It is clear that the reversed curve is a symptom—certainly a significant and fundamental one—of a process which was affecting the system to its depths. Even if we confine our attention to the sphere of effects, it is not the only indication of the tendency to set architecture in motion. In innumerable cases the masters endeavour to counteract, by the contrast of oblique lines or in other ways, the dominance of the verticals—for instance, in piers twined round with elongated spirals as at Saint-Séverin in Paris (a phenomenon of which Romanesque Baroque offers more pronounced forms in its twisted colonnettes), or cut into oblique lozenge-shaped facets, as at Gisors (sixteenth century). At Saint-Marc-la-Lande in Poitou, the piers, which resemble the old Romanesque turrets flanking the tall opening of the west front, are divided into zones with flutings running in opposite directions. There are even instances in which the bases themselves, by a kind of false logic, follow this peculiar motion, with their elements not perpendicular to the ground but taking up the same direction as the spiral mouldings which they are destined to receive, with the result that the vertical base of the pier is made up of small engaged bases lying obliquely. This is a strange deviation of the feeling for functions under the despotic pressure of effects. This new instinct, which, as we have just seen, assailed the fundamental

*[1] This phenomenon takes place at an early date in England, for instance in the monastic buildings at Fountains or in the chapter house vestibule at Chester cathedral, both in the first half of the thirteenth century. This solution was also adopted in Normandy as early as the mid-thirteenth century in the south elevation of the nave of Saint Pierre at Jumièges: see G. Lanfry, *L'église carolingienne Saint-Pierre de l'abbaye de Jumièges* (*Seine-Maritime*), Bulletin monumental, XCVIII, 1939, p. 47–66.

[2] See the excellent analysis of the rigid, openwork flying-buttress, given by E. Viollet-le-Duc, *Dictionnaire d'architecture*, I. Paris, 1858, article *Arc-boutant*, p. 76. He points out extravagant examples without condemning the principle. On p. 79, Viollet-le-Duc examines late medieval and Renaissance flying buttresses composed of multiple curves, especially those of Saint-Vulfran at Abbeville (early sixteenth century). As a result of the settling of the free-standing buttresses, there has been a rupture at the point of impact, the method of construction having prevented any slipping, which might have occurred without serious disorder.

principles of the structure, also undermined the strength and stability of the external masses. These disappeared beneath a heavy mesh of balustrades, galleries and gables, in which curves and reversed curves pursue each other and intertwine, and beneath filigree stonework, in which the void devours the solid, excavating and outlining it with an astounding virtuosity of the chisel. Space is everywhere caught up on projections, perforated with airy ornament, inscribed with arabesques. Beneath the arches and vaults of the porches, and beneath the vaults of the interior likewise, in the midpoint of the network of true and false ribs, enormous keystones, carved into openwork cages or figures, are suspended like the stalactites of Islamic art. Never—and not in this respect alone—has Western architecture come closer to the luxuriant ornament of the East and to its fanciful profusion, which seems without purpose, and is certainly unrelated to the structure. This stippling of light and shadow, this undulating movement of the forms, these flames of stone are the most prominent features of the glistening cloak, an optical illusionism which conceals the annihilated masses. It is theatrical in the way it throws forward certain outworks, such as the porches, like bits of stage scenery, but first and foremost it is a great pictorial, or rather painterly, art, which adds brushstroke to brushstroke, creating vibrant effects; it warns us that Gothic architecture, in its Baroque phase, no longer imposes its discipline on the other arts and is about to relinquish its 'primacy'.

Was this not, in some respects, the same situation as had arisen earlier when the Baroque phase of Romanesque art had produced an abundance of pictorial effects, of applied ornaments and twisted colonnettes, and should we not interpret as a symptom of internal disorganization the reappearance of traditional twelfth-century forms in *Flamboyant* decoration? We must not forget that the themes and methods of Romanesque sculpture had survived down to a very late date in certain workshops, and that they had not entirely disappeared even in the genuinely Gothic centres. The gargoyles, for instance, had provided an asylum for a whole zoology of wyverns, chimeras and salamanders, which were petrified in the upper levels of the building in order to spew forth the waters of the heavens. Other monsters found shelter in various nooks and crannies of the architecture. The last phase of the Middle Ages witnessed the re-emergence into the light of day, along with a flexible and fantastic collection of vegetable life, of the creatures which had been produced by the conjunction or contortion of bodies according to ornamental schemes. They swarm over the band-capitals, the spandrels of the gables, the consoles and the keystones. Yet more remarkable—entirely Romanesque methods of composition reappear in some major works of sculpture, as, for instance, in the left-hand tympanum of the west

front of Saint-Vulfran at Abbeville. It is in the swirls and eddies of minor *148*
architectural sculpture, however, that the phenomenon attains its greatest
intensity. Thus the fantasy of the Gothic decline coincided with a renaissance of
fantastic forms in the architectural ornament of the *Flamboyant* style.[1]

It may be that the significance of this style has long been misunderstood. Each
period seeks in the past those things which evoke the deepest response in itself: the
Romantics saw the Middle Ages primarily through the medium of *Flamboyant*
art, just as, of post-Renaissance classicism, what they principally remembered
and savoured were late forms, the rococo taste. Perhaps I myself suffer
from a tendency—peculiar to our present age (though hardly common, much less
apparent)—to look for the stability and grandeur of an intellectual 'order' in
thirteenth-century art. . . . But a wider view of the life of forms enables us to
comprehend their successive phases and to perceive in them something more than
an inevitable sequence. The architecture of the late Middle Ages was blessed with
a quality of magic. It, too, in so far as it distorted the old harmony of architectural
relationships, was an art of fantasy. The tormented style, the quick sensibility,
the luxury, even the disorder were in accord with the moral life of the century and
contributed to its essential qualities. These vast settings, as in all periods, reacted
upon the actors. Despite the nuances which distinguished the various regions,
France showed a remarkable unity of style. Perhaps there is greater luxuriance
and more subtle flame in the north and west—in Normandy, at Rouen,
Caudebec, Louviers, in Picardy, at Saint-Vulfran d'Abbeville and the chapel of
Rue, in Britanny, where the Flamboyant style moulded the obdurate granite into
its characteristic curves—and more sobriety and restraint in the Paris area and on
the Loire.[2] But whether one looks at it in Champagne, at Notre-Dame-de-
l'Épine, in Lorraine, at Saint-Nicolas-du-Port, or in the Midi, in the south porch
of Sainte-Cécile at Albi, where its refined delicacy, as of an *objet d'art*, contrasts *160*
so oddly with the bare enormity of the brick curtain walls, it appears everywhere
as the expression of the same spirit. Everywhere there is the same opposition
between dry, sterile interiors, which, except for the vaults, are continuations of
the *Rayonnant* style, and the external abundance of effects, the luxury of inessen-
tial parts, and their fortuitous and friable appearance. The architecture of Europe

[1]See my study, *Quelques survivances de la sculpture romane dans l'art français*, in Mediaeval Studies
in Memory of A. K. Porter, Cambridge, Mass., 1939, *reprinted in H. Focillon, *Moyen-âge,
Survivances et réveils*, Montreal, 1945.
*[2]The connections between the architecture of the north of France and the Netherlands in the
fifteenth century have been stressed by P. Héliot, *La façade et la tour des abbatiales de Saint-Bertin
et de Saint-Riquier*, Revue Belge d'Archéologie et d'Histoire de l'Art, XVIII, 1949, pp. 12–26, and
Les églises du moyen-âge dans le Pas-de-Calais, Mémoires de la Commission départementale des
Monuments Historiques du Pas-de-Calais, VII, 2 vols., Arras, 1951–53.

in general displayed the same phenomena, or phenomena of the same type, but this uniformity, based on the collapse of a system, allowed perhaps rather more scope to the individual life of the regions.

England had lived through the maturity of its *Flamboyant* style during the first two-thirds of the fourteenth century, with the blossoming of Curvilinear architecture. The Perpendicular style, which succeeded the latter,[1] may be considered as a reaction against it. Its name exactly describes its essential characteristic, the use of verticals which break up the surfaces and, with the aid of subsidiary horizontals, form a system of shallow rectangular frames uniformly applied over the bare wall. This is the revenge of the straight line, supplanting, with all its rigidity and purity, the capricious sinuosities of curve and counter-curve. The treatment of the structural elements, however, underwent remarkable changes of the same kind as those whose significance we have expounded in dealing with the Flamboyant style, and even more paradoxical. The springing of the vault from an inverted cone, which extends the complex network of the vault ribs down over an enormous conglomeration of stone with its point resting on a fragile colonnette, had a remarkable development. But still more curious was the way in which the substance of the vaults was scooped out, as in the choir aisles of Bristol cathedral, where the transverse arches, entirely detached from the vault, carry on their extrados a rigid stone beam to which they are linked by openwork daggers and which supports the point of the conical keystone whereon the ribs converge. The Gothic vault was not the offspring of the timber roof: it espoused similar forms at the end of its career, by deviating from its original conception.[2] In the Netherlands, where the *Flamboyant* style extended into the sixteenth century with the fine churches of Malines and Liège, there was a comparable development, but without the individuality of the English forms: at St. Bavo in Haarlem, the ribbed vault is a plaster imitation; at St. James in The Hague, the ribbed transverse barrels are of wood. Germany no doubt found in the English Perpendicular style the models for its dry, thin manner, as well as the prototypes of the springing of the vaults from fan-shaped masses of masonry: these, however, are simply barrel-vaults resting on inverted pyramids emphasized

[1] It revealed itself for the first time at Gloucester Cathedral (1337). From about 1360, it was in general use. *Earlier manifestations of the Perpendicular style have been recognized in the works of two London masters: the architect William Ramsey, who was building the chapter house and cloisters of Saint Paul's Cathedral in 1332, and the carpenter William Hurley, who took charge of the octagon at Ely Cathedral between 1326 and 1334. See J. H. Harvey, *Saint-Stephen's Chapel and the Origin of the Perpendicular Style*, Burlington Magazine, LXXXVIII, 1946; J. M. Hastings, *Saint-Stephen's Chapel and its Place in the Development of Perpendicular Architecture in England*, Cambridge, 1955, traces the origins of the new style as far back as the 1290s.
*[2] It is not immaterial to note that one of the originators of the Perpendicular style was the master carpenter William Hurley. Gloucester is an amazing work of carpentry in stone.

by groining[1]. It is here, in the vaults, the vital part of the church, that it is possible to perceive the simultaneous emergence, though in various forms, of the fundamental characteristic of late medieval structure—the degeneration of the structural functions. In Germany as in France, the *Flamboyant* style embellished the exteriors with dainty subsidiary structures, such as the porches of the cathedrals of Regensburg and Ulm, the latter opened in the base of a colossal tower, admirable for its strength and vertical impetus. The immense roof of Vienna cathedral is pierced with dormer windows of three lights surmounted by gables, which in turn are inscribed within a vast carved gable, as high as a house. A taste for complex detail and a confused enthusiasm bound by no rule multiplied the convolutions of the stone. Episodes and accessories were brought forth in abundance; everywhere we find the growth and unease of a disorder in search of its natural law.

149

In all this we no doubt see the late flowering of a racial temperament, operating within the general tonality of the period and style. The long-held error whereby Gothic art was interpreted as Germanic in essence and origin was doubtless rooted in the study of the monuments of the fifteenth century, at a time when these seemed to constitute the whole of the Middle Ages. The beautiful *Flamboyant* art of Germany, however, is no more than the German form of a stylistic development which rests on wider principles than those of regional characteristics. It must be appreciated, on the other hand, that German masters worked far afield, as did also the French masters of the same century, and that they were

*[1]This method of vaulting, characterized by a close network of ribs and by small penetrations, originated in Anjou in the early thirteenth century, but followed a complex pattern of evolution in which England played an important part. Three main types have to be distinguished: (a) Domical vaults on square plan, with short orthogonal penetrations. These are common in Anjou from c. 1210: e.g. Saint-Florent near Saumur, La Toussaint and Saint-Serge at Angers, etc. Similar vaults, but with a flatter curve, are found over the lantern of the Liebfrauenkirche at Trier by 1253 and a little before in the Consistory Court or south-western chapel at Lincoln cathedral. This may have been the original form of vaulting in the lantern at Lincoln; at any rate the present vault, built c. 1360–80, conforms also to this type and was copied at York cathedral and at Louth soon after. The late thirteenth century Lady Chapel at Dol in Brittany and the central part of the crypt at Glasgow cathedral are other examples of an early propagation of this type of vault. (b) Domical vaults on polygonal plan such as the Lady Chapel of Wells, c. 1315, or the hexagonal north porch at Saint Mary Redcliffe, Bristol, c. 1325–30, may owe something also to the Spanish cimborios: the Prior's Kitchen at Durham, 1366–71, where the same type of short penetrations is used, seems to be a late confirmation of these Spanish sources. (c) The last type is based on the shape of a barrel vault. It appears early in the thirteenth century at La Toussaint, Angers, followed by Airvault, Saint-Jouin-de-Marnes and Saint-Germain-sur-Vienne. The south-west of England adopts this type of vaults c. 1320: choir aisles of Bristol cathedral, where they are used in the manner of transverse barrels, choir of Wells, nave and choir of Ottery-Saint-Mary, nave of Tewkesbury, choir of Gloucester. In Germany the earliest examples are in the Baltic region, e.g. crypt of Marienburg, c. 1335, where the ribs follow the typical English pattern of a tierceron vault; but this method of vaulting was popularized only by Peter Parler, after 1350, this time with a lozenge ribbing probably derived from Wells. See K. H. Clasen, *Deutsche Gewölbe der Spätgotik*, Berlin, 1958.*

active in Spain, where Hans of Cologne built the spires of Burgos cathedral, and in Italy, where they succeeded to the leading positions in the construction of the cathedral of Milan. This latter is the masterpiece of all false masterpieces. The history of its construction[1] displays a clash of two conceptions—one maintaining its loyalty to the great principles of the art of building, the other regarding architecture merely as the carcase of a decorative scheme. The French master Mignot, who was brought in to save the threatened enterprise, declared energetically that art could not exist without science. As an optical illusion, Milan cathedral successfully produces an effect of grandeur and luxury. But the profusion of gables, pinnacles, finials, balustrades, statues and statuettes cannot conceal from the practised eye the poverty of the architecture and the extreme mediocrity of the technique. It is not here that we must look for the fine qualities of the late Gothic art of Italy, nor yet in the south of the peninsula, where Aragonese influence took its place alongside the persistent influence of French fourteenth-century art, but rather in Venice, which produced, in civil architecture, masterpieces in an unusual and delightful taste, in the *Cà d'Oro*, in the Palazzo Contarini, and in the Doge's Palace, where the gate called *della Carta* sets the seal of *Flamboyant* art on this miraculous palace which is simultaneously Romanesque, Oriental and Gothic. The architects were not called upon to solve the difficult constructional problems of a high nave. On façades which have canals for forecourts, the luxury of the windows and of balconies adorned with pierced rosettes obeys the rhythms of an exquisite order, while in its quivering colour, the old Byzantine city retains a reflection of the splendours of the Levant.

It was on Iberian soil, however, that the development of Mudejar art and the beginnings of Manueline art tinged the declining Middle Ages with their most lively and individual note. The first of these was the continuation of that original fusion of the two great Spanish cultures which had taken place in an earlier period; the other commemorated the discovery of new worlds by the navigators. There is no doubt that unanimity with the West continued to be a powerful force in Spain and Portugal: Pamplona retains the combined vaulting of ambulatory and chapels, after the fashion of Soissons and Bayonne; the influence of the wide naves of Languedoc is found not only in Catalonia but also at Seville, where the cathedral has one of those superb, massive silhouettes characteristic of the Gothic of the South, with flat roofs and much air under the flying buttresses;

[1]See C. Enlart, in André Michel's *Histoire de l'art*, III, Part I, p. 59–60. *Two articles have since thrown new light on the subject: P. Frankl, *The Secret of the Mediaeval Mason*, Art Bulletin, XXVII, 1945, pp. 46–64, and J. S. Ackermann, *Ars Sine Scientia Nihil Est: Gothic Theory of Architecture at the Cathedral of Milan*, Art Bulletin, XXXI, 1949, pp. 84–111.

the additions made to Burgos and Toledo are part of the history of the *Flamboyant* style; and finally, the façade of Santa Maria de Batalha, one of the most beautiful and original buildings of the *Rayonnant* style, reveals a certain influence Tom English Perpendicular which finds its justification in the facts of history. At froledo, San Juan de los Reyes, built in the last third of the fifteenth century, shows (especially in the abundance and colour of the decoration of the transept-ends) the originality of Spain's contribution to the life of the style. At the moment when France was tempering the endless variegation of the effects with intervals of repose, and seeking a truer balance between the plain and decorated parts, at the close of the fifteenth century, the Spanish masters, in façade compositions such as those of San Pablo at Valladolid (1448–61) and Santa Maria *162* at Aranda de Duero (some thirty or forty years later), were scattering generously *163* modelled reliefs in picturesque profusion, set within semicircular or ogee-headed frames, or hung on the walls like trophies, in chequer patterns of mouldings. In the Cappella del Conestabile, at Burgos, as in the transept of San Juan de los *164* Reyes, enormous coats-of-arms, surrounded with scrolls and volutes, recall the armorial enthusiasm of Germany, with its endless shields, crests, banderoles and *165* heraldic monsters.

But, even more than by Spain's unanimity with the West, in this period when the life of forms, so long held captive in the stone and submissive to its laws, shook off this bondage and acquired an unsuspected virulence, we are impressed by her union with Oriental art, reflecting the duality of her nature. The Islamic art of this period, and no doubt earlier, was passing through the same critical phase in the history of style: profuse richness and extreme complexity of composition are equally characteristic of the art of Egypt under the Mameluke Sultans and the art of southern Spain under the last emirs. In both churches and palaces, the Mudejar style bears the marks of its influence—not only in the Villaviciosa chapel in Cordova and the ribbed domes of the *cruceros*, but on the façades of numerous houses, in the facings of glazed tiles and the panels of fretted stucco. Sometimes the cruder traces of Moorish art, such as the enormous keystones of certain doors with pointed arches, are found in association with the curves and counter-curves of *Flamboyant* art. And these latter, by an exaggeration of their concavity, finally form around the apertures a fringe of little semicircles or inverted multifoils. This art, in which two magnificent declining styles, perhaps more attractive to the imagination than the strict development of pure forms, seem to fuse and interchange their resources, has left most interesting monuments in Portugal as well as in Spain. But on the spot where Vasco da Gama disembarked, at Belem, a country's gratitude to the mariners who had just

endowed it with a new world found expression in Manueline art. This art was new by virtue of the novelty of the elements which it encrusted in the stone to form its scheme of decoration—its sea-creatures and its navigational instruments. On the doorways of some Breton churches one may see shells, fishes and ships carved in the granite. But the profusion, colour and powerful objectivity of the Manueline trophies make them iconographically unique. Their repertory of forms is entirely new. As to its stylistic tendencies and its spirit, it is linked, like the Plateresque art of Spain, with the late Middle Ages by its extravagant vitality, its plethoric tumult and the poetry of its chiaroscuro. More than ever, in these stones laden with crustaceans, armillary spheres, hawsers and symbols of civilizations beyond the seas, the dominant sentiment is of the magical quality of life.

III

WE have just seen, from the example of Venice, that these vast transformations cannot be gauged by religious architecture alone. Civil architecture had always been closely linked with the latter, despite differences of purpose and programme. In the stone-built house of the evelenth and twelfth centuries, such as the town-hall of Saint-Antonin or the Manécanterie at Lyons, we can distinguish, in the design of the windows and the decoration of archivolts and capitals, the same principles as we have observed in ecclesiastical art. The intellectual unity of the period is demonstrated by the uniformity of the stylistic evolution. We find further proof of this in a type of dwelling whose form was strictly determined by factors of human geography, weather, climate, the resources of the soil, population and economic conditions—the half-timbered house. This consisted of a framework of timber built up on the main beams, corner-posts and wall-plates, with each storey corbelled out beyond the one below and braced with struts set diagonally or in the form of a St. Andrew's cross. The intervals between the wood were filled with a connecting tissue of rammed earth, light stone or brick (in the south of France). This was the stoutest and most widespread type of house in Western Europe and persisted far beyond the Middle Ages. With its gable end on the street and encroaching on the void by the progressive overhang of its storeys, in order to compensate for the meagre sites, which were all that the over-populated communities could offer, it defines the silhouette of our old towns in England, France and Germany (at Chester, Rouen, Bourges, Dijon, etc.), and its gable-ends sometimes attain enormous proportions, beneath roofs pierced by

range on range of dormer windows. Like the churches, it tended to eliminate the wall, so that, at the close of the Middle Ages, the façades were composed almost exclusively of windows. At the same time the wooden parts, like the panels of furniture, received an abundant decoration; the iconography of death nowhere enjoyed a richer and more varied development than in the graveyard of Saint-Maclou at Rouen, an old charnel house planned as a cloister and of timber-framed construction.

The history of the greater houses was subject to more far-reaching changes. They too were defined by the general conditions of the historical setting, by the state of the social system, by current habits of life and by the relative wealth of the various classes. In the same period, the same country and the same social group—that of the merchant aristocracy—the Venetian palace, with the general accessibility of a trading post and with its little quay and colonnaded gallery opening on the sea, is very different from the Florentine palace, which remained massive and enclosed, like a fortress. The evolution of military science provides the reasons for the differences which distinguish, for example, Coucy, Château-Gaillard, La Ferté-Milon and Pierrefonds, as well as for the successive alterations which converted the City of Carcassonne from an old Visigothic fort into the redoubtable stronghold of St. Louis on the marches of southern France, dominating and protecting the new town laid out in chequer-board pattern at the foot of the ramparts. The town house long retained its military aspect. When art intervened, after wealth and a certain degree of security had been assured, it was as a new force impinging on the life of history, and gave to human existence settings such as had never been seen before. The most considerable factor in the change wrought by the later Middle Ages in the planning of the building, and of life, was without doubt the staircase tower, giving access to each storey from the exterior, the most famous example of which, now vanished, was that built by Raymond du Temple for the Louvre of Charles V. It may be seen in many later buildings, such as the house of Jacques Coeur in Bourges and the house of the abbots of Cluny in Paris. At Bourges, it rises alongside the main block, at the far end of a courtyard ringed round, on either side of the gatehouse, by open galleries with depressed arches. Each surface or facet of its elegant polygonal mass is emphasized by means of several roll mouldings, characterized by nervous strength and linearity. This is an art with no exaggerations, and charming in its restraint. This period of superb towers also excelled in stair turrets; these contain a newel stair, which coils round upon itself as it rises up its central pier (which may have spiral fluting, like those of Saint-Séverin or the Lonja in Valencia), and spreads out at the summit in palm-like ribs. The house of Jacques

Coeur and the Hôtel de Cluny help us to visualize the life led by the great
burghers and the prelates of the late Middle Ages, the conduct of their little
domestic courts and the survival of feudal and military elements in the richer
dwelling houses of the period. Seen from the Place Berry, from the side of the
old town ramparts, the palace at Bourges, with its massive towers and heavy
curtain walls, is still a fortress. The interior displays, not the ducal pomp of the
palace of Poitiers, with its monumental chimney-piece and the delicately
Flamboyant tracery of the window above, but the taste of a refined parvenu, the
prop of the monarchy and the country, one of those King's burghers who form
a kind of dynasty of custom in Capetian France. This type of old noble house,
with its irregular planning, in which no attempt is made to conceal the disjointed
effect, is very different, not only from the palaces of Venice and Florence,
but also from the Spanish palace, which is disposed around a rectangular
courtyard or *patio*, with the several blocks of the building opening on to it
by a double range of porticos. This is the scheme of the Roman, and of the Arab,
house. The external wall has few openings, but it may be decorated, and some-
times in a singular fashion, as in the case of the house in Salamanca which takes
its name from the shells which are carved in relief all over the walls, at regular
intervals. Within, a high panelled plinth runs around the rooms, above which the
walls are sometimes whitewashed and sometimes faced with glazed tiles or
Cordovan leather.

 Although the particular purpose which the civil buildings were designed to
serve forced them everywhere to assume forms which are rarely found in religious
architecture—the division into storeys, for example, which entails the flattening
of the arches of doors and windows and the substitution of plaster ceilings for
vaults—it remains true that in them the life of the decoration and the spirit of
the style is precisely that which we have already seen in the churches. *Flamboyant*
art can show few more characteristic examples than the dormer windows of the
147 *Palais de Justice* at Rouen. These are not simple apertures linked to the main
roof by small subsidiary roofs; on the contrary, they are complex structures of
considerable extent. Their fretted masses, bristling with finials and pinnacles,
propped like the tower lanterns with flying buttresses, overrun with undulating
ornament and perforated in every part, terminate in openwork gables of slender
ogee form. Each one is linked with its neighbours by means of a balustrade
surmounted by a system of twin arches, beneath ogees crowned with finials:
these curious arches serve no purpose, but form a kind of openwork screen
masking the slope of the roof. This is ironwork in stone, the last word in a
pictorial architecture which aims above all at effects, movement, colour and

illusion. The plants with which it decks itself are those which best respond to its needs. In secular buildings, as in the churches, the predominant form is that of the cabbage leaf, broad, fleshy, swollen, with uneven, goffered edges. The virtuosity of the carver matches that of the architect. It appears in varying degrees in the fine town halls with belfry towers which rose at this time in north French and Netherlandish towns as the symbol of municipal prosperity—an art which shows its more sober and powerful vein at Saint-Quentin, for example, and its prolixity at Audenarde. But, throughout the West, the silhouette of the fifteenth-century town as seen against the horizon of history, with its steep-pitched roofs, its church spires, its corbelled half-timbered gables, its angle turrets, its tall stone chimneys, its sharp-pointed pepperpot towers, created a unique region of human dreams. It outlasted its period and gave shelter to the thought of the Northern Renaissance, at Prague, the city of cabbalists, at Bourges, the capital of the threatened monarchy of France, at Antwerp, Augsburg, Dijon. We find it again in the rude woodcuts of the Nuremberg Chronicle, and once more, with its mysterious masses, at once near and far away, upon the crag at whose foot meditates Dürer's St. Jerome.

BIBLIOGRAPHY

GENERAL WORKS
J. Huizinga, *The Waning of the Middle Ages*, London, 1924; R. Schneider and G. Cohen, *La formation du génie moderne dans l'art de l'Occident*, Paris, 1936. *J. Baltrusaitis, *Le moyen âge fantastique, antiquités et exotismes dans l'art gothique*, Paris, 1955, and *Réveils et prodiges, Le gothique fantastique*, Paris, 1960.

ARCHITECTURE
(A) France. C. Enlart, *Origine anglaise du style flamboyant*, Bulletin monumental, LXX, 1906, and Archaeological Journal, LXIII, 1906 (Cf. R. de Lasteyrie, *L'architecture religieuse en France à l'époque gothique*, Vol. II, Paris, 1927, Chap. XIII, pp. 33–68, on the origins of the *Flamboyant* style; Chanoine J. M. Abgrall, *Au pays dès clochers à jour*, Paris, 1902; A. de Champeaux and P. Gauchery, *Les travaux d'art exécuté pour Jean de France, Duc de Berry*, Paris, 1894; L. Jarry, *Notre-Dame de Cléry*, Orléans, 1899; E. Delignières, *Notes relatives aux premières défenses, de 1487 a 1504, pour la construction de l'église Saint-Vulfran à Abbeville*, Bulletin de la Societé d'Émulation d'Abbeville, IV, 1899; L. Deschamps de Pas, *L'église Notre-Dame de Saint-Omer d'après les comptes de fabrique et les registres capitulaires*, Mémoires de la Société des antiquaires de la Morinie, XXII, Saint-Omer, 1890–92, and XXIII, 1894–1896; L. Serbat, *Lisieux*, Paris, 1926; Abbé J. Fossey, *Monographie de la cathédrale d'Évreux*, Évreux, 1898; G. Bazin, *Le Mont Saint-Michel*, Paris, 1933; L. Lécureux, *Saint-Pol de Léon*, Paris, 1909; L. Demaison, *Documents inédits sur Notre-Dame de l'Épine*, Mémoires de l'Académie de Reims, 1895; V. Nodet, *L'église de Brou*, Paris, 1911. *M. M. Tamir, *The English Origin of the Flamboyant Style*, Gazette des Beaux-Arts, 1946; M. Dumolin and G. Outardel, *Les églises de France: Paris et la Seine*, Paris, 1936; G. Bonenfant, *Notre-Dame d'Évreux*, Paris, 1939; R. Couffon, *L'architecture flamboyante en Cornouaille*, Memoires de la Société historique et archéologique de Bretagne, 1952; G. Durand, *Abbeville, collégiale Saint-Vulfran*, Congrès archéologique d'Amiens, 1936; P. Héliot, *Saint-Omer, abbaye de Saint-Bertin*, ibid., and *La façade et la tour des abbatiales de Saint-Bertin et de Saint-Riquier*, Revue Belge d'archéologie et d'Histoire de l'art, 1949.
(B) Other Countries. D. Knoop and G. P. Jones, *The Medieval Mason, An Economic History of English Stone Building in the Later Middle Ages and Early Modern Times*, Manchester, 1933; F. Bond, *Gothic Architecture in England*, London, 1905; C. Hussey, *King's College Chapel, Cambridge, and the College Buildings*, Cambridge, 1926; J. C. A. Hezenmans, *La cathédrale Saint-Jean à Bois-le-Duc*, Bulletin monumental, 1873; A. Podlaha, *Führer durch den Dom zu Prag*, 1906; C. Boïto, *Il duomo di Milano*, Milan, 1889; P. Molmenti, *Venezia*, Florence, 1897; W. Crumm-Watson, *Portuguese Architecture*, London, 1908; R. Dos Santos, *Arquitectura em Portugal*, Lisbon, 1929; J. Barreira, *L'art manuélin*, Gazette des Beaux-Arts, 1934; H. Cottingham, *The History and Description of the Royal Monastery of Batalha*, London, 1836. *J. H. Harvey, *The Gothic World, 1100–1600*, London, 1950; J. Evans, *English Art, 1307–1461* (Oxford History of English Art, V), Oxford, 1949; M. Hastings, *St. Stephen's Chapel*, Cambridge, 1955; J. H. Harvey, *Henry Yevele, c. 1320 to 1400. The Life of an English Architect*, London, 1944, and *English Medieval Architects: A Biographical Dictionary, down to 1550*, London, 1954; K. H. Clasen, *Deutsche Gewölbe der Spätgotik*, Berlin, 1958 (and review by N. Pevsner in Art Bulletin, XLI, 1959, pp. 333–336); K. M. Swoboda, *Peter Parler, der Baukünstler und Bildhauer*, Vienna, 1940; P. Frankl, *The*

Secret of Medieval Masons, Art Bulletin, XXVIII, 1945; J. S. Ackerman, *Ars Sine Scientia Nihil Est: Gothic Theory of Architecture at the Cathedral of Milan*, ibid., XXXI, 1949; G. Kubler, *A Late Gothic Computation of Rib-Vault Thrusts*, Gazette des Beaux-Arts, 6th series, XXVI, 1944; G. Weise, *Die spanischen Hallenkirchen der Spätgotik und der Renaissance*, I, Tübingen, 1953.

(c) Civil and Military Architecture in the Middle Ages. P. Lavedan, *Histoire de l'urbanisme, antiquité, moyen âge*, Paris, 1926; C. Enlart, *Manuel d'archéologie française, Architecture civile et militaire*, 2 vols., 1919–32; A. Verdier and F. Cattois, *Architecture civile et domestique au moyen âge et à la Renaissance*, 2 vols., Paris, 1855; R. Quenedey, *L'habitation rouennaise*, Paris, 1926; E. Lefèvre-Pontalis, *Le château de Coucy*, Paris, 1913 and 1928; J. Poux, *La Cité de Carcassonne*, Toulouse, 1923; M. Dieulafoy, *Le Châteaux-Gaillard*, Paris, 1898; F. de Fossa, *Le château de Vincennes*, 2 vols., Paris, 1908; L. H. Labande, *Le palais des papes et les monuments d'Avignon au XIVe siècle*, Marseilles, 1925; A. Gandilhon and R. Gauchery, *Bourges, Hôtel Jacques Coeur*, Congrès archéologique de Bourges, 1931. *R. Ritter, *Châteaux, donjons et places fortes*, Paris, 1953; S. Toy, *Castles, A Short History of Fortifications from 1600 B.C. to A.D. 1600*, London, 1939, and *The Castles of Great Britain*, London, 1953; R. A. Brown, *English Medieval Castles*, London, 1954, and *Royal Castle Building in England, 1154–1216*, English Historical Review, LXX, 1955; D. F. Renn, *The Anglo-Norman Keep, 1066–1138*, Journal of the British Archaeological Association, 3rd series, XXIII, 1960; W. D. Simpson, *Harlech Castle and the Edwardian Castle-Plan*, Archaeologia Cambrensis, XCV, 2, 1940; K. H. Clasen, *Die mittelalterliche Kunst im Deutschordensstaate Preussen*, I. *Die Burgbauten*, Königsberg, 1927; S. O. Addy, *The Evolution of the English House*, London, 1933; M. E. Wood, *Norman Domestic Architecture*, Archaeological Journal, XCII, 1936, and *Thirteenth Century Domestic Architecture in England*, ibid., CV, Supplement, 1950; P. A. Faulkner, *Domestic Planning from the Twelfth to the Fourteenth Centuries*, Archaeological Journal, CXV, 1958; J. T. Smith, *Medieval Roofs. A Classification*, ibid.

Sluter and Van Eyck

I

IN this curious setting, a new world of figures. Two great names: Sluter, Van Eyck. Both are grappled to the Middle Ages by some of their innermost fibres; both announce and propagate a new conception of man and nature. They carry within them a thought which is essentially Western and medieval, but the force which they confer on it, and the methods they use to do so, are such that it to some extent recoils upon itself and destroys the old order. Sluter conceives sculpture like a great painter and an epic poet; though the instinct for the monumental law still possesses him, he replaces it with a new law which draws all its strength from the work itself and its expressive qualities; he creates a style. Van Eyck deepens the space behind the images; he invents a new dimension, that of transparency, and within a universe which has now no limits and is entirely accessible to the eye, his rigorous analysis sets man and object in their places; he inaugurates a scale of truth more exacting than that of life itself, which the word 'realism' is powerless to define.

Each of these two men, the one at Dijon, the other at Bruges, belonged to the great dukedom of Burgundy, including Flanders, which passed through the apogee of its historical career in the late fourteenth and the first half of the fifteenth centuries. Philip the Bold and Philip the Good were of the same lineage, and felt the same instinct and need for magnificence, as Jean de Berry, but with a wider range of vision, and a more powerful apanage to back their political activity.[1] They loved beautiful things, not as collectors, but as princes for whom they were a kind of necessary function, an aspect of the art of life, in the same way as the brilliant and singular festivities, the lengthy banquets and the chapters of the orders of chivalry. The chronicles and inventories bring before us the episodes and ornaments of these lordly pageants of the great nobility, luxuriating in a kind of real-life romance, though so soon to feel the shrewd blows of a bourgeois king. They had the faculty of attracting everything great and rare, and fashioning from it an ornament for themselves, but in their fine Flemish towns, the municipal authorities and the merchant patriciate were no less favourable to enterprise and talent. It was natural that the Dukes should summon Flemings to

*[1] See H. David, *Philippe-le-Hardi, duc de Bourgogne et co-régent de France. Le train somptuaire d'un grand Valois*, Dijon, 1947.

Dijon; it was no novelty, for Flemings were numerous in Paris and in the royal workshops in the fourteenth century, and their art differed from that of France only in a certain trick of hand, habits derived from the use of certain materials, such as the stone of the Meuse valley, and some nuances which were merely variants of the basic style.

The state of French sculpture in the late fourteenth century may be seen in the statues of the Quinze-Vingts and Poitiers, and, in a heavier vein, in those of the Amiens buttresses.[1] They are equilibrium itself, and we have seen how much of the monumental substance remained, beneath the more closely studied details, and in the melting unity of the modelling: the tranquillity of the light is the expression of a profound repose and of the harmonious life of the forms. This, however, was the tone of Paris and the royal workshops, and we must not forget that funerary sculpture, from the mausoleum of Cosenza down to the tomb of Cardinal de Lagrange, had given a violent rendering of life's disorder in the very image of death. Nothing in Flemish art, except perhaps the heaviness of some of the volumes, gives any hint of a forthcoming transformation of sculpture. The same heaviness is still more apparent in Germany, together with a certain luxuriance of the draperies, from the second half of the thirteenth century onwards, especially in the fine figures of the Naumburg choir. But we must allow that the business of genius is not so much to illustrate a tradition or the spirit of a period as to discover new things. Claus Sluter was in touch with the masters who worked for Jean de Berry at Mehun-sur-Yèvre; at Dijon itself, he worked for some time under Jean de Marville, before he succeeded to his position. The documents leave little room for doubt concerning his origins: he came from the county of Holland.[2]

Three groups of works, either from his own hand or under his immediate influence, still survive in Dijon—the portal of the dynastic chapel of the Dukes at the Charterhouse of Champmol, the base of a crucifix nearby, adorned with

*[1] On the state of sculpture in France in the late fourteenth century, see G. Troescher, *Die burgundische Plastik des ausgehenden Mittelalters und ihre Wirkungen auf die europäishe Kunst*, Frankfurt-am-Main, 2 vols., 1940. Many points are still under discussion, for instance the exact definition of André Beauneveu's style and influence. On this question, see: P. Pradel, *Les tombeaux de Charles V*, Bulletin monumental, CIX, 1951, pp. 273–296; L. Labande-Mailfert, *Le Palais de Justice de Poitiers*, Congrès Archéologique de Poitiers, 1951, pp. 27–43; H. Bober, *André Beauneveu and Mehun-sur-Yèvre*, Speculum, XXVIII, 1953, pp. 741–753.

[2] The Cartulary of the abbey of Saint-Étienne at Dijon mentions, under the date 7th April, 1404, 'Claus Sluter de Orlandes, ouvrier d'ymages'. *Orlandes* is traditionally accepted as a form of *Hollande*. Lieutenant-Colonel Andrieu regards it as a reference to a place in the Boulonnais. We know, however, that Claus de Werve, Sluter's nephew, came from Hatheim in Holland, which strengthens the case for the Dutch origin of the family. Finally, a document of pardon, discovered by H. Stein, indicates the presence in Bourges in September 1385 of a certain Claus de Sleusseure, surnamed 'of Mainz'. . . . In March of the same year, Sluter was working in Dijon as assistant to

144
143 figures of prophets and known by the name of the Well of Moses, and finally the two tombs in the Museum, designed (perhaps after an idea of Marville's) and partially executed by him and completed by his successors, his nephew Claus de Werve, Juan de la Huerta and Antoine Le Moiturier. Some fragments of the crucifix are also preserved, notably the head and part of the torso of Christ. Each of these memorable *ensembles*—and not only the Well of Moses—merits the special attention which is owed to an art which dominates its period by the example and manifest superiority of its innovations. Certainly one could not expect to find at Champol—which was meant as a mortuary chapel—a portal composed on the lines of a cathedral doorway; it is quite natural to find the founders and their patron saints occupying this position. But the statues no longer hold the wall, do not stand on engaged columns, but are raised on consoles. Some are erect, some kneeling, and those which are given a vertical development —the Virgin, St. John and St. Catherine—are caught up in the swirl of their own movement. The Virgin of the *trumeau*, traditionally ascribed to Jean de Marville, has nothing in common with the French Virgins of the fourteenth century, still less with their elder sisters of the thirteenth. She emerges from the architecture and seems to advance towards us in a tumult of draperies, which she seizes energetically in her clenched fist. Sluter's draperies are complete dramatic compositions in their own right. The body which inhabits them, and which they conceal, has no significance except as the support for their movements, their cascades and their voluminous waves. It is not so much a living organism as a system of forces, a composition of axes, manoeuvring and contriving grandiose folds which are intersected by deep, shifting shadows. The tomb-weepers are

Jean de Marville, whom he succeeded in 1389. In 1392, he went to Paris; in 1393, to Mehun-sur-Yèvre, where he studied the works of André Beauneveu; in 1395, to Liège. In addition to the tomb of Philip the Bold, conceived by Jean de Marville (?), the Charterhouse portal and the Well of Moses, he executed many other works, especially in the castles of Argilly and Germolles (1397–99). It is presumed that he died in January 1406, after his retirement (1404) to the abbey of Saint-Étienne. Claus de Werve was working with his uncle from 1396 onwards. In 1410 he completed the tomb of Philip the Bold (d. 1404). The execution of the tomb of John the Fearless and Margaret of Bavaria was deferred until 1435. It remained unfinished at the death of the artist in 1439, and Philip the Good transferred the commission to the Aragonese Juan de la Huerta (1443–62), who was in turn replaced by Antoine Le Moiturier from Avignon. The tomb was completed in 1476. The tomb of Philippe Pot is also attributed to Le Moiturier but surpasses the normal level of accomplishment of that master. *The most recent monograph on Sluter is H. David, *Claus Sluter*, Paris, 1951, where unfortunately the problems of the origins of Sluter's style and of his early works prior to his Dijon period are not discussed. On these delicate questions, in addition to G. Troescher's important volumes, see J. Duverger, *De brusselsche steenbickeleren der XIVe en XVe eeuw . . .Klaas Sluter* . . . , Ghent, 1933, *Brussel als Kunstcentrum in de XIVe en de XVe eeuw*, Antwerp-Ghent, 1935; A. Liebreich, *Recherches sur Claus Sluter*, Brussels, 1936; and D. Roggen, *Klaas Sluter voor zijn Vertrek naar Dijon in 1385*, Gentse Bijdragen tot de Kunstgeschiedenis, XI, 1945–8, pp. 7–40. Sluter was settled in Brussels in 1380 and several carved consoles at the Bruges town hall as well as the Prophets from the Brussels town hall can fairly safely be attributed to him.

less ostentatious, but no less authoritative. As is well known, they represent, not *143* monks, but the relatives, vassals, officers and intimates of the Dukes, shown as they took part in the funeral rites, clad in those frocks and hoods of black cloth, the cost of which we find entered in the account books. This was not the first occurrence of the representation of the funeral ceremony on the sides of the tomb, but it had never hitherto been treated with such amplitude and variety. The procession of weepers, headed by the clergy, moves forward beneath delicate marble arcades. They are all individual studies, many of them of great power. Some of the latest among them reveal the anecdotal taste of the period, and even that homeliness of inspiration, which the Middle Ages was at all times apt to introduce among its most solemn images and ideas. But many of them also have that feeling for the unity of the block, which is absent from the portal figures, but which is admirably exemplified by the finest statues of the *Puits de Moïse*. If we isolate them, and magnify them to life-size, we see that they possess that special monumental strength which, even when the laws of architectural fitness had been forgotten, continued to reside in broadly carved, compact figures, such as were, in and by themselves, entire sculptural schemes and architectural monuments. We may judge of this, in the later fifteenth century, from a master-piece similar in inspiration but larger in scale, the tomb of Philippe Pot, lord of La Roche-Pot, and Grand Seneschal of Burgundy on behalf of Louis XI. The weepers of Philippe Pot, however, compose a human architecture which is stronger and more resistant than the colonnettes and arches of the ducal tombs; upon their shoulders, into which the bier sinks deeply, they bear their lord, recumbent in the accoutrements of war; they have the grandeur of the primitive monuments of the Celts, formed of standing stones surmounted by a massive slab.

This scale of grandeur, which belongs to history as a whole and exceeds the scope of its subdivisions, we find also in the *Puits de Moïse*. Iconographically, Sluter has interpreted the old correspondence of the two Testaments which, in former days, had figured in the portals, but the *cortège* of prophets who had introduced the faithful into the church of Christ has transformed itself into a kind of superhuman plinth, supporting the Passion. We have here, no doubt, the most striking instance of that unanimity of the theatre and the figure-arts, which is one of the characteristics of the later Middle Ages, and, if not a direct trans-position into stone, at least a reminiscence, in subject, and perhaps in costume also, of a grandiose drama—the Prophets passing judgement on the Lord. But it is easy to see how far removed from stage deployment is the unity of this scheme, proper to the genius of a great sculptor, which turns the masters of the Old Law

into the caryatids of the Gospel. Grouped around a polyhedral block, and surmounted by weeping angels carrying a cornice, above which rose the Cross between the Virgin and St. John, they are both figures of contemporary life, whose dress and lineaments some of them wear and the mysterious visionaries of the Scriptures. Moses stands outside time. He may be a portrait, but a portrait transfigured. His awe-inspiring decrepitude belongs, not to humanity, but to some older race. His head is thrown back, his eyes deep-set beneath arched brows, his long forked beard flows down over his chest, his broad and compact body is made still broader by the transverse folds of his tunic: in the genius of the master who imagined him, we must recognize, not the reflection of a moment of history, but the continuity of a dynasty of the spirit, which began perhaps with Master Mateo and which descends to our own day through Michelangelo and Rodin.

The art of Claus Sluter and the masters of his workshop defined the scope of the fifteenth century art of Burgundy. It is true that it took on inflexions which came to it, in course of time, from the south of France, from the Loire and from the Rhineland. But it retained the imprint of its beginnings, and continued with the constancy of a 'manner'. The type of the Burgundian Virgin, stocky, block-like, muffled in her draperies, enjoyed the same wide diffusion as the supple Virgins of the fourteenth century. The type of the aged prophet fared likewise. At the same time sculpture became more and more independent of architecture and, taking hints from painting and the theatre, produced retables of wood or stone, with many figures, divided into separate scenes, full of episodic touches and ingenious or pretty inventions: homeliness killed monumentality. The statues, forsaking the portals, grouped themselves in the scene of the Entombment of *142* Christ, well mimed by excellent actors. At Tonnerre, Chaumont, Solesmes, later at Saint-Mihiel, and still later in Brittany, where the art of the Calvaries and Sepulchres, in its popular form, is rude but not unbeautiful, and, in a more general view, throughout Western Europe, this last act of the drama of the Passion snapped the last links which still bound monumental sculpture to architecture. In the twilight of the chapels, the life-size figures, which are some-times made more vivid by bright colouring, compose a *tableau vivant* intended to strike the imagination by the strangeness of its effect, by the verisimilitude of the likenesses and by the devices of elementary stagecraft. These characteristics did not exclude the poetry of individual talent. This is equally apparent in the *Pietà* groups, representations, often very lovely, of the Compassion of the Mother of God, of which the cult, the vogue and the image had been spread abroad by the Meditations of the pseudo-Bonaventura. The composition of two

bodies, one arched backwards across the knees of the other offers, moreover, an admirable formal motif. Set in the rigid curve of death, or still warm with the life which he has just expired, the Son, lying in the arms of His Mother, who bends over Him, is the most pathetic expression of that religion of pain and death which filled the thoughts of the later Middle Ages. In the workshops of southern Champagne, at Troyes, the masters of this period and their successors in the sixteenth century, executed many fine examples in wood and stone, with variations on this single theme which display both sensitivity and virtuosity. They were also called on to provide, in choir-screens, overrun with an exuberant vegetation of ornamental forms and allied with, or rather tacked on to, the most prolix architecture, the final chord of that Gothic Baroque which survived the importation of Italian forms by incorporating them within itself. From the first half of the fifteenth century onwards, the independence of figure sculpture in relation to its architectural settings and the quest for *inherent* monumentality— which, however, was at odds with the taste for anecdotes, the ostentatious *mise en scène* and the pictorial treatment—these characteristics, in conjunction with those which had been impressed on the art of the time by the mysticism and aestheticism of pain, demonstrate very clearly to what extent this Gothic romanticism was opposed to the order, the luminous calm, and the Christian optimism of the thirteenth century.

II

WHEN architecture ceased to wield over the other arts that influence which had enabled it to impose its own laws on the disposition and even on the form of the images, painting became the laboratory of experiments in space. This was certainly the most remarkable development of the fifteenth century in Western Europe and Italy. With regard to the latter, we shall see later how it could take place, without conflict, concurrently with the birth or revival of an architectural style. The signs of fundamental change in this respect are not to be found in Gothic mural painting. This was still held in check by the wall and gave expression to the contemporary spirit in other ways, by its delicate secular atmosphere, the fullness of the draperies, the elongation of the figures, by its representations of Virtues, Vices and Sibyls, and, in the Dance of Death—from that of the charnel-house of the Innocents in Paris, no longer extant, down to the memorable paintings of La Chaise-Dieu and those which adorn, beneath a keeled vault, the

chapel of Kermaria-Nisquit in Brittany[1]—by the preoccupation with death, allied with an egalitarian sentiment which was already apparent, though in a quieter and graver treatment, in the Last Judgement reliefs of the thirteenth-century cathedrals. It is in the manuscripts that we must study the progress of a line of research which gradually replaced the solid decorated surface by the illusion of depth, first of all as a magical device—the transparency of the atmosphere—and eventually as a rationally constructed space. Perhaps it was the natural consequence of that vast discovery of the world which Gothic art initiated long before the advent of the Italian Renaissance, but it was a consequence which recoiled upon its original progenitor. Perhaps it was contained in embryo in all the attempts to 'rationalize' form, in, for instance, the geometry of Villard de Honnecourt and the physical science of Robert Grosseteste. But it long retained, through the various phases which brought it finally to the possession of 'reality' and 'objectivity', its quality of fantasy or, in other words, its own special poetry. To put it in another way, life was more than ever miraculous. On the delicately illuminated leaves it is both a truthful image and a fairy tale. Let us look once more at the most famous of the manuscripts of the period. The calendar of the *Très Riches Heures*[2] of Jean de Berry is a continuation of the old stone calendars in which the cathedral carver summarized in a few sober figures the works and days of the Christian year, but, behind the tillers of the fields, the grape-harvesters, the shepherds, the hunt servants and the nobility, there rise the shapes of the earth's surface—the gentle slopes of the meadows, the backcloth of the royal forests, and the Duke's castles, treated with the exquisite minuteness of the masterpieces of the goldsmith or those church models which donors hold in their hand as an offering to the Virgin. Objects are at once far off and close at hand, arranged in strata one behind the other, in a scheme reminiscent of

[1]These paintings have been described by M. Thibout, *La chapelle de Kermaria-Nisquit et ses peintures murales*, Congrès Archéologique de Saint-Brieuc, 1949, pp. 70–81.

[2]About 1410, when Jean de Berry was nearly seventy, the *Très Riches Heures* (Chantilly) were begun by three nephews of Jean Malouel, who were known by the name of the town from whence they came, Limburg, in Guelderland. The two elder, Pol and Hennequin, were already in the service of the Duke in 1402. The youngest, Hermant, was in apprenticeship in 1399, originally as a goldsmith. In 1411, all three had the title of *valet de chambre* to the prince. When Jean de Berry died in 1416, 39 large miniatures, 24 small ones, and 86 decorated initials had been finished. Some compositions were in the state of line-drawings. Late in the century (1485), Charles of Savoy entrusted the completion of the manuscript to Jean Colombe, brother of Michel Colombe, who executed 23 large miniatures and 38 small ones (f. 52–f. 199), together with the missing initials. See Comte Paul Durrieu, *Les Très Riches Heures du duc de Berry*, Bibliothèque de l'École des Chartres, LXIX, 1903; G. Hulin de Loo, *Les Très Riches Heures de Jean de France*, Bulletin de la Société d'histoire et d'archéologie de Gand, 1903; H. Malo, *Les Très Riches Heures du duc de Berry*, Paris, 1933. *The Italian origin of the landscapes which illustrate the *Très Riches Heures* and the slightly earlier Chester-Beatty Hours has been demonstrated by O. Pächt, *Early Italian Nature Studies and the Early Calendar Landscape*, Journal of the Warburg and Courtauld Institutes, XIII, 1950, pp. 13–47.

Sienese 'cartography' yet with no impatient longing to deepen space. At the same time, the *Très Riches Heures* finds room also for those visionary landscapes which have nothing in common with terrestrial realities and which, side by side with the landscape of lord and peasant, give form and substance to the marvels of the Christian imagination. Precipitous rocks, impossible overhangs, a hollowed cave-like world, a golden light, steady yet scintillating—these features of the daydreams of the period recur, not only in the first three leaves of the *Antiquités judaïques*, which belong to the same tradition, but also in the subsequent pages and throughout Jean Fouquet's *oeuvre*, where it is combined with the tranquil morning poetry of the Loire and with reminiscences of Italy.

But until they were, so to speak, filtered into the subtle rays and sensitive touches which are those of the 'real' light and the light of an imagined world, the unreality of gold grounds in the Sienese fashion continued to dominate the spatial conceptions of the pre-Eyckian panel painters of the North. Their works were a halfway house between wall painting and miniature. They attained, on occasion, the large dimensions of the former, and the gesso which was laid on canvas stuck down over the wood provided a support for the colour analogous to that offered by the wall. At the same time they shared with the miniatures the exquisite quality of their hues, the even, untransparent brightness, and the heightening with touches of gold. Even those of the pre-Eyckian painters who were most attentive to the life of forms were still limited to the poetry of lovely surfaces and to a colour harmony without brilliance. It is understandable that, in experiments with space, they were less advanced than the illuminators, who ran no risk of breaking up an architectural surface, and could safely entrust to small portable objects, to the pages of a book, the most daringly advanced experiments in landscape depth. Both groups of artists, however, the Malouels and Broederlams as well as the Limbourgs, worked, so to speak, in the same water-colour world. The event which is, with extreme impropriety, entitled 'the discovery of oil-painting', was primarily the transference of the 'precious quality' into another material, richer, deeper and above all more varied than gold. The gold reflects the light, creating around and within the figures an abstract radiance of unvarying purity, as is clearly shown by the efforts which the painters made to give it variety and to make it vibrate with a kind of feigned diversity. The colour of the Van Eycks absorbs the light, allows it to pass undimmed through its crystalline substance, and returns it again full of life and warmth. This was the great innovation. It is possible that the technique was known to Margaritone of Arezzo; it is certain that oil painting is referred to in

the account books of John the Good. But the systematic employment of a medium which gave the artist's materials transparency and brilliance—advantages which remained as permanent acquisitions of the art of painting—was introduced in the workshops of Flanders, by the brothers Van Eyck.[1]

Its consequences were not limited to a new beauty of material and light. It created around the forms a fluid atmosphere which the eye could traverse and penetrate without let or hindrance, and even the horizon itself constitutes no barrier, but an undefined suggestion of an ulterior dimension, from which the figures seem to come towards us with enhanced scale, consistency and brilliance. It is, in some degree, a way of breaking down the limits of space, and of revealing its crystalline purity, even in the bodies which inhabit it. Finally, in the handling of the brush, it introduced a hitherto unknown analytical keenness by allowing the hand to glide, without running of the colour, and to retain a constant firmness of touch with a material which lost none of its ductile freshness in course of

[1]Jan van Eyck, a native of Guelderland, was born between 1385 and 1390. He must have worked prior to 1417 for William of Bavaria, Count of Holland (collaboration on the Turin and Milan Hours ?), and, from 1422 onwards, for the brother of the latter, John of Bavaria. In 1425 he entered the service of Philip the Good. From 1425 to 1430, he was travelling in Portugal and Spain. In 1432 he was settled at Bruges and there completed the altarpiece of the *Adoration of the Lamb*. He was married in 1433 and became the father of a son in 1434, in which year he painted the portrait of Arnolfini. It is presumed that the *Virgin with the Chancellor Rolin* was contemporary with the Peace of Arras (1435). The *Virgin of Canon Van der Paele* dates from 1436. Jan van Eyck died in Bruges prior to 9th July, 1441. His brother Hubert, d. 1426, is reputed to have begun the Adoration of the Lamb. We have no exact information regarding his activity, and his collaboration with Jan has been much disputed. See K. Voll, *Die Werke des Jan van Eyck, eine kritische Studie*, Strasbourg, 1900; M. J. Friedländer, *Altniederländische Malerei*, Vol. I, Berlin, 1924, and especially E. Renders, *Hubert van Eyck*, Paris–Brussels, 1933. The traditional view is accepted by A. Schmarsow, *Hubert und Jan van Eyck*, Leipzig, 1924, and F. Winkler, *Die flämische Buchmalerei des XV. und XVI. Jahrhunderts*, Leipzig, 1925. *A considerable number of publications have been devoted to the brothers Van Eyck since 1938. Of particular importance is the volume by Ch. de Tolnay, *Le maître de Flémalle et les frères van Eyck*, Brussels, 1939, which alters the traditional perspective by showing that many of the inventions attributed to the Van Eycks were actually present in the slightly earlier works of Robert Campin (the Master of Flémalle). This view has been widely adopted. The present state of scholarship on early Flemish painting will be found in E. Panofsky, *Early Netherlandish Painting. Its Origins and Character*, 2 vols., Cambridge, U.S.A., 1953; see also L. van Puyvelde, *The Flemish Primitives*, Brussels, 1948, *La peinture flamande au siècle des van Eyck*, Brussels, 1953, and the excellent *mise au point* by O. Pächt, *A New Book on the Van Eycks*, Burlington Magazine, 1953, pp. 249–253, written *à propos* the publication of L. van Baldass, *Jan van Eyck*, London (Phaidon), 1952. The question of the Turin Book of Hours is still very controversial: the attribution of 'Hand G' to an early Dutch painter first proposed by M. Dvořák and supported among others by Ch. de Tolnay and O. Pächt, is not accepted by E. Panofsky, who favours again the attribution of these miniatures to Jan van Eyck during his stay at The Hague, 1422–24. As for the Hubert van Eyck dispute, in spite of the negative attitude maintained by E. Renders, *Jean van Eyck et le polyptyque: deux problèmes résolus*, 2 vols., Brussels, 1950, his existence is now accepted by most scholars and the publication of P. B. Coremans, *L'Agneau Mystique au laboratoire* . . . , Collection 'Les Primitifs Flamands', Series III, Vol. 2, Antwerp, 1953, gives a firmer basis for a renewed assessment of the part of the two brothers in the Ghent altarpiece. On the technical aspects of Flemish paintings, see J. Maroger, *The Secret Formulas and Techniques of the Old Masters*, New York, 1948, and P. B. Coremans, R. J. Gettens and J. Thissen, *La technique des primitifs flamands*, Studies in (Etudes de) Conservation, I, 1952.

application. Thus it endows painting under our very eyes with the triple advantage—beauty of colour, transparency of atmosphere, and firm analysis. It was the progenitor of modern painting.

The Eyckian genius, however, remained closely bound to the Middle Ages and to its own time—in iconography, of course, but more especially in its poetry, and perhaps also in a certain philosophy of the microcosm, in connection with which there is room for a definition of character and an enquiry into origins. In proportion as the principles of the art of the monuments loosed its hold and painting replaced sculpture as a medium of expression, and particularly as a means of investigating the universe, there sprang up a taste for the infinitely small. Can this passion for minutely executed detail be identified with the attitude of vulgar passivity usually called realism? If we saw the real world thus we should be overcome with vertigo. In looking at these immense yet minute views of towns, where creatures, hardly discernible, yet equipped for the exact performance of all the necessities of life, move hither and thither across the public squares, one wonders whether the artist's conception was not connected with that of the astrologers and mystics, and whether his intention was not to introduce into the world of God a painted world which should be an infinitesimal reflection of its proportions, just as the human figure placed in the centre of the zodiacal circle is the microcosm of universal being. I seem to see a proof of this in the circular convex mirror which hangs on the wall of the nuptial chamber wherein the Arnolfini couple plight their troth (London).[1] This is not a picturesque fancy or furnishing accessory, this optical instrument which is placed in the exact centre of the composition and which reflects both the realm of truth and the realm of the imagination. It is not empty. It contains a microcosm of the scene viewed from the opposite direction, and, behind the reflection of husband and wife, the reflection of two witnesses who are not part of the picture world. We

[1]See E. Panofsky, *Jan van Eyck's Arnolfini Portrait*, Burlington Magazine, 1934. The picture, which commemorates and certifies the marriage of Giovanni Arnolfini of Lucca, residing at Bruges before 1421, subsequently counsellor to the Duke of Burgundy, later director of finances in Normandy, with Giovanna Cenami, the daughter of a Lucchese family settled in Paris, incontestably figures in the inventory of Margaret of Austria, where Arnolfini is rendered as Hernoul le fin. It was described by Van Mander, who had not seen it, in his biography of Van Eyck (1664): on the basis of the words 'per fidem', which signify simply the plighted troth, this writer introduces into his imaginary description an allegorical personification of Faith, joining the hands of the pair—an excellent example of misunderstanding giving rise to fiction. All the elements of the composition, which are disposed with solemn symmetry, are evocative of the profound significance of the marriage ceremony, at which Jan van Eyck states that he was present—note, in addition to the dog, symbolizing fidelity, the single candle burning in the chandelier, a nuptial taper, reminiscent of the classical *taeda*, etc. The bridegroom's left hand is joined with the bride's right, but this is to enable Arnolfini to raise his right hand in the gesture of prayer—at the same time balancing the volume of the body and 'closing' this part of the composition. The event is transfigured in this mysterious, almost mystical, rendering.

see an inversion and reduction which transpose into a sphere at once far away and near at hand this ceremony whose image has been traced like a certificate by the artist: 'Johannes de Eyck fuit hic'.

Admittedly, the development of the science known as perspective made such compositions possible, or rather clothed the mystery in an air of verisimilitude. In the framework of perspective, however, the smallness of distant figures is only one element, among many others, of the rational structure of space, and it is by virtue of this agreement of all the parts that perspective is 'natural', that is to say, creates a perfect illusion. We are so familiar, both by the exercise of vision and by our acquaintance with works of art in 'correct perspective', with the diminution of distant figures that it requires an effort to consider them as small—they are not so, and they do not seem to us to be so. But the artists who applied the rules of perspective when they were as yet new-minted, felt their effects to be curiosities worthy of attention and instinct with their own peculiar kind of poetry. The distances with their tiny figures seemed to them a microcosm of the universe. The diminished image in the convex mirror exaggerates distance by reducing the size of the figures. The reflection in a plane mirror merely doubles the distance between it and the image, but the convex surface takes on the hollowness and the curvature of the world. Thus, within the circumference of the frame, the microcosm is renewed by an arbitrary perspective; thus the universe contains its own image, minute and in reverse direction, an arm's length away, yet for ever out of reach.

This studious 'realist', this Flemish burgher, so firmly entrenched in his class by municipal institutions, is thus the exact opposite of the passive observer fettered to the chaos of phenomena. The hidden structure of his compositions, which were perhaps built up over a geometric grid, is admirable not only for the way in which the masses are equilibrated and counterbalanced, but also in the actual design of their component parts. They have a breadth and majesty which dominates their profuse draperies of Burgundian type, those splendid mountains of clothes or linen piled up and contrived like the forms of the Apennines as seen by Leonardo. The *Virgin of Canon Van der Paele* at Bruges is perhaps the best example of this, but the same skill and mystery extends even into the composition of the portraits. In a more general sense, Van Eyck found mystery everywhere; he looked at every object as if he were seeing it for the first time, he studied it as if he wished, by virtue of his poet's perseverance, to wrest from it the answer to some riddle, to bind it with a spell and to endow its image with a secret, duplicate life. For him, everything was unique and, in the true sense of the word, singular. In this world where nothing can be interchanged

with any other thing, the accessory and the inanimate object acquired individuality of feature. In the enclosed chamber where Arnolfini and his bride stand, the tall hat of the husband, the fretted chandelier which hangs down from the ceiling like a fiery flower and the mirror, whose role I have attempted to explain, are all part of a reverie on the strangeness of everyday things, and the town which, beyond the colonnettes and arches of the *Virgin of the Chancellor Rolin* (Louvre) spreads out its double landscape of rooftops on either side of a broad river, whether it be Lyons or Liège or Maastricht, as the uncertain identifications would have it, is first and foremost, in the transparency of motionless air, in the serenity of blue and gold evening, a reverie of Van Eyck. And what a breadth this capacity for imagining and feeling the truth of things could attain, in the spheres of mystic life and meditation in God! In Saint-Bavon at Ghent, the retable of the *Adoration of the Lamb* revives an early Christian idea (as if the declining Middle Ages were turning back to the beginnings of the faith), in the setting of a landscape which is both earthly and heavenly, actual and paradisiacal, combining Netherlandish forms and monuments with elements of remoter visions. The terraced zones of vegetation, from the meadow to the conifers, lead the eye towards a horizon on which stand churches which can be recognized and named, *128* such as the cathedral of Utrecht, along with other structures which are compilations or inventions. The Christian Knights and the Just Judges have the direct and vigorous quality of life; they are not exempt from the force of gravity, they are creatures of flesh and blood, yet their very solidity bears the mark of an enigma of greater beauty, created by the energy of the style, the brilliance of the colour and the deeply meditative tone. The large figures which are associated with them are in a yet sublimer style—God the Father, enthroned in Majesty, has the epic grandeur of the Apocalyptic God, while Adam and Eve, in their unveiled humanity, are at once timid and tranquil.

III

THIS deep tranquillity of an intense yet contemplative art—was it a characteristic of a particular social environment or a national trait, as has been repeated *ad nauseam*? On the contrary, it was the heritage of a family of intellects. This concentrated harmony which knits together, subordinates and compresses the elements of the composition, within a transparent, compact world—was it derived from miniature painting? And should we, on the other hand, regard the

subtle rhythms and splendid organization of Rogier van der Weyden[1] as the result of influence from the great decorative tapestries or painted hangings? It is certain that the painters and tapestry weavers collaborated. Jean de Bruges, who was responsible for the designs of the Apocalypse of Angers, executed by Nicolas Bataille from 1370 onwards, was by no means an exceptional case. Though we no longer possess the renowned compositions with which Rogier decorated the Salle de Justice in the town hall of Brussels, we know that they are reproduced in the Berne tapestries. In these vast hangings, the old grandeur of style still subsisted.[2]

The art of tapestry was the equivalent, in the West, of fresco painting in Italy. Together with stained glass, it was perhaps the most original expression of the Western spirit. It is true that wall paintings were still very numerous in this area in the fifteenth century. The Dance of Death at La Chaise-Dieu and the

[1]Rogier de la Pasture, Van der Weyden, was born in Tournai at the end of the fourteenth century. A document of 1426 gives him the title of master and informs us that the town of Tournai had granted him eight measures of wine, in this honouring him even higher than Jan van Eyck. We find him established in Brussels in 1436, in which year he was already official painter to the town, which suggests that he had been settled and known there for some time. The *Deposition* in the Escurial was painted in 1435 or 1436 for the crossbowmen of Louvain. The *Last Judgement* in the Hospice at Beaune dates from before 1445. In 1450, Rogier visited Rome; he remained in contact with Francesco Sforza and the Duchess of Milan, who recommended to him a Milanese artist, Bugatto. The triptych of Christ between St. John and St. Mary Magdalene (Louvre) was painted for Jean de Braque in 1451 or 1452. Rogier died at Brussels in 1464 as a renowned figure, loaded with honours, and was buried in Sainte-Gudule. As against this, a document discovered by Alexandre Pinchart in 1867 indicates that a certain Rogelet de la Pasture began his apprenticeship in the Tournai studio of Robert Campin (b. Valenciennes, 1378; d. Tournai, 1444) in 1427 and was admitted a master in 1432. How can we admit that the same painter was both eminent in Tournai in 1426 and beginning his apprenticeship in the following year? And how are we to distribute the works in the 'earliest manner'? They were grouped for a time around a triptych belonging to the Mérode family, alleged to have come from the hypothetical abbey of Flémalle, and a 'Master of Flémalle' was postulated, who was identified first of all with Jacques Daret, Rogelet's fellow-pupil under Campin, and subsequently, after Hulin de Loo had discovered authentic and very inferior works by Daret, with Campin himself. Paul Jamot restored to Van der Weyden the Mérode *Annunciation* (painted between 1425 and 1428). For J. Destrée, *Roger de la Pasture*, 2 vols., Paris and Brussels, 1930, the Tournai painter Rogier de la Pasture and the Tournai painter Rogelet de la Pasture were one and the same; the art of Tournai, a town in the French tradition, was quite distinct from that of Bruges. For E. Renders, *Rogier van der Weyden et le problème Flémalle-Campin*, 2 vols., Bruges, 1931, Rogier de la Pasture, settled in Brussels at the time when Rogelet was working with Campin, was a great painter imbued with the Eyckian teachings, to whom the greater part of the works ascribed to the Master of Flémalle must be restored, while Campin was a mediocre decorator and scandalous demagogue, Rogelet an obscure painter, and Tournai a town unacquainted with the arts. Cf. articles by P. Jamot, *Rogier van der Weyden et le prétendu Maître de Flémalle* (Renders' theory), Gazette des Beaux-Arts, 1928; by E. Michel (Destrée's theory), *ibid.*, 1931, and by M. J. Friedländer, Monatshefte für Kunstwissenschaft, 1931 (Renders' theory). *The importance of Campin has been vindicated by Ch. de Tolnay, *Le Maître de Flémalle et les frères van Eyck*, Brussels, 1939, whose views have on the whole been adopted, although with a number of different attributions, by E. Panofsky, *Early Netherlandish Painting. Its Origins and Character*, Cambridge, U.S.A., 1953. On Rogier van der Weyden, in addition to E. Panofsky, *op. cit.*, see H. Beenken, *Rogier van der Weyden*, Munich, 1951.

*[2]See J. Maquet-Tombu, *Les tableaux de justice de Rogier van der Weyden à l'Hôtel de Ville de Bruxelles*, Phoebus, II, 1949, p. 178 ff.

Liberal Arts at Le Puy are a sufficient indication of their interest and importance. But the qualities of monumentality are still more apparent in the hangings. The tall woven figures, set against ornamental backgrounds or in half-imaginary, half-real landscapes, surrounded the great lords with the chivalrous dreams, the hunts and the sports from which they fashioned the adornments and even the very style of their lives, and with the vision of that idyllic existence, far from the *nugae curialium*, the delights of which had been extolled in former days by Jacques de Vitry, in the *Dit de Franc-Gontier*. In the churches, the art of tapestry displayed, sometimes in sets of formidable scope, a picture of human life, in which the teachings of the Gospels and the combat of the Virtues and Vices were interspersed with historical events and allusions. It is true that the Apocalypse of Angers is still imbued with the charms of fourteenth-century art and owes allegiance to the figure style of the Parisian miniaturists; the monsters, which were to be restored to vigorous and terrible life—a Romanesque life—by the moral crisis of the next century, still possess the elegance of heraldic beasts. But sixty years later, in the workshops of Arras and Brussels, tapestry had thrown off the spirit of the miniatures and asserted its own style and scale. We are struck, not so much by certain connections with the accessories, the 'mansions' and the *mise en scène* of the mystery plays, as by the epic quality of the organization, and the number, stature and diversity of the hosts of figures with which they are filled. Hung against cathedral stones, they are not over-matched by the gigantic scale of their surroundings. The material of which they are composed is warmer and more subtle than the material of the walls. They satisfied the taste for things rare, precious and laboriously contrived, which was part of the inmost soul of this civilization, and, at the same time, raised it to the plane of true grandeur. Thus the part played by the tapestry designers was a considerable one —not only in the history of tapestry, but also, through mutual influence and reaction, in the history of painting itself, and in the life of the spirit. Nevertheless, in Rogier's case, and perhaps in that of Hugo van der Goes, we must take account also of special gifts which brought the Tournai painter into relationship with the art of the imagers and which place him in the first rank of those masters who have been sculptors in painting.

The central section of the retable of the *Last Judgement*, preserved in the Hospice at Beaune, is composed like a tympanum, with the Resurrection of the Dead in the lower register, subdivided by the angel weighing souls, above which appears the figure of Christ the Judge and, framing Him with striking symmetry, the Virgin and saints in prayer. The nudes, simple and strong, as they appear on the old French lintels, have something of the nudes of the painter-sculptor Degas.

It was again a sculptor's instinct which retained a feeling for grandeur of form and, in the faces, the sober economy of a modelling with no excess of analytical observation, attaining the force of its expression by simple means. And yet no art could be more pathetic, even though pain is not rendered by convulsions:
131 in the Escurial *Deposition*, it seems to flow back to the heart of each participant and to numb the vital senses of the Virgin, who sinks to the ground, with one arm supported, whilst the other hangs down, in the same gesture of inert abandon as that of her Crucified Son.

It would not be difficult to discover compositional principles similar to those of the *Last Judgement* in other works of Van der Weyden, even in those with a landscape setting, like the *Entombment* in the Uffizi, where the heads of the figures, alternately bent and erect, describe the semicircle of a tympanum upon the rectangle of the open sepulchre. If we directed the full rigour of analysis against a disputed piece, such as the Mérode *Annunciation*, we should find that, in this particular, it stood apart from Rogier's style. It is a delightful picture, but its 'toy-like' aspect is disconcerting. The composition is thin, multiple and anecdotal, with a wealth of intimate detail, which is without grandeur though not without poetry. Is there anything here that foreshadows Rogier's grandiose art? Perhaps the figure of the angel, which is too large for this exquisite doll's house interior. A deeper, wider peace reigns in the Louvre *Annunciation*, to which a slightly later date (about 1430) is assigned: but is it not still Eyckian in many of its accessory details, in certain features also of the physical types, and in its mysterious serenity, which approximates to that of the *Rolin Virgin*? In short, these attributions are, in my view, less sure than that of the *Last Judgement*, where we find expressed, within a monumental frame, a conception capable of fulfilling the demands of the latter and built, so to speak, on the same scale.

Is this then the whole of Van der Weyden? It is perhaps the most essential part, though we must take care that we do not, by conducting our analysis with too rigid a criterion of style, cut the cloth of this magnificent figure too narrowly. And it is impossible fully to appreciate his qualities without having studied his portraits. Those that he has left us of *Meliaduse d'Este* (New York) and *Philippe*
138 *de Croy* (Antwerp) have a decision, a keenness, an incisiveness, which border on violence. Assuredly they belong to a different race of men than Van Eyck's figures—the Grand Chancellor of Burgundy praying before the Virgin, or the man who holds a pink with unheeding daintiness in his powerful hand. The great donor figures of the *Lamb*, Jodocus Vydt and his wife Isabella, are as if plunged in majestic torpor, inaccessible to the human passions, which Rogier's sitters are

about to experience and master, and which are already apparent in their keen profiles. Thus we discover the various facets of an art whose emotional content is, if not richer, at least more intense, than that of Van Eyck, and which, in its grandest expressions, is connected with the style of the monuments rather than with that of the miniatures.

These were, perhaps, the two main directions of Netherlandish painting in the fifteenth century and, in a wider view, of the painting of all the various schools of the time. From Van der Weyden, Dirk Bouts of Haarlem, settled in *134* Louvain (1420–75), derived a vein of pathetic power and that tenderly proud sorrow which distinguishes his Christs and Virgins of Pity.[1] To the same tradition, by virtue of the grandeur and characteristic accent of his design, belonged Hugo van der Goes, who graduated as a master in Ghent in 1467, and died in the monastery of Rougemont (1482) between madness and music. But though Lemaire de Belges, in the following century, rightly praised 'Hugh of Ghent who excelled in clarity of line', he was also a colourist of that rich, profound and magical lineage inaugurated by the Van Eycks, and one who, through his *Nativity* in the Uffizi, intervened in the destinies of Florentine painting.[2] The twilight of the Middle Ages, and the early years of the sixteenth century were still irradiated with the same subtle brilliance, the same exquisite note, by the art of Gerard David (d. 1523) and especially by Memlinc (d. 1494). The latter was a Rhinelander, doubtless a pupil of Van der Weyden, and settled in Bruges, the centre of the Eyckian tradition. We may perhaps deduce from this the various sources and nuances of his art, but not the secret of the gentle unity which binds them together, wherein miraculous purity of execution and morning freshness of colour are joined with steadfastness of accent and grandeur of form: the portrait of *Martin van Nieuwenhove* (Hôpital Saint-Jean, Bruges) is one example. But the *136* light which falls through the rectangular windows of the oratory in which this gentleman kneels at prayer is a filtration from all the visions of Van Eyck.[3]

*[1]On Dirk Bouts, see W. Schöne, *Dieric Bouts und seine Schule*, Berlin, 1938, and L. von Baldass, *Dirk Bouts, seine Werkstatt und Schule*, Pantheon, XXV, 1940, p. 93 ff.

[2]Hugo van der Goes also produced painted hangings, and, as has been shown by F. H. Taylor, *A Piece of Arras of the Judgment . . .*, Worcester Art Museum Bulletin, I, 1935–6, p. 1 ff., tapestry-cartoons of extraordinary breadth and brilliance. The *Last Judgement* at Worcester belonged to a series of eight hangings representing the allegorical history of Christianity. Links with the *mise en scène* of the mystery-plays are not lacking. It was executed on the occasion of the marriage of Charles the Bold and Margaret of York (1468) and includes portraits of the couple. It gives us the name of the master-weaver, Philippe de Mol, who was famous in Brussels at this time and who also produced other well-known sets, the *Life of the Virgin* in Madrid, the *Triumphs* of the Musée des Arts décoratifs in Lyons, etc.

*[3]In addition to K. Voll, *Memling, Des Meisters Gemälde*, Stuttgart and Leipzig, 1909 (Klassiker der Kunst, XIV), see L. von Baldass, *Hans Memling*, Vienna, 1942, and M. J. Friedländer, *Memling*, Amsterdam, 1950.

The world in which these figures have their motionless being, enwrapped in a miraculous tranquillity of objects, creatures and thoughts, yielding to no impulse, untouched by the shadows of time, seems exalted above the centuries, above the vicissitudes of life, by virtue of some magical charm. But suddenly, as we watch, there is a silent explosion. This stable universe, with its clear-cut edges, where everything has an air of being fixed for all eternity, totters and breaks, and its remnants hang fluttering in the air. The laws of humanism in God and the subtle architecture of the microcosm are shattered by a new force, by a demon of the Anticosmos. The limits of the several realms of nature are transgressed; inanimate things take on life and the forms of life, objects fashioned by the hand of man assume man's image, his face, his limbs, his restlessness and appetites. The divine order is assailed by a kind of frantic revolt, which is none the less inspired by a pious thought. It is the revelation of a new Apocalypse, but a gay one. Demons, horned and hairy, armed with pincers, supported in the air by membranous wings, hybrids composed from insects, mammals and man himself, throng through a gloaming lit by forge-fires and blazing buildings. Flying machines glide through the skies. At the entry of a cave, the whole rout of hell besets the hermit saints with torments. The ship of fools sails across the waters of an abyss, carrying a frenzied picnic-party of rogues and papery-hued lunatics seated at a merry banquet. Such were the art and the visions of Jerome Bosch, a quiet provincial from s'Hertogenbosch, where he lived from 1460 to 1516, working for Margaret of Austria. He is a delightful painter, rich in delicate tones which are already those of the 'Flemish' colour-harmonies of the seventeenth century, with sharp, clear, fresh, aggressive notes, which still smack of playing-cards or stained glass; he is a great comic poet—and a still more curious phenomenon.[1]

We see here a sudden eruption from the hidden underside of the Middle Ages; these are its subterranean regions, full of buffooneries, follies, impure dreams and upsoarings towards God. This great age would be incomplete, inexplicable, but for the existence of this reverse side. It had always been present, but held in check by the discipline of the stone, in the upper levels of towers, in the plinths of the portals and under the shadow of the archivolts. The gargoyles, vestiges of the association of Romanesque biology in the architectural functions, had preserved its image, taut and rigid, at the summit of the buttresses. The grotesques which lent themselves to decoration bore witness, in the full flowering

*[1]On Bosch the fundamental work is Ch. de Tolnay, *Hieronymus Bosch*, Basle, 1937. More recent publications are listed in G. Ring, *Hieronymus Bosch*, Burlington Magazine, XCII, 1950, pp. 28–29; and C. D. Cutler, *The Lisbon 'Temptation of St. Anthony' by Jerome Bosch*, Art Bulletin, XXXIX, 1957, pp. 109–126.

of the thirteenth century, to the greatness of another age and its inexhaustible repertory of monsters. The *Flamboyant* style brought them back into the sculpture of the churches: in the convolutions of the ornament, Romanesque teratology lived anew, freed from its bondage and subjected to no law, and at this time also, Gothic calligraphy revived the interlace, as if the Middle Ages, near to their end, were yielding up all their dreams with precipitate haste and returning to the oldest among them. The astonishing liveliness of drawing in Bosch, while anticipating the elder Breughel, re-animates the little figures, so incredibly alive, of the Utrecht Psalter.

His masterpiece is the *Temptation of St. Anthony* (Lisbon). This very ancient theme, derived from the Lives of the Desert Fathers, had figured on a number of Romanesque capitals. It had undergone a kind of eclipse, to reappear in the fourteenth and particularly in the fifteenth century, with the development of the order of St. Anthony, who specialized in the cure of St. Anthony's fire, the *mal des ardents*. He appears both in miniature and panel painting, especially at Siena, where he was treated with poetic grace and inimitable candour. Among iconographical novelties and revivals, he occupies a place as important as (though opposite to) the cardinalizing and humanistic theme of St. Jerome, the exemplary ascetic and typical intellectual. And just as this cruel time crushed Christ in the mystic wine-press, and buried the seven swords of the seven sorrows in the heart of the Virgin, so it unleashed against St. Anthony a swarm of childishly frightening hobgoblins and all the forms with which it clothed, in nightmare, the *negotium perambulans in tenebris*—a topsy-turvy Genesis which unmakes all that God has made. It is the romance of the devil, the witches' sabbath—as conceived by a devout man in a small town, who likes a good tale and is scared o'nights.

Was Bosch the source of the fantastic landscapes, studded with abrupt blocks high as church steeples and hollowed out below in grottoes where pious ascetics sit in meditation? Patenier is linked with the master of s'Hertogenbosch in more than one respect, but this cataclysmic world was foreshadowed, long before either of these painters, by the brothers Limburg, and it may be said to be a fundamental aspect of medieval romanticism and one of its favourite settings. Emerging from the walls of the little town, from the streets with their skilful alignment of tall gabled houses, we come out into the morning after the Deluge. It was on this soil, split with crevasses and shaken with convulsions, in amphitheatres formed of high mountains, indented with arms of the sea, that the painters of the Tower of Babel were to work a few years later. This vision was long a favourite of the Netherlanders, but was less influential elsewhere; the radiation of the art of Van Eyck and Van der Weyden, on the other hand, was immeasurable.

IV

ONCE again, it was from the West that the last great medieval idea entered Germany. Its teachings were received, and mingled with native instincts, to produce eventually, in the early sixteenth century, the trinity of masters— Grünewald, Holbein, Dürer. These new lessons impinged upon very traditional centres, of sluggish vitality, enervated by the urban revolt of the fourteenth century. Their effect was sudden, like that of Courbet on the languishing Romanticism of Düsseldorf. The old pre-Eyckian painting of Germany varied, according to workshop, from violence to finical affectation. In the peasant centres of the North, around Soest, Dortmund and Münster, in Westphalia, it maintained a kind of rustic Byzantinism. There is more skill, allied with the vehemence of popular drama, in the artists of the Hanse, in Master Bertram, the painter of the Grabow altarpiece, and especially in his disciple, Master Francke. The emotions which Rogier and Bouts held in check, thereby rendering them more impressive, were the subject of unrestrained ostentation in Germany. This trait was still more apparent in the south, among the inhabitants of Franconia, by reason of influences from Bohemia and Upper Italy, as in the Bamberg altarpiece (1426, Munich). On the Rhine, on the other hand, we find an art of piety, a bourgeois mysticism originating in a Sienese interpretation of the visions of Heinrich Suso, and the tender Virgins of Cologne, little girls, plump, rosy and untroubled. There is a long series of figures of a type of which the pretty *Veronica* of the Wallraf Museum (about 1426) seems almost the definitive formulation; to it, however, *130* Stephan Lochner, from Constance, added, along with greater fullness and brilliance, a note of worldly femininity and the charm of his pious nosegays. Far into the fifteenth century, in the old city of goldsmiths, paintings were still executed on a gold ground.

Such was the setting, such the traditions. Flemish art made its appearance suddenly, as a startling innovation. Private persons bought or commissioned works from Netherlandish painters, but it was Rogier's visit to Cologne in 1451, the very year of Lochner's death, that gave the decisive, and very vigorous, impulse to the new movement. Returning from Rome, he painted, for the church of St. Columba, the triptych of the *Adoration of the Kings*. A whole school sprang from him—the Master of the Life of the Virgin, the Master of the Glorification of the Virgin, and many others, among them the painter of the *Deposition* in the Louvre, a translation into the Cologne idiom, rich in attractive inflexions, of the great sculptural style of Rogier. It was with less authority, through secondary hands, that the Flemish manner found its way to Franconia.

In Nuremberg, the mediocre Pleydenwurff makes one look back regretfully to the grandeur and austerity of an earlier style, that of the Tucher altarpiece. There was still a discordance between the new stream from abroad and the old bases of style. The harmonization was effected on the Upper Rhine by Martin Schongauer. It has been said that he fused the style of Cologne with that of Van der Weyden, and this is true in so far as opposites are not mutually exclusive. Furthermore, the Colmar master was neither copyist nor acolyte. His conception of Netherlandish art was not based on Rogier alone. He was certainly receptive also to the influence of Hugo van der Goes. As a goldsmith's son and an engraver, he was attuned to the 'clarity of line' of the painter of the Portinari *Nativity*. The force of German drawing, graved in metal or carved in relief on wood, was the decisive aspect of his art. It was indubitably in this field that Germany, by the simultaneous use of the delicate tools of the goldsmith and the ruder craft of the old popular imagery, found its most concise and energetic expression.

This enormous stylistic diffusion found fertile soil in centres which were already internationalized, such as the great cities of the Church councils, Basle and Constance. It was from this latter town that Lochner had come to settle in Cologne. The first generation of the Netherlanders in Burgundy, the Malouels, the Broederlams and the imagers of Champmol, were known, admired and held up as models, in accordance with an age-old tradition, which had constantly linked the Transjura with the Cisjura. The vigorous genius of Conrad Witz was nourished by these examples, but handled them with an inventive power and grandeur, which find complete expression in the *Miraculous Draught of Fishes*, in Geneva, a fragment of a great triptych executed before 1443. Here the Middle Ages are combined with a modern attitude towards the interrelationship of man and nature, and perhaps no other work stands closer to us than this. It exceeds any definitition based on a summation or correlation of influences—as does also the work of Michael Pacher, in the Tyrol, a carver of wooden images, an architect and a painter of altarpieces, oriented towards the school of Padua, yet not Italianized.

Pacher was not an isolated figure in his own territory and the adjacent regions, for these had for a century past produced skilful artists, who exemplify, often with an individual note, the various phases of late medieval painting. These areas were dominated first of all by Prague and Bohemia, by virtue of the charm and brilliance of a refined culture. Nowhere, perhaps, were the lessons of Siena and Paris better understood, nowhere assimilated more completely and with greater originality. The proof of this lies in the great cycles of secular frescoes, but such a delightful little panel as that, in black and gold, of the Morgan

Collection, is sufficient to convey the exquisite tone of this civilization, within the overriding unity of the 'international style'. In Austria also, though with different means, a comparable sonority appears in the Master of Heiligenkreuz, and even later, between 1420 and 1440, in the Master of the Abbey of Sankt Lambrecht, whose *Victory of Louis of Hungary over the Bulgars* (Graz) is in line of descent from the battle-pieces and magical hunts which had cast a spell on the fourteenth century. A generation passed and, about 1470, the Master of the Schottenstift set his *Flight into Egypt* against a boundless landscape immersed in air, and a view of Vienna as manifold and microscopic as a background of Van Eyck. But neither the example of the Flemings nor the dominant influence of Mantegna suffice to explain Michael Pacher (master in 1467, d. 1498), who tempered his profound skill with rustic strength. A slain prelate, lying on a rude litter and covered with a pall, is surrounded by his clergy, within a cathedral which is not a goldsmith's model but a real building raised by the toil of men's hands, through the door of which we catch a glimpse of the vista down a little street. We see the corpse from behind, in a foreshortened view which does not mar the proportions of the handsome features, now at rest. In this way, Pacher imagined the *Obsequies of Thomas Becket* (Vienna), together with another scene representing his murder. Here flesh, like stone and wood, is weighty. Even space is a three-dimensional solid. Architectural form reasserts its breadth and authority. Pacher ranks as an artist with Conrad Witz, but with a southern inflexion which becomes still more marked in the works of his studio, such as the episodes from the *Life of St. Lawrence* (Vienna).

133

What then were the constant factors in German art, which, though affected now by Siena, now by Upper Italy, now by Bohemia, now by Burgundy and now by Van der Weyden, nevertheless preserved through all these variations its own perfectly recognizable lineaments? One perhaps was that quest for intensity of expression, that theatrical physiognomy, of which its religious sculpture can show examples as early as the thirteenth century. This is neither the contemplative calm of Van Eyck nor the restrained fervour of Van der Weyden, but an attribute of more superficial character, though not without force and beauty. This it was which impelled Conrad Witz to saturate his tones with unexampled richness, giving even to his whites the luxurious dominance of sonorous colour; this was not a characteristic peculiar to that great painter, but recurs also in the masters of the Danube school. Perhaps it still persists as a fundamental trait in German painting, which even now retains this tendency to saturated and vitrified hues. It was again this same demand which guided, with inflexible rigour, the burin of the German engraver in his analytical enquiry into the geography of

living forms. This same virulence was an abiding quality in Dürer. Before him, it had sent a fiery sap coursing through the heraldic vegetation of the German fifteenth century, through its capriciously ramified ironwork, through the luxuriant flourishes of its calligraphy and even into the vigorous image of the strongly built, powerfully articulated human body.

Thus, at the very time when a new style was asserting its supremacy and presenting everywhere a united front, it was also serving as a theme which was variously interpreted by the various families of the human spirit. Was it not the same formerly, with the art of the fourteenth century, which was everywhere made up of similar elements, but infinitely varied in the proportions and inflexions of the resultant mixtures? Equally remarkable with this process of differentiation was the enthusiasm with which the new forms were accepted and founded families of their own. It was a phenomenon which appeared much more rapidly and with much greater variations in intensity than in the life of languages, and one in which we must take care not to neglect the part played by individual reactions and talents. If we were to study the diffusion of the Sienese style in Spain and, in particular, in Catalonia, Aragon and the kingdom of Valencia, we should find abundant proof of what we might provisionally call the idiomatic capacity of imported forms. They assume the local accent and turn of phrase, like the traveller from abroad who settles in a distant country. Could we with impunity take even the most 'Sienese' picture from the Catalan Museum of Vich and hang it in the Siena Gallery? Ferrer Bassa, Luis Borassa, Jaume and Pere Serra, the painters of the *'vierges de lait'*, the painters of altarpieces with many scenes, were not merely provincial pupils of a masterly teaching. Their language was the storehouse of their own instinct and culture. The first impact of Flemish influence on this small but very lively artistic province was very violent and seemed in that overpraised pastiche, Luis Dalmau's Altar of the Counsellors, on the point of effacing all that had gone before. But Jaume Huguet, one of the greatest and most singular artists of the period, combined it, in his portrait-like treatment of figures, with his own generous sense of monumentality, and his continued loyalty to the use of gold, that is, to a decorative conception of space.

It was the visit of Van der Weyden to Cologne which directed the German painters into new paths. It was the visit of Jan van Eyck to Lisbon (1427-28) which made Netherlandish art known in Spain. When we are concerned with men of this stature, the fact of their physical presence constitutes a historical force. In Portugal, Van Eyck painted the portrait of Dona Isabel, the daughter of John I. He must also have worked in Castile; in the Prado there is preserved a copy after a *Fountain of Life* which he is said to have painted for the cathedral of

Palencia. From this time forward the Flemish manner spread throughout the peninsula with an infectious potency which is the proof of its human and universal quality. The influence of Van der Weyden was felt in its turn, through the Miraflores triptych (1445) now in Berlin. Flemish and Hispano-Flemish pictures abound in the inventories of the rich collections of the Catholic Kings. As far as Andalusia, with Juan Nuñez, but primarily in Castile, with Nicolas of León, Jorge l'Inglès and especially the master of Salamanca, Gallego, the forms which at Bruges and Tournai had crystallized around a particular poetry of thought and a particular mode of life became familiar and natural to the tenants of the old Mudejar palaces and their painters. What spiritual harmony did they discover between their own needs and this language, with its wealth of revelations and of secrets—beyond the vogue for the exotic, for the charm of miraculous execution, and for the profound beauty of a material which was capable of being enamel, flesh, fur and velvet all at the same time ? The attraction, perhaps, of the great visions of human fantasy—especially the pain of God and of His Mother, which were never more moving than here, and finally that kind of supreme tension, which contrasts with the facile tenderness and the elegant effusion of Italy. One feels that this can be understood in the work of Pedro Berruguete, who produced a Spanish version of this manner, exaggerating it perhaps by an excessive severity and a kind of mordant cruelty, which he mingles with his inflexible architecture and his reddish shadows. It was not he, however, in his Avila workshop, who produced the masterpiece of Gothic paintings in these regions, for this had been painted a generation earlier by the Lusitanian Nuno *137* Gonçalves, painter to Alfonso V in 1450, in his *St. Vincent Altar* (Lisbon)—a work which stands outside the usual categories by its passionate and romantic iconography, concerned with the holy exploits of a captive prince and a dynasty struggling against Africa, and by its great strange figures of imperishable beauty. From the mouths of the Scheldt to the mouths of the Tagus, the West had fixed for ever its moral relationships and diversities in this sumptuous, severe and profound style, which comprehends every aspect of life.

V

W AS it equally dominant everywhere ? Did it replace completely the older traditions in those regions which, a short time before, had produced and propagated an oecumenical definition of Western thought ? Was not the art of Van der Weyden himself at the confluence of the art of the French sculptors and Eyckian

painting? Admittedly the *Man with the glass of wine* is the twin brother of the *Man with the pink*. In the northern towns—Amiens, and Valenciennes, the home-town of Beauneveu, Campin, and, later, the enigmatic Simon Marmion[1]— that is, in the immediate sphere of influence of the great Netherlandish workshops, the latter exercised a direct and profound influence. Or rather, the spirit and the country were one and the same. Burgundy too was Flemish territory since Jean de Beaumetz, Malouel and Bellechose. Naturally the lessons of the Northern masters were long remembered there, even when, as in the second half of the fifteenth century, other influences—perhaps that of Conrad Witz— were superimposed on the great tradition of Van der Weyden in the wall paintings at Beaune and Autun and the tapestries of the life of the Virgin, designed by Pierre Spicre. But there were many other centres, new and old— Paris with its wealth of experience, the Loire of Charles VII and Louis XI, the new axis of French life, the Anjou of King René, the vast Midi, extending from Nice to Catalonia, and including the great town of painters, Avignon.

Paris retained its characteristic stamp, despite the sapping of its vitality by the wars. It was that of a refined counterpoise of opposing forces, deliberately cultivated, filtered by exacting taste and urban moderation. At a time when the 'Flemish' style was as yet unformed, it was in part in the royal circle that it was gradually elaborated, by successive researches, and subtle compromises with the Parisian tradition. The Parisian stamp continued to appear in many works of illumination, from the *Bedford Hours* down to certain pages of Master François. The insistence on the geographical determinism and the landscapes of Touraine must not be allowed to obscure its presence in Fouquet himself. In this great romantic century, it was a symptom, not of regression, but of restraint, subtle analysis and moral tranquillity. This close-meshed sieve, plaited centuries before, was a discriminating instrument.

The effect of this can be better seen by a comparison between the way in which the Limbourg heritage was utilized by these masters, and its transformation in western France, at the hands of the Master of the *Rohan Hours* (Paris, Bibl.

[1]We find Marmion in Amiens between 1449 and 1454 and at Valenciennes in 1458. He executed a book of hours for Philip the Good between 1467 and 1470 and died in 1489. The key work and touchstone for attributions, is the *Life of St. Bertin* (Berlin and London), painted between 1454 and 1459 for Abbot Guillaume Fillastre at Valenciennes, where Marmion was the leading master. Around this probable work, a certain number of panel-paintings have been assembled—the *Discovery of the True Cross* in the Louvre, the *Crucifixion* and the *St. Jerome* of the Johnson collection (Philadelphia) and the *Christ of Pity* at Strasbourg, as well as manuscripts such as the *Sens Pontifical*, the *Livre des sept âges du monde* and the *Fleur des histoires*, all three in Brussels, etc. See F. Winkler, *Simon Marmion als Miniaturmaler*, Jahrbuch de K. Preuss. Kunstsammlungen, XXIV, 1913; É. Michel, *A propos de Simon Marmion*, Gazette des Beaux-Arts, 1927.

Nat.)[1] One feels that this abrupt genius has emerged from the depths of the
Middle Ages and that, with that revivalism which is perhaps a constant
phenomenon of the final phase of all great historical cycles, he has suddenly
resurrected the old Apocalyptic visions and combined them with the tragic
preoccupations of the period. In his art, realism and fantasy collide, with
unparalleled force—a dreamer's realism which tends to hugeness of scale and
bestows colossal proportions, not only on God, but also on the sleeping shepherd
in the Annunciation to the Shepherds. The dead man before the final judge
is rendered as a thin, stiff and naked corpse, lying among bones, confronted by a
terrible figure armed with a sword, who is both the Ancient of Days and the
Christ of Pity. This same extraordinary apparition also presides over the Last
Judgement, where angels snatch up the thin pale bodies of the resurrected out of
a fearful mouldering cemetery. In the *Deposition*, the Virgin is as if broken in
two in the arms of St. John; she hangs over her Son, half-fallen to the ground,
and the enormous visage of the Eternal Father contemplates the scene. Yet this
strange art, in which the sequence of time seems to be confounded, was only a
few years earlier than the calm and refined balance of Jean Fouquet, and the
delicate researches into light, the entirely courtly and worldly sensibility of the
master who painted for King René the miniatures of the *Coeur d'amour épris*
(Vienna).[2] It is no doubt a characteristic of periods of this kind, brought out by
eclectic tastes and unexpected contacts, to liberate great original forces which
have the power to combine within themselves opposing tendencies.

More than one instance is to be found in the south of France. This region had
its own character, its own tradition, but, like all active artistic provinces, it was a
132 meeting place of styles. The *Pietà* of Villeneuve-lès-Avignon is Flemish, if you
will, in its donor-portrait, and pre-Eyckian in its gold background, but the
figure of the Magdalene and the body of Christ, arched nervously back with a

[1]According to P. Durrieu, Revue de l'art, 1912, the Master of the *Rohan Hours* was a provincial
master. For A. Heimann, *Der Meister der Grandes Heures de Rohan und seine Werkstatt*, Städel
Jahrbuch, VII–VIII, 1932, who distinguishes the works of his own hand from those of his studio,
this was a Parisian group, connected with the style of the *Boucicaut Hours* and that of the Limbourg
brothers. The period of activity of this master fell between 1415 and 1430. M. Meiss, Gazette des
Beaux-Arts, 1935, recognized his manner in a drawing in the Brunswick Museum, which had
already been studied by P. Lavallée, *Le dessin français du XIIIe au XVe siècle*, Paris, 1930; it has
the same elongated figure-style, the same linear quality and the same pathetic sentiment. *On this
master must be added now: J. Porcher, *Les Grandes Heures de Rohan*, (Coll. Les Trésors de la
Peinture Française, I, 7), Geneva, 1943, *Two Models for the 'Heures de Rohan'*, Journal of the War-
burg and Courtauld Institutes, VII, 1945, p. 1–6, and *The Rohan Book of Hours*, London, 1959.
E. Panofsky, *The de Buz Book of Hours, a New Manuscript from the Workshop of the Grandes Heures
de Rohan*, Harvard Library Bulletin, III, 1949, p. 163 et seq. A panel painting at the museum of
Laon is now attributed to the Master of the Heures de Rohan: see G. Ring, *A Century of French
Painting, 1400–1500*, London, 1949, No. 89, pl. 41–42.
*[2]See E. Trenkler, *Das Livre du Cuer d'Amours Espris des Herzog René von Anjou*, Vienna, 1946.

deathly rigidity which lends an accent of pathos to the elegance of the form, can be related to nothing in the art of the Northern schools, or in that of Italy. In the same region, between Aix and Avignon, there were working three such diverse artists as Enguerrand Charonton, from the diocese of Laon, the master of the Aix Annunciation and Nicolas Froment of Uzès.[1] One thing is certain—that they had abandoned the teaching of Siena, and that they were all more or less affected, in various ways, by the Flemish manner. But they continued loyal to older traditions, and most of all Charonton, in his *Coronation of the Virgin* of 1453, which, once again, is composed after the fashion of a tympanum—not, it is true, in accordance with the iconographical type established at Senlis and modified at Notre-Dame in Paris, but with a distribution of masses and figures which is derived from the monumental order.[2] It may even be asserted that it is thoroughly Romanesque, and not Gothic, in conception—and this is not the least remarkable feature of a work which provides striking confirmation of what I have said concerning the Romanesque 'revival' at the end of the Middle Ages. The extensive landscape with the Crucifixion, on which the composition rests, corresponds with the lintel. Above, God the Father and Christ, who are precisely symmetrical and practically mirror-reflections of each other, are conjoined with Mary, who is placed between them, in a triple figure which conforms to the ornamental pattern of the Virgin's ample robe. On either side, the angels, saints and elect obey the hierarchic rule of proportions which, from the lintel to the tympanum and from the frame towards the centre, had increased or diminished the stature of the figures. It is an example, which is still inadequately appreciated, of the revival of the old procedures which may be verified time and again in the churches of the twelfth century. Thus we can extend our series of 'tympanum painters', with this return into the past which goes beyond the Gothic stage reached by the *Last Judgement* at Beaune. Thus there begins to take shape before us a line of masters who were linked with the sculptors of the churches and who maintained, in their panels, the rules of the architectural compositions. To Rogier of Tournai, and to Enguerrand Charonton, we must add Fouquet, but for different reasons.

[1]Nicolas Froment is known to us through two triptychs, one in the Uffizi, signed and dated 1461, the central panel of which depicts the *Raising of Lazarus*, and the other, the *Burning Bush* (1475–76), in the cathedral of Aix. King René and his wife, Jeanne of Laval, are depicted in the wings of the latter. René of Anjou, Count of Provence, King of Sicily, himself a painter, is an instance of the eclectic tastes of the great amateurs of the period. According to a note by Jean Robertet, Van der Weyden and Perugino were included among the painters of the 'late King of Sicily'. *On the subject of the Burning Bush, see E. Harris, *Mary in the Burning Bush: Nicolas Froment's Triptych at Aix-en-Provence*, Journal of the Warburg Institute, I, 1938, pp. 281–286.

*[2]This famous painting has been the subject of a monograph by C. Sterling, *Le Couronnement de la Vierge par Enguerrand Quarton*, Paris, 1939.

A summary analysis of Fouquet,[1] the painter of Charles VII and Louis XI, normally stresses the importance, in his art, of the charm, balance and moderation of the Loire districts, which were to become, intermediate between the northern and the southern province, an increasingly active centre of French civilization; his talent is considered to represent, along with that of the sculptor, Michel Colombe, the slackening of tension in France, after the violence and the convulsions of the later Middle Ages. Our knowledge of him is based on the royal accounts, on the reports of his contemporaries, on the miniatures of the *Antiquités Judaïques* which are certainly his and on a fair number of other works which can be safely attributed to him. There is little room for doubt in the case of the *Hours* of Étienne Chevalier, at Chantilly. He had visited Italy, where he had won great fame by his portrait of Eugenius IV. In his native town he was a kind of director of the arts, skilled and highly reputed in every technique. His art is modern in its profound knowledge of the forms of life, in its exquisite landscape-poetry and in its sense of historic grandeur. But it belongs first and foremost to the Middle Ages in France, not only in its mysticism, or by its vision of Paradise in the form of a church portal with the blessed and the seraphim arranged as archivolts, not only in its links with the theatre and its lively representation of the mystery play of St. Apollonia, but also by its direct contacts with monumental sculpture in the large portraits, painted with an austerity which seems at first surprising when one recalls the delightful inventiveness and the sensitive quality of the miniatures. Whether he is portraying Charles VII, Étienne

137

[1]The reconstitution of Fouquet's *œuvre* is based on a note by François Robertet, who states that he was the painter of eleven of the miniatures which decorate a manuscript of the *Antiquités judaïques*, which had been begun for Jean de Berry by a master of the Limbourg studio (Bibliothèque Nationale ms. fr. 247). We know also that he painted pictures for the Order of St. Michael, and the Bibliothèque Nationale possesses a copy of the statutes of the order with a fine miniature representing Louis XI presiding over a chapter of its officers (ms. fr. 19,819). An enamel medallion, bearing his name and portrait (Louvre), formed part of a diptych, formerly in the church of Notre-Dame in Melun, with, on one wing, Étienne Chevalier in prayer, accompanied by his patron saint (Berlin), and, on the other, the Virgin and Child (Antwerp). Close stylistic relationships justify the association of the *Guillaume Jouvenel des Ursins* and the *Charles VII* in the Louvre with these panels. The *Étienne Chevalier* in the Book of *Hours* formerly in the possession of that noble is by the same hand as the *Étienne Chevalier* in Berlin, and the miniatures of this manuscript are related to those of the *Antiquités Judaïques*, as well as to those of the *Boccacio* in Munich, of the *Grandes Chroniques de France* (Bibliothèque Nationale, ms. fr. 6,465), etc. The name Fouquet appears more than once in the accounts. It was also borne, I find, by Angevin painters of an earlier period. We learn of the Italian visit and the portrait (lost) of Eugenius IV from Filarete and Vasari. A document drawn up in Tours in 1481 refers to the painter's widow. For Fouquet's art, see, in addition to the books by Comte P. Durrieu mentioned in the bibliography, my study, *Le style monumental dans l'art de Jean Fouquet*, Gazette des Beaux-Arts, 1936. *Since 1938, two monographs have been devoted to Fouquet: K. G. Perls, *Jean Fouquet*, Paris and London, 1940, and P. Wescher, *Jean Fouquet und seine Zeit*, Basle, 1945. See also the two important articles by O. Pächt, *Jean Fouquet: a Study of his style*, Journal of the Warburg and Courtauld Institutes, IV, 1940–41, p. 85 ff., and by J. White, *Developments in Renaissance Perspective*, I, ibid., XII, 1949, p. 58 ff., especially pp. 61–67.

Chevalier, Guillaume Jouvenel des Ursins or Agnès Sorel in the guise of the Virgin, he renders the figure as a solid in space—like a block of stone faintly tinged with the colour of flesh—and installs it there with great monumentality. He magnifies man by reproducing the whole fullness of his volume. Whereas Van Eyck proceeded patiently to analyse each detail, pursued his investigation into the individuality of outline and the interplay of values down to the smallest particle of the living substance, and presented his model in such a way as to give full effect to the intensity of his study, Jean Fouquet constructed his portraits in broad masses and simple planes with easy transitions. These firm-based blocks, this supple modelling are those of French sculpture, in the royal workshops, at the end of the fourteenth century. The mantle of those sculptors had fallen upon Fouquet.

Here, beyond doubt, is the fundamental quality, the profound originality, of this great French school of the fifteenth century—its monumental character. It allows us to distinguish with certainty the spirit of the forms and the astounding persistence of a tradition. To regard it in the conventional fashion as a simple mixture of Flemish and Italian influences is to misunderstand it completely. It is true that the former influence is well-marked, and the latter begins to appear, though in the form of exotic imports. Both, however, were subsidiary phenomena with the French painters. First and foremost we must remember whence they came, the soil which bore them—richer than any other in monuments of stone— and the long dynasties of the image makers. One may feel, at first sight, that the Master of Moulins, at the close of the century, falls outside this definition. Yet the figures of the Autun *Nativity* are of the same race and have the same solidity as the saints of the porches; the *Virgin* in Moulins cathedral is arranged as a theophany with angels forming the spandrels.[1] Bourdichon, Fouquet's successor, is exquisite but firm, and his polished modelling is possible only with hard, well-set, broad volumes. At the end of the Middle Ages, in the early sixteenth century—and even later—the Middle Ages persisted in their boldest form. French art was destined to preserve this fundamental heritage even in the most daring of its later experiments.

[1] The Master of Moulins was a stained glass painter as well as a panel painter: he may be identified as Jean Prévost, also called Jean le Peintre or Jean le Verrier, whose career can be followed from Lyon to Moulins, where he came in 1498. See P. Durieux, *Les maîtres de Moulins*, Moulins, 1946. Recent monograph by Mlle. M. Huillet d'Istria, Paris, 1961.

BIBLIOGRAPHY

SCULPTURE

E. Mâle, *L'art religieux de la fin du moyen âge en France*, 4th ed., Paris, 1931; L. de Laborde, *Les ducs de Bourgogne*, 3 vols., Paris, 1849–51; C. Monget, *La chartreuse de Dijon*, 2 vols., 1898–1901; A. Kleinclausz, *L'atelier de Claus Sluter*, *Les prédécesseurs de Claus Sluter*, Gazette des Beaux-Arts, 1903, 1905, *Claus Sluter et la sculpture bourguignonne du XVe siècle*, Paris, n.d.; G. Troescher, *Claus Sluter und die burgundische Plastik um die Wende des XIV. Jahrhunderts*, Freiburg-im-Breisgau, 1932; A. Liebreich, *Claus Sluter*, Brussels, 1936; Abbé H. Requin, *Antoine le Moiturier*, Réunion des Societés des Beaux-Arts des départements, 1890; L. Courajod, *De la part de la France du Nord dans l'oeuvre de la Renaissance*, Paris, 1889, *Jacques Morel, sculpteur bourguignon*, Gazette archéologique, 1885, *La sculpture à Dijon*, Paris, 1892; H. Chabeuf, *Jean de la Huerta, Antoine Le Moiturier et le tombeau de Jean sans Peur*, Dijon, 1891; H. David, *De Sluter à Sambin*, 2 vols., Paris, 1933; B. Prost, *Le Saint-Sépulcre de l'hôpital de Tonnerre*, Gazette des Beaux-Arts, 1893; R. Koechlin and J. Marquet de Vasselot, *La sculpture à Troyes et dans la Champagne méridionale au XVIe siècle*, Paris, 1900; P. Vitry, *Michel Colombe et la sculpture française de son temps*, Paris, 1901; Abbé A. Bouillet, *La fabrication industrielle des rétables en albâtre*, Bulletin monumental, 1901; J. Bilson, *A French Purchase of Alabaster in 1414*, Archaeological Journal, LXVI, 1907; G. Rubio and I. Acemel, *La escultura española del siglo XV*, Madrid, 1913; J. Barreira, *A escultura em Portugal*, Lisbon, 1929. *G. Troescher, *Die burgundische Plastik des ausgehenden Mittelalters und ihre Wirkungen auf die europäische Kunst*, 2 vols., Frankfurt a.M., 1940; H. David, *Claus Sluter*, Paris, 1951; H. Zanettacci, *Les ateliers picards de sculpture à la fin du moyen âge*, Alger (Etudes d'Art, publiées par le Musée National d'Alger), 1954; J. de Borchgrave d'Altena, *Les rétables brabançons*, 1450–1550, Brussels, 1942; P. Pradel, *La sculpture belge de la fin du moyen âge au Musée du Louvre*, Brussels, 1947; W. Pinder, *Die Deutsche Plastik des XIV. und XV. Jahrhunderts*, Munich, 1925; G. Weise, *Spanische Plastik*, Vols. I and II, Reutlingen, 1925–27; R. dos Santos, *A escultura em Portugal*, 2 vols., Lisbon, 1950–1952.

PAINTING

P. Durrieu, *La miniature flamande au temps de la cour de Bourgogne*, Brussels, 1921, 2nd ed. Paris, 1924, *Heures de Turin*, Paris, 1902, *Jacques Coëne, peintre de Bruges établi à Paris sous le règne de Charles VI*, Les Arts Anciens de Flandre, II, Brussels, 1905, *Les débuts des Van Eyck*, Gazette des Beaux-Arts, 1903; M. J. Friedländer, *Von Eyck bis Bruegel*, 2nd ed., Berlin, 1923; G. Hulin de Loo, *Les Heures de Milan*, Brussels and Paris, 1911, *L'exposition des primitifs français au point de vue de l'influence des frères Van Eyck*, Bulletin de la Societé d'histoire et d'archéologie de Gand, 1904; A. Schmarsow, *Hubert und Jan van Eyck*, Leipzig, 1924; Dvořák, *Das Rätsel der Kunst der Brüder Van Eyck*, Munich, 1925; E. Renders, *Hubert van Eyck, personnage de légende*, Brussels and Paris, 1933; P. Rolland, *Les primitifs tournaisiens, peintres et sculpteurs*, Brussels and Paris, 1932; Jules Destrée, *Roger de la Pasture, Van der Weyden*, 2 vols., Brussels and Paris, 1930; E. Renders, *Rogier van der Weyden et la problème Flémalle-Campin*, 2 vols., Bruges, 1931; Joseph Destrée, *Hugo van der Goes*, Brussels and Paris, 1914; G. Huisman, *Memling*, Paris, 1932; G. Marlier, *Memlinc*, Brussels, 1934; C. de Tolnay, *Hieronymus Bosch*, Basel, 1937; Musée de l'Orangerie, *Catalogue de l'exposition de Van Eyck à Bruegel*, Paris, 1935; L. Réau, *Les primitifs allemands*, Paris, 1910; P. Ganz,

La peinture suisse avant la Renaissance, Paris, 1925; H. Reiners, *Die Kölner Malerschule*, München-Gladbach, 1925; H. Graber, *Konrad Witz*, Basle, 1921; E. Hempel, *Michael Pacher*, Vienna, 1931; *La peinture catalane à la fin du moyen âge* (Fondation Cambo, Bibliothèque catalane), Paris, 1932; B. Rowland, *Jaume Huguet*, Cambridge, Mass., U.S.A., 1932; V. Correia, *Pintores portugueses dos Sec. XV e XVI*, Coimbra, 1929; J. de Figueiredo, *O pintor Nuno Gonçalves*, Lisbon, 1929. *M. J. Friedländer, *Die altniederländische Malerei*, 14 vols., Berlin, 1924–1933 (I–XI), and Leyden, 1935–37 (XII–XIV); P. Fierens-Gevaert, *Histoire de la peinture flamande, des origines à la fin du XVe siècle*, 3 vols., Brussels and Paris, 1927–30; E. Panofsky, *Early Netherlandish Painting. Its Origin and Character*, 2 vols., Cambridge, Mass., U.S.A., 1953 (reviewed by O. Pächt, in Burlington Magazine, 1956); L. van Puyvelde, *The Flemish Primitives*, Brussels and London, 1948, and *La peinture flamande au siècle des Van Eyck*, Brussels, 1953; C. de Tolnay, *Le Maître de Flémalle et les frères Van Eyck*, Brussels, 1939; L. Baldass, *Jan Van Eyck*, London, 1952 (review by O. Pächt, in Burlington Magazine, 1953); C. Gaspar and F. Lyna, *Philippe-le-Bon et ses Beaux Livres*, Brussels, 1944; O. Pächt, *The Master of Mary of Burgundy*, London, 1948; H. Beenken, *Rogier van der Weyden*, Munich, 1951; E. G. Millar, *English Illuminated Manuscripts of the XIVth and XVth Centuries*, Brussels and Paris, 1928; A. Stange, *Deutsche Malerei der Gotik*, 7 vols., Berlin, 1934–1955, and *German Painting, XIVth–XVIth Centuries*, London, 1950; J. Gantner, *Konrad Witz*, Vienna, 1942; O. Pächt, *Œsterreichische Tafelmalerei der Gotik*, Augsburg and Vienna, 1929; E. Buschbeck, *Primitifs autrichiens*, Brussels, 1937; C. R. Post, *A History of Spanish Painting*, Vols. II to VII, Cambridge, U.S.A., 1930–38; L. van Puyvelde, *Les primitifs portugais et la peinture flamande*, XVIe Congrès international d'Histoire de l'art, Lisbon, 1949, Rapports et communications, Vol. I, Lisbon, 1950; R. dos Santos, *Nuno Gonçalves*, London, 1955.

P. A. Lemoisne, *La peinture française à l'époque gothique*, Paris, 1931; *Catalogue de l'exposition des primitifs français*, Paris, 1904; P. Durrieu, *La peinture à l'exposition des primitifs français*, Paris, 1904; H. Bouchot, *Les primitifs français*, Paris, 1904; M. Poëte, *Les primitifs parisiens*, Paris, 1904; A. Kleinclausz, *Les peintres des Ducs de Bourgogne*, Revue de l'Art ancien et moderne, 1906; J. Guiffrey, *Inventaires de Jean duc de Berry*, 2 vols., Paris, 1894–96; A. Lecoy de la Marche, *Le roi René*, 2 vols., Paris, 1875; Abbé H. Requin, *Les peintures d'Avignon*, Réunion des Sociétés des Beaux-Arts des départements, 1890; L. H. Labande, *Les primitifs français, Peintres et peintres-verriers de la Provence occidentale*, 2 vols., Marseilles, 1932; A. Blum and P. Lauer, *La miniature française au XVe et au XVIe siècle*, Paris and Brussels, 1930; L. Delisle, *Les Livres d'Heures du duc de Berry*, Gazette des Beaux-Arts, 1884; L. Curmer, *L'oeuvre de Jean Fouquet*, 2 vols., Paris, 1866; F. A. Gruyer, *Chantilly, Les quarante Fouquet*, Paris, 1897; P. Durrieu, *Les Antiquités judaïques et le peintre Jean Fouquet*, Paris, 1908; Trenchard Cox, *Jehan Foucquet, Native of Tours*, 1931; A. Heimann, *Der Meister der 'Grandes Heures de Rohan' und seiner Werkstatt*, Frankfurt, 1932; L. Chamson, *Nicolas Froment et l'école avignonnaise au XVe siècle*, Paris, 1931; G. J. Demotte, *La tapisserie gothique*, Paris, 1922; B. Kurth, *Gotische Bildteppiche aus Frankreich und Flandern*, Munich, 1928. *C. Sterling, *La peinture française. Les primitifs*, Paris, 1938; C. Jacques (Sterling), *Les peintres du moyen âge*, Paris, 1942; G. Ring, *A Century of French Painting, 1400–1500*, London, 1949; F. Gorissen, *Jan Maelwael und die Brüder Limburg; eine Nieweger Künstlerfamilie am die Wende des 14. Jahrhunderts*, Vereeniging tot beoefening van Geldersche geschiedenis, oudheidkunde en recht, Bijdragen en mededelingen, LIV, 1954, pp. 153–221; G. Bazin, *L'école franco-flamande*, Geneva, 1941, and *L'école parisienne*, Geneva, 1942; J. Porcher, *Les Belles Heures de Jean de France, duc de Berry*, Paris, 1953, *Les Très Belles Heures de Jean de Berry et les ateliers parisiens*, Scriptorium, VII, 1953, and *The Rohan Book of Hours*,

London, 1959; G. Bazin, *L'école provençale*, Geneva, 1944; M. Laclotte, *L'école d'Avignon La peinture en Provence aux XIVe et XVe siècles*, Paris, 1960; C. Sterling, *Le Couronnement de la Vierge par Enguerrand Quarton*, Paris, 1939; H. Focillon, *Le peintre des Miracles de Notre-Dame*, Paris, 1950, and *Le style monumental dans l'art de Jean Fouquet*, Gazette des Beaux-Arts, 1936, I (reprinted in *Moyen âge, survivances et réveils*, Montréal, 1945); K. G. Perls, *Jean Fouquet*, London, 1940; P. Wescher, *Jean Fouquet und seine Zeit*, Basle, 1945; O. Pächt, *Réné d'Anjou et les Van Eyck*, Cahiers de l'Association Internationale des Etudes Françaises, VIII, 1956, pp. 42 *et seq.*; R. Limousin, *Jean Bourdichon*, Lyon, 1954; M. Huillet d'Istria, *Jean Perréal*, Gazette des Beaux-Arts, 1949, I, and *Le Maître de Moulins*, Paris, 1961; F. Salet, *La tapisserie française du moyen âge à nos jours*, Paris, 1946; R. Planchenault, *La tenture de l'Apocalypse d'Angers*, Bulletin monumental, 1953; J. J. Rorimer and M. B. Freeman, *The Nine Heroes Tapestries at The Cloisters*, The Metropolitan Museum of Art Bulletin, New Series, VII, 1948–49.

The Medieval Aspect of the Italian Renaissance

I

IT may seem that we have come to the end of our historical cycle, that Italy can show us nothing further that is relevant to our subject, and that, in taking up the study of the first half of the Quattrocento, we are entering another age and a different world. For the idea of the Renaissance, though rendered more historical by the analysis of transitional phenomena, still weighs on our minds as an absolute fact. It may be that the critics of the seventeenth and eighteenth century saw things more clearly, when they declared forms anterior to Raphael to be 'Gothic'. A few preliminary observations may serve to put into proper perspective these fifty years of Italian civilization, which are one of the great epochs of human history, but which we cannot isolate without falling into a fundamental error. Although the Middle Ages in Italy were already touched by what is known as the Renaissance spirit, the Italian Renaissance was in its beginnings an essentially medieval phenomenon. The Italy of the thirteenth and fourteenth centuries lived its Gothic ideal in all its fullness, but its Roman ideal with some uncertainty. The former gave it a style, that is, a pattern of life and of the spirit, the latter inspired it with a nostalgia which only rarely achieved form. The former was uneasy in architecture, but it produced three figures of universal significance—St. Francis, Dante and Giotto. The latter only occasionally found a suitable moment, a suitable model and an artist—Cavallini, Nicola Pisano—to body it forth. Imperial Capua was no more than an episode: the old Cavallinian Rome, the city of the great pontifical tradition, might perhaps have ripened this dream rapidly into the real and vigorous life of art, had it not been for the exile in Avignon, but the event was otherwise. Renaissance 'romanticism' long retained, to the glory of Italian art, what one might call an exclusively tonal character, capable of giving the style a certain tinge and accent, but not of diverting it into imitative formulae.

It is true that it was not merely nostalgic, but enthusiastic also, and that, in a more general view, it exceeded the limits of humanism and, during the first half of the fifteenth century, laboured with admirable ardour on all kinds of innovations. But Italian life ran parallel with European life and followed—with some tardiness—the same curve of time; this re-awakening, this activity, were not specifically Italian phenomena. In the same period, the workshops of Burgundy

and Flanders were producing those models whose importance we have already examined. Claus Sluter lived before Donatello. Van Eyck preceded the constructors of geometrical space and created the material of painting. The history of Flamboyant architecture is not one of enfeeblement but of profusion and overflowing vitality. Though we may say with accuracy that it was based on deviations and even misinterpretations, it nevertheless derived from those very misinterpretations a remarkable prodigality of effects. Lastly, the powerful accord which existed between the higher forms of this activity and the lives and passions of men, the taste of the princes and the interest of the towns in things of beauty, were characteristics common to the whole of Western civilization in this period, as is attested by Charles V, Jean de Berry, the Dukes of Burgundy and the Flemish and German cities, Bruges, Ghent, Tournai, Colmar, Basle and Nuremberg.

The historians of the Renaissance have rightly been at pains to emphasize a constant feature of Italian life, its Mediterranean aspect, the capacity for happiness, which at that time assumed a kind of expansive power and which, awaking gradually in the various forms of life, filled them with a new sentiment, with a gaiety, a joyful acceptance of destiny which the middle ages, it is said, had never known. But do not the Middle Ages in the West, as seen in the iconography and spirit of the French cathedrals, demonstrate the harmony of a Christian optimism which likewise accepts and rejoices? The vast panorama of life which they present to us breathes, not the terror of the unseen, but the serenity of tasks cheerfully performed and a complete acceptance of man's destiny; and, in the smile of the angels at Reims, they communicate to us a joyous message of youth. Do they testify to less curiosity for the things of the world and the marvels of nature than the Italian fifteenth century, and is not this sense of the marvellousness of the creation, in all its levels and forms, this desire to penetrate its every secret and to welcome it without exception or reticence, is this not a fundamental characteristic of medieval art? Italy awoke belatedly to this encyclopaedic passion for all the forces and forms of life, men, beasts and plants, and the French thirteenth century, by assigning to the human figure the preponderant place and role in these natural hierarchies, had already given powerful definition to a humanism wider and more comprehensive than any which could arise from the perusal of texts and the copying of tombs. One would fall into grave error if one interpreted Villard de Honnecourt, in his researches into canons of forms and in the manifold aspects of his curiosity, as a precursor, an anticipation of the Renaissance; no one was ever more vigorously of his own time. It may be claimed, on the contrary, that Italy was in this respect both magnificent and slow: the mind of Pisanello, and, still more, the mind of Da Vinci, belonged to the Middle Ages.

II

IT is an illusion to believe that the fifteenth century was connected with the fourteenth by a kind of hinge and that, after a few 'transitional' masters—Gentile da Fabriano, Masolino da Panicale, Pisanello—painting in Umbria, Florence and Northern Italy then set off down the royal road of the new style, making fresh acquisitions as it proceeded. In fact, masters who were deeply involved in the spirit and forms of the Middle Ages persisted alongside the innovators, whose researches, moreover, were not unknown to them, and these latter were themselves, in a whole aspect of their genius, sunk deep in the past.[1] Pisanello of Verona, painter and medallist, one of the most enigmatic and fascinating figures of a period which numbered many such, is without doubt the supreme poet of that vast reverie which ran through the whole of the later Middle Ages in the West; he may have learned to know its charm from the miniatures and tapestries, which came from France, through Lombardy, to the towns of northern Italy, but primarily he was predisposed towards it by the example of the great Altichiero and his own inherent affinity; he brought together all its enchantment in his paintings in Sant' Anastasia, devoted to the chivalrous legend of St. George and the princess of Trebizond, which unfolds itself against a landscape of crags and romantic castles. The drawings of the Recueil Vallardi are a superb testimony to his enquiries into the marvels of human and animal form, set down in the ornamental calligraphy of profile and silhouette, their inner structure and their outer skin accurately rendered, and situated in space with a diversity which produces, in identical objects, an astonishing variety of appearances. Courtly dress extends and disguises men and women, so that they look like enchanted birds. In his medals, Pisanello revived a technique of antiquity, but they are so full and vivid that, magnified, they could well adorn a façade. This is the summary of one of those lives which belonged both to the constructive experiments of the historical moment and to the last great reveries of the Middle Ages.

There were others, more single-minded, whose limpid reflection appears in works wherein the art of the illuminators survives undimmed. Craftsmen of seraphic dreams—Gentile da Fabriano, Fra Angelico, even Benozzo Gozzoli—

*[1] In Northern Italy it is possible to see how the Gothic accuracy of details paved the way for the naturalism of the Renaissance. Interesting examples of this conjunction of tendencies are provided by the animal studies of Michelino di Besozzo and Giovannino de' Grassi, c. 1400, by the elegant illustrations of pharmacological treatises such as the Tacuina Sanitatis and more generally by the sketch-books called 'ouvrage de Lombardie', with their characteristic admixture of realism and of stylized designing. See O. Pächt, *Early Italian nature Studies and the Early Calendar Landscape*, Journal of the Warburg and Courtauld Institutes, XIII, 1950, pp. 13-47.

followed one upon the other. In the convent of San Marco in Florence, beneath that unsullied light of the Tuscan sky which seems to prefigure eternity, Angelico seems outside time, blessed with the advantage of perpetual childhood. Yet nothing of the researches of his century passed him by, and he profited by them, although one could believe his pictures, and even his frescoes, to be the loveliest miniatures of the Middle Ages and, in their deep calm, their wealth of symbols, their airy shining quality, earlier than their actual date. The same conception of life, form and colour inspired the procession of the Three Kings which Gozzoli wound around the walls of the Riccardi chapel, with an oriental pomp, with which the Tuscan spirit had long been acquainted and which had no doubt been re-animated by the stay of the emperor Michael Palaeologus in Florence, on the occasion of the council which was to have brought together the Churches of East and West. If one compares his interpretation of the life of St. Francis at Montefalco with that of Giotto at Assisi, one realises that it is the latter which is the more modern of the two, by virtue of its greater monument-ality and its establishment of the future greatness of painting in Italy. Even in the Old Testament series in the Campo Santo at Pisa, where the canephori and the labourers on the Tower of Babel are among the proudest and loveliest figures of the Renaissance, there persists this anecdotal charm which shows that Gozzoli was as much a delightful illustrator as he was a painter of vast wall spaces.[1]

They were all, it is true, attentive to the contemporary hubbub of ideas and to the experimental researches into the nature of space, and its rational structure, the enquiry in which mathematicians like Manetti collaborated with the painters and with that universal genius, the head of a whole dynasty of the mind, himself a painter, a sculptor, a great architect, a great humanist, an athlete and also a philosopher, Leon Battista Alberti. Here we are in the centre of the new dis-coveries, and that uneasiness concerning perspective, which we find in the previous century disturbing the Giottesque painters of Tuscany, is at an end. The *Trattato della Pittura* formulates for the first time a group of practices based on the habits of natural vision, as interpreted by the geometric grid of the '*piramide visiva*', and whose extension constituted a direct menace to the monu-mental order of the Middle Ages by abolishing the homogeneity of the surfaces and the volumes of the walls, and advancing beyond painting into all the arts, on which *trompe-l'oeil* artifice tended to confer an illusory identity of purpose.

[1]All through the fifteenth century Siena remained the Gothic conscience of Florence. This did not prevent her from assimilating in her own way the new tendencies of the time. A proof of it is the amazing figure of the painter-architect-sculptor Francesco di Giorgio Martini: see A. S. Weller, *Francesco di Giorgio*, Chicago, 1943.

And yet the sources of Alberti's thought must be looked for in the Middle Ages, in the Arabic perspectives and in the theory of Robert Grosseteste, Bacon's master, concerning the propagation of light. It is likewise curious to note that a painter such as Paolo Uccello, one of those who were most exercised by perspective, remained profoundly medieval in his pictures of battles, which are simply the old battle pieces enriched with fine studies of horses, seen from behind, in three-quarter view, in profile or from directly in front, as in some of the drawings of the *Recueil Vallardi*. Composition and treatment of colour, in the dominance of the local tones, the great expanses of white, the blacks and the reds, recall the art of the glass-painters. Nor was Uccello's perspective directed solely to verisimilitude; it served also for the creation of ornamental pattern.

In addition, it was an illusionistic technique, a device which was capable of giving the artfully treated plane surface a convincing appearance of relief and of conferring the full roundness of sculpture on the equestrian statue which Uccello painted in memory of the English *condottiere* Giovanni Acuto, and on Andrea del Castagno's standing figures of Boccaccio, Farinata degli Uberti and Filippo Spano, painted in false niches, at the convent of Sant' Apollonia.[1] This skilful deceit, attractive to the eye and delightful yet disconcerting to our sense of space, was not simply the early and capricious phase of an immature experiment: Italian art consistently retained its loyalty to, and its superior capacity for it, as, for instance, in architectural illusionism and theatrical decoration, and even in large-scale frescoes and the paintings of the masters. Early in the fifteenth century it produced its sculptural masterpiece in the doors executed by Lorenzo Ghiberti for the Florentine baptistery, which are admirable for the distribution and framework of the panels, for their wealth of invention, their fluid elegance and the noble sentiment of the subjects. The gradation of the relief in accordance with the supposed distance of the various planes, the skilfully calculated transition from the fully round to high relief, from the latter to low relief and finally to the almost flat modelling of the medal, the strict foreshortening of the architecture, and the suggestion in the bronze of an atmospheric landscape struck the popular mind like a miraculous revelation: henceforward, the baptistery doors were the gates of Paradise. One is conscious of the factors—the science, the dignity, the quality, the great models of classical antiquity—which distinguish this memorable ensemble from the contemporary altarpieces of Western Europe: the basic principle was, nevertheless, identical.

*[1]These 'painted statues' come from the dilapidated villa la Legnaia at Soffiano, near Florence. They were part of a gallery of famous personages. A magnificent figure of Eve, standing under a portico treated in perspective, has recently been found under a coat of plaster: see M. Salmi, *Gli affreschi di Andrea del Castagno ritrovati*, Bollettino d'Arte, IV, 1950, pp. 295–308.

III

THERE existed also a certain number of concrete achievements, by means of which Italy was able, in the first half of the fifteenth century, to launch power-fully into European art, a system of ideas, a poetry and a style, whose expansion was one of the most manifest signs of the new age of historical life. At the moment when Gothic architecture was collapsing beneath its own abundance, Florence was creating an architecture which deserves to be called unexampled and personal, for, although Brunellesco took hints from the monuments of ancient Rome, and even, at San Lorenzo, copied the scheme of the Christian basilicas, the Florentine palaces which are due to him, and his successors Michelozzo and Alberti, despite their colossal rustication and superposed orders, are not a pastiche of Roman imperial art but a personal and vigorous definition of the monumental mass, set on a plinth like the base of an Etruscan citadel and terminated above by the energetic shadow of the cornice. Even in these cubic fortresses—for such, in many respects, the Ruccellai and Medici palaces still remain—one may discern the future of an art which no longer set itself to solve constructional problems—save in the raising of domes, for which Brunellesci established the rules and created the first modern example in Florence cathedral—but dominates by the elegance of its proportions and the subtlety of its effects. The Pazzi chapel suffices to give the measure of his taste and of his inventive power by bringing home to us the qualities of the rigorous Tuscan dryness as against those of the *Flamboyant* Baroque. In addition, painting found its way back, across the Giot-tesques, to the splendid path traced by Giotto and returned, in Masaccio's frescoes in the Brancacci chapel, to the breadth and stability of the monumental style. Here was the perpetual yardstick of Italian art and the model of all great decorative painting; capricious, illusory and romantic instincts tended occasion-ally to entice it into other courses, but it constantly returned, as if it found in this the authentic and definitive expression of its best gifts. Masolino da Panicale and Masaccio, who were near-contemporaries and collaborators in the same scheme of decoration, might be thought to be two or three generations apart; Masolino is a master—his almost effaced frescoes at Castiglione d'Olona[1] still retain, in their surviving fragments, the poetry of their captivating purity, and his Adam and Eve in the Brancacci chapel exhale the charm of the lovely nudes

*[1]The frescoes at Castiglione d'Olona are heavily restored and therefore all the more legible. Dating from c. 1435, they are later than the works in collaboration of Masolino and Masaccio at the Carmine, 1427–28. On the respective share of the two artists, see U. Procacci, *Masaccio*, Milan, 2nd ed., 1952. On the conflict of styles, see R. Longhi, *Fatti di Masolino e di Masaccio*, Critica d'Arte, XXV–XXVI, 1940.

of Italy before it attained its historical maturity—but Masaccio has the massive draperies, the slow rhythms, the tranquillity of space between the figures and that richness of substance which, without doing violence to the wall, confers on painting the full and calm authority of statuary. Finally, statuary itself, in the art of the Sienese Jacopo della Quercia and the Florentine Donatello, introduced the virile poetry of majestic form, not into sterile copies after the antique or experiments in pictorial effects, but into a reconciliation, apparently far-fetched or indeed impossible, of elements derived on the one hand from Greco-Roman statues and on the other from the workshops of the North. From the former they drew harmony and gravity, from the latter their contact with life. Jacopo della Quercia takes his place between Claus Sluter, whose disciple he sometimes appears to be, and Michelangelo, of whom he is the first draft and forerunner. At Lucca, the San Frediano altarpiece might be the work of a master imager imbued with the latest Gothic teachings; at Bologna, the San Petronio reliefs, monumental, colossal almost, despite their small scale, renouncing ostentatious draperies and riotous folds, illustrate a marble Genesis with nude figures only, without architecture and without landscape. Nothing could be more rigorously opposed to the pictorial modelling of Ghiberti. The antique inspiration is here graver and more robust. Is it intermingled with some reminiscence of the Middle Ages? It is not out of place to recall the lintels with the nude figures of the General Resurrection. Donatello likewise has two aspects. In his Campanile prophets, his *Zuccone*, he seems to belong to the Sluterian family; his collaboration with Brunellesci and Michelozzo taught him to have eyes for antiquity, but he did not found his manner upon it and, as a tomb-sculptor, he never became a producer of sarcophagi. When he set up his Gattamelata before the Santo in Padua, it was not the first equestrian statue since imperial times, nor even the first inspired by the Marcus Aurelius of the Capitol, since we still possess the Romanesque effigies of Constantine, but, like the Saintonge sculptors of the twelfth century who transposed the antique into the medieval mode, he retained the individual strength of his own genius. Form, for him, had always that quality of sharp profile which distinguished all the great artists of Florence. In this way, the Atticism of Tuscany was able to combat and correct the heaviness and profusion of the figured monuments of Rome and to rediscover for itself the pure, bold and sensitive aspects of Hellenistic art. Donatello created a style, but he did not abandon himself to it, and never ceased from enquiry. The dramatic genius of the fifteenth century and the Italian instinct for happiness each sought to claim him for its own. When we look at the high altar in Padua, we seem to witness in the tumult of the bronze the conflict of two worlds, or of two aspects of mankind.

The close of the century offers us a still more striking example. Leonardo remained, in many respects, a medieval thinker. The grid which Alberti made, as it were, of threads stretched across his open window, did not, for Leonardo, contain the whole universe. Other and more fascinating secrets determined the ordering of forms. How were these to be rendered apparent by that instrument of knowledge, the art of the painter? We seem to see in Da Vinci a revival of forgotten skills, the wizardry of the metamorphoses. It is said that in his youth, taking a lizard, to which he added wings, he set himself, as if in jest, to startle nature. This irruption of imaginary creatures, this apparent challenge to the divine order of things, no doubt sprang from the whim of an unusual spirit, but it was also an episode of that 'reawakening' which we have noticed in the French cathedrals and in Flemish painting and of which other aspects appear in the *Apocalypse* of Dürer. The master who looked at an old cracked wall and sought among the capricious lines of the fissures for the secrets of strange compositions, was following the example of the old sculptors of the eleventh and twelfth century, who, in the labyrinth of geometric motifs and abstract patterns, saw the interplay of the world of images. Though, as an inventor of machines, his links were perhaps with the school of Byzantine 'engineers', his conception of nature was infinitely richer and more modern; yet he attached considerable importance to its ornamental aspects. The logical sequences of the various shapes of movements were not yet subjected by him to the idea of a general law, but he found in ornament a harmonic rule which could be used as a key. He catalogued certain analogies, such as the likeness between the spiral motion of currents in fast-flowing water and the plaiting of a woman's hair. We have already followed several stages of this idea that nature draws regular shapes, in the Romanesque Middle Age and its Gothic successor. And we have seen the development in the fifteenth century of the rocky landscape which found its most sublime expression in those visionary settings, the background of the *Gioconda* and the grotto of the *Virgin of the Rocks*. The evening shadows, which Leonardo so much admired as they fell about the serving-women sitting at the inn doors, were the twilight of the Middle Ages. The religious reverie of the *Last Supper* sprang from quite another source than the art of the athletes and the pseudo-Romans.

Thus the Middle Ages extended and propagated themselves in the Italian Renaissance, which long remained merely one of their aspects. Even in Florence, that great workshop of forms and techniques, we come upon them still full of the warmth of life. In the painting of Venice, where Northern influence and models were not wanting, they persisted still longer. Rome welcomed both

Italian and foreign masters; Fra Angelico and Jean Fouquet must have met there. The smaller feudal courts were not unaware of Flemish art. In the town where Raphael spent his youth, Urbino, Federigo da Montefeltro found room in his picture-gallery for Van Eyck and Justus of Ghent. The travels of the artists and their masterpieces linked Europe with Europe, and we can no longer consider these contemporary and intermingled forms of civilization as successive and separate.[1] It is, however, true that they were tending to split asunder and that, after this accord lasting several generations, a disequilibrium was produced, into whose causes it is not our task to enquire. We should not, perhaps, expect to find the most potent of them in humanism. The Christian humanism of the thirteenth century has shown us the high degree of compatibility which existed between this mode of thought and the formal and historical structure of the Middle Ages. Does not the life of style depend on a more general law, and can we not learn, from the concrete examples which it offers us, to understand its meaning and development? The limitation of the ideas of classicism and humanism to the recollection and emulation of the Mediterranean cultures is an arbitrary one: these cultures have not always been 'classical', and their definition of man suffered eclipse. The more historical view is to recognize that each great age of civilization achieves its own classicism, that is, its moment of wide intelligibility and general acceptance, and that it then contains and propagates its own particular kind of humanism. This moment of equilibrium for the Gothic Middle Age was the thirteenth century, and its critical moment was the fifteenth. Architecture then contained two opposing systems, or rather two modes of thought. Of these, one had probably given all that could be expected of its resources, and the splendour of what we call its decline must not disguise from us its sickness and disorder. The other was multiplying its initial experiments and trying out a variety of styles, prior to propounding its own stylistic definition and going on to serve universal ends. But the image of man was long to retain the warmth and passion which the Middle Ages had given it. A sort of hidden middle age was to outlive the triumph of 'classicism'. Perhaps we can feel it vibrating still in the Old Testament of Rembrandt. An epoch does not cease upon the moment, but lives on in the life of the spirit.

[1] Another example is Ferrara, where around 1450, come one after the other Pisanello, Jacopo Bellini, then Piero della Francesca, Mantegna and Rogier van der Weyden. The restless and noble style which followed, with Cosimo Tura and Ercole de' Roberti, is one of the most original aspects of Italian Quattrocento: see R. Longhi, *Officina Ferrarese*, Rome, 1934, re-edited as Vol. V of R. Longhi's complete works, Florence, 1956; B. Nicolson, *The Painters of Ferrara*, London, 1952.

BIBLIOGRAPHY

H. de Geymüller, *Die Architektur der Renaissance in Toskana*, 11 vols., Munich, 1885–1908; M. Reymond, *Brunelleschi et l'architecture italienne au XVe siècle*, Paris, n.d.; H. Michel, L. B. Alberti, Paris, 1931; M. Reymond, *La sculpture florentine*, 4 vols., Florence, 1897–1900; E. Bertaux, *Donatello*, Paris, 1910; B. Berenson, *The Venetian Painters of the Renaissance*, New York, 1894, *The Florentine Painters of the Renaissance*, New York, 1896, *The Central Italian Painters of the Renaissance*, New York, 1897, *The North Italian Painters of the Renaissance*, New York, 1907, French translation, 4 vols., Paris, 1926; A. Colasanti, *Gentile da Fabriano*, Bergamo, 1909; G. F. Hill, *Pisanello*, London, 1905; A. Calabi and G. Cornaggia, *Pisanello*, Milan, 1928; P. Toesca, *Masolino da Panicale*, Bergamo, 1908; A. Schmarsow, *Masaccio*, Cassel, 1900; J. Mesnil, *Masaccio et les débuts de la Renaissance*, The Hague, 1927; J. B. Supino, *Beato Angelico*, Florence, 1901; A. Pichon, *Fra Angelico*, Paris, 1911; G. Loeser, *Paolo Uccello*, Repertorium für Kunstwissenschaft, 1898; M. Lagaisse, *Benozzo Gozzoli*, Paris, 1934.* E. Panofsky, *Renaissance and Renascences in Western Art*, Stockholm, 1960; W. Paatz, *Renaissance oder Renovatio*, Beiträge zur Kunst des Mittelalters, Berlin, 1950; A. Chastel, *Art et Humanisme à Florence au temps de Laurent-le-Magnifique*, Paris, 1959; W. Paatz, *Die Kirchen von Florenz*, 6 vols., Frankfurt a.M., 1940–54; H. Folnesics, *Brunelleschi*, Vienna, 1915; P. Sanpaolesi, *La cupola di Santa Maria del Fiore*, Rome, 1941; L. H. Heydenreich, *Spätwerke Brunelleschis*, Jahrbuch der preussischen Kunstsammlungen, II, 1931; O. Morisani, *Michelozzo architetto*, Milan, 1951; J. Pope-Hennessy, *Italian Renaissance Sculpture*, London, 1958; G. Galassi, *La scultura fiorentina del Quattrocento*, Milan, 1949; R. Krautheimer and T. Krautheimer-Hess, *Lorenzo Ghiberti*, Princeton, 1956; L. Planiscig, *Lorenzo Ghiberti*, Vienna, 1940, and *Donatello*, Florence, 1947; H. W. Janson, *The Sculpture of Donatello*, Princeton, 1957; L. Biagi, *Jacopo della Quercia*, Florence, 1946; B. Berenson, *The Italian Painters of the Renaissance*, Oxford, 1930, new edition, London, 1952 (new French edition, Paris, 1953); B. Molaioli, *Gentile da Fabriano*, Fabriano, 1927; B. Degenhardt, *Pisanello*, Vienna, 1940; U. Procacci, *Sulla cronologia delle opere di Masaccio e di Masolino tra il 1425 e il 1428*, Rassegna d'arte, XXVIII, 1953; M. Pittaluga, *Masaccio*, Florence, 1935; M. Salmi, *Masaccio*, 2nd edition, Milan, 1948; K. Steinbart, *Masaccio*, Vienna, 1947; J. Pope-Hennessy, *Fra Angelico*, London, 1952, and *Paolo Ucello*, London 1950; M. Pittaluga, *Paolo Uccello*, Rome, 1946; E. Carli, *Tutta la pittura di Paolo Uccello*, Milan, 1954; W. Weisbach, *F. Pesellino und die Romantik der Renaissance*, Berlin, 1901; R. Longhi, *Officina ferrarese*, Rome, 1934, and *Ampliamenti dell'officina ferrarese*, Critica d'arte, IV, 1940, supplement; B. Nicolson, *The Painters of Ferrara*, London, 1952; G. Baroni, *La pittura lombarda del Quattrocento*, Messina, 1952; S. Bottari, *La pittura del Quattrocento in Sicilia*, Messina, 1954; L. van Puyvelde, *La peinture flamande à Rome*, Brussels, 1950.

CONCLUSION

ORIENTAL and barbarian influences inaugurated the Middle Ages; Mediterranean influences accompanied and hastened their decline. Between these two chapters of their history, they elaborated a new civilization and a mode of thought which found its highest expression in an architectural system, and which had its base and its support in the West of Europe. It did not, far from it, work in isolation. At the moment when the Romanesque age began its career, the historical circumstances were more than ever favourable to the exchange of ideas, and the prestige of the ancient East, the Byzantine East and Islam had far-reaching effects on Christendom. It seems almost as if the West was on the point of being overwhelmed by the wealth and variety of the contributions which it received from these dazzling civilizations. Yet it absorbed nothing passively, it multiplied its constructional experiments within the framework of the ideas which it accepted, and it gave expression to a new spirit.

An art is not made up solely of internal traditions and external influences, but also of researches which create for it its own law and originality. The action of these various factors, and their interrelationships, varies according to time and place and it is of these inequalities that history is composed. The antique tradition is not a vertical force rising in a straight line from the depths of the centuries with no deflection or break. At the outset of the Middle Ages it had lost its creative vitality, which already in the fourth century had been compromised by the inadequacy of craftsmanship and the disuse of good techniques, as is shown by the edicts of Constantine. The restoration of the empire by Charlemagne, and later by Otto I, had conditionally revived it by associating it with a political programme, but in an age which had long been impregnated with habits of a different kind. It acquired renewed vigour in the late eleventh century in the Cluniac churches, in the south-west French group and in the Romanesque art of the Rhône. But, though it added a particular nuance, it did not set the key: it was simply superimposed upon other values.

Were these other values derived by the West exclusively from barbarian tradition and Oriental influences? The barbarian contribution was considerable. It introduced into our territories the forms and spirit of the great proto-historic cultures, which long survived, in all their brilliance and purity, in certain regions which remained untouched by Christianity: Scandinavia continued to develop and enrich the art of interlace down to the eleventh century. Much earlier, in the

(201)

time of the invasions, the nomadic and hunting peoples, even after their stabilization, had transmitted to the sedentary town-building peoples the traditions and techniques of the steppes. It may be that they also helped to revive local traditions which had fallen into disuse under the imperial civilization. Certainly they were intimately blended into the medieval spirit, not in the art of building, as was alleged by the old nineteenth-century teaching, but in the elements of decoration and in a tone, a habit of thought, redolent of folklore.

As to the influence of the East, it was twice felt, and in very different ways. Romanesque Orientalism was quite unlike pre-Romanesque Orientalism. The latter was the result of a deep, continuous penetration which arose out of the general historical situation. From the fourth to the seventh century, Asia Minor, Egypt and North Africa created a great monumental art, which made use, to a greater or less extent, within a coherent system, of elements from past time and distant places. While the West was in process of collapse, these regions lived and prospered under the protection of the Byzantine empire down to the Muhammadan conquest. Christian Europe in this period drew its nourishment from a vast common fund of Mediterranean and Eastern resources, animated by reciprocal trade and expanding waves of ideas. The development of monasticism mingled Coptic Christianity with the Christianity of Ireland. The incessant Syrian *diaspora* spread through the old Gaulish towns exotic beliefs, exotic practices and exotic objects.

Did Islam destroy this community and cut Europe in two, as Pirenne maintains, by closing the sea routes and confining the empire of Charlemagne within the European land-mass? Despite the 'Roman' programme which it set itself, Carolingian art retained oriental features, such as the Armenian plan of Germigny and the Asturian churches. But these were of less significance for the future than such powerful innovations as the porch-church, the ambulatory with radiating chapels, the compound pier and the disposition of the towers. We have seen how, to these fundamental elements, the great activity of the eleventh century, from its very beginning, added others. And, with the last barbarians finally converted, settled or confined, with Islam in retreat, the routes opened and reciprocal movement re-established, the art of the West on which new Asiatic influences impinged was no longer an oriental art. These new influences were important, but they were no longer decisive. They were now subject to selection and interpretation. Romanesque art broke with the most characteristic feature of the oriental communities, the boxed or enclosed plans, and gave up the Armenian type of Germigny. It developed its architectural thought in basilicas of a new type. It gave it ample scope for expression in three of its most attractive problems:

a problem of programme, that of a church which would permit the circulation of vast crowds of people; a problem of construction, the lighting of a vaulted nave; and a problem of masses, the composition of a multiple east end and the harmonic arrangement of the west front.

We find convincing evidence of this vitality, this spirit of discovery, even in 'first Romanesque art'. It was an academic legacy from ancient Mesopotamian formulae, and its wide and rapid expansion might induce us to think of it as uniform and static; but we have seen that it sheltered within its walls experiments full of daring and variety. Romanesque sculpture reproduced the ornamental dialectic of Sumerian art, but subjected it to the laws of an architecture conceived as a rational order, and, bringing forth a multitude of new monsters, gave them in bondage to the monument which they adorn and which everywhere bears heavily on their servitude. It is true that the Islam of the Maghreb propagated its wood-shaving modillions, its Cordovan capitals, its domes on squinches, its Kufic inscriptions, its ivory caskets and its multifoil arches of geometric form. Poitou, Saintonge, Auvergne and Velay accepted and absorbed these elements in varying degrees; but in the very places where they are most apparent and coherent, the buildings in which they are incorporated are purely Romanesque in their construction, their masses and their weight. Nothing could be further than this masons' architecture from the cabinet-makers' architecture of Islam. Muhammadan vault ribs were a decorative mesh; the vault ribs of the West were vigorous members designed to carry, not fragile miniature domes, but vaults of cut stone; Armenian ribs are also the work of structural engineers, but are turned beneath barrel vaults, domes and ceilings. Finally, out of the capacity for logical thought and deduction, there arose in the West a style which had nothing in common with its predecessor, the Gothic style. Its primitive forms have the rigorous purity of a reaction against the exotic in all its manifestations. They strip off the cloak of the East and the monsters, preferring their own nudity. Then, out of the resources of its own territory, its gardens and its forests, Gothic art composed its own universe. It extended this definition to include the Bible itself. The Hellenistic and Oriental Gospel assumed a new form; Christ submitted to a new incarnation which brought Him closer to us and made His teachings more human.

The hybrids produced on the periphery or in the interior of this vast creative area by the commingling of oriental elements and local traditions—Mozarabic art, Mudejar art, Siculo-Norman art and, in the heart of France, the domed churches of Aquitaine, based on a Cypriot model—demonstrate by their narrow limits in space and time the extent to which the rest of the territory remained hostile to any unqualified intrusion. Furthermore, the extreme diversity of the

Romanesque groups bears witness to the general capacity for fresh invention. The same applies, in the following period, to the Gothic groups—English Gothic, the Romanesque Gothic of Germany, Catalan Gothic—which must not be forced into conformity with the French style. They were very varied aspects of a single spirit, whose guiding principle was based on an architectural law, or whose highest manifestations resulted from that law. It was a law which had nothing of aridity, for it included the colour, illusion and warmth of human life. It was a poetic vision. And it lived on after the demise of the age which it inspired.

Mankind does not renew itself by wiping the slate clean. It always preserves intellectual and moral compartments which belong to its past and may be made use of in the future, characteristic types which one period may bring to the fore, while another relegates them to some obscure lumber room—yet they subsist. Again, the impression made by forms on the historical memory is no fleeting one. Even when their actuality has passed, they keep their place, with the authority of solid values and the prestige which attaches, through all the variations of taste, to a great and powerful art. The Middle Ages were perhaps the leaven of the Renaissance and it was due to their authenticity, their lived-through quality that it was impossible for the Renaissance to be a simple 'revival'. Their vitality, however, was still stronger and more lasting in the West proper, whose power of original invention they had defined. Men continued to build in the Gothic fashion down to the end of the sixteenth century, and even later. It may even be asserted that the technique of the ribbed vault was never entirely dropped from building practice, as may be seen from the vaults of more than one church of the age of classicism. The French painters who travelled to Italy in the first half of the seventeenth century still belonged to the Middle Ages through their native traditions. The masters of Troyes, Dijon, Langres and Lunéville still painted Jesse trees, and portraits in which the modelling is dominated by the forms of wood and stone. It is not by chance that the quiet communion of volumes in Georges de la Tour is oddly reminiscent of the art of the sculptors of southern Champagne in the late fifteenth and early sixteenth centuries. That elegant arranger of the tournaments and ballets of the court of Lorraine, Jacques Callot, was medieval in his vision of the microcosm, which came to him, not so much from Gassendi, as from a much older idea of the relationship between the infinitely small and the infinitely great. The Baroque of Bernini links hands with the Gothic Baroque, and it is for the frame of the tympanum, for a stone structure of the twelfth century, that the distortions and convolutions of El Greco seem to have been designed. Among the Netherlandish masters there was not only similarity and re-emergence but actual continuity. Here the fantastic landscape

was developed, the last great reverie of the Middle Ages, with its monstrous piles of rock-work, its towers of Babel, its diabolic transformations of objects, its country-fair humour and its obsession with the seven deadly sins combined with its sense of universal catastrophe. The strangest and most complete rendering of it is that of Breughel, and the figures with which he peopled it, though they have the authority of imposing form, seem nevertheless to have tumbled pell-mell out of the Utrecht Psalter, the calendar of the *Très Riches Heures*, or certain pages of the *Heures de Rohan*. Finally, in that county of Holland, from which in earlier times Claus Sluter and Dirk Bouts had come, the mysterious dream of Van Eyck was resumed in Vermeer's little street and in the withdrawn contemplation of the intimists.

Thus affinities of place and talent sustained the vitality of the Middle Ages in all its warmth and profundity. They did not vanish, they were not effaced. It might be said that the West retained a kind of nostalgia for them. This achieved actuality in England, during the eighteenth century, with the neo-Gothic beloved of Walpole. It gained strength with the advance of Romanticism, and finally the nineteenth century conferred on it the function and power of an historical force, struggling against the final forms of Mediterranean Baroque and French academism. But resurrections of this kind are only possible and effective if they are profoundly interwoven with the life of the mind. Just as the Renaissance and the age of classicism had modelled their image of antiquity in the likeness of their own passions, investigating one by one the remains of imperial times, of republican Rome, then of Greece and Egypt, and finally, with the extremism of David's studio, the Homeric age, so the nineteenth century relived the Middle Ages, so to speak, in reverse. We find it carrying its search further and further back, from the *Flamboyant* style to the thirteenth century, and eventually to Romanesque art. The earliest studies of Lenoir, Millin and Waagen ran parallel with the art of the Pre-Raphaelite painters of Germany and France. It was the opening of a vast enquiry which, taking its point of departure from a reaction of taste and constantly sustained by more active forces, led finally to a wider knowledge of the past and to a fuller understanding of man.

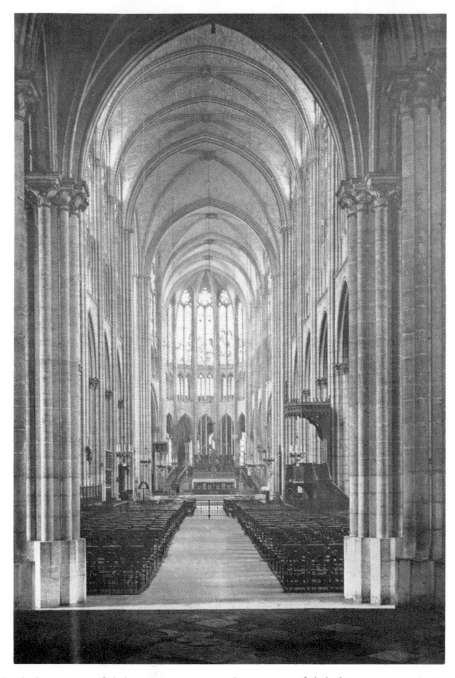

1. Saint-Denis. Lower parts of choir, 1140–1144; nave and upper parts of choir, between 1231 and 1281.

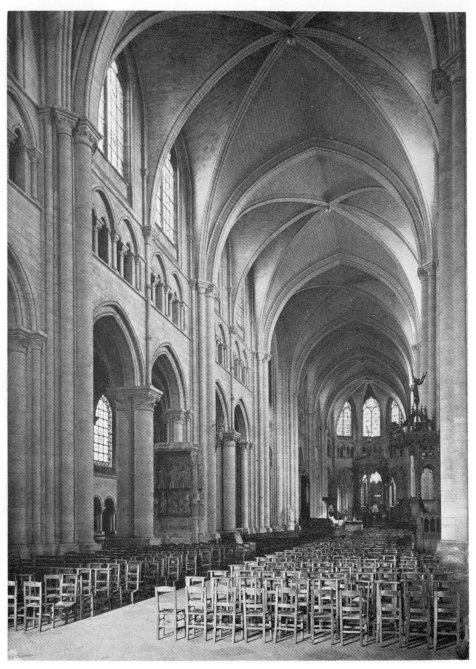

2. Sens Cathedral (Yonne). Nave, begun before 1142.

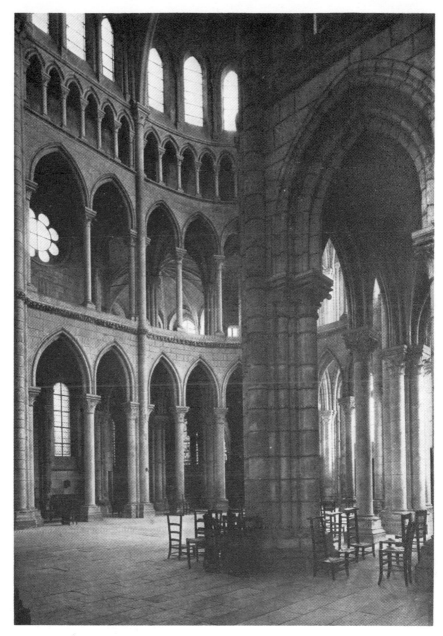

3. Soissons Cathedral (Aisne). South transept, begun about 1177.

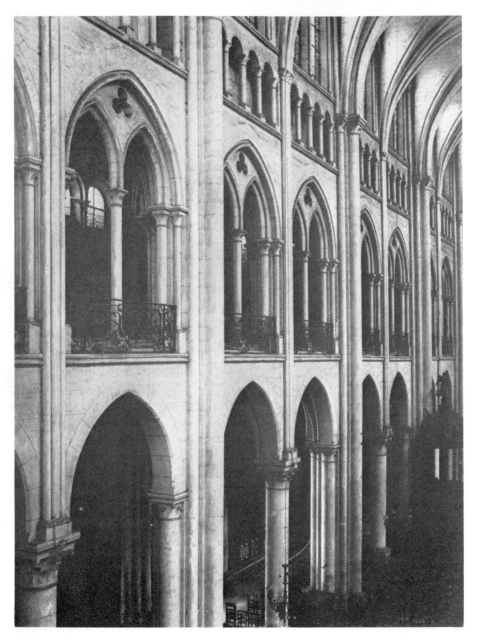

4. Noyon (Oise), Cathedral. North wall of nave, *c.* 1170–1200.

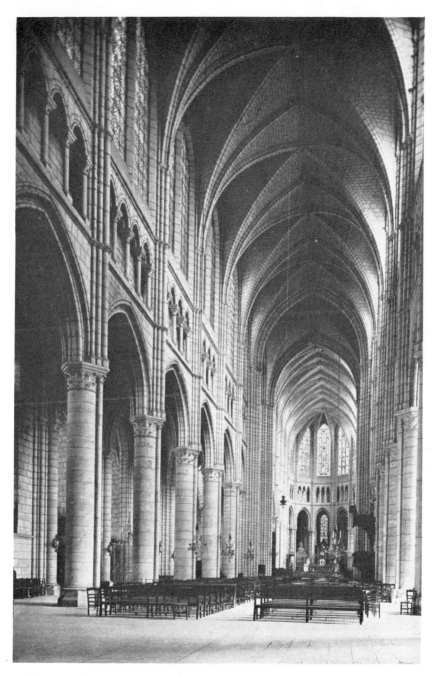

5. Soissons Cathedral (Aisne). Nave and choir, begun about 1200.

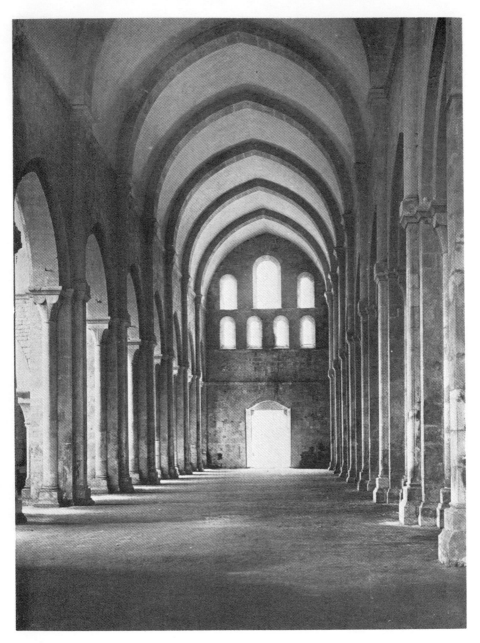

6. Fontenay (Deux-Sèvres). Nave, about 1140.

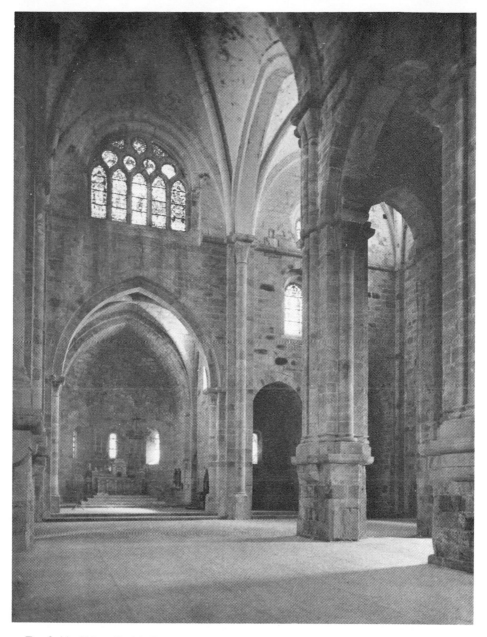

7. Fontfroide Abbey (Aude). East end and part of south transept, middle of twelfth century.

8. Fountains Abbey (Yorkshire). North arcade of nave, after 1135.

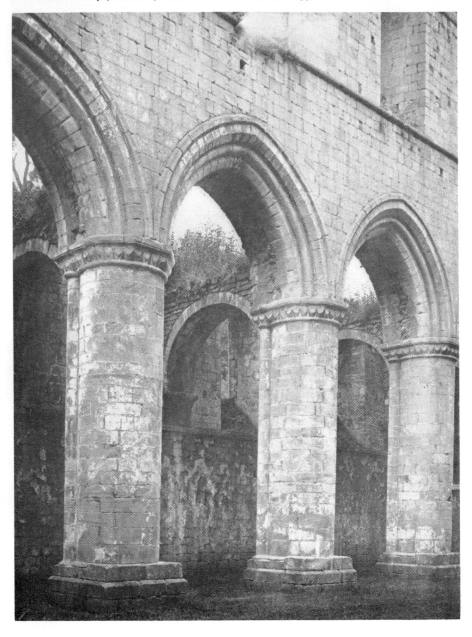

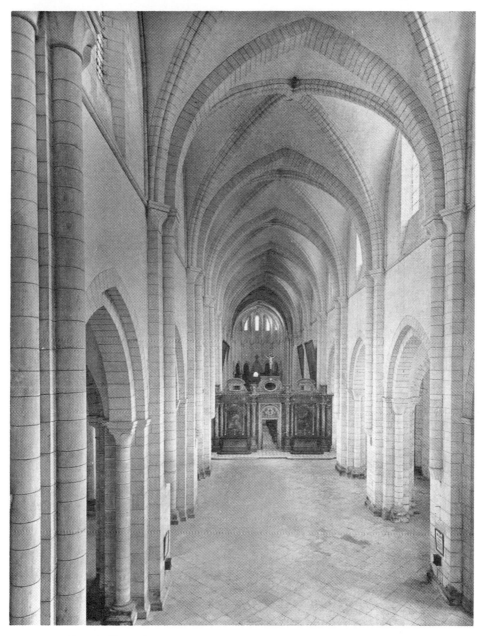

9. Pontigny (Yonne). Nave, about 1150.

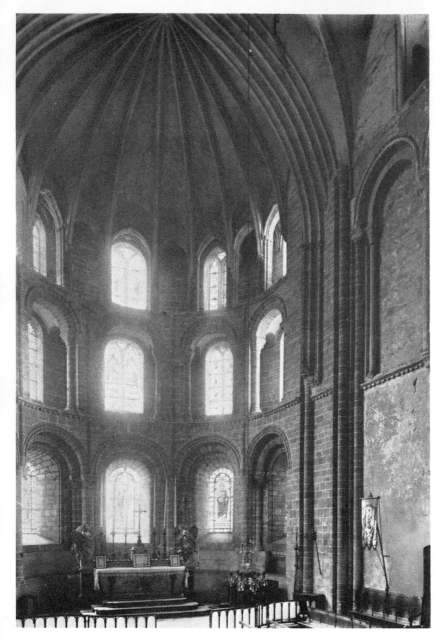

10. Cerisy-la-Forêt (Manche), Saint-Vigor. Choir, end of eleventh century.

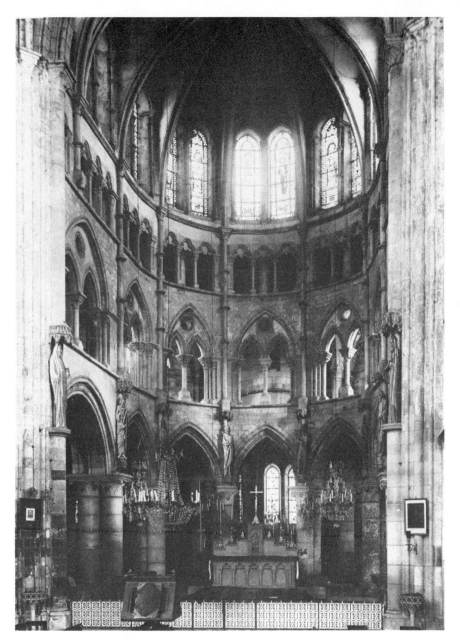

11. Montiérender (Haute-Marne). Choir, end of twelfth century.

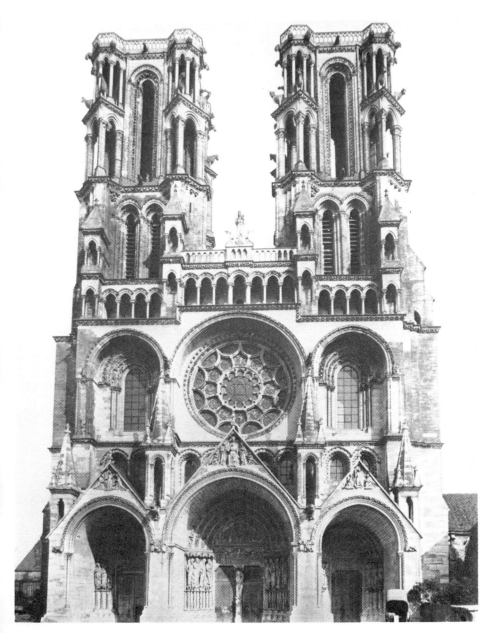

12. Laon Cathedral (Aisne). West front, begun about 1185.

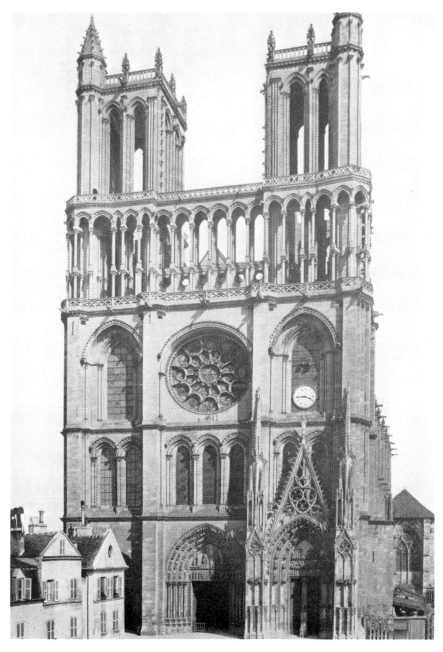

13. Mantes (Seine-et-Oise), Notre-Dame. West front. Portal storey begun soon after 1170;
rest of façade after 1215.

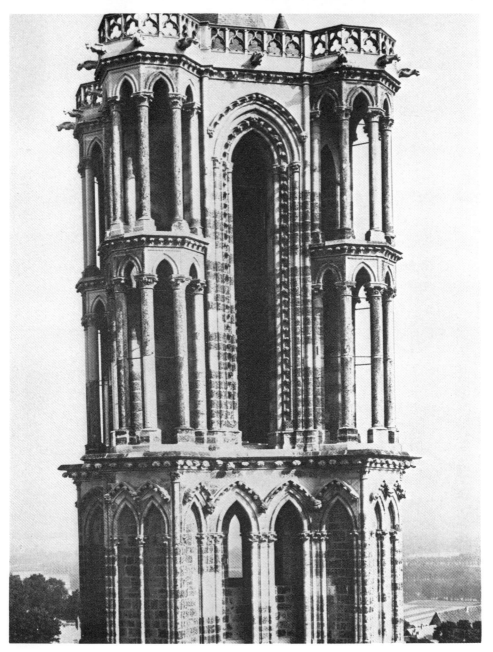

14. Laon Cathedral (Aisne). Tower over south transept, early thirteenth century.

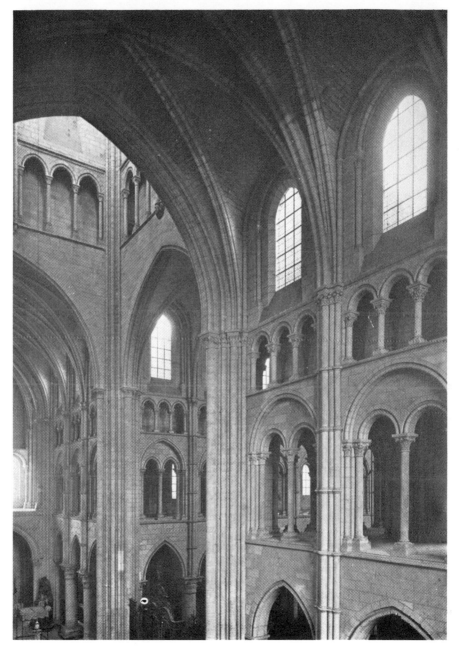

15. Laon Cathedral (Aisne). Crossing, with view into north transept, last quarter of twelfth century.

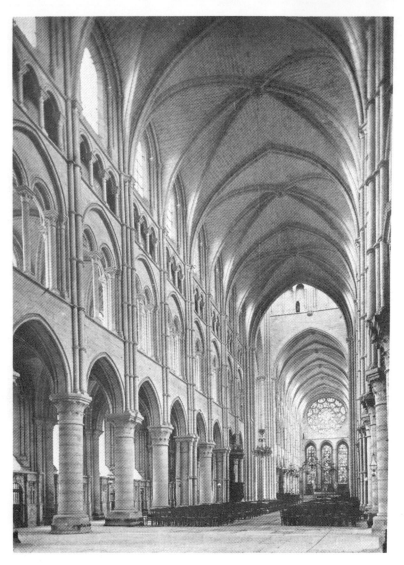

16. Laon Cathedral (Aisne). Nave, last quarter of twelfth century.

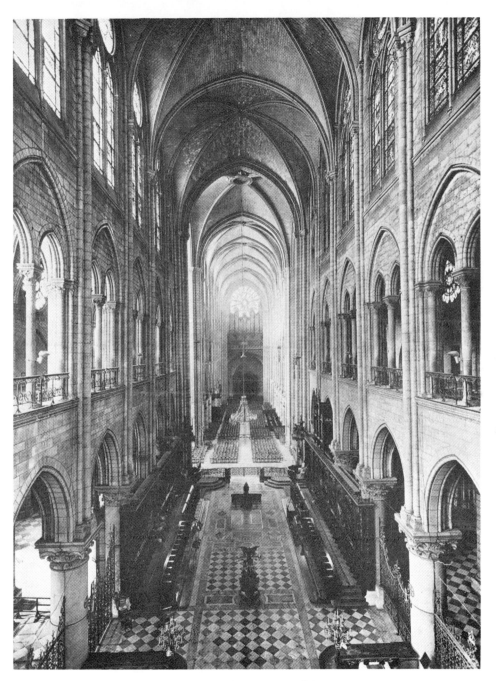

17. Paris, Notre-Dame. Begun 1163. Choir looking west toward the nave.

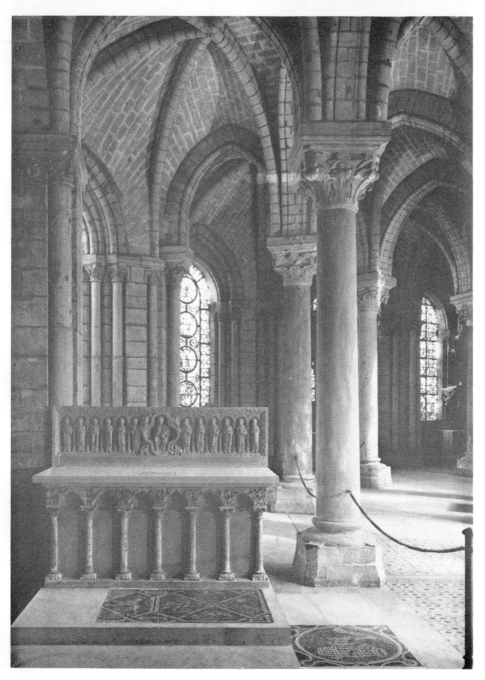

18. Saint-Denis. Ambulatory, 1140–1144.

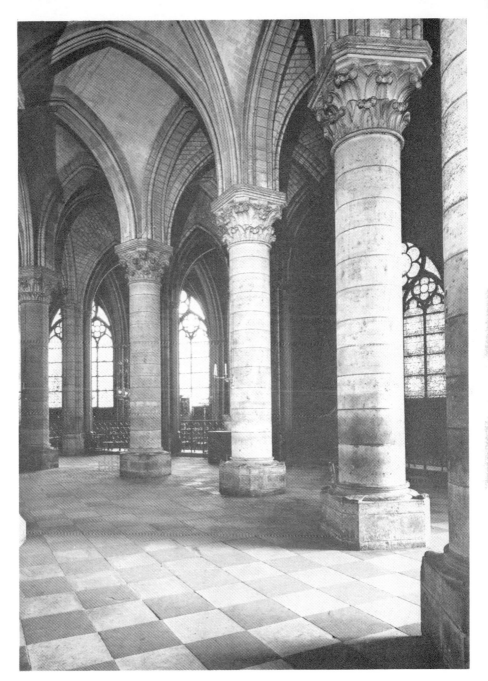

19. Paris, Notre-Dame. Begun 1163. Ambulatory.

20. Morienval (Aisne). Rib vault in the choir, *c.* 1135–1140.

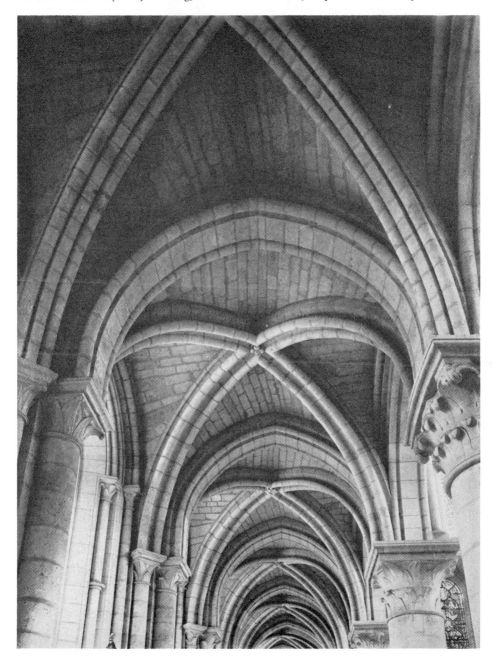

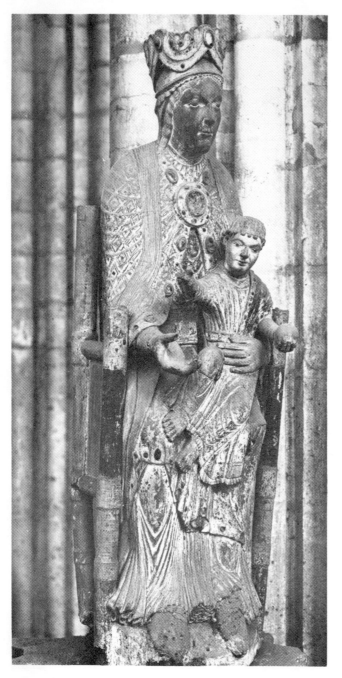

22. *Virgin and Child.*

Wood sculpture from Saint-Martin-des-Champs in Paris, about 1140. Now in the Abbey of Saint-Denis.

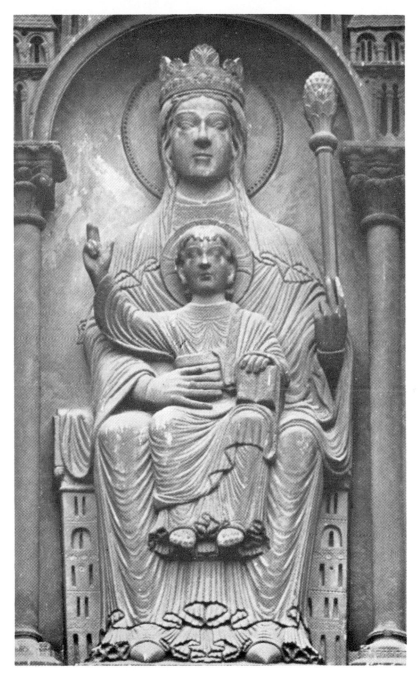

23. Paris, Notre-Dame. Detail from the portal of Sainte-Anne, *Virgin and Child*, soon after 1163.

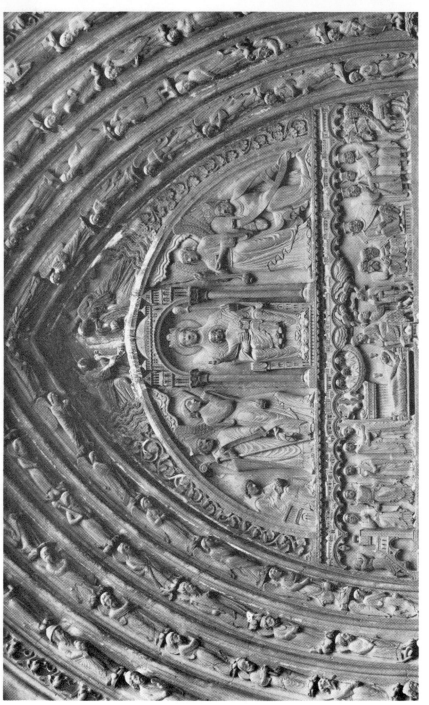

24. Paris, Notre-Dame. Tymparum of the portal of Sainte-Anne, soon after 1163.

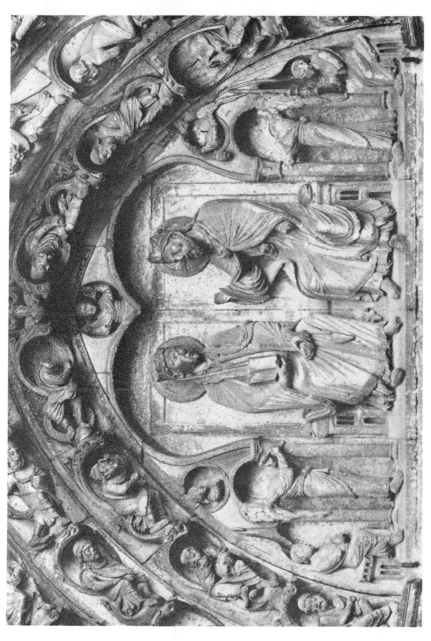

25. Senlis Cathedral (Oise). Tympanum over central door of west façade, *The Coronation of the Virgin, c.* 1170–1175.

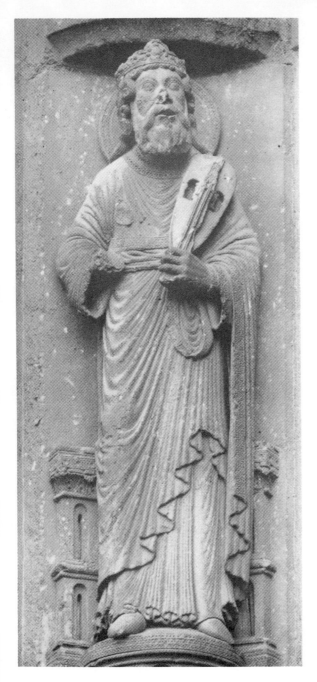

26. Chartres Cathedral. Figure from the archivolts of the central door of the west front, about 1150.

27. Chartres Cathedral. *The Archangel Michael*,
 from the jambs of the central door of the west front, about 1150.

28. Chartres Cathedral. Figures from the central door of the west front, about 1150.

29. Chartres Cathedral. Figures from the central door of the west front, about 1150.

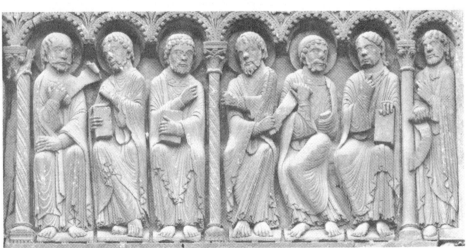

30 and 31. Chartres Cathedral. Tympanum of the central door of the west front, *Christ and the Symbols of the Evangelists; The Apostles*, about 1150.

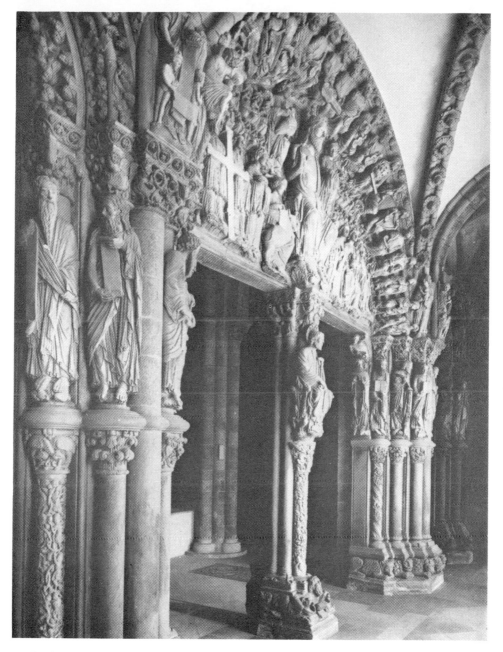

32. Santiago de Compostela (Galicia). Portico de la Gloria, between 1168 and 1188.

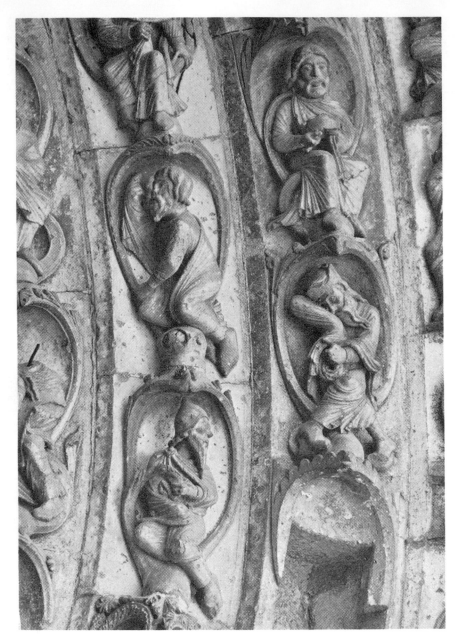

33. Senlis Cathedral (Oise). Archivolt figures, *c.* 1170–1175.

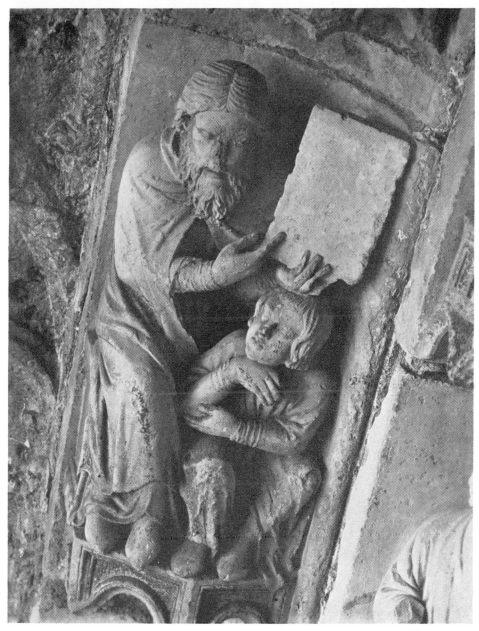

34. Chartres Cathedral. *Tobias*, from the archivolts of the north porch, about 1220.

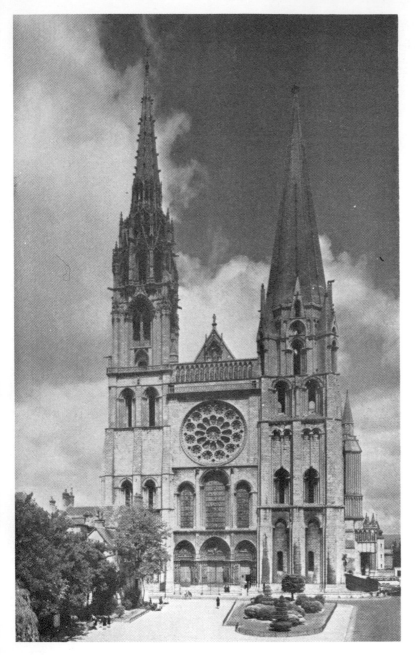

35. Chartres Cathedral. West front: Royal portal, lower parts of towers and south spire *c.* 1134–1170; rose window *c.* 1210; north tower spire, sixteenth century.

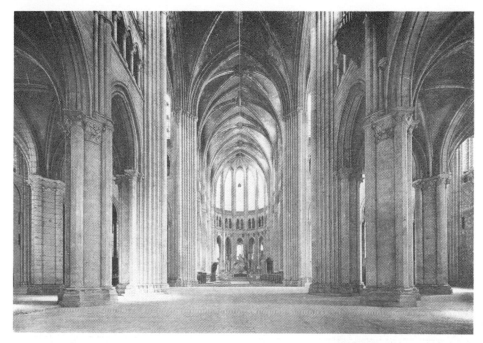

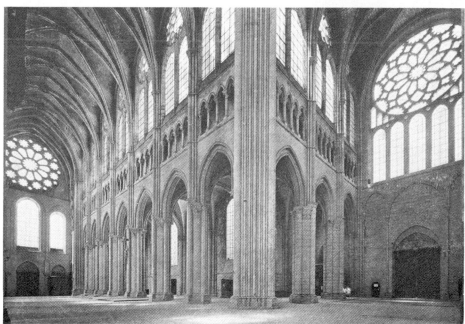

36 and 37. Chartres Cathedral. Nave and crossing, begun 1194.

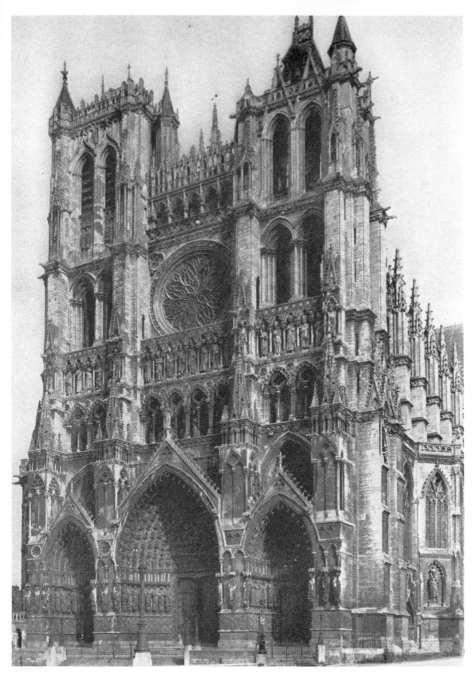

38. Amiens Cathedral. West front, 1220–1235; top storey, fourteenth and fifteenth centuries.

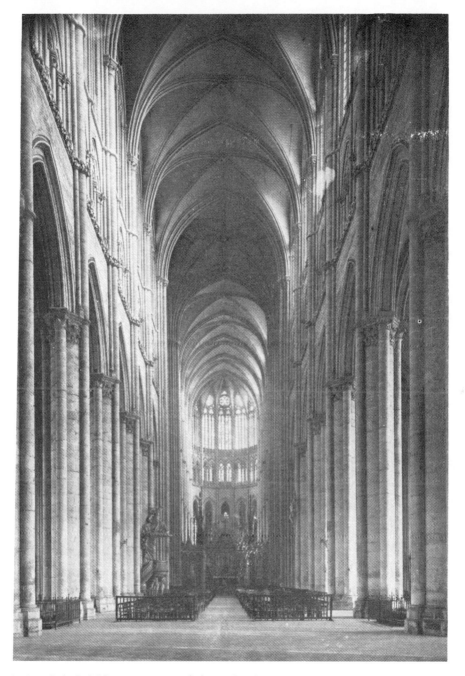

39. Amiens Cathedral. Nave, 1220–1233; choir, 1236–1269.

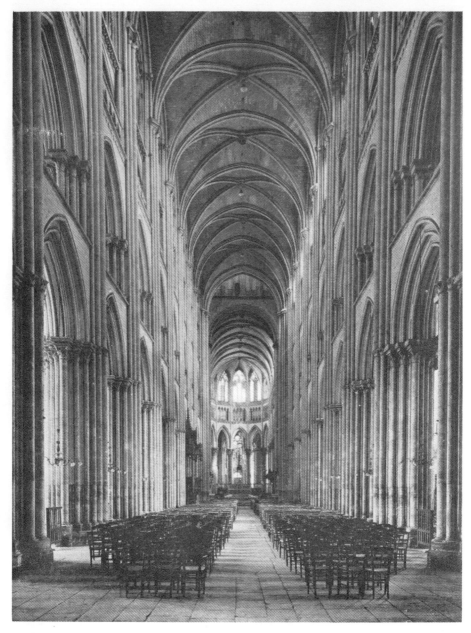

40. Rouen Cathedral. Nave, beginning of thirteenth century.

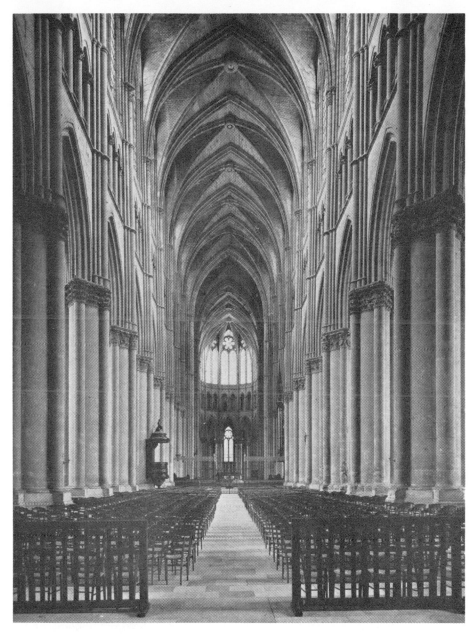

41. Reims Cathedral, begun 1211. Nave, mostly after 1241.

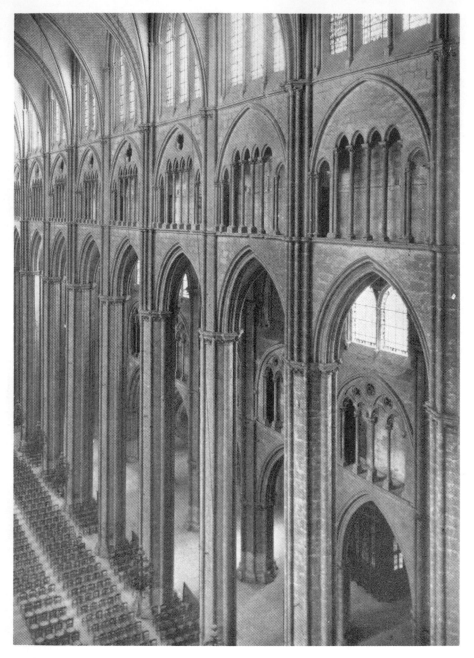

42. Bourges Cathedral. Nave, north side, eastern bays, 1195–1214; rest of nave, 1225–1260.

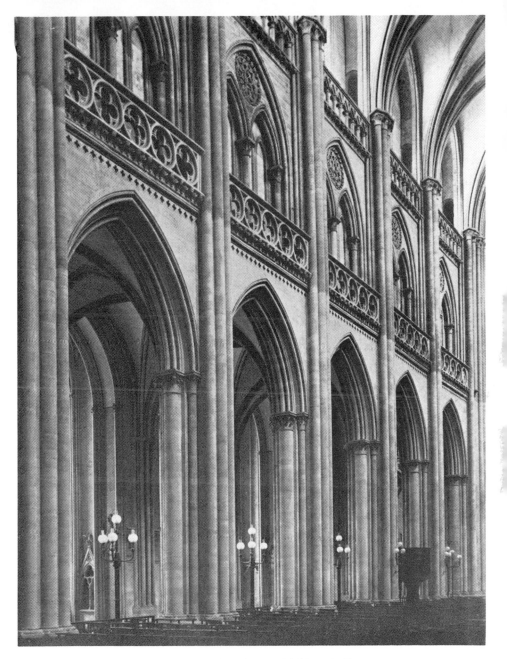

43. Coutances Cathedral (Manche). North side of nave, with blocked tribunes, *c.* 1220–1240.

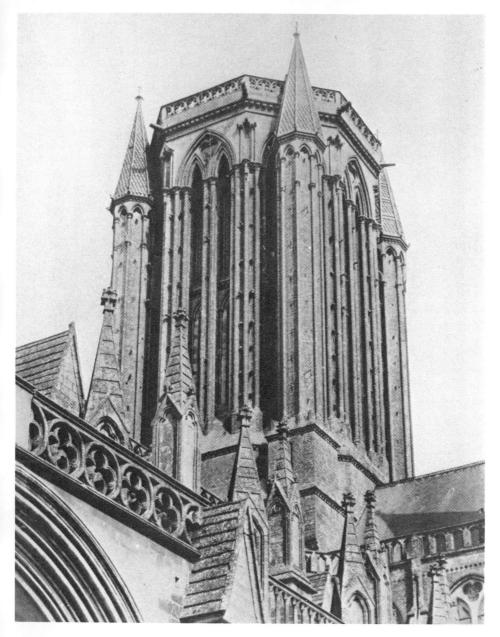

44. Coutances Cathedral (Manche). Lantern, third quarter of thirteenth century.

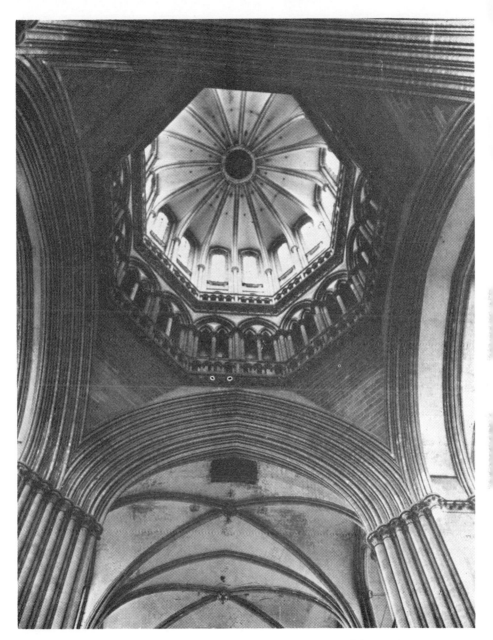

45. Coutances Cathedral (Manche). Interior of lantern, third quarter of thirteenth century.

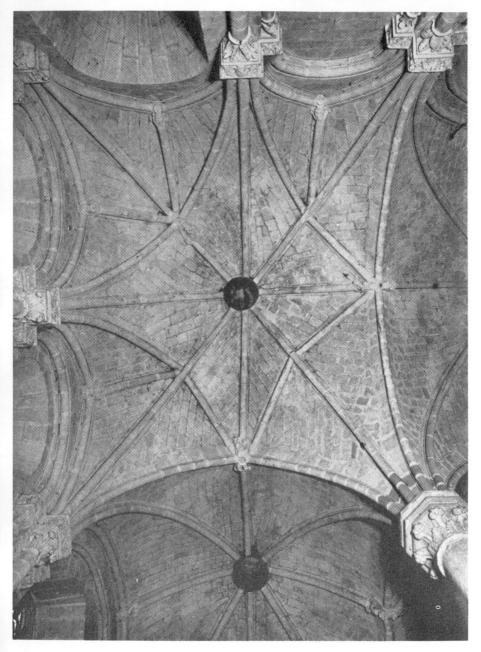

46. Angers (Maine-et-Loire), Saint-Serge. Choir vaulting, *c.* 1215–1225.

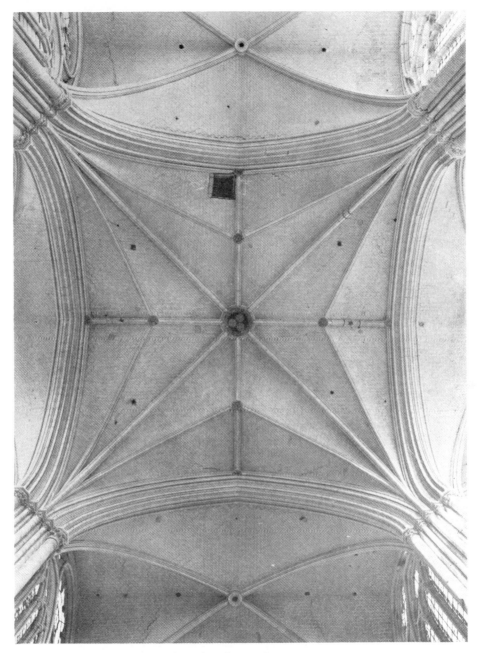

47. Amiens Cathedral. Vaulting of crossing, about 1260.

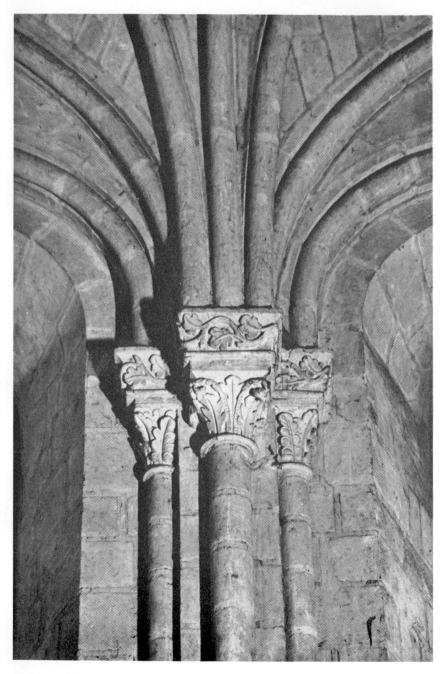

48. Angers (Maine-et-Loire), Saint-Serge. Springing of arches in the choir.

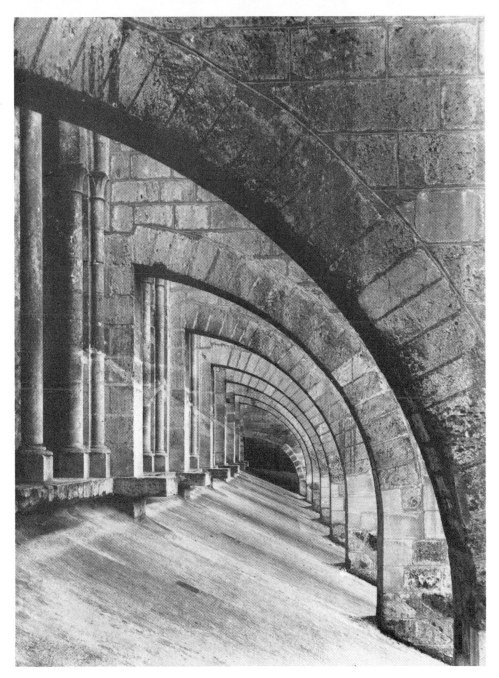

49. Noyon Cathedral (Oise). Flying buttresses on exterior of nave.

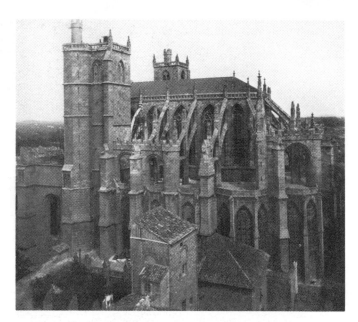

50. Narbonne (Aude),
Cathedral Saint-Just.
Choir, begun 1272.

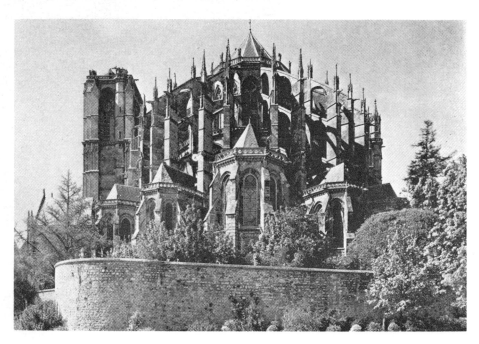

51. Le Mans Cathedral (Sarthe). Choir, 1217–1254.

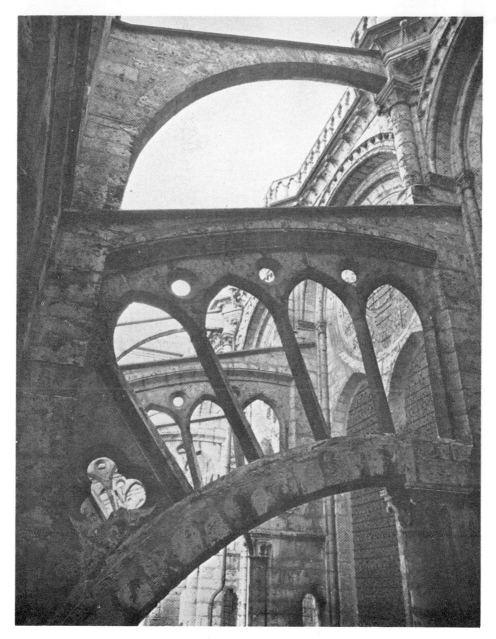

52. Chartres Cathedral. Flying buttresses round the choir.

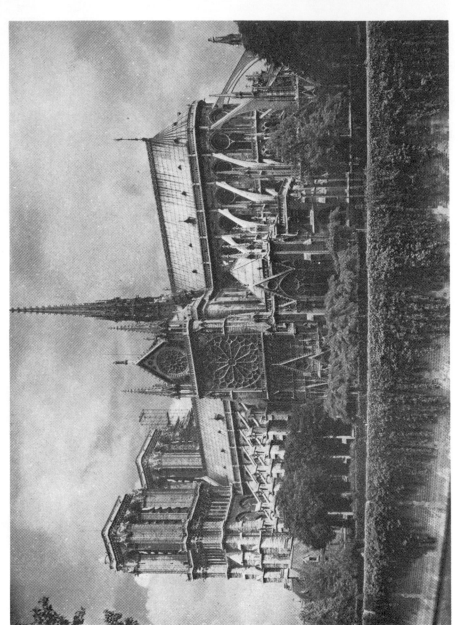

53. Paris, Notre-Dame. South façade and east end, second half of thirteenth century.

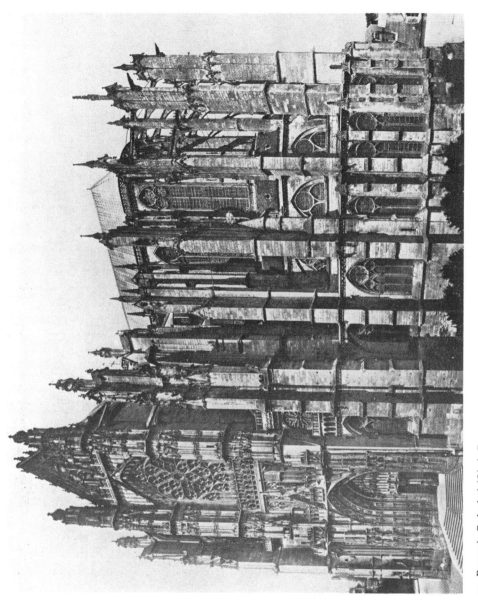

54. Beauvais Cathedral (Oise). Begun 1225.

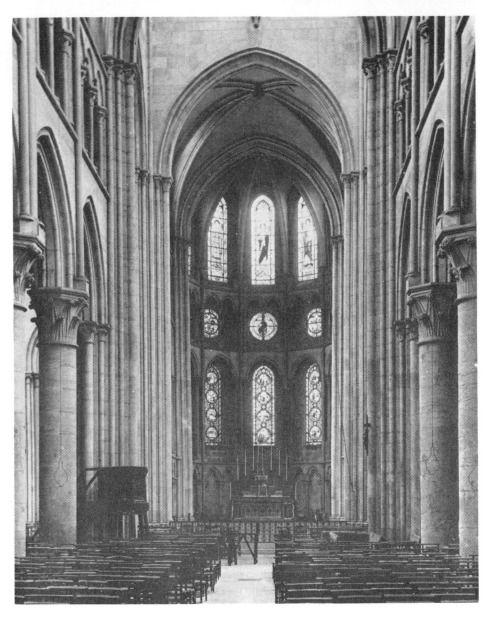

55. Dijon, Notre-Dame. Choir, *c.* 1220–1240.

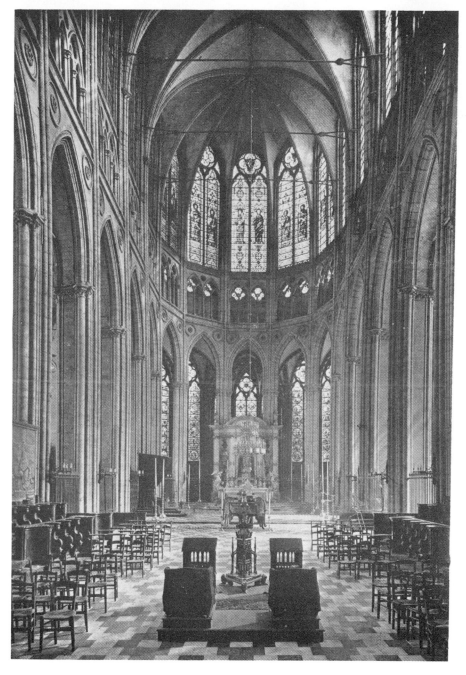

56. Tournai Cathedral (Belgium). Choir, begun 1243.

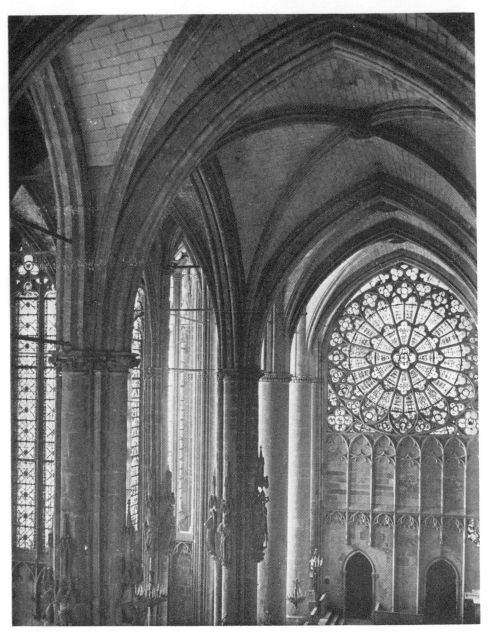

57. Carcassonne (Aude), Saint-Nazaire. South transept, begun 1269.

58. Paris, Sainte-Chapelle, 1243–1248.

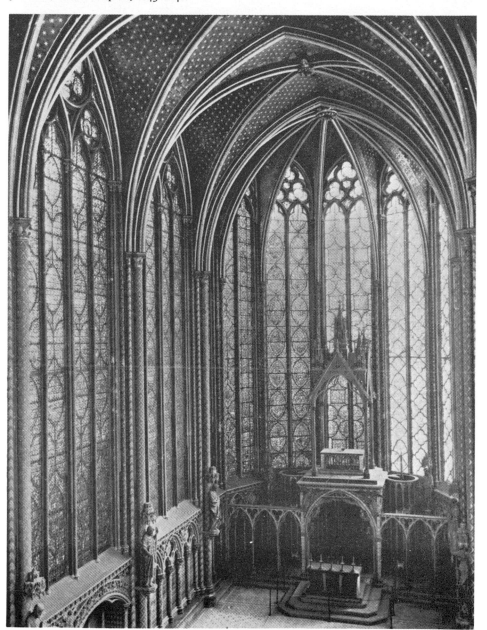

59. Saint-Denis. Stained glass, *Moses showing the tables of the Law*, about 1145.

60. Canterbury Cathedral. Stained glass, *Solomon and the Queen of Sheba*, late twelfth century.

61. Poitiers Cathedral. Stained glass, *The Crucifixion*, about 1180.

62. Chartres Cathedral. Stained glass, *La Belle Verrière*, middle of twelfth century.

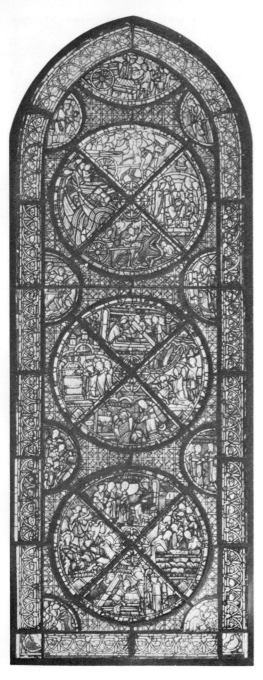

63. Bourges Cathedral. Stained glass,
The Discovery of the Relics of St. Étienne, c. 1215.

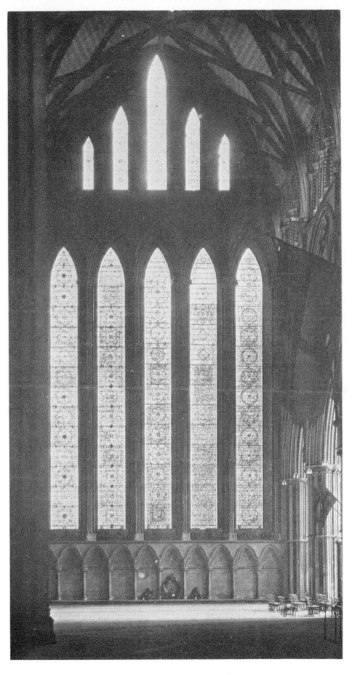

64. York Minster. 'Five Sisters' window, mid-thirteenth century.

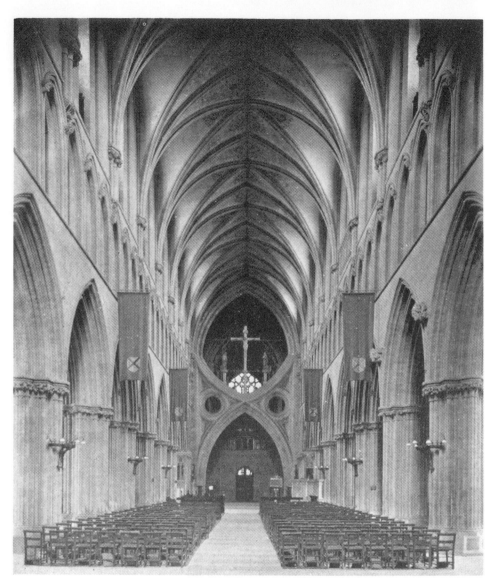

65. Wells Cathedral. Nave, *c.* 1200–1230.

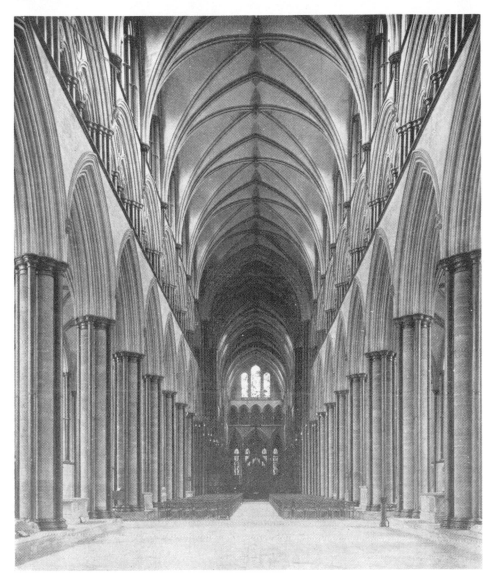

66. Salisbury Cathedral. Nave, 1220–1258.

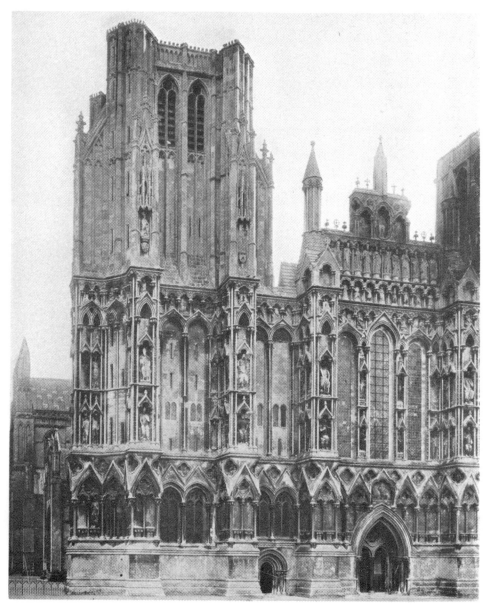

67. Wells Cathedral. North tower and part of west front, begun *c.* 1230.

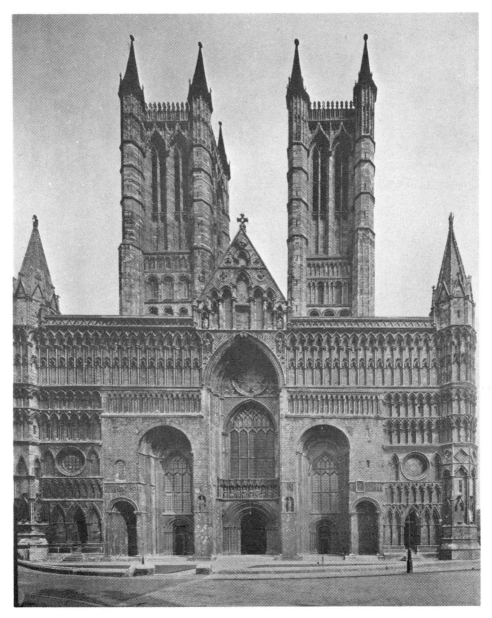

68. Lincoln Cathedral. West front; central part, Norman on two-thirds of its height; screen façade, mid-thirteenth century; towers, late fourteenth century.

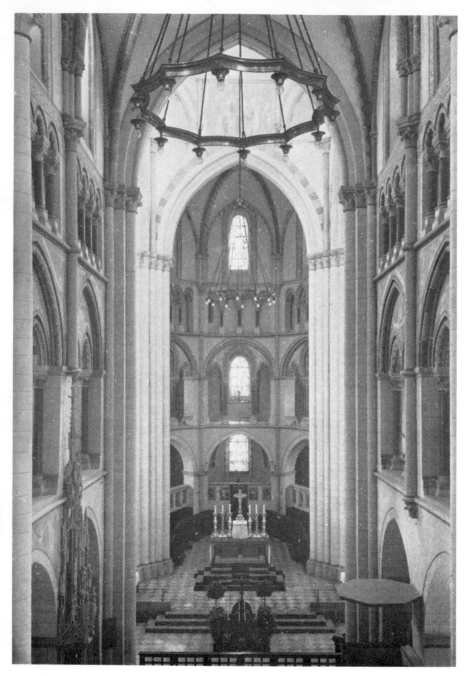

69. Limburg-an-der-Lahn. Nave and choir, c. 1220–1235.

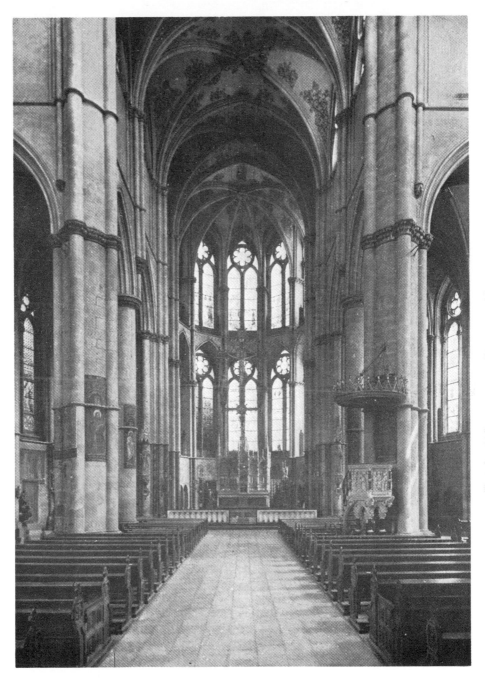

70. Trier, Liebfrauenkirche. Interior, *c.* 1235–1253.

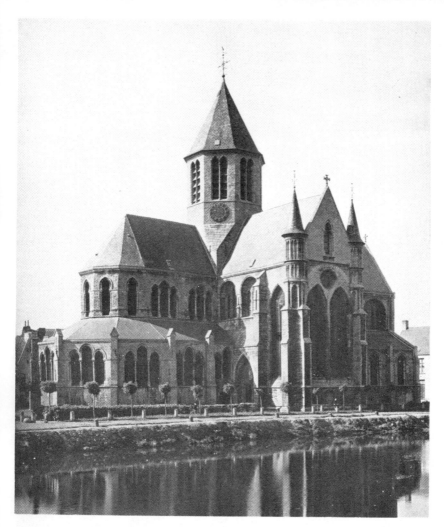

71. Audenarde (Belgium), Notre-Dame de Pamèle, 1235 and after.

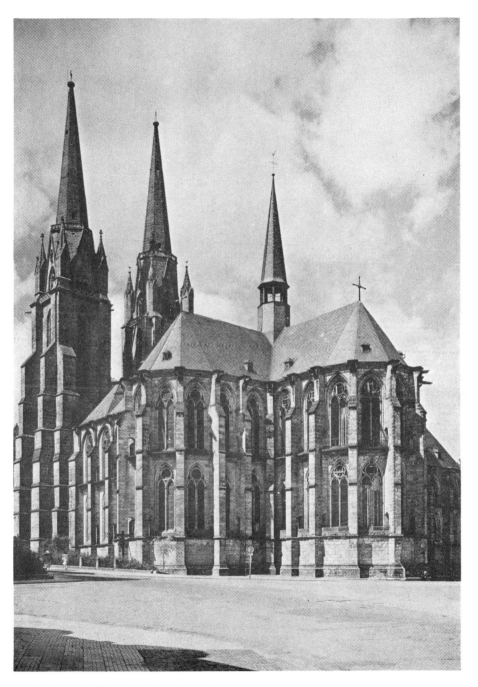

72. Marburg, St. Elisabethkirche. Begun about 1236.

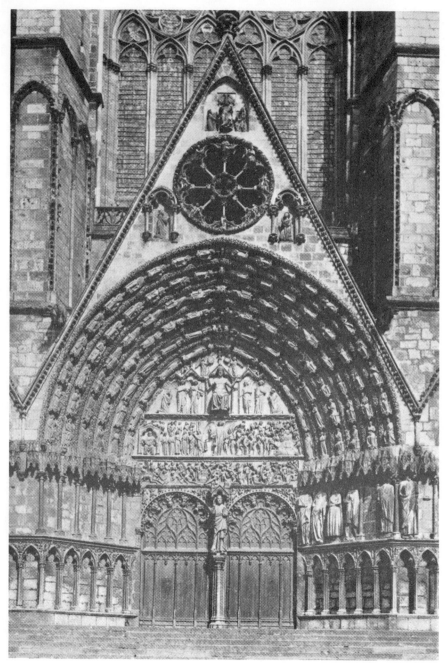

73. Bourges Cathedral. Central door of west façade, between 1230 and 1265.

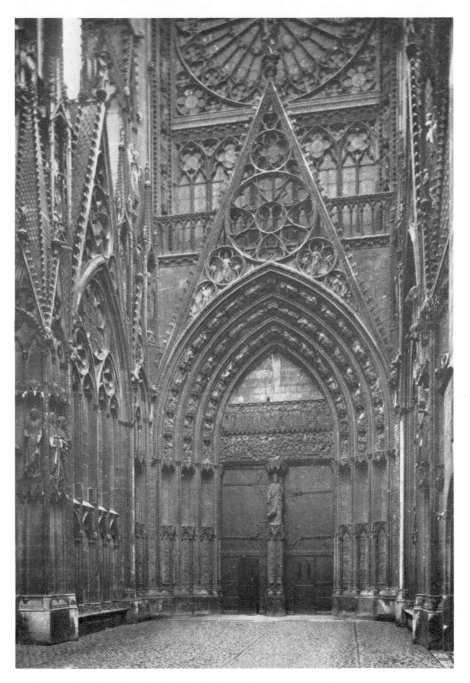

74. Rouen Cathedral. 'Portail des Libraires', north transept portal, between 1280 and 1310.

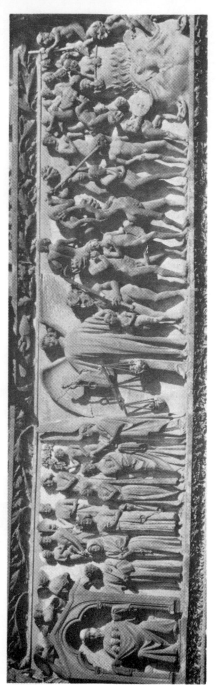

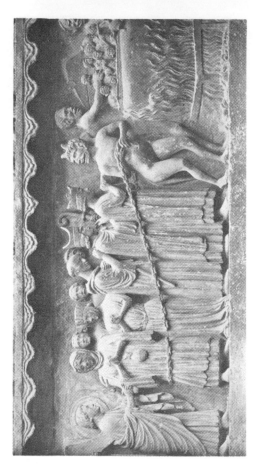

75. Bourges Cathedral.
Detail from the central door of the west façade,
The Last Judgement, c. 1255–1260.

76. Reims Cathedral.
Detail from the left door of the north façade,
The Damned led to Hell, c. 1230.

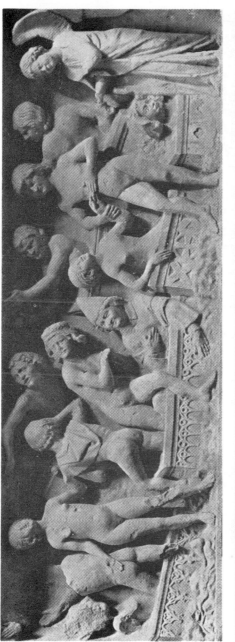
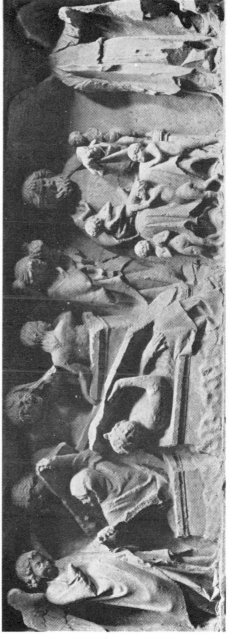

77 and 78. Rampillon. Lintel of doorway, *The Resurrection of the Dead*, c. 1270.

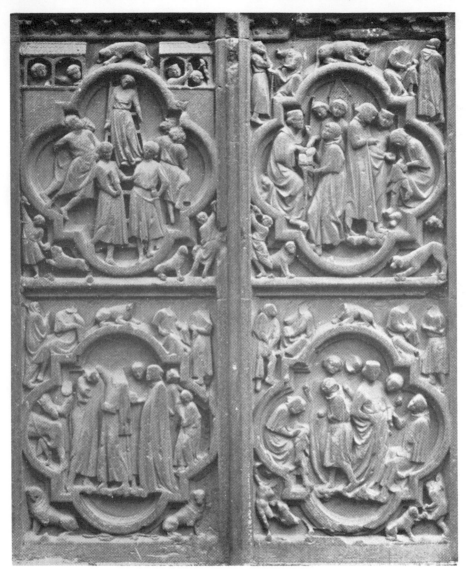

79. Paris, Notre-Dame. *Scenes from Students' Life,* about 1260.

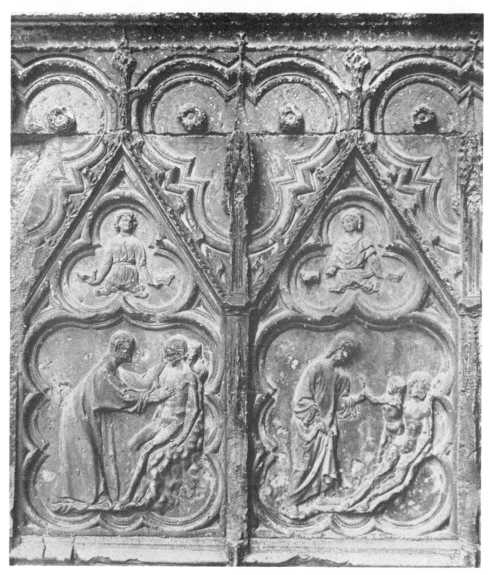

80. Auxerre (Yonne), Cathedral Saint-Etienne. Detail from the left door of the west front, *The Creation of Adam and Eve*, late thirteenth century.

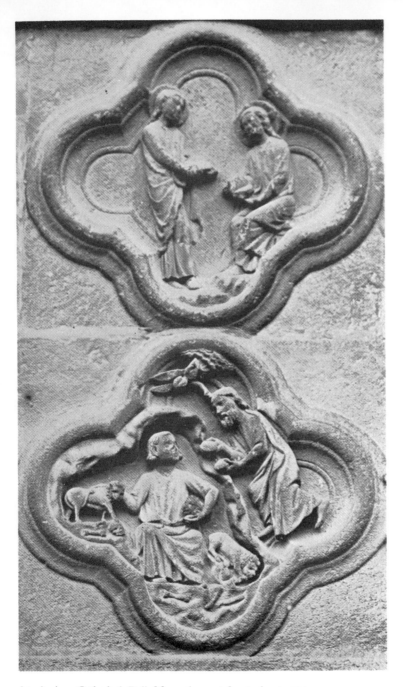

81. Amiens Cathedral. Relief from the west front, about 1225.

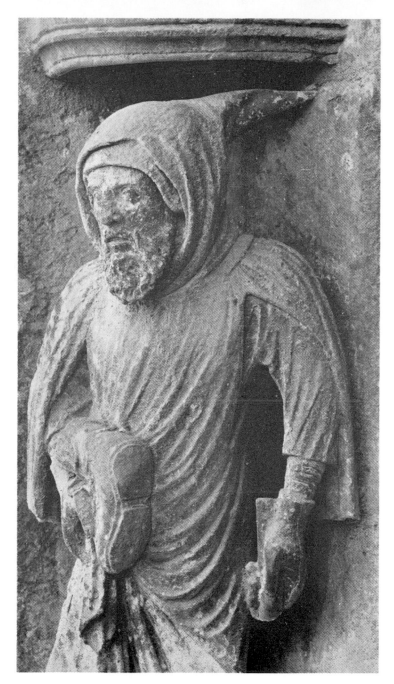

52. Chartres Cathedral. *'Winter'*, *Peasant taking off his shoes*. From the right door of the north portal, *c.* 1220.

83. Chartres Cathedral. *Head of St. Theodore*, from the west door of the south portal, *c.* 1230.

84. Reims Cathedral. *Head of Joseph*, from the central door of the west front, about 1240.

85. Reims Cathedral. *The Visitation*, from the central door of the west portal, about 1240.

86. Reims Cathedral. *Angel*, from the west front, about 1240.

87. Paris, Notre-Dame. Nave capital, *c.* 1178.

88. Reims Cathedral. Foliage, *c.* 1260–1270.

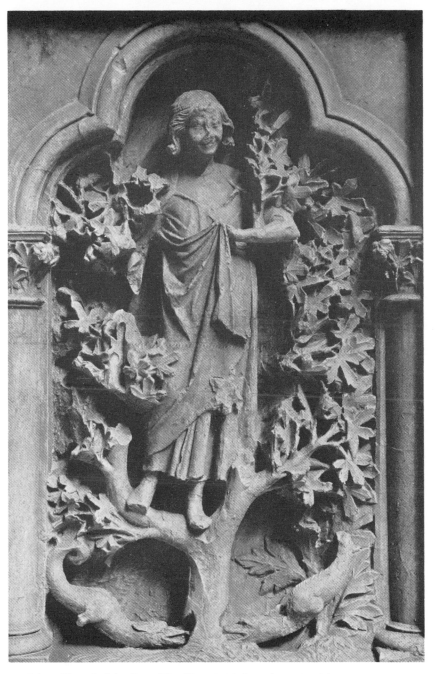

89. Joigny (Yonne), Saint-Jean. '*Youth*', probably from the tomb of the Comtesse de Joigny, end of thirteenth century.

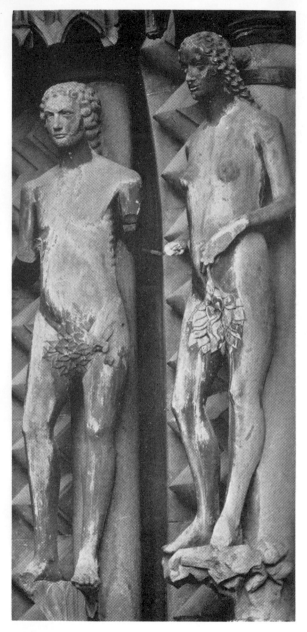

90. Bamberg Cathedral. *Adam and Eve*, from the 'Adamspforte', about 1230–1235.

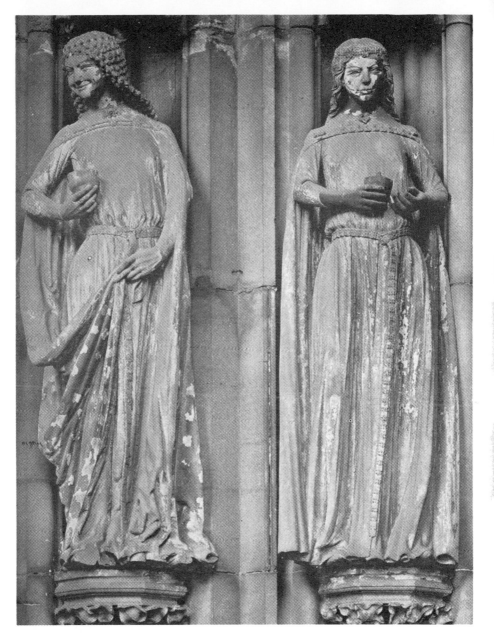

91. Magdeburg Cathedral. *The Wise Virgins*, from the 'Paradiespforte', 1240–1250.

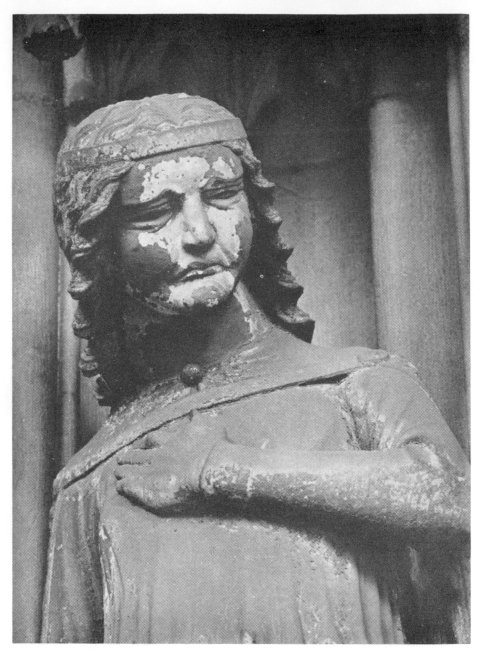

92. Magdeburg Cathedral. *Head of Foolish Virgin*, from the 'Paradiespforte', 1240–1250.

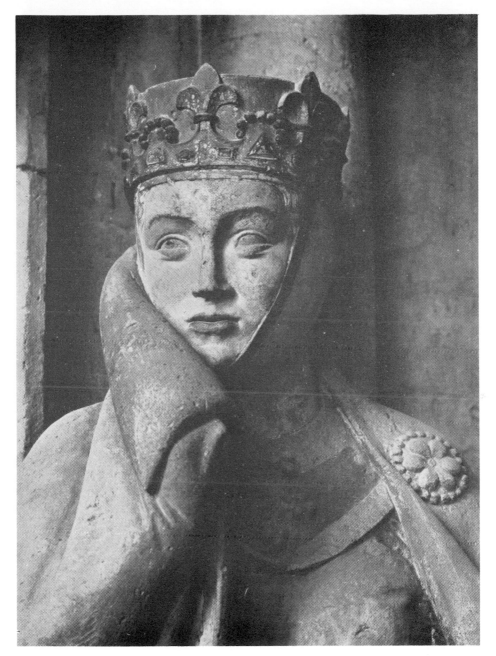

93. Naumburg Cathedral. *Head of Uta*, about 1260.

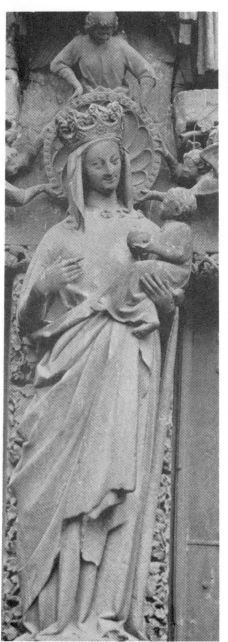
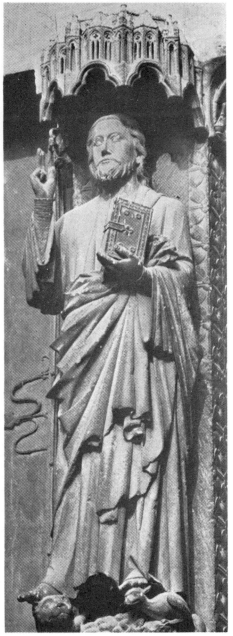

94 and 95. Amiens Cathedral.
Left: 'La Vierge Dorée', trumeau of the south portal, about 1250.
Above: 'Le Beau Dieu', central door of the west front, about 1225–1230.

96. Burgos Cathedral. Statues of *Alfonso the Wise and Violante of Aragon* in the cloisters, second half of thirteenth century.

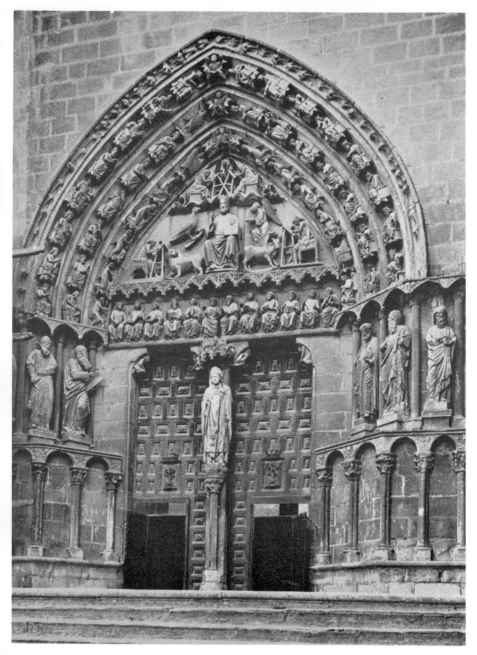

97. Burgos Cathedral. Puerta del Sarmental, *c.* 1240–1250.

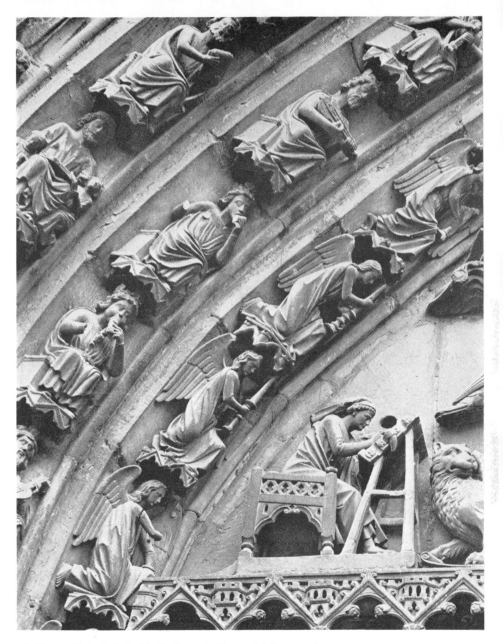

98. Burgos Cathedral. Archivolts from the Puerta del Sarmental, *c.* 1240-1250.

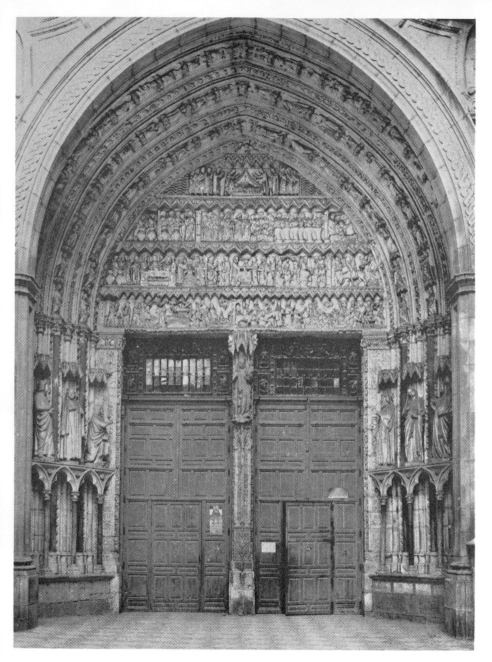

99. Toledo Cathedral. Portada de la Chapineria, fourteenth century.

100. Batalha (Portugal), Santa Maria da Vitória. Decorative detail from the cloisters, 1387–1415.

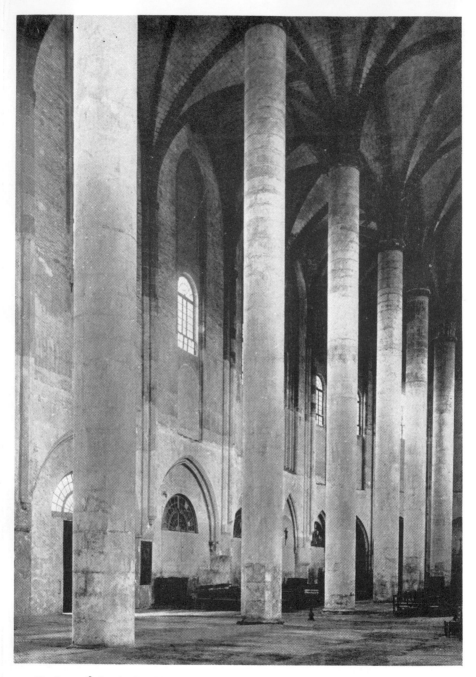

101. Toulouse, Église des Jacobins. Nave, *c.* 1245-1298 and 1330-1385.

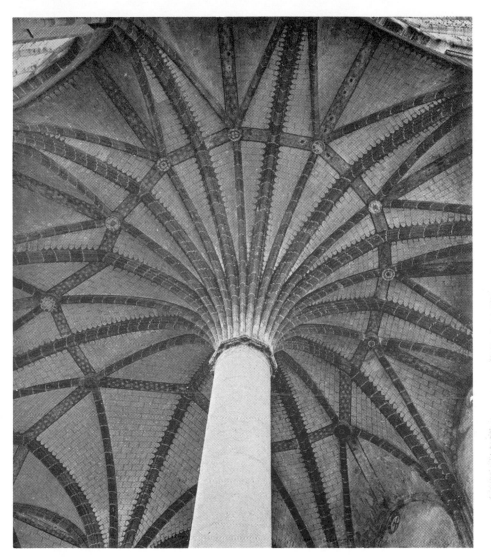

102. Toulouse, Église des Jacobins. Apse vaulting, late fourteenth century.

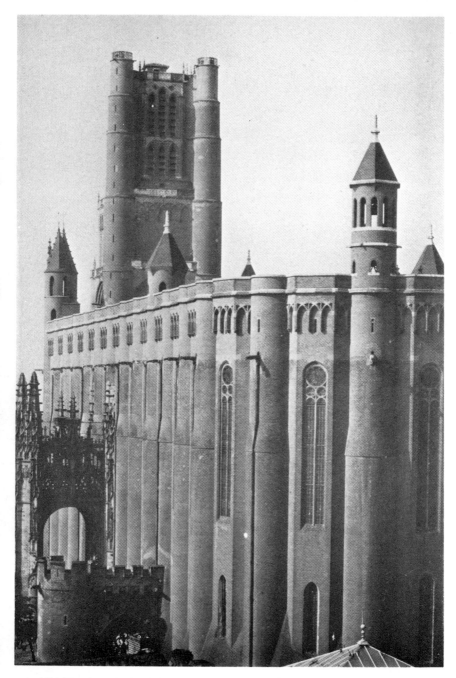

103. Albi (Tarn), Cathedral Sainte-Cécile, 1282–end of fourteenth century.

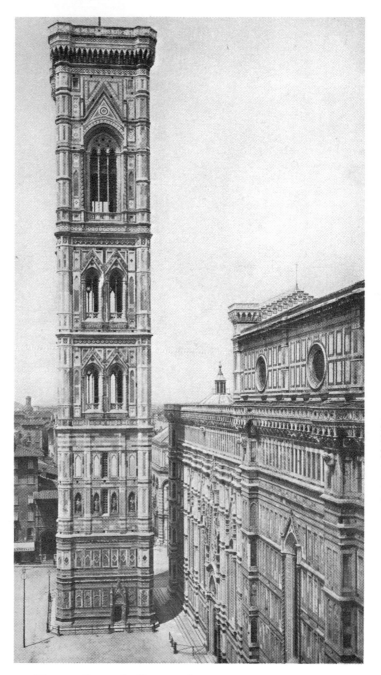

104. Florence, Campanile. Begun 1336.

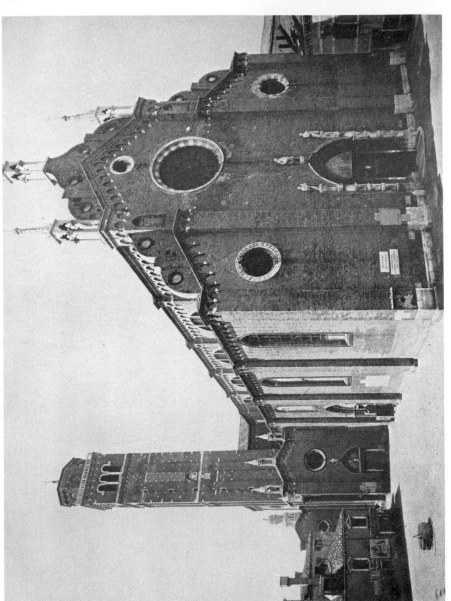

105. Venice, S. Maria dei Frari. Begun *c.* 1330–1335.

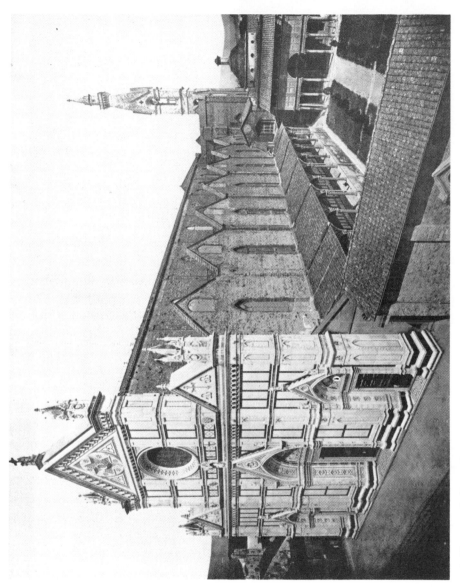

106. Florence, S. Croce. Begun 1294 or 1295.

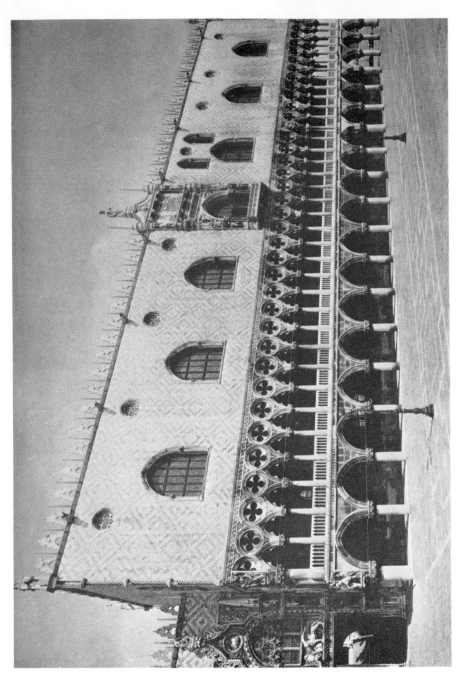

107. Venice, Ducal Palace. Begun 1340.

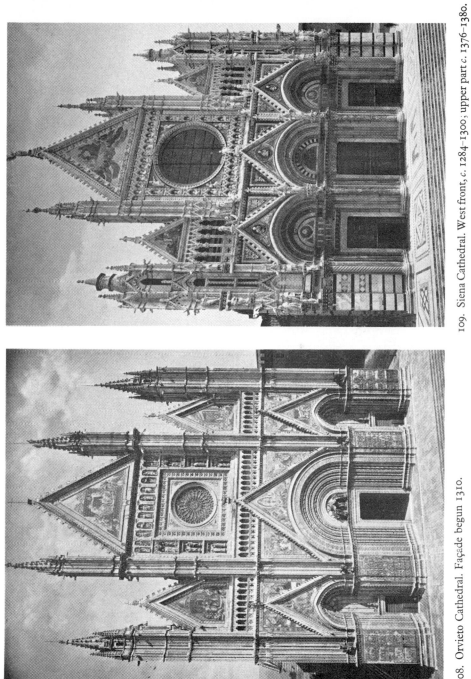

108. Orvieto Cathedral. Façade begun 1310.

109. Siena Cathedral. West front, c. 1284–1300; upper part c. 1376–1380.

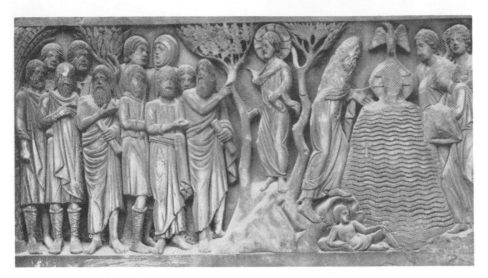

110. Pisa, Baptistery. Architrave of the main door with the *Story of St. John*, mid-thirteenth century.

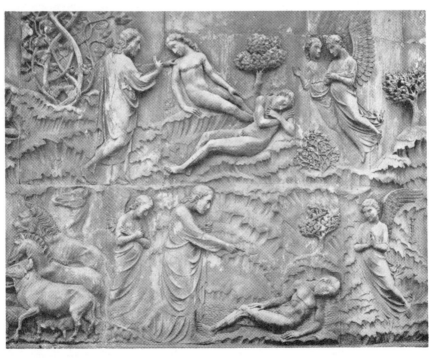

111. Orvieto Cathedral. *The Creation of Adam and Eve* by LORENZO MAITANI, between 1310 and 1330.

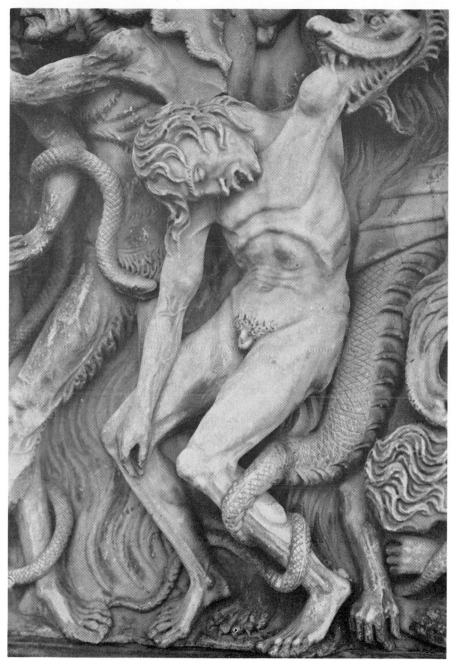

112. Orvieto Cathedral. *The Damned*, detail from the *Last Judgement* by LORENZO MAITANI, between 1310 and 1330.

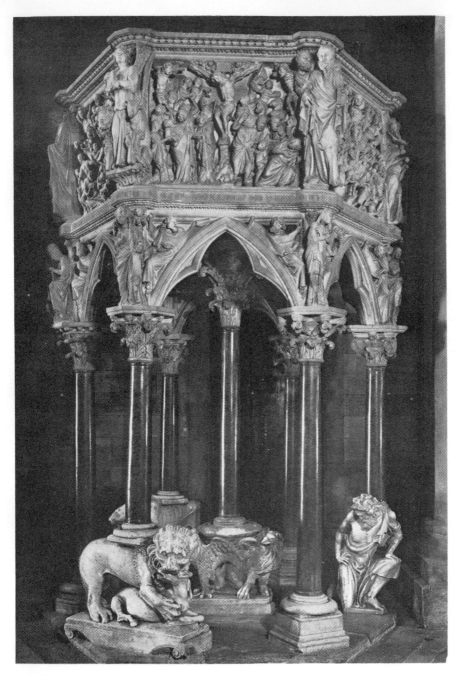

113. Pistoia, S. Andrea. Pulpit by GIOVANNI PISANO, 1301.

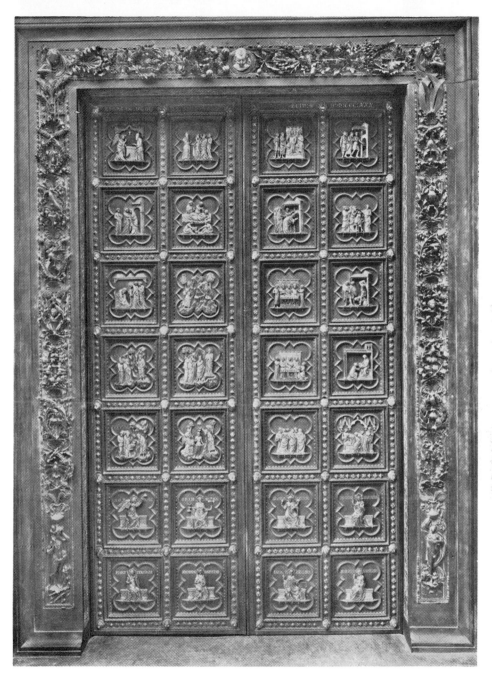

114. Florence, Baptistery. Bronze door by ANDREA PISANO, 1330–1336.

115. Florence, Or San Michele. Tabernacle by ANDREA ORCAGNA, between 1352 and 1359.

116. CIMABUE: *Madonna and Child Enthroned*, about 1280. Florence, Uffizi.

117. GIOTTO: *Marriage of the Virgin*, 1304–1313. Padua, Arena Chapel.

118. SIMONE MARTINI:
Annunciation, 1333.
(Side panels of Saints
by LIPPO MEMMI).
Florence, Uffizi.

119. Detail from the fresco '*Le Coeur d'amour*' from Sorgues, about 1360. Paris, Louvre.

120. AMBROGIO LORENZETTI: Detail from the fresco '*Good and Bad Government*', 1338–1339. Siena, Palazzo Pubblico.

121. JACQUES IVERNY: *Six Heroines of Antiquity*. Detail from the fresco in the Castello della Manta, about 1420–1430.

122. *The Falconer*. Detail from the fresco in the Palace of the Popes, Avignon, 1343.

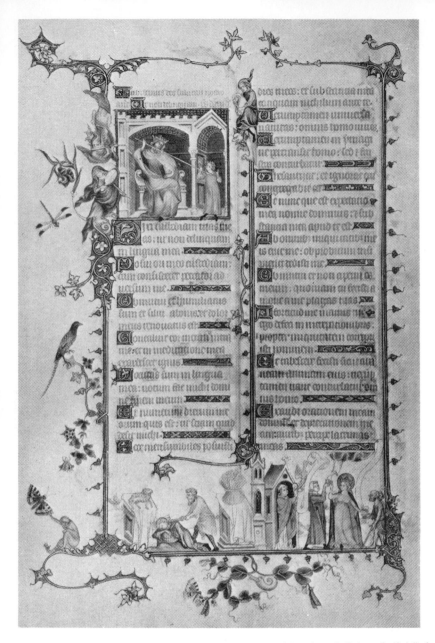

123. Belleville Breviary, showing *Saul threatening David* (above), and *Cain and Abel* (below), about 1323–1326. Paris, Bibliothèque Nationale, Ms. Lat. 10483, fol. 24 v.

124. Detail from the fresco in the Palace of the Popes, Avignon, 1343.

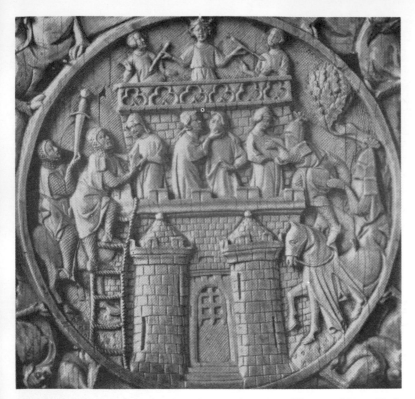

125. Ivory carving on a mirror case, fourteenth century. Florence, Museo Nazionale, Collezione Carrand.

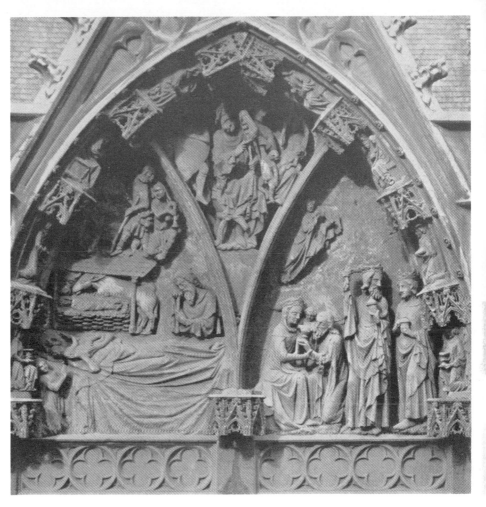

126. Huy (Belgium), Notre-Dame. Tympanum with *Scenes from the Childhood of Christ*, second half of the fourteenth century.

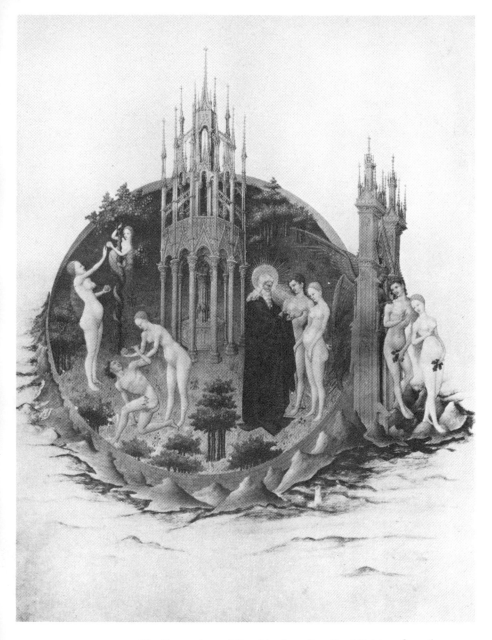

127. POL DE LIMBOURG: *The Temptation and Expulsion from Paradise*. Miniature from the Très Riches Heures du Duc de Berry, before 1416. Chantilly, Musée Condé.

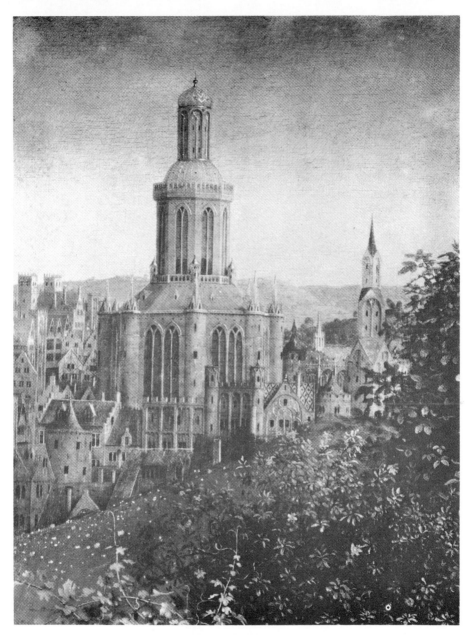

128. VAN EYCK: Detail from the altar-piece at Ghent, St. Bavon, 1432.

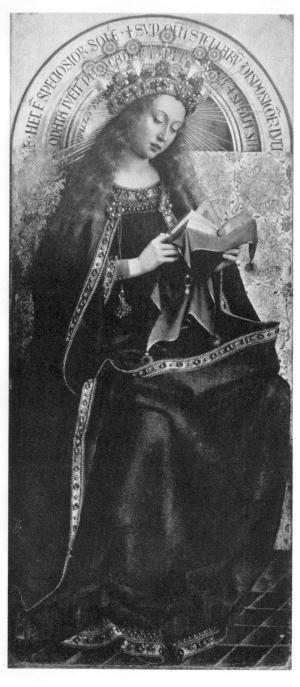

129. VAN EYCK: *The Virgin Mary.*
Detail from the altar-piece
at Ghent, St. Bavon, 1432.

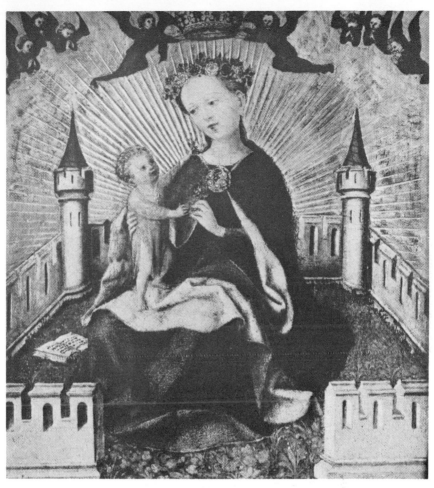

130. STEPHAN LOCHNER: *Madonna and Child*. Centre panel of a triptych, between 1430 and 1442. Cologne, Wallraf-Richartz Museum.

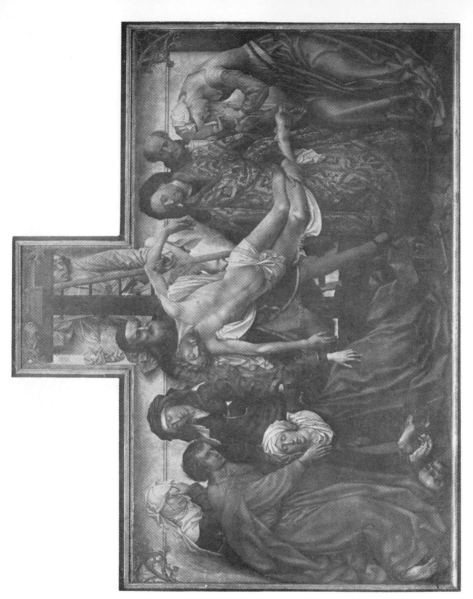

131. ROGIER VAN DER WEYDEN: *The Descent from the Cross*, soon after 1432. Madrid, Prado.

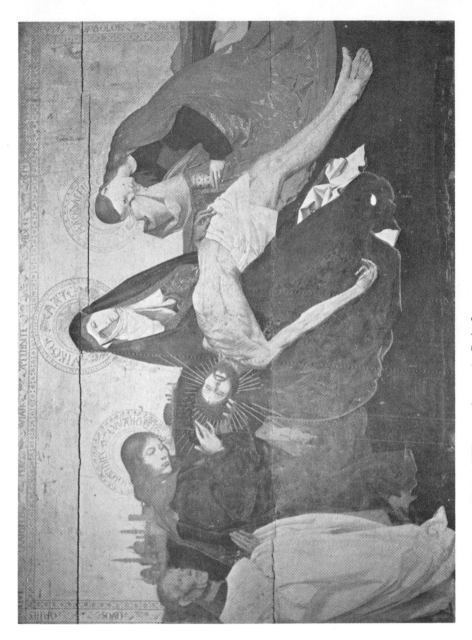

132. School of Avignon: *Pietà de Villeneuve*, about 1460. Paris, Louvre.

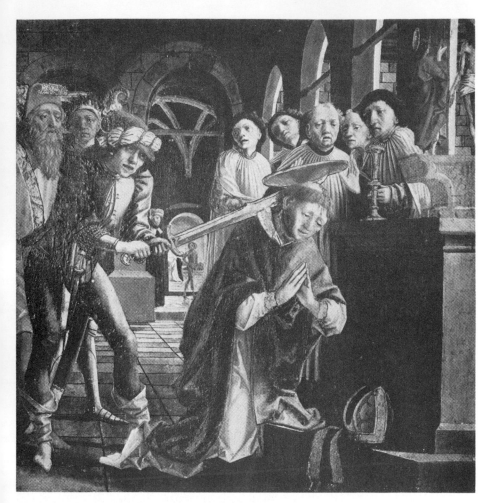

133. MICHAEL PACHER: *The Murder of Thomas à Becket*, about 1481. Graz, Joanneum.

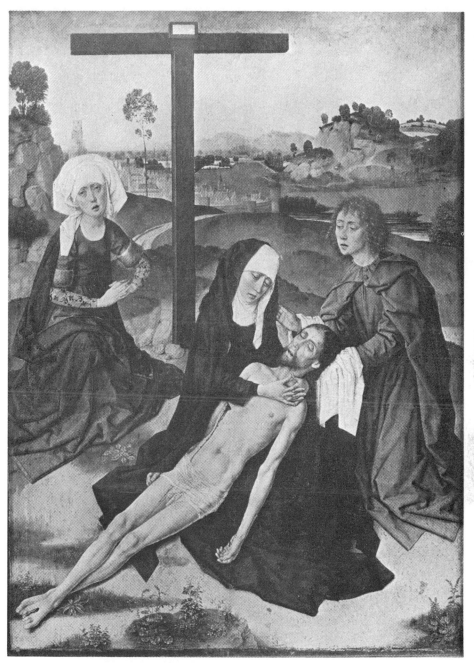

134. DIRK BOUTS: *The Deposition of Christ*, about 1450. Paris, Louvre.

136. HANS MEMLINC: Portrait of Martin van Nieuwenhove. Bruges, Memlinc Museum, St. John's Hospital.

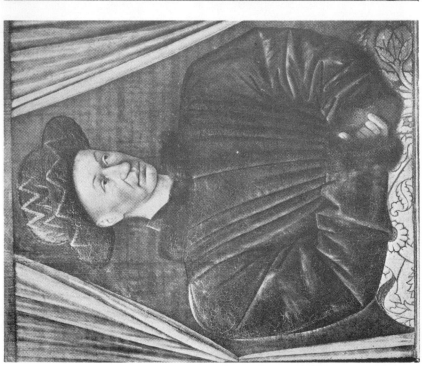

135. JEAN FOUQUET: Portrait of King Charles VII, about 1445. Paris, Louvre.

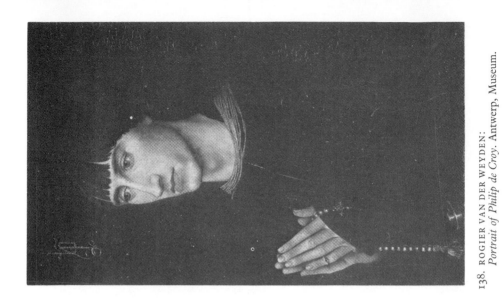

138. ROGIER VAN DER WEYDEN:
Portrait of Philip de Croy. Antwerp, Museum.

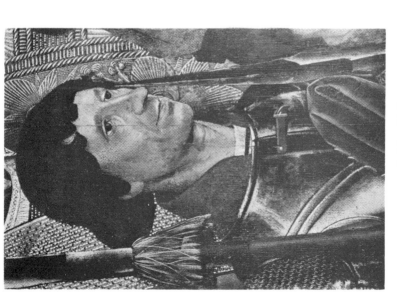

137. NUNO GONÇALVES: *Knight with Lance.*
Detail from the S. Vicente altar-piece, between 1460 and 1470.
Lisbon, Museum.

139. PISANELLO: Detail from *The Vision of St. Eustace*, second quarter of fifteenth century. London, National Gallery.

141. Bourges, Hotel Jacques Coeur. Fireplace, 1443–1451.

142. Solesmes Abbey (Sarthe). Entombment on the south wall of the south transept, about 1496.

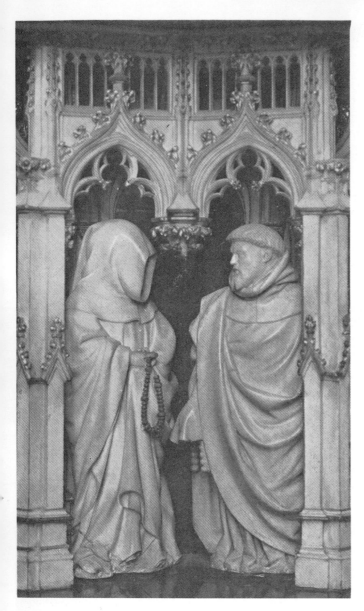

143. CLAUS SLUTER: Tomb of Philip the Bold, 1397–1405. Dijon Museum.

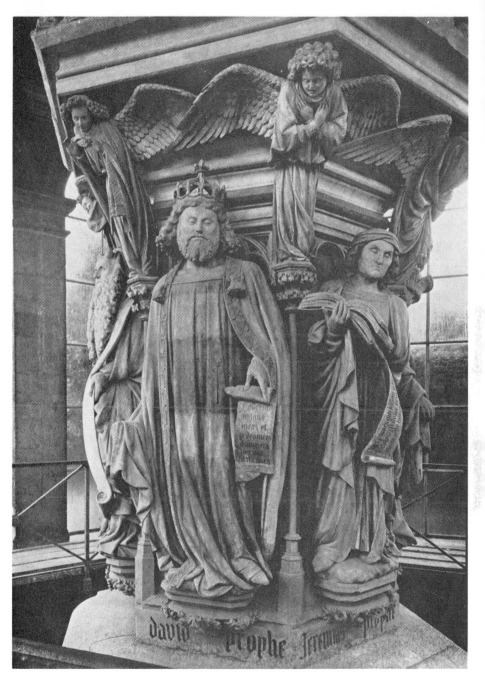

144. CLAUS SLUTER: *Moses Fountain*, 1395–1403. Dijon, Chartreuse de Champmol.

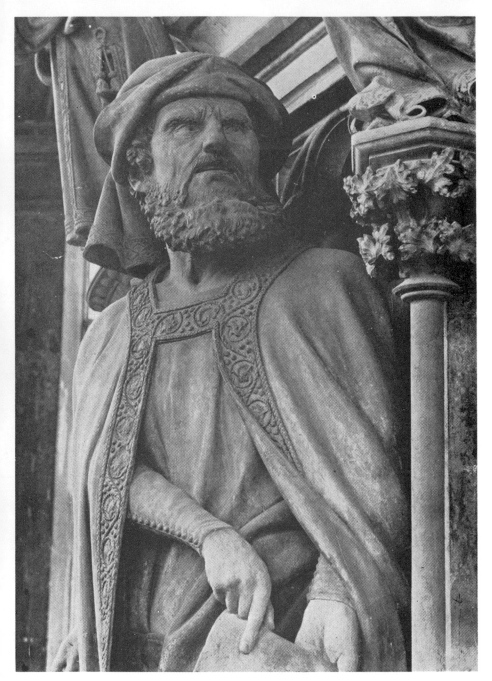

145. CLAUS SLUTER: *The Prophet Daniel*. Detail from the *Moses Fountain*, 1395–1403. Dijon, Chartreuse de Champmol.

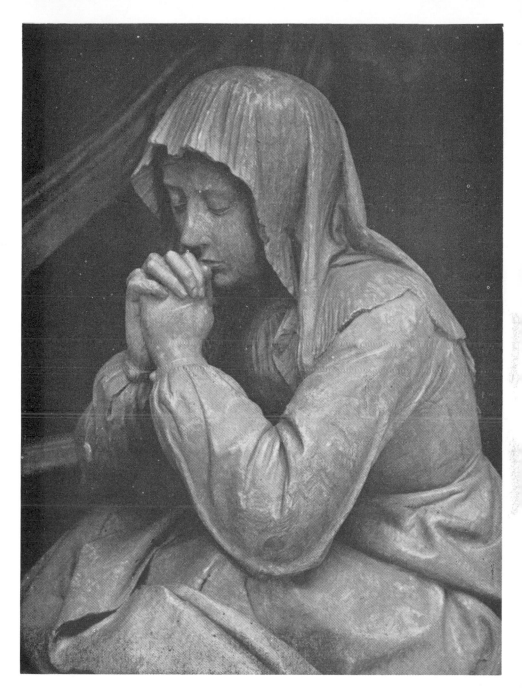

146. Solesmes Abbey (Sarthe). *St. Magdalen*, detail from Plate 142.

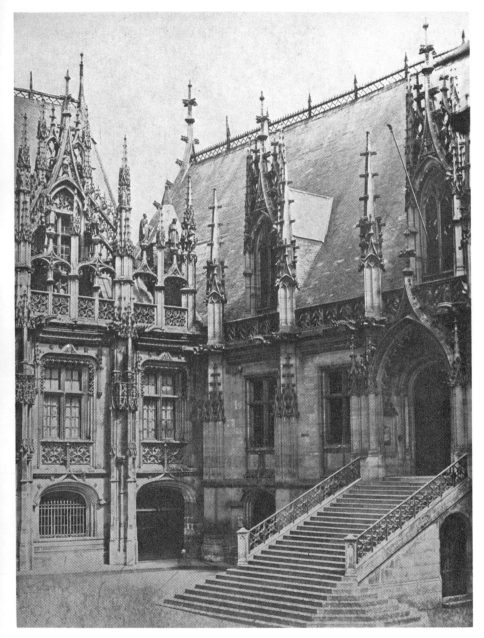

147. Rouen, Palais de Justice (before destruction), 1499–1509.

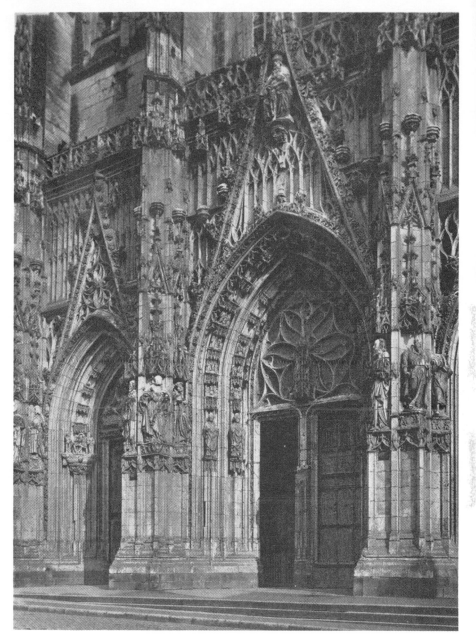

148. Abbeville, Saint-Vulfran. Centre door of west front, begun about 1488.

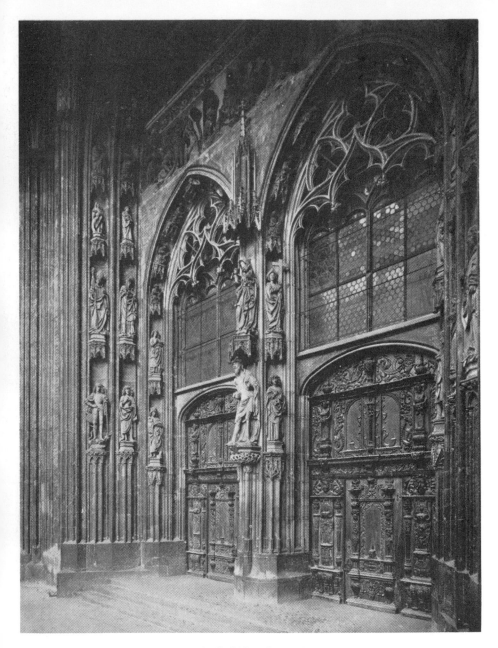

149. Ulm, Cathedral. West portal, first half of fifteenth century.

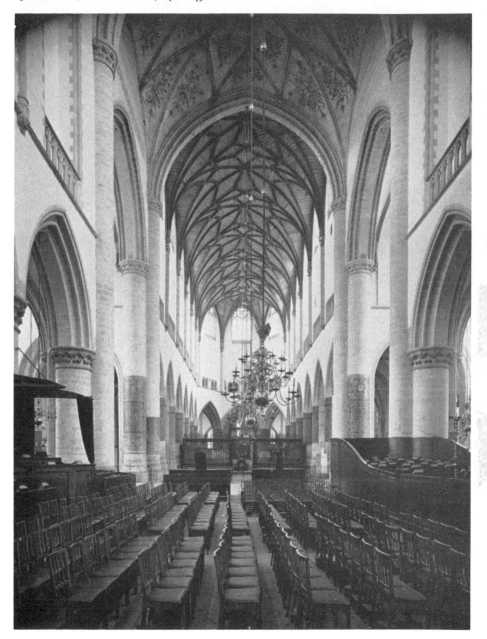

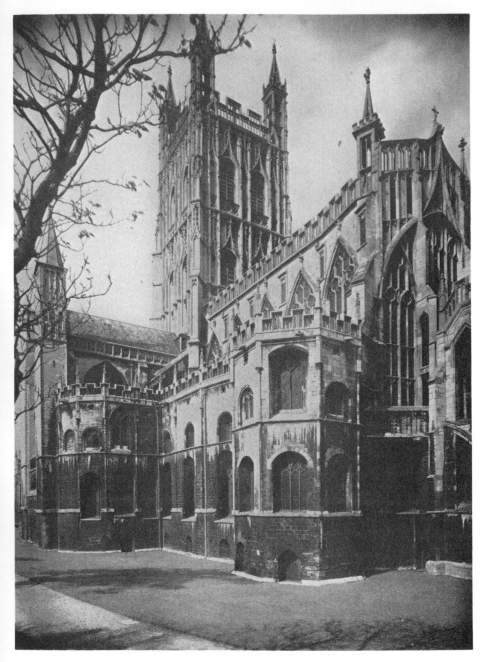

151. Gloucester Cathedral. Exterior of choir and south transept, 1331–1350;
crossing tower, 1450–1460.

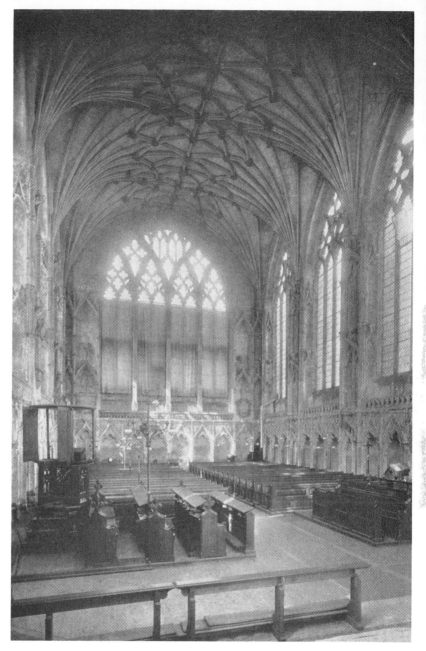

152. Ely Cathedral. Lady Chapel, 1321–1349.

153. Gloucester Cathedral. Detail from the Tomb of Edward II, about 1331.

154. Lincoln Cathedral. Decorative detail, *c.* 1260.

155. Beverley Minster. Corbel from the nave, south aisle, fourteenth century.

156. Ely Cathedral. Boss from the Lady Chapel, second quarter of fourteenth century.

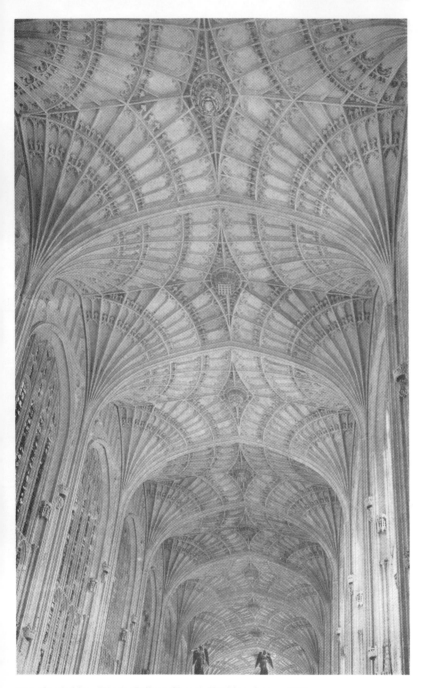

157. Cambridge, King's College Chapel. Vaulting, begun 1508.

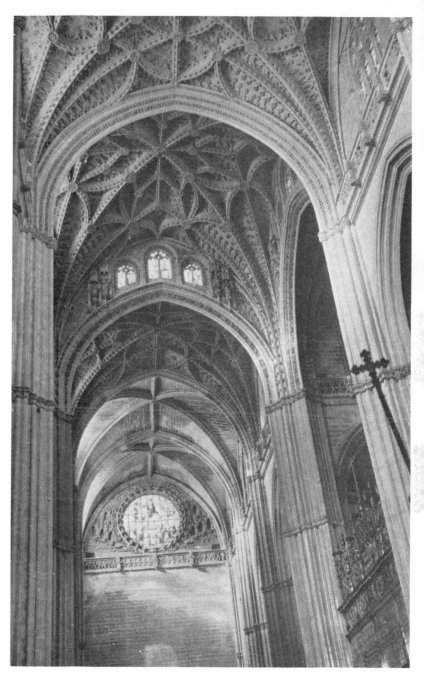

158. Seville Cathedral. Vaulting, fifteenth century.

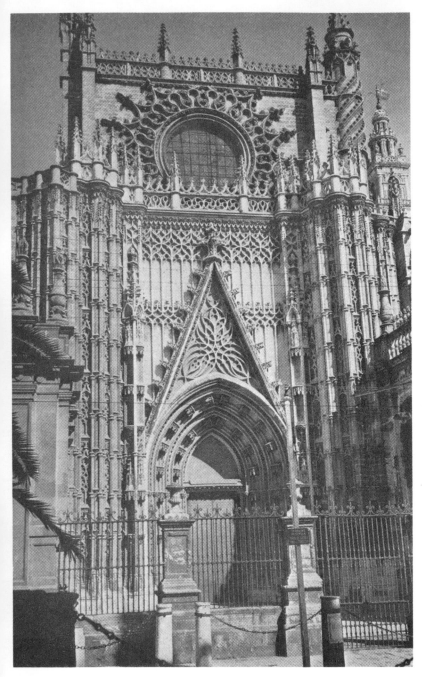

159. Seville Cathedral. Doorway, first half of fifteenth century.

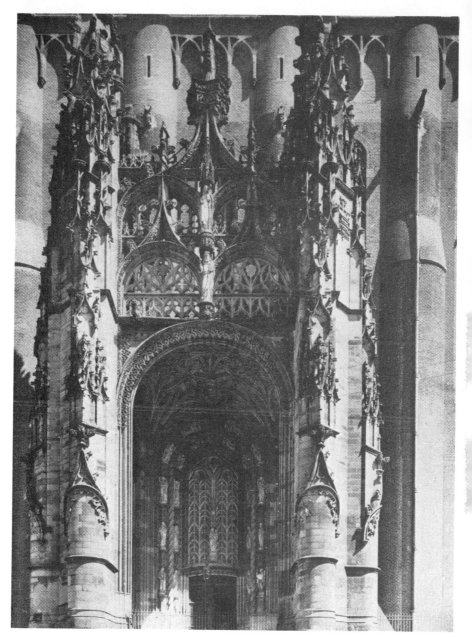

160. Albi (Tarn), Cathedral Sainte-Cécile. Porch, 1473–1502.

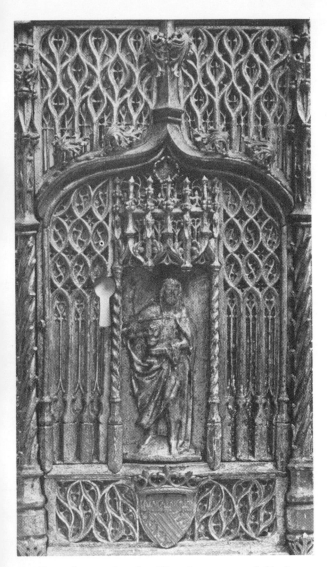

161. Door of an aumbry, late fifteenth century, probably from Saint-Loup in Troyes. London, Victoria and Albert Museum.

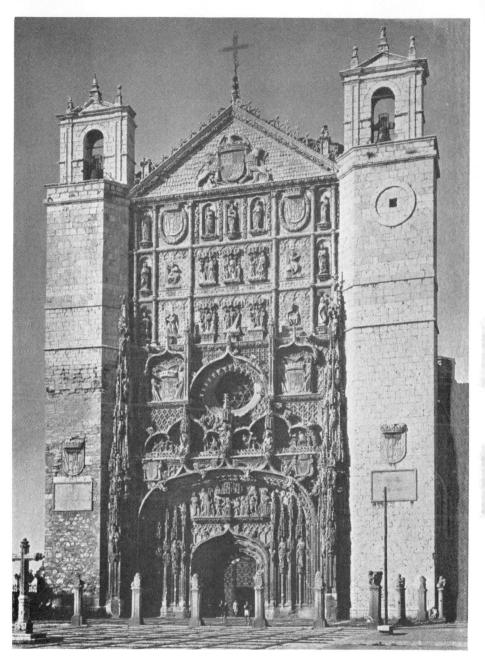

162. Valladolid, S. Pablo. Main doorway, 1486–1492.

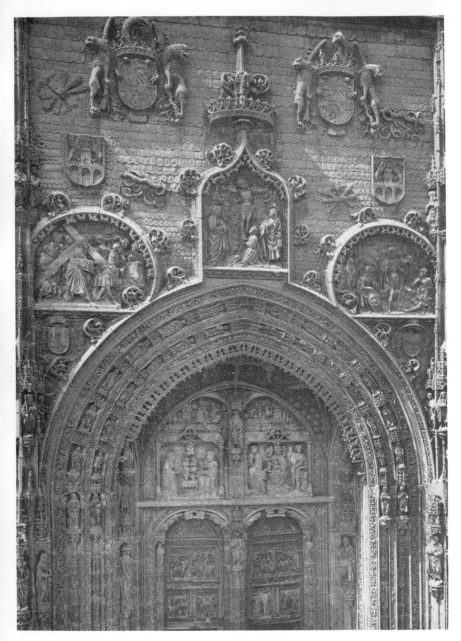

163. Aranda de Duero (Castile), Santa Maria. End of fifteenth century.

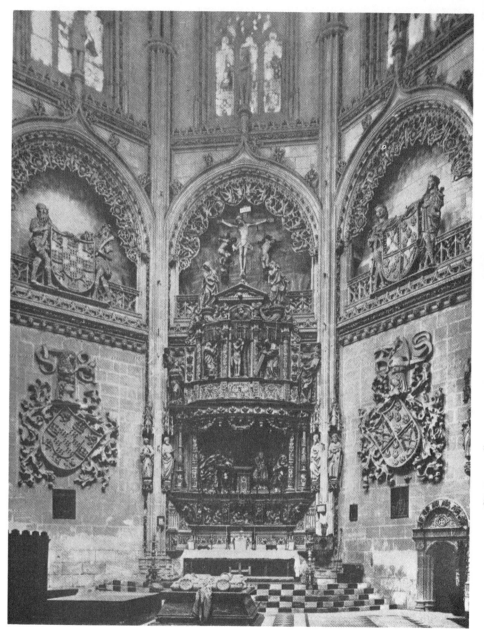

164. Burgos Cathedral. Cappella del Conestabile, begun 1482.

165. Coat of Arms from the Cappella del Conestabile in Burgos Cathedral.

LIST OF ILLUSTRATIONS

ACKNOWLEDGEMENTS

The Publishers wish to thank all who have helped with the selection of illustrations. They are grateful to all who have provided photographs, in particular to ACL, Brussels; Alinari, Florence; Archives Photographiques, Paris; Bibliothèque Nationale, Paris; Photo Bulloz, Paris; Courtauld Institute, London; Pierre Dévinoy, Paris; Giraudon, Paris; Joanneum, Graz; Foto Mas, Barcelona; Foto Marburg, Marburg-an-der-Lahn; National Buildings Record, London; National Gallery, London; Jean Roubier, Paris; Soprintendenza alle Gallerie, Florence; Victoria and Albert Museum, London; Roger Viollet, Paris; Wallraf-Richartz Museum, Cologne.

GLOSSARY

abacus, flat block of masonry between the capital of a column and the arch or lintel which is supported by the column.

aedicule, as at Silos, p. 123, Vol. I, an arch framing relief sculpture, with architectural embellishments to suggest that the figures are inside a building. Aedicular canopies, canopies projecting over the heads of sculptured figures, in the form of miniature architecture, usually battlements, gables and towers.

(akme) ακμή the Greek word for summit or climax, used of a style to denote the point of most intense development.

ambo, a pulpit, one of a pair which in early Christian churches were placed on either side of the choir enclosure. One was used for reading the Epistle, the other for the Gospel during Mass.

ambulatory, extension of the aisles of the choir around the apse, often giving access to subordinate chapels. In French churches the ambulatory is usually semi-circular with chapels disposed radially from a point in the centre of the main apse. In England, however, the ambulatory in certain twelfth and thirteenth century churches is rectangular and the chapels are parallel to the main axis of the church.

angle volute, spiral form used at the corners of Ionic and Corinthian capitals, and their medieval derivations.

antependium, an altar frontal, either a metal relief, or painted wood, or textiles.

apse, the name given to the east end of a church or chapel when this was designed around a fixed point—i.e., apses are usually circular or polygonal. But there are instances where triangular apses are used, and irregular polygons occur.

apses in echelon, or staggered apses, a series of parallel chapels, aisles, chancel, etc., each of which terminates in an apse, and designed to produce an arrow head or chevron formation.

horseshoe apse, a curved apse in which the segment is more than a semi-circle.

apsidal chapel, a subordinate chapel, usually circular or polygonal, opening from the ambulatory around the apse of a great church.

arcade, a range of arches supported on piers or columns.

blind arcade, arches supported on attached columns or pilasters ranged along a wall surface for decorative purposes only.

arcade and band, see Lombard bands.

arch, a structural mechanism composed of a series of wedge-shaped blocks of masonry, called voussoirs, arranged concentrically. When suitably buttressed arches can support a much greater load than a horizontal lintel, and are therefore a more effective means of spanning space than the latter.

1. *Round arch,* a semicircular arrangement of voussoirs around a single centre.

2. *Pointed arch,* an arch composed of arcs struck from an even number of centres, usually two.

3. *Segmental arch,* an arch composed of a single arc, less than a semicircle. Sometimes called a depressed arch.

4. *Transverse arch,* an arch set at right-angles between two parallel walls.

5. *Relieving arch,* an arch constructed within the masonry of a wall to concentrate the downward thrust of the superstructure on to pre-selected points.

6. *Quadrant arch,* an arch composed of half a semi-circular or half a pointed arch, used as buttressing in the construction of a flying buttress (Gothic) and also in the vaults of side aisles and galleries in certain Romanesque churches, where they perform the same function as flying buttresses.

architrave, horizontal lintel supported by two columns or piers. Principally found in classical architecture, or in derivations from classical models, where it functions as an alternative to the arch.

archivolt, inner or under surfaces of an arch, more especially the recessed arches of doorways in Romanesque architecture. Sometimes loosely used as a synonym to voussoirs.

arkose sandstone, a type of sandstone containing quartz.

armillary sphere, a skeleton celestial globe made up of metal bands to represent the equator and the arctic and antarctic circles, revolving on an axis.

arris, an edge formed by the intersection of two surfaces in masonry.

atlantes, the plural form of atlas, the name derived from the giant in classical mythology to denote a sculptured figure carrying a load. The masculine equivalent of caryatids.

astragal, simple moulding around the neck of a capital masking the break between column and capital.

atrium, the forecourt of a Roman house, whose centre was occupied by an impluvium or basin, and whose roof was open to the sky over the ampluvium. By extension, the term was applied to an open court in front of early Christian and some Romanesque churches.

attic bases, a moulded base for columns or half columns with a concave member between two convex. Derived from classical Ionic and Corinthian forms.

banderole, a long narrow pennant or streamer.

basilica, originally a large administrative hall, but now generally applied to any aisled church with a clerestory.

bastion, a rampart or bulwark projecting from the corner of a fortified building.

bay, a spatial compartment achieved by the regular or near-regular subdivision of a larger unit such as a nave or aisle.

billet (of timber), the trunk or branch of a tree; i.e., length of timber with circular section.

billet moulding, a pattern of small cylinders of masonry, used in Romanesque architecture.

bosses (roof bosses), projecting keystones which usually have sculptural decoration to mask an intersection of ribs in a vault.

burin, chisel-like tool used for working an engraved plate.

buttress, a projecting mass of masonry, usually placed at right angles to a wall, but occasionally diagonally as at the corners of towers, to provide additional strength in order to resist the thrusts imposed against the wall from within by the vaults, or from above by the roof of a building. Buttresses usually take the form of a short section of wall, but flying buttresses are in effect quadrant arches which lean on the walls which they are meant to support at the points where this support is needed, and which are in turn supported at their fulcrums by buttresses proper.

cabbalist, one who claims acquaintance with the Cabbala, the unwritten (mystical after thirteen century) tradition of the Jewish Rabbis about the Old Testament. A secret or esoteric doctrine.

cabochon, any precious stone that is polished but uncut.

campanile, a bell tower often isolated from the church and having arcaded openings on several levels.

canephori, originally Greek sculptured female figures bearing baskets on their heads. Often used as supports in a similar way to caryatid figures.

capital, the architectural member which surmounts a column or a pilaster and which effects a transition between the support and what is supported. When used in conjunction with columns or half-columns capitals usually connect forms of circular sections with forms of square section. The transition therefore requires either concave or convex curves at the corners of the capital. The Corinthian capital exemplifies the former; the cushion capital the latter. But many variants are known and the capital at all times provided an excuse for decorative display.

caryatid, sculptured female figure supporting a superstructure in the same way as a column.

cella, the enclosed space within the walls of an ancient temple.

chamfer, a diagonal surface made by cutting off the edge of the right angle join between two surfaces.

champlevé, an enamelling technique in which each compartment of the enamel is cut away into the substance of the foundation plaque.

chapel, originally part of a large church set apart to house an altar other than that of the principal dedication. Usually a subordinate structure attached to the main building, but sometimes an extension of the main building itself, and sometimes defined only by an arrangement of screens. Chapels were also independent buildings serving the private needs of individuals, or corporate

and collegiate organisations. In this sense they are to be found in castles, palaces, colleges.

axial chapel, chapel set at the east end of a church on the same E.W. axis as the main building.

chapels in echelon, parallel chapels at the east end of a large church on staggered plan so that the central chapel projects further than the lateral ones.

radiating chapels, chapels opening on to a semicircular ambulatory.

chequer pattern, decorative patterning arranged in squares as on a chequerboard.

chevet, eastern complex of the church usually comprising the apse, ambulatory and chapels.

chevron, zig-zag ornament.

chlamys, a short mantle of Greek origin.

ciborium, a canopy over a tomb or an altar, usually supported on columns.

cinnabar, a red pigment obtained from mercuric sulphide.

clerestory, the upper part of the nave wall containing a range of windows.

cloisonné, an enamelling technique in which the compartments are first marked out with strips of metal and then each section filled with enamel.

collegiate church, a church other than a cathedral served by a body of secular canons.

colonnade, a range of columns.

colonnettes, small columns.

columns, vertical supports for a superstructure usually made of circular blocks of stone placed one on top of another, or of one single monolithic shaft.

coupled columns, are simply double shafts used for the same purpose as a single column.

communes, a corporate feudal lordship, usually exercised by the inhabitants of towns, whose immunity from other forms of feudal lordship, if recognised, was embodied in a charter. Communes arose all over Europe during the twelfth century.

consoles, classical form of corbel made up on scrolls and volutes.

corbel, a projection on the surface of a wall, often elaborately carved, to support a weight. Thus: to corbel out is to make a supporting projection on a flat surface.

cornice, in classic architecture this is the top part of the entablature, but the term is extended to describe any projecting decorative moulding along the top of a wall or arch.

coursed masonry, masonry arranged in regular layers instead of haphazardly.

crenellation, a parapet with indentations, most common in military architecture.

crockets, decorative projecting knobs of foliage arranged at regular intervals and much used in thirteenth-century architecture on spires, pinnacles and capitals.

crossing, the part of a church on which chancel, nave, and transepts converge. In a true crossing all four arches should be approximately the same height.

crown (of arch), highest point of an arch.

cruceros, Spanish for crossing.

cupola, a dome, semi-dome, or dome-shaped vault.

dagger, in Decorated or Flamboyant tracery, an elongated derivative of the cusped circle of the earlier Geometrical tracery (in French, *soufflet*).

damascene, to inlay metal, e.g., steel with patterns of gold and silver; by analogy, the similar technique applied to glass.

diptych, an altarpiece or painting of two hinged panels which close like the leaves of a book.

dripstone, or hood mould is a projecting moulding above an opening to throw off rainwater.

en delit, the setting of masonry at right angles to its bed in the coursing; e.g., detached shafts stood on end.

engaged column, column attached to a compound pier or wall immediately behind it.

extrados, the outer curve of an arch.

falchion, literally a broad curved sword, but on p. 145, Vol. II, it is applied to a particular tracery motif, elongated and asymmetrical (in French, *mouchette*).

finial, the sharply pointed peak of a gable or pinnacle, often decorated with foliage.

flamboyant, the name given to the latest style of French Gothic architecture, originating from the undulating, flame-like shapes in the window tracery.

fluting, decorative channelling in vertical parallel lines on the surface of a column or pilaster.

foliage scroll, decorative arrangement of leaves along a twisting stem.

formeret, in a ribbed vault the arch that carries the vault where it meets the wall—hence the alternative: 'wall rib'.

freestone, any good quality fine-grained sandstone or limestone.

fretted stone, stone that is carved with intersecting decorative patterns.

gallery, a substantial upper storey carried on the aisles of a church—also called a tribune.

annular gallery, a gallery turning round a semi-circular chapel, or an apse.

gesso, the prepared ground of plaster and size on which a painting can be applied.

glacis, any sloping wall or surface of masonry. More particularly the slope at the base of fortifications.

goffer, to indent with regular recesses, so as to produce a wavy or rippling effect.

grisaille, monochrome painting that gives the effect of a piece of sculpture.

guilloche-ornament, is a circular pattern formed by two or more intertwining bands.

Hathor, Egyptian goddess with cow's head.

hawser, a thick rope or cable used for mooring and anchoring ships.

high-warp, tapestries made with the frame holding the threads in a vertical as opposed to a horizontal position.

hypogeum, a subterranean chamber as in Saint-Hilaire at Poitiers.

icon, originating in the Eastern church, it is votive painting of a sacred figure.

impost, the moulding on which an arch rests.

interlace, a geometric criss-cross ornamentation.

intrados, inner moulding or soffit of an arch.

keystone, the central or topmost voussoir of an arch which locks the others in position.

(koinê) κοινή, the common form of Greek used in the Hellenistic world after the conquests of Alexander the Great—hence any universally understood idiom.

lancet, a slender window with an acutely pointed arch at the top.

lantern, a tower or turret pierced with windows that can admit light to the interior of a church.

lierne, short intermediate rib connecting bosses and intersections of vaulting ribs.

lintel, a horizontal beam of stone joining two uprights. Usually used over doors or windows. Because of its inability to carry heavy loads, in large churches the lintel was usually used in conjunction with an arch, and the intervening semicircular surface filled with a tympanum.

liwan, barrel-vaulted reception room opening axially on to a courtyard in Mesopotamian palace architecture, Sassanian and Islamic.

Lombard bands, flat pilaster strips used to articulate a large expanse of wall surface; usually connected at the top of the wall to which they are applied by small arcades. Found in N. Italy, N. Spain, Germany, and parts of France. It was one of the distinctive features of first Romanesque architecture, but persisted, especially in Germany, into the thirteenth century.

lunette, semicircular decorative arch.

maestà, in Italian this literally means Majesty, but in iconography it describes a large painting showing the Virgin enthroned.

Mameluke, Circassian, a military body, originally of Caucasian slaves, which seized control of Egypt in 1254 and ruled that country until 1517.

mandorla, a halo framing the figure of Christ or the Virgin Mary, either square, round or elliptical in shape.

meander ornament, a pattern of wavy lines winding in and out or crossing each other.

mihrab, a projecting niche on the side of a mosque that points towards the Great Mosque at Mecca.

minaret, a slender tower on a mosque surrounded by a balcony from which the muezzin can call the faithful to prayer.

miniature, in medieval art this term is used for the paintings in illuminated manuscripts.

modillions, small corbels supporting a cornice or corbel table.

mozarabic, term used to denote art and architecture of Christian origin produced under Moorish rule in Spain, especially during eighth–eleventh centuries.

mudejar, term used to denote the style of Moorish art and architecture, produced under Christian rule in Spain, especially during fourteenth–fifteenth centuries.

mullion, upright shaft dividing a window into a number of 'lights'.

multifoil arch, an arch which is decorated with numerous cusps and foils, as in Islamic architecture.

narthex, large enclosed porch at the main entrance of a church.

newel, a post in the centre of a circular or winding staircase.

nymphaeum, in classical architecture literally: a sanctuary for nymphs, i.e. a small temple structure in a pleasant rustic setting.

ochrous, of the colour of ochre which is a light browny yellow.

oculus, a round window, with or without tracery.

offset, the part of a wall that is exposed on its upper surface when the part above is reduced in thickness.

ogee, a moulding consisting of a curve and a hollow, thus an ogee headed frame has an arch with a double curve, one concave and one convex.

ogive, the French term for the diagonal rib in a ribbed vault.

openwork gable, spire, etc., architectural forms in which tracery patterns take the place of solid masonry.

orans, a standing figure with arms upraised and outstretched in an attitude of prayer.

oratory, small chapel for private devotion.

orthogonal (adjectival), projecting at right angles; hence sometimes applied to the illusory dimension of depth in a perspective construction.

pala, Italian name for an altarpiece.

palmette, ornamental motif in the shape of a single leaf.

pantocrator, in Byzantine art the Image of Christ Omnipotent, usually set in the apex of a dome or semi-dome.

patina, literally a film caused by the oxidisation of a metal, but on p. 113, the word describes the high quality finish on a painting.

patio, paved open space outside a house, particularly characteristic of Spanish and Moorish architecture.

pediment, low pitched gable over a portico or doorway.

pendentive, spherical triangle of masonry. One of the means of effecting a transition between a cube and a dome.

pier, in masonry any support other than a column. Medieval piers were usually made of coursed stone or brick, with or without a rubble core. The simplest forms were square or rectangular in section; but many more elaborate profiles were used.

compound pier, one whose profile includes re-entrant angles.

cylindrical pier, a pier without angles in which the courses of masonry are arranged concentrically, perhaps in imitation of a column, but not to be confused with one.

clustered pier, a pier comprising a bundle of colonnettes without the intervention of angular recessions.

angle pier, 'L' shaped pier to turn the corner of a rectangular building such as a cloister.

pier shaft, the part of the pier between the base and the capital, or one member of a compound pier.

pilaster strips, decorative vertical features attached to the wall surface in the shape of shallow pillars.

podium, a pedestal or base.

polychromy, colouring.

portal, doorway.

portico, colonnaded entrance to a building.

transverse portico, an entrance with columns running parallel to the face of the building.

predella, horizontal strip of smaller scenes below a main altarpiece.

psychomachia, an iconographical subject depicting the constant duel in the soul (psyche) between the virtues and the vices.

pyx, a sacred vessel to contain the host or the Sacramental Bread.

quadrant moulding, a moulding in the form of a quarter-circle.

quatrefoil, a geometric pattern arranged in the shape of a four leaf clover.

quoin, corner stone at angle of a building.

Rayonnant architecture, the style of French Gothic architecture which prevailed roughly 1250–1350; characterised by large tracery windows and refined, linear mouldings. The name is derived from the radiating tracery of rose windows for which the style is well-known.

reliquary, a portable casket containing sacred relics.

retable, a painting or carved screen standing on the back of the altar.

ribs, arches used to carry a vault.

ridge rib, a species of lierne used to connect keystones along the crown of a vault.

roof, lean-to, roof with one inclined surface.

span, roof with two inclined surfaces.

frame, timber construction in which the inclined rafters are connected by tie-beams.

rosette, round boss with radiating petals or leaf forms.

rotunda, a building with a circular plan.

samite, a rich silk cloth often enriched with gold thread.

scriptorium, literally a place for writing, but generally applied to a group of scribes working in a single place.

scutcheon, to carve a shield-shaped base for a coat of arms.

seven liberal arts, the group of sciences which in medieval times were the basis of secular education. They are: grammar, dialectic, rhetoric, music, arithmetic, astronomy and geometry.

severies, compartments of a vault.

trapezoidal severy, a polygonal compartment with two parallel and two converging sides, e.g. part of a turning ambulatory.

silver stain method, the application of a solution of silver to colourless glass, producing in the furnace a range of yellows; or green when grey-blue glass was used. Discovered c. 1300.

solar, a private chamber in a residential suite, usually adjoining the hall of a medieval castle or palace.

spandrel, a triangular space between the curves of two adjacent arches or between an arch and the rectangle formed by the outer mouldings over it.

spire, tall conical projection from the roof of a tower.

imbricated spire, a spire covered with tiles to repel the rain.

splay, a chamfered edge at the side of a door or window.

springing, level at which an arch rises from its supporting member.

squinch, an arch placed diagonally at the angle of a square tower to support a round or octagonal tower.

stringcourse, a horizontal moulding along the face of a building dividing one register from another.

strut, part of a framework placed so that it can resist a thrust or pressure.

taïfas, the provincial dynasties which ruled in Moorish Spain after the break-up of the Caliphate in 1031.

tempera, a kind of paint in which the pigment is mixed with a glutinous vehicle, often egg white, that is soluble in water. It can only be used on a gesso or fresco ground.

teratological, referring to monsters.

terra sigillata, clay coloured by iron oxide, also known as Earth of Lemnos. Used for manufacturing moulded pottery in the Roman Empire, and the name is applied to this ware.

tetramorph, composite representation of the four Symbols of the Evangelists.

theophany, the appearance of God or other heavenly bodies to Man.

thermae, public baths built in classical times.

tierceron, rib other than the transverse or ogive, running from the main springer to the crown of the vault.

toric, rounded, as applied to a roll moulding or torus.

tracery, geometrical patterns of cut stone, used in windows, on walls, or freestanding.

bar tracery, tracery composed of thin strips of moulded stone, in which the proportion of void to solid is relatively high.

plate tracery, tracery in which the patterns are formed by perforating continuous surfaces of masonry.

rose tracery, tracery pattern radiating outward from a single centre, e.g. in round windows.

tribune, gallery above the aisles with an arcaded opening on to the nave.

depressed tribune, less than a full gallery,

but not walled off to form a passage-way, like a triforium.

triforium, passage with an arcade opening on to the nave, and a wall behind, corresponding to the rafters of an aisle or gallery roof.

triptych, an altarpiece or votive painting which has hinged panels on either side that, when closed, cover the central panel.

trompe-l'oeil, illusionary effect of reality.

trumeau, central support for a tympanum in a large doorway.

truncated dome, a dome that is flatter than a half circle in section.

tufa, rough porous stone.

tympanum, the space between the lintel and the arch above a doorway.

typological, symbolical representation based on the notion of cyclical repetitions or parallelisms.

uncial, a rounded type of script used in classical manuscripts.

vault, a form of masonry ceiling, based on the principle of the arch. In classical Roman buildings, and certain buildings inspired by classical Roman examples, the vaults carry the roof directly. In most Northern medieval buildings, the roof was carried on a completely independent timber structure above the vaults.

barrel vault, a continuous half-cylinder of masonry, sometimes articulated by transverse ribs.

transverse barrel vault, sections of barrel vault carried on transverse arches, at right angles to the main axis of the building.

pointed barrel, a barrel vault whose section is that of a pointed arch.

half-barrel, an asymmetrical vault whose section is a quadrant, used to cover side aisles or galleries, and at the same time to act as buttresses for the adjacent main vault.

annular barrel vault, a barrel vault over a turning ambulatory.

groined vault, originally perhaps conceived as two barrel vaults intersecting one another at right angles. So-called because the lines of intersection form groins. Few medieval groined vaults however, strictly conform to this definition. In the majority of cases, the groins are rationalised into simple arcs, and

the cells of the vault are contiguous spherical triangles of different radii.

ribbed vault, a vault of which the cells are carried on a structure of arches. The minimum number of arches required are two transverse, and two ogives. In a fully developed ribbed vault however the system is completed by wall ribs (formerets). Additional ribs were sometimes included, either to strengthen the structure, or for the sake of visual effects.

domical vault, vaults of which the crown rises much higher than the sides. Hence an approximation to the form of a dome.

level crown vaults, vaults in which the longitudinal section through the crowns is approximately horizontal.

semidome vault, half a dome used to vault apses.

quadripartite vault, a ribbed vault of which the web is divided into four cells by two intersecting ogives.

sexpartite vault, a ribbed vault of which the web is divided into six cells by two intersecting ogives and an additional transverse rib through the same keystone.

five-part and eight-part, a ribbed vault in which five or eight ribs converge on the central keystone.

vault cell, any part of the web of a vault as defined by ribs or groins.

volutes, the term strictly refers to the spiral scroll of a classical capital but its more general sense applies to any curved ornament particularly on capitals and consoles.

volvic stone, stone from the quarries of Volvic, a district in Puy-de-Dome, France, about 4 miles from Riom.

voussoirs, the wedge shaped stones which are used to build an arch.

web, the stone infilling between the ribs of a vault.

window embrasure, the splay of a window.

dormer windows, windows placed vertically on a sloping roof—thus normally in an attic.

rose window, circular window with radiating stone tracery.

window register, range of windows.

woodshaving pattern, an arrangement of superimposed volutes, sometimes used to decorate the sides of modillions and corbels in Romanesque architecture.

INDEX

CONTENTS OF VOLUME ONE

CHAPTER III. ROMANESQUE DECORATION

I. The epic sentiment in the iconography. The Apocalyptic source. Visionary theology. The ancient East. Theophany. The metamorphosis of man. II. The style. The architectural character of sculpture. The positioning of Romanesque sculpture. The form determined by the setting. The capital, the archivolt, the tympanum. The rectangular panel and the principle of contacts. Experiments to achieve movement.—The decorative character of the sculpture. Romanesque sculpture as a dialectic development. III. The sources.—The East Christian communities. Syria, Egypt, Transcaucasia, and Sumerian art.—Islam: geometrical forms.—Ireland: interlacements.—Carolingian art.—Local traditions: the Roman art of Gaul. IV. The question of beginnings. The Burgundy-Languedoc problem. The Spain-Languedoc problem.—The French workshops.—The peripheral groups.—The evolution of sculpture in the twelfth century. The baroque phase of Romanesque art. V. Romanesque art and colour. The problem of polychromy.—Relationships of metalwork, illumination, and wall-painting. The architectural rule governing colour.—Monumental painting. Technique, groups and workshops. Bibliography.

ACKNOWLEDGEMENTS

ILLUSTRATIONS · LIST OF ILLUSTRATIONS

GLOSSARY · INDEX